Beyond Vision

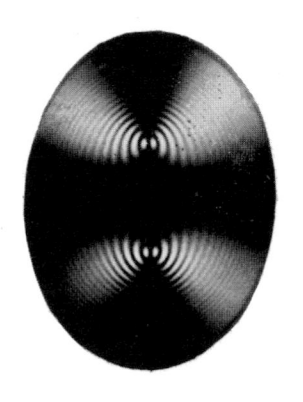

*One Hundred Historic
Scientific Photographs*

Beyond Vision
Jon Darius

Oxford New York
Oxford University Press
1984

Oxford University Press, Walton Street, Oxford OX2 6DP

London Glasgow New York Toronto
Delhi Bombay Calcutta Madras Karachi
Kuala Lumpur Singapore Hong Kong Tokyo
Nairobi Dar es Salaam Cape Town
Melbourne Auckland
and associates in
Beirut Berlin Ibadan Mexico City Nicosia

OXFORD is a trade mark of Oxford University Press

British Library Cataloguing in Publication Data
Darius, Jon
 Beyond vision.
 1. Science——History——Pictorial works
 I. Title
 509 Q125.6
 ISBN 0–19–853245–8

Library of Congress Cataloging in Publication Data
Darius, Jon
 Beyond vision.

 Bibliography: p.
 Includes index.
 1. Photography——Scientific applications. I. Title
TR692.D37 1984 778.3 84–4405
ISBN 0–19–853245–8

This book was designed and produced by
A. H. JOLLY (EDITORIAL) LTD
for Oxford University Press

Printed in Great Britain by
JOLLY & BARBER LTD, RUGBY, WARWICKSHIRE

Preface

It was the inauguration of a new museum – the National Museum of Photography, Film and Television – which lit the fuse leading to *Beyond Vision*. Inspired in part by the creation of the new museum as an outpost of the Science Museum, London, the idea of assembling a set of historic scientific photographs germinated in 1982.

This book and the corresponding exhibition can claim with some justice to be the first of their kind. Of course scientific photographs have been collected in books and displays on many previous occasions for the edification, amusement, even bewilderment of the public. The images are usually selected either to illustrate the range and power of a tool or technique wielded by the scientific photographer (electron microscopy, for instance) or else to dazzle the viewer with aesthetically pleasing shots of balloons at burstpoint, heat maps of the body, supernova remnants in blazing colour and so forth. Neither of these categories is to be denigrated and both have produced memorable collections – but in spite of several aims in common with the present collection, they diverge from it in one particular above all: for the most part their photographs, however praiseworthy, are *typical* examples whereas the criterion for inclusion in *Beyond Vision* is that they be *unique*.

Beyond Vision is more than a catchy title: it nicely defines what is meant by a "scientific" photograph for our purposes, namely one which provides information inaccessible to the human eye. On all scales from the submicroscopic to the cosmic, photography has the ability to expand our limited vision, revealing invisible radiations, fleeting events, vanishingly faint images, remote realms of space and ocean which the naked eye cannot capture. Francis Thompson could have been describing scientific photography when he wrote, "O world invisible, we view thee ... O world unknowable, we know thee,/Inapprehensible, we clutch thee."

This definition neatly sidesteps the deluge of photographs which merely depict scientific subjects, so that we shall not be compelled to consider pictures of butterflies parading in the guise of entomology, nor rocky outcrops representing geology, not even records of skin diseases dermatology. Scientists may find them handy, technical journals may publish them – but in such photographs the camera does not afford us an understanding that the eye alone could not attain. Equally, the domain of documentary photography is completely foreign: there are no photographic records of the Curies' laboratory, nor candid shots of Einstein sticking out his tongue.

"Historic" may but need not be "historical". The images herein span the history of photography from its origins nearly 150 years ago to the present day, from the once popular daguerreotype to digitally encoded photographs from deep space. Some of the pictures will already be well known, such as the discovery plates of Pluto, outermost planet in the Solar System; or *a fortiori* classic images of the Earth seen from space. Others, like the discovery of charm or an infrared rainbow, will not be familiar to the general public, but they are just as historic in their way. Each image included is unique because of its intrinsic significance (e.g., the faintest image ever recorded), because of

its place in the history of science (discovery of the positron), or because it is a classic in its own right (the first picture returned from the surface of Mars). Many of these historic photographs gained their particular significance as objects of measurement, but others earn their place on account of their influence even though they may never have been submitted to ruler or densitometer.

Finally, the definition of a "photograph" is allowed to be almost as flexible as "historic" and "scientific" are tightly constrained. To insist on the presence of an emulsion would be to exclude most space imagery – no venial omission. The definition is stretched to cover photographs comprised of more than one image, either in space (photomontage) or in time; images at non-visual wavelengths coded in false colours; non-pictorial photographs such as spectra and interference patterns. It is high time that we expand our narrow vision of photography to allow for the incursion of more recent technologies. The only firm exclusion applies to employment of the light-sensitive surface simply as a flux collector in one dimension; thus there are no examples of photometry or of plates blackened by radioactive sources.

Put all these criteria together and it will be obvious how this heterogeneous selection came together, a selection made from an initial cast of several hundred in which the emphasis falls not on the photographically representative but on the historically unique. Indeed, as might be expected, there are whole areas of both scientific research and photographic technique without representation at all. The photographic plate reigned supreme for the better part of a century in astronomy and for several decades in nuclear physics – so it is only just that the collection should favour these topics. On the other hand, photography has scarcely ever been the primary source of information in, say, botany or zoology except for purposes of record and illustration – and this paucity is also reflected. Different sciences, after all, call for different tools. As for photographic technique, the existence of historic – not just typical – photographs was once again the determining factor. Thus the omission of infrared luminescence, for example, is no mere oversight.

The genres of photography which do figure are already wide-ranging: high-speed and its alter ego time-lapse photography; X-ray, ultraviolet, optical, infrared, even microwave images; microscopy in its optical, electron and field-ion varieties; patterns created by interference, scattering, polarization and spectral dispersion; holography; and specialized techniques from inner space (e.g., angiography) to outer space (digital reconstruction and enhancement). In the best tradition of Guinness-style record-chasing, the collection also boasts photographic medallists in the realms of the smallest, the fastest, the faintest and the farthest.

So intense has the hunt been for suitable historic scientific photographs that in many cases the pictures will be a revelation no less to the specialist than to the general public. Many cardiologists will be unaware that the historic radiographs of W. Forssmann's self-catheterization still exist, and neither optical physicists nor photographic historians are likely to have encountered William Crookes' polarization patterns. Sadly, the list of photographs whose originals (or direct copies) could nowhere be unearthed has grown quite as long. The endemic disinterest of the research scientist in his own photographic creations, coupled with the negligence of archivists and historians, must account for the disappearance of so many strong candidates for *Beyond Vision*: the historic arteriogram made in Vienna by E. Haschek and O. T. Lindenthal in 1896 by injecting the hand of a female corpse with a mixture of mercury compound and paraffin; the earliest X-ray diffraction pattern of cupric sulphate crystals made by the great Max von Laue at Easter 1912 with W. Friedrich and P. Knipping; electron micrographs of a diatom by F. Krause (1937) which surpassed the resolution of the light microscope for the first time; the very first thermogram of a human being, a prostrate man recorded in France in 1946... Reproductions of all of these have been published, but the originals

may never come to light. In other cases, such as the "instantaneous" calotype picture by W. H. Fox Talbot (1851) or the first photograph of a comet (1858), no traces whatever remain.

For each of the hundred photographs, the supporting text supplies not only the scientific and historical context but wherever possible information on the photographic methods and equipment employed. At the end of every entry appears a summary of technical data: ideally the exact date, place, photographer, apparatus, emulsion, exposure time and source for the picture in question. It is not a little remarkable how often these basic facts are omitted from the published account of a scientist's work. Three or four references are appended to assist in probing further, preference being given to articles and books dealing with the particular photograph at hand and the technique by which it was obtained. Primary sources generally take precedence. Only in the case of ten or more authors on a given paper are co-authors rendered *et alii*. The references collected alphabetically on pp 220–222 tend to exclude bibliographical material not immediately germane to the individual photographs. The introductory essay sets the scene for the photographs which follow, but does not pretend to mine even the sparser veins of this rich subject.

For convenience a chronological order is followed in this book. Note that unlike most other volumes of scientific photographs for a lay audience, the initial selection criteria were scientific and historic, not aesthetic. Only when the final "hot hundred" were picked did a measure of aesthetic judgment come into play. Even so, many pictures whose beauty is intellectual rather than visual have not been displaced by more alluring rivals. The most distant known object may be an undistinguished dot, but it still carries a special excitement. Happily the scientifically significant and the visually seductive are not always mortal enemies.

In addition to the individuals and institutions already *explicitly* acknowledged in the text, I should like to thank the many other people whose support – and criticism – have made *Beyond Vision* a reality. The rationale for the exhibition evolved from discussions with David Thomas and Dame Margaret Weston, Director of the Science Museum. Execution of the idea owes a lot to my Museum colleagues, too numerous to list though special mention must be made of Ray Batchelor and Judit Brody for their help with translations. I am exceedingly grateful to the scientists and historians who assisted in tracking down particular photographs or supplying pertinent technical information: J. Kelly Beatty, Berlyn Brixner, Robert Brucato, Gail Buckland, Chick Capen, Robert Dietz, Janet Dudley, Elsbet Forssmann, Owen Gingerich, Al Glassgold, Leon Golub, Brian Hadley, G. Hartl, Franz Heymann, Peter Hingley, Anne Kahle, Carolyn Kopp, Anita Kuisle, Enid Lake, Steve Larson, Martha Liller, Franz Loogen, Gary Mechler, John Morgan, Philip Morrison, David Pieri, Leslie Pieri, Dai Rees, Marie-Pierre Romand, Leon Salanave, Steve Saunders, Ann Savage, Elliot Sivowitch, Dan Sprod, Faith Stephens, A. J. Stilp, Rich Terrile, Philip Weimerskirch, H. Wenninger and Alwyne Wheeler. I also very much appreciate more general help and advice from Andy Eskind, Barney Finn, Hank Holt, Emory Kristof, Martin Scott, Jim Soha, Brian Thompson and Jurrie van der Woude; as well as members of the Centre for Remote Sensing (Imperial College) and the Planetary Image Centre (University of London Observatory). Acknowledgments are due to George Batchelor, Basil Blackwell (and Sir Fred Hoyle), W. H. Freeman and Co., MacDonald and Co., *The Observatory* (and Martin Rees), the *Journal of Experimental Medicine* (Rockefeller University Press), Rutgers University Press, St. Martin's Press and *Sky and Telescope* (and Clyde Tombaugh) for permission to quote short passages. Finally, very special thanks are due to David Abramson and Alec Jolly for their encouragement and advice, and to my wife for her support and forbearance.

Jon Darius
Science Museum, 1984

Contents

Introduction

A Concise History of Scientific Photography

The single most extraordinary fact of the history of scientific photography is that it did not languish in the wings watching the rehearsals of mainstream photography, but joined the act very early indeed. Photographic chemistry was still in its experimental stages when its application to scientific problems was first mooted. Yet the origins of photography some 150 years ago at first owed precious little to the demands of science.

The impetus for the invention of photography in fact arose not so much in the chemical laboratory as in the artist's studio. It is not to resourceful scientists studying photochemistry but to aspiring artists attempting to compensate for their mediocre drawing talents that we owe the earliest photographic images. So much is evident from the camera obscura, a forerunner of the photographic camera first described by the Arab mathematician Ibn al-Haytham around 1000 AD, and the camera lucida invented by W. H. Wollaston in 1807 – both widely used as aids for draughtsmen and unskilled artists.

The first photographic positive was achieved in about 1826 by J. N. Niépce who placed a bitumen-coated pewter plate at the rear of a camera obscura, exposed for the whole day, and finally washed it in lavender oil which dissolved the shadowed portions of the bitumen "emulsion". The first practical photographic process was invented by L. J. M. Daguerre ten years later, inspired by the need to produce illusionist paintings for his Diorama theatre. Even W. H. F. Talbot, originator of the negative-positive process, turned to photographic experiments not initially out of scientific curiosity but from the desire to supplement his limited artistic skills. In 1844 he recalled that eleven years earlier he had tried in vain to sketch the scenery around Lake Como with the help of a camera lucida. "After various fruitless attempts, I laid aside the instrument and came to the conclusion that its use required a previous knowledge of drawing which unfortunately I did not possess. I then thought of trying again a method which I had tried many years before. This method was to take a Camera Obscura and to throw the image of the objects on a piece of transparent tracing paper laid on a pane of glass in the focus of the instrument [to produce] fairy pictures, creations of a moment, and destined as rapidly to fade away. It was during these thoughts that the idea occurred to me: how charming it would be if it were possible to cause these natural images to imprint themselves durably, and remain fixed upon the paper!"

Granted such scientifically inauspicious origins, one could be forgiven for expecting that recognition of the scientific significance of photography would be slow in coming. Not a bit of it! It was not Daguerre who issued the first *public* announcement of his invention but F. Arago, director of the Paris Observatory. The occasion was appropriately a joint meeting of the Académie des Sciences and the Académie des Beaux-Arts on 19 August 1839, and it created a public furore. Within days Parisian opticians were inundated with demands for the new apparatus; within four months thirty editions of Daguerre's booklet describing the process had appeared.

Arago at once foresaw astronomical applications for Daguerre's new process and already in 1839 advocated its use to obtain an improved map of the Moon,

to undertake absolute and relative photometry of celestial bodies and to enumerate the absorption lines first seen visually in the solar spectrum by W. H. Wollaston in 1802 and by J. Fraunhofer in 1814. Enthusiasm over the scientific promise of photography has always run high, even when the realization of that promise lay many years distant. Echoing Arago, the French chemist J. L. Gay-Lussac affirmed again in 1839 that "it is certain that through Monsieur Daguerre's invention physics is today in possession of a reagent extraordinarily sensitive to the influence of light, a new instrument which will be to the study of the intensity of light and of luminous phenomena what the microscope is in the study of minute objects, and it will furnish the nucleus around which new researches and new discoveries will be made." In 1860 F. F. Statham wrote, "To give a just and accurate idea of all that photography [which he elsewhere calls 'handmaid of the sciences'] has done for science would be to write anew the whole history of the art." In a similar vein a review in 1864 proclaims, "It is to science ... that photography, the child of science, renders, and will unceasingly render, the most valuable aid. There is scarcely one in the whole list of sciences which is not largely indebted to it. Astronomy and microscopic observations have benefited singularly from the increased accuracy that has been secured. It is a boon of enormous value to be able in any instance to eliminate that fruitful source of error, the fallibility of the observer. Photography is never imaginative, and is never in any danger of arranging its records by the light of a preconceived theory."

But the most poetic paean was delivered by the French astronomer P. J. C. Janssen in a postprandial speech at the Société Française de la Photographie in June 1888: "The sensitive photographic film is the true retina of the scientist, ... for it possesses all the properties which Science could want: it faithfully preserves the images which depict themselves upon it, and reproduces and multiplies them indefinitely on request; in the radiative spectrum it covers a range more than double that which the eye can perceive and soon perhaps will cover it all; finally, it takes advantage of that admirable property which allows the accumulation of events, and whereas our retina erases all impressions more than a tenth of a second old, the photographic retina preserves them and accumulates them over a practically limitless time." By this time, of course, there was little need to discourse on the great future of the subject, for it could already lay claim to a praiseworthy past.

The first two decades of photography saw the growth of three predominant processes, along with many variants: the daguerreotype, the calotype and the wet collodion plate; the dry-plate process was conceived another two decades later. A skeleton outline of the four processes *as first practised* is shown below.

Process	Publication	Sensitization	Exposure	Development	Fixing
Daguerreotype	1839, L.J.M. Daguerre	Silver iodide coating on copper plate	Within one hour	Mercury vapour from hot bath	Salt solution
Calotype	1840, W.H.F. Talbot	Treatment with silver nitrate and potassium iodide solutions	Gallonitrate of silver ("exciting liquid") few hours in advance	Negative image: exciting liquid; positive print: ammonium chloride and silver nitrate solutions	Hypo and other salt solutions
Wet collodion	1851, F.S. Archer	Collodion coating on plate treated with ammonium iodide and bromide solution; silver nitrate bath	At once (whilst plate still wet)	As above but pyrogallic acid in place of exciting liquid	Hypo
Dry plate	1871, R.L. Maddox	As above, but gelatine in place of collodion, cadmium for ammonium	Whenever desired	Similar to above	Hypo

Notes: Hypo = sodium thiosulphate
Collodion = clear, viscous solution of pyroxyline (gun-cutton) in alcohol and ether

In every case the broad principle is the same albeit that the practice varies widely. The surface destined to record the photographic image must be suit-

ably prepared and then sensitized, that is to say coated with emulsion. The paper or plate is loaded into the camera and exposed. The next stage is to develop and fix the latent image, and if a negative to print and fix its positive counterpart. The end product is washed and dried. However, it must be borne in mind that the practical details of the photographic operations were every bit as subtle, as intricate, and often as mysterious, as those of the alchemist's art. For detailed historical accounts, refer to the standard texts by J. M. Eder and by H. and A. Gernsheim (plus the partial revision by H. Gernsheim) or to the popular work by B. Newhall.

In the earliest examples of photomicrography, we see photography's first tentative steps in a scientific direction. (Let us distinguish between photomicrography, the photographic enlargement of microscopic objects; and microphotography, the microscopic reduction of photographic images.) It must be said that the mere application of a camera to a microscope does not betoken a scientific photograph; the trained eye can often infer quite as much from direct observation through the microscope as from scrutiny of the photomicrograph. Nevertheless, later scientific photomicrography owes a dept to its early antecedents.

Calotype photomicrograph of two lantern-fly wings. W.H.F. Talbot, circa 1840. (Science Museum, London)

The date of the first fixed photomicrograph is somewhat debatable. The calotype process was used in conjunction with the solar microscope around 1837 by Talbot and 1839 by J. B. Reade (1837 is frequently but erroneously claimed). Reade photographed and sold a "solar mezzotint" of a flea. At one point Talbot claimed to have started working with the solar microscope as early as 1835, but in any case he had sufficiently perfected these images by 1839 to include solar micrographs of wood-shavings and an insect's wing in an exhibition of "photogenic drawings" at the Royal Institution in January and others of lace magnified 100 to 400 times in an exhibition at the British Association meeting in August. By 1839 the daguerreotypists too were turning to the microscope, the first probably being the Paris doctor Alfred Donné. He addressed the Académie des Sciences on the appearance of the daguerreotyped plate under the microscope, and a few months later displayed the image of a fly's eye before the Academicians. In 1843 Donné combined forces with J. B. L. Foucault to produce a monumental atlas of "microscopic anatomy" to complement his *Cours de Microscopie* published that year, and the illustrations prepared by the engraver Oudet from their photomicrographs for the *Atlas* (published 1845) are of historic significance. Others in various countries – A. Berres, C. L. Chevalier, J. B. Dancer, H. R. Goeppert, R. Hodgson – obtained early photomicrographs but to little scientific purpose. Dancer, now best remembered as inventor of microphotography and as scientific instrument maker, was probably the first to produce high-quality photomicrographs on glass a decade later; he was closely followed by A. Bertsch in Paris.

Calotype photomicrograph of the polarization pattern from a uniaxial crystal. W.H.F. Talbot, circa 1842. (Science Museum, London)

For the Sun as light source, substitutes began to emerge surprisingly early, encouraged by the steadily increasing sensitivity of the emulsion. In 1839 Donné had applied an oxy-hydrogen torch for microscopic illumination; he and Foucault later used it to good effect for some of the plates in their *Atlas*. Berres in Vienna and Dancer in Manchester, who photographed a flea by gaslight in 1840, were the first to use artificial light successfully in photomicrography. Bertsch and Castracanne came to grips with the problem that light of different wavelengths does not come to the same focus; Bertsch used a "chromatic polarizer" to isolate monochromatic light and obtained very impressive results. The first modern photographic microscope is claimed to have been built by Nachet in 1866.

Just how valuable an aid was photomicrography in its first few decades? Contemporary opinions differ, but few would disagree with Gerard Turner's contention that it was crucial to the communication of scientific ideas. (The first photomicrographs to appear in a scientific journal were prepared by J. Delves and S. Highley in 1852 and published in the *Transactions of the Microscopical Society of London* the following year.) But R. L. Maddox, future

inventor of the dry-plate process, felt compelled to declare in 1867 that "as yet, photomicrography can scarcely be said to be embraced by the arms of science; silently it has crept towards the fingers, but has not yet fairly shaken hands." The pioneer bacteriologist Robert Koch viewed its status quite differently in the 1880s. To him photography "comes both as a harmonizing mediator [among discordant microscopists] and as an instructress. Indeed, under certain circumstances, the photographic picture of a microscopic object is more valuable than the original preparation."

A persistent problem which plagued all collodion and early gelatine photographers – but none more so than photomicrographers – was the unrealistic response to light of different colours (that is, different wavelengths). The monochrome emulsions responded far better in the blue region than elsewhere. Microscopists had recourse either to delicate staining techniques to compensate or to blue filters to attenuate the shorter wavelengths, the first use of such a filter (of blue glass) being imputed to J.W. Draper. Experiments by H.W. Vogel in 1873 led to a more uniform response in collodion emulsion, and in 1884 J.M. Eder perfected "orthochromatic" plates of gelatine emulsion, literally colour-corrected to strengthen the yellow-green region. Finally in 1903 the first panchromatic emulsion, one which balanced all colour tones successfully (still in monochrome!), was at last achieved.

First electron micrograph of a biological specimen: the root of a Bird's-nest Orchid. L. Marton, 1934. (Smithsonian Institution, Washington, D.C.)

The subsequent evolution of microscopy has depended rather more on instrumental than on photographic developments, apart from the manufacture of films specially designed for microscopists' needs by Agfa-Gevaert, Ilford, Kodak, Polaroid and others. Photographs of rock sections taken by H.C. Sorby through the polarizing microscope (first employed by Talbot about 1842) set metallography and microscopic photography on their feet although Sorby was derided at the time for "studying mountains by microscopes". Improvements in the microtome to slice thin sections and in staining techniques to distinguish micro-organisms; the invention in historical order of the ultraviolet and fluorescence microscopes, of the phase-contrast and interference methods – certainly these innovations radically altered microscopy. But far more spectacular was the invention of electron microscopy.

The electron microscope was born largely through the efforts of E. Ruska who with M. Knoll demonstrated two-stage magnification with magnetic lenses in 1931. At first its potential was not fully appreciated in view of several daunting problems, notably the fact that the specimen of interest was severely damaged by the powerful electron beam. The foundations had nevertheless been laid. L. Marton obtained the first electron micrographs of a biological specimen (the root of a sundew plant) in April 1934, E. Driest and H.O. Müller a year later recorded the wings of a common butterfly at higher resolution than could be attained optically, and in 1937 Marton published the earliest bacteriological micrographs. As questions of image interpretation and technical design problems were resolved, the electron microscope afforded major advances. Visualization of viruses (tobacco mosaic virus, bacteriophage T2 and others), of fine structure in the cell, and of macromolecular crystals mark the highlights of the 1940s. Techniques of specimen preparation improved – notably in the production of ultrathin sections, in metallic shadowing using heavy atoms to enhance contrast and much later in new staining techniques.

Scanning transmission electron micrograph showing images of paired uranium atoms on a carbon substrate. A.V. Crewe, circa 1970. (Science Museum, London)

Contrast and resolution progressed to the stage where microscopy of atoms could be envisaged. E.W. Müller had meanwhile developed field-emission, then field-ion microscopy, achieving his first real success in 1951 and realizing optimum resolution about 1960. But field-ion images differ sharply from electron micrographs in formation and appearance. A.V. Crewe first photographed single atoms with a scanning transmission electron microscope in 1970. The resolving power of the conventional transmission electron microscope has been pushed by H. Hashimoto and others to the point where rows of atoms can be seen; even their dynamic behaviour can be monitored.

Remaining for the present with the life sciences, we may ask what photography has done for medicine on the larger scale. The answer is surprisingly different from the one a physical scientist might give. The photographs which proliferate in medical textbooks have diagnostic as well as pedagogic value. Clinical medicine is forever returning to such photographs to check details of anatomy, to confirm diagnoses of diseases, to compare microbiological specimens with standard photomicrographs. In this respect medical science has more in common with zoology, where photographs serve along with "type specimens" to establish standards with which new observations are compared.

Medical record photography began in 1852 at the Surrey County Asylum, where superintendent H. W. Diamond regularly took portraits of the psychiatrically disturbed inmates. An orthopaedic surgeon in Berlin, F. J. Behrend, independently started a photographic record in the same year. Medical photographs, properly speaking, were first published in the following decade, the collection of facial expressions induced by electrical stimulation (a technique originated by G. B. Duchenne) and the six-volume set depicting Civil War wounds (from the U.S. Surgeon General's Office) being particularly important.

Early radiogram taken for clinical purposes: buckshot in the hand of New York lawyer Butler Hall. M.I. Pupin, 1896. (Burndy Library, Norwalk, Connecticut)

The nervous system first came before the lens in 1861 (J. Albert in Munich); skin diseases, in 1864 (A. B. Squire in London); the human larynx, in 1860 but not very successfully until 1882 (T. R. French and G. B. Brainerd in New York); the human retina, in 1885 (W. T. Jackman and J. D. Webster in London). Photographic probing of the interior of the living body – that is, endoscopy – was the last hurdle to be tackled. A gastroscope first surveyed the interior of the stomach photographically in 1890, and a cystoscope the bladder in 1894. Subsequent developments owed as much to improvements in endoscopes (gastroscopes, cystoscopes, bronchoscopes [for the lungs], culdoscopes [vagina], laparoscopes [abdomen] and so forth) as to advances in photography. Landmarks in this century include the semiflexible gastroscope of R. Schindler (1922); the modern bronchoscope of M. Fourestier, A. Gladu and J. Vulmière (1952); the first colour photographs of the stomach taken with electronic flash by C. Debray and P. Housset (1956); the introduction of fibre optics by B. I. Hirschowitz (1961); and the classic photographs of the human foetus *in vivo* by L. Nilsson (1965).

The discovery of X-rays in November 1895 furnished a quite different means of penetrating the living body, this time beyond the soft tissues. In the history of technological change, perhaps the laser alone can match X-rays for the explosion of worldwide publicity, research, instrumental innovation and practical application which ensued. Within just six months of W. C. Röntgen's discovery, radiograms had been taken through a huge array of subjects, from teeth to mummified birds, by hundreds of experimenters around the world. In the same period we encounter the first X-ray emulsion, the first metal X-ray tubes, the invention of the intensifying screen and the earliest stereoscopic studies. Historians disagree on the first clinical use of X-rays, but M. Jastrowitz in Berlin (splinters in a glassblower's hand), G. Kaiser in Vienna (gunshot in a forester's hand) and A. Schuster in Manchester (needle in a dancer's foot) are all contenders.

Exposure times initially ran from 15 minutes to an hour (for dense bones such as the skull), but by 1898 they had dropped to typically a few minutes. The principal manufacturers of special radiographic emulsions were Eastman Kodak in America, Ilford in the UK and Schleussner in Germany. (However, *caveat lector*: early radiologists did not always turn unswervingly to the photographic emulsion; it was often more practical to study metabolic function, for example in W. B. Cannon's investigation of the digestive system, on a fluoroscope.) The subsequent history of radiology does not belong here, but perhaps the invention of the hot-cathode tube by W. D. Coolidge in 1913 ought to be singled out.

Equally, an extended exposition on modern imaging techniques of diagnostic importance would be out of place. They must nevertheless stage a brief

appearance: ultrasound, employed in a crude form for medical purposes as early as 1942 in the transmission mode and 1949 in the pulse-echo mode; computer-assisted tomography and nuclear magnetic resonance imaging, techniques which reached fruition in the early 1970s and are both capable of disclosing tissue detail previously unimaginable; and positron-emission tomography using radioactive tracers, conceived in 1951 and at last producing valuable results. The use of tracers boasts a venerable history running from the first arteriogram of a cadaver's hand by E. Haschek and O. T. Lindenthal in Vienna (1896) through the cerebral angiography of living patients by E. Moniz in Lisbon (1927 ff.) to sophisticated digital-subtraction angiography today, surpassing all other imaging techniques in resolution. Amazingly, the basic idea of this last technique – essentially differencing of radiograms showing bones plus blood vessels and bones alone – was conceived as early as 1935 by B. G. Ziedses des Plantes. It should be added parenthetically that although radioactive tracers may be employed as contrast agents, not all such agents are radioactive. With radioactive tracers, biological and medical researchers can choose between a photographic record (the first autoradiogram is attributed to E. S. London in St. Petersburg [Leningrad] in 1904) and other sensors, such as a scintillation counter.

X-rays generated a second impact on scientific photography when it was realized that their diffraction by crystals yields vital clues to the lattice structure. Stimulated by Max von Laue, W. Friedrich and P. Knipping achieved the first X-ray diffraction pattern in 1912 with copper sulphate although the pattern was rather blurred. Not only did this work portend a crystallographic revolution, and eventually a biochemical one; it also stimulated W. H. Bragg to design the X-ray ionization spectrometer and thereby to reveal X-ray spectra. Soon X-ray spectroscopy was vigorously pursued by H. G. J. Moseley. Powder photography was a seminal development conceived by P. Debye and P. Scherrer in 1916 in which a finely ground crystalline material reveals all components of its structure in a single pattern. The usual photographic arrangement called for the film to be wrapped cylindrically concentric with the powder sample.

Early X-ray diffraction pattern. W. Friedrich, 1913. (Burndy Library, Norwalk, Connecticut)

The influence of X-ray diffraction on the course of science was immense. The debate over the nature of X-rays (undulatory or corpuscular, waves or particles) continued to simmer until wave-particle duality could be swallowed by the scientific community. (The same controversy raged over electrons, particles finally shown to have a wave-like aspect by G. P. Thomson and others.) Other research fields dependent on X-ray diffraction photographs include atomic and ionic radii, lattice dislocations, and the optical, electrical and thermal behaviour of crystals. Nor was the scope restricted to inorganic molecules. J. D. Bernal would show in 1934 that large, complex organic molecules such as proteins were also amenable to analysis. The foundation stones for molecular biology were laid by Bernal, W. T. Astbury, D. C. Hodgkin and others in the 1930s. The breakthrough of the century, of course, was the interpretation of an X-ray diffraction photograph of DNA in terms of a double helix with its implications for the nature of the genetic code.

X-rays comprise only one segment of the invisible (non-optical) spectrum where photography plies its trade. To view ultraviolet images, it is necessary to circumvent the absorptive qualities of glass, for instance by using quartz optics. The "more refrangible" ultraviolet (UV) rays were not discovered photographically, having been found by J. W. Ritter in 1801, but they were recognized by photographers at an early date. The first laboratory UV spectra were taken by W. A. Miller in 1864, and in this century much of our knowledge of atomic structure is inferred from UV spectra stretching from the violet down to the short wavelengths of X-rays. Astronomy uses UV spectroscopy to study hot stars and interstellar gas, aeronomy employs UV imaging to explore the upper atmosphere, and medicine applies direct photography and UV fluorescence (dubbed "black light" in other contexts) to examine the skin. Important work was conducted with UV microscopes – e.g., T. Caspersson's

observations of chromosome banding around 1935 – until they were supplanted by electron beams.

Knowledge of the infrared (IR) also predates photography. The "less refrangible" IR rays were soon found to affect photographic emulsions, but Talbot's prophecy in 1844 that "the eye of the camera would see plainly where the human eye would find nothing but darkness" went unfulfilled until 1930. It was not for lack of experiments, witness the lecture in 1859 by M. Niépce de St. Victor on "thermography – calorific radiations considered as a means of producing images on sensitive paper". Today the term thermography designates that long-wavelength portion of the IR spectrum where the emulsion must yield to other detectors. IR photography and thermography can boast a prodigious number of applications in remote sensing (e.g., aerial and satellite imagery in which healthy vegetation appears white or on IR colour film red), in microscopy (e.g., the selective staining of bacteria), in astronomy (e.g., the detection of warm dust clouds), in medicine (e.g., diagnosis of breast cancer), in spectroscopy (ever since W. de W. Abney's classic mapping of the solar IR spectrum around 1880), even in botany (IR luminescence of chlorophyll).

The science to which the benefits of photography accrued before and beyond any other was unquestionably astronomy. J. W. Draper took the first successful daguerreotype of the Moon in 1840: "By the aid of a lens and a heliostat, I caused the moonbeams to converge on a plate, the lens being three inches in diameter. In half an hour a very strong impression was obtained." This photograph was reputedly destroyed in a fire at the Lyceum (the New York Academy of Sciences) in 1866, but that supposition is suspect. Indeed, a fungus-eaten daguerreotype of the last-quarter Moon taken by Draper and dated 26 March 1840, found in 1969 in a Greenwich Village bookshop, may be that very image.

Daguerreotype of gibbous Moon, probably earliest astronomical photograph. J. W. Draper, 1840. (Department of Physics, New York University)

Oddly enough, apart from a photograph of the crescent Sun at the 1842 eclipse, no attempt was made to daguerreotype the Sun until 1845 when, at the behest of Arago, L. Foucault and H. Fizeau obtained an excellent image in 1/60 second showing two sunspot groups. This delay was all the more curious in that the solar *spectrum* had already been photographed many times. In fact the first real success of scientific photography can be pinned to the spectrum taken by Draper on 27 July 1842 and forwarded to Sir John Herschel for comment. This spectrum revealed new dark absorption lines in the infrared and ultraviolet portions of the solar spectrum invisible to the eye – the first photograph literally "beyond vision".

Progress in daguerreotyping the sky accelerated at the end of the decade when in rapid succession a series of high-quality lunar photographs was initiated by J. A. Whipple on the Harvard refractor in 1849, the first photograph of a star (Vega) was accomplished in 1850 and of a planet (Jupiter) in 1851 by Whipple and G. P. Bond, and the first passable record of a solar eclipse was obtained by Berkowski again in 1851. It should be noted that whereas the calotype proved serviceable in photomicrography despite its coarse grain, it was not sufficiently sensitive for astronomical purposes.

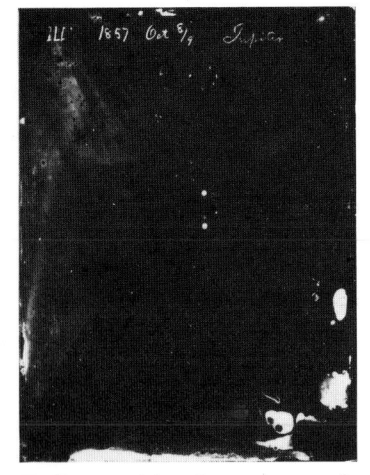

Earliest surviving daguerreotype of a planet: two exposures of Jupiter. G. P. Bond, 1857. (Harvard College Observatory, Cambridge, Massachusetts)

The wet-plate process vastly extended the capabilities of scientific photography. Comparison of the lunar photographs by Warren De La Rue (1852 ff.) with their daguerreotyped predecessors, or of William Crookes' polarization patterns with the indistinct example by Talbot surviving from 1848, emphasizes the qualities of collodion. G. P. Bond, considered by E. Holden "the father of celestial photography", used collodion plates to perform the first measures of double stars and of photographic photometry. De La Rue adopted them for eclipse photography in 1860 – quite a daring move since they had never been tested in that role – and for solar patrol photography at Kew Observatory. Stellar spectra, however, lay at the limit of collodion's capabilities and despite Henry Draper's limited success with Vega in 1872 stellar spectroscopy had to await the dry-plate process. A crucial development during this period was the first photographic objective, ground for L. Rutherfurd by H. Fitz around 1864, several years before Nachet's microscopic counterpart.

With the advent of the dry process using gelatino-bromide plates, astronomers initiated programmes of systematic photography: at Harvard from 1882 under the Pickerings, who later oversaw the first spectrophotographic survey of stars (Henry Draper Memorial); at the Royal Observatory, Cape of Good Hope in 1891 to produce under the direction of Sir David Gill the first catalogue of stellar positions wholly derived from photographs; and at eighteen observatories round the globe to assemble the first complete photographic survey of the sky (the Carte du Ciel, begun 1891).

When the next major sky survey was undertaken (begun 1949 on the Schmidt telescope at Palomar Observatory), it was light-years ahead of the Carte du Ciel in more ways than one, but let us dwell only on its photographic advantage. One of the hallmarks of 20th-century scientific photography is the development of specialized emulsions for scientific applications. In the case of the Palomar survey these were Kodak IIa–E (red-sensitive plates) and IIa–O (blue-sensitive), produced for low-intensity astronomical use and Raman spectroscopy. Photographic manufacturers have evolved emulsions specifically intended for spectroscopy, photomicrography, nuclear physics, radiography, thermography – each of which demands a particular range of spectral sensitivity, resolving power and contrast.

Kew photoheliograph used for eclipse and solar patrol photography. Made by A. Ross to the design of Warren De La Rue. See pp 32–33. (Science Museum, London)

Before leaving astrophotography for other realms, two vital features which have emerged this century deserve comment. First, the astronomer's arsenal now contains a range of detectors which enhance or even replace the traditional photographic image. On the one hand, electronography with devices such as those designed by A. Lallemand and by J. D. McGee allows electrons from the photocathode to impinge directly on the emulsion. Image tubes (or image intensifiers) such as the microchannel plate accelerate the electrons onto a phosphor screen before they reach the recording medium which *may* be a photographic plate or film. On the other hand, the final image may be recorded instead on a phosphor screen (in television-type camera tubes like the SEC and SIT vidicons) or on a solid-state array of silicon detectors (in the charge-coupled device). The result in all cases is an image; at what point it ceases to be a photograph is a matter of semantics.

The second feature relates to the enhancement of existing plates or films: it is the art and science of hypersensitization. To extract the very best performance from his material at low light levels, the astronomer resorts to a variety of tricks. The most widely used include cooling the emulsion (whilst taking precautions to avoid condensation), pre-exposure flashing, flushing with hydrogen gas and baking in nitrogen. "Hypering", as these arcane arts are called in the trade, has such a dramatic effect on the resulting image – even to its presence or absence! – that it is now carried out routinely at all major observatories.

Imaging has taken wing and most space photography relies not on chemical emulsions but on electronic sensing, digitization, transmission, processing and reconstruction. Photographic film proved its worth in such missions as Lunar Orbiter and Skylab, but most space reconnaissance has been conducted with other sensors. Pioneer employed photomultipliers in its imaging photopolarimeter. Scanning sensors of various types have provided microwave, infrared and ultraviolet imagery. In the optical region television systems have come to be the norm, particularly the slow-scan vidicons which from Ranger 7 in 1964 to the latest Voyager probes have remained "NASA's workhorse sensing element" in the words of M. M. Mirabito. From some satellites a live performance is received – telemetry in "real time"; from others, a taped replay. No less important than the remote sensing is the terrestrial reconstruction ("image processing"), often with the aid of sophisticated computer algorithms.

Stroboscope with rotating shutter used to record the Crab pulsar. See pp 128–129. (Lick Observatory, Santa Cruz, California)

It seems appropriate to plunge from one remote realm photographically rendered accessible to another. The majority of underwater photographs, however entrancing they may look as vignettes of marine life, disclose little

to the scientist. But for some years the camera alone penetrated to the ocean bottom, first in the hands of L. Boutan off the French Riviera in 1893. Among those who made valuable contributions to the establishment of deep-sea photography, three men deserve special mention: W. M. Ewing, whose apparatus reached a depth of 5000 m in 1941; J. D. Isaacs, who obtained the first photographs of deep-sea life significant for marine biology; and H. E. Edgerton, inventor of the electronic flash and of the sonar "pinger" for positioning the camera underwater. Ocean-bottom photography has also reaped dividends for submarine geology.

For the better part of this century the photographic detector has dominated atomic and nuclear physics. In its first role, cameras were wedded to cloud chambers to record the transitory tracks produced by the passage of ionized particles through supersaturated vapour. From the earliest studies by its inventor C. T. R. Wilson until the 1950s, the cloud chamber vouchsafed innumerable discoveries: the curvature of alpha rays in a magnetic field (P. Kapitza, 1924), artificial transmutation (P. M. S. Blackett, 1925 f.), the X-ray phenomenon called the Auger effect (P. Auger, 1926), the positron (C. D. Anderson, 1932) and so forth. In a sense the bubble chamber supplanted the cloud chamber in the 1950s but maintained an analogous relation to the camera, triggered to expose with a timed flash when the desired particles manifest themselves.

Meanwhile an utterly different role had arisen for photography in particle detection. Whilst S. Kinoshita must be credited with recognition of the blackening effect produced by alpha particles on an emulsion, the first photomicrographs of individual particle tracks were published by H. P. Walmsley and W. Makower in 1914. For the next 25 years this approach languished for lack of suitable emulsions. Then C. F. Powell and others at the University of Bristol, convinced that this "photographic method is equivalent to a continuously sensitive expansion [cloud] chamber", pursued the method with vigour. The turning point arrived in 1945 when Ilford Ltd. improved on their R1 and R2 emulsions with new concentrated nuclear emulsions whose merits were fine grain, high sensitivity and uniform quality. With such plates H. L. Bradt discovered heavy nuclei in cosmic rays (first visualized in the cloud chamber by D. Skobelzyn in 1929) and C. M. G. Lattes and his colleagues found H. Yukawa's long-sought particle, the pi meson. Stacks of nuclear emulsions are employed to this day as detectors of particles whenever high spatial resolution is paramount and the lack of temporal resolution does not hinder. Among the evocatively named flavours of quarks, charm has already been captured by hybrid emulsions, beauty is "well suited for direct observation by the emulsion technique" in the words of D. H. Davis, and truth will not be attained because particles with this property are expected to be too short-lived. (The critical lifetime is about a hundred millionth of a microsecond, at which the track length dwindles almost to the grain size.)

In addition to space, intensity and wavelength, the scientific photographer has command of time. At the two extremes of the temporal spectrum stand high-speed photography to capture rapid events and time-lapse photography to record slow ones. Fast and slow are anthropomorphically defined, our retinal integration and cerebral processing rates being taken as the norm. The first high-speed photograph or "instantaneous photogenic image" was made by Talbot himself in 1851 when at the Royal Institution he recorded a sheet of the *Times* on a rotating drum by the light of an electric spark. The notion of time-lapse photography we owe to E. Mach writing in 1888 and its first major exploitation to A. Pizon in 1904 depicting the growth of a bacterial colony by what he termed "biotachygraphy".

The electric spark dominated high-speed photography during its first half-century. Thus sound waves were frozen by A. Töpler, shock waves behind projectiles by E. Mach and later C. V. Boys, water jets by Lord Rayleigh and water splashes by A. M. Worthington. In this century the invention of the

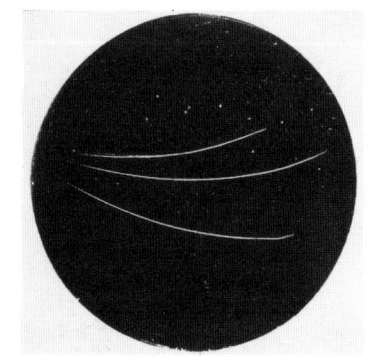

Discovery photograph through cloud-chamber window of alpha-particle tracks bending in a magnetic field. P. Kapitza, 1924. (Science Museum, London)

Shock waves generated by a bullet striking a glass plate. C. V. Boys, 1893. (Science Museum, London)

electronic flash by H. E. Edgerton revolutionized photography. (Gjon Mili, an early practitioner, spoke of the flash discharge as "this highly sophisticated, magical light source".) The briefest exposure time has been further whittled down through the use of the Kerr cell (an electro-optical shutter based on an effect discovered in 1875), the image tube (developed by G. H. Lunn, J. S. Courtney-Pratt and others) and later the advent of the mode-locked laser. The picosecond barrier (a millionth of a microsecond) was first broken in 1975 by D. J. Bradley and W. Sibbett with a streak camera by which the image is smeared out in one dimension through the motion of film and subject at right angles. Among "conventional" two-dimensional images, however, the record is held instead by an ingenious application of holography.

For transient events a single spark or flash will not suffice unless elaborate timing mechanisms are devised. So one must turn to methods permitting successive rapid exposures – that is, to the multiple spark, to the strobe flash, indeed to what may quite properly be called cinematography. The great forerunner of the motion picture was, of course, E. J. Muybridge who initially used trip-wires to release the shutters on a phalanx of cameras – a cumbersome if innovative approach. In his rotating-shutter cameras and continuous film-strips, E.-J. Marey achieved a more elegant solution and by means of "chronophotography" established the study of movement in all its forms – human and animal locomotion (in the wake of Muybridge), blood circulation and heartbeat, mechanical vibration, hydro- and aerodynamics – on a firm scientific basis. Subsequent films of insect flight by L. Bull and of bacteria under the microscope by J. Ries were also anticipated by Marey. Camera technology has progressively eliminated the problems of filming short-lived phenomena through the use of rotating mirrors, rotating prisms and other devices mechanical and electronic culminating in high-speed video.

Photographic gun for high-speed studies of bird flight. E.-J. Marey, 1882. (Musée Marey de Beaune, France)

This brief introduction to the history of scientific photography makes no pretence whatever at plumbing the depths of the subject. (Sadly, there exists no single work which does). It is intended to supply a skeletal stage set, just enough to provide a backdrop for the main characters in this book, the historic photographs themselves. Conventional photography and contemporary imaging techniques have been woven together quite deliberately; they must *not* be seen as the dinosaur giving way to the mammal, but as complementary *modus operandi*. The chemical emulsion is far from dead; at low light levels, for example, image enhancement techniques like photographic amplification can render it a potent match for electronic detectors. If the means of supplementing the range of human vision are evolving, the end remains constant; to interpret the images the better to account for observed phenomena.

Interpretation is the key. Photographs, and *a fortiori* scientific photographs, utter sterling truths no more than do galvanometer readings. (It is salutory to compare the three quite different images in this book which purport to show atoms.) In another context John Ciardi warned that

> *Even the camera, focused and exact,*
> *To a two-dimensional conclusion,*
> *Uttered its formula of physical fact,*
> *Only to lend data to illusion.*

Spark drum camera for high-speed studies of insect flight. L. Bull, 1903. (Science Museum, London)

On the other hand, if he includes in his scrutiny not only the image but also the photographic technique by which it was acquired, the scientist can achieve insight beyond vision.

First Foray into the Invisible

It is remarkable that virtually from its birth photography was turned to account for scientific ends. Sir John F. W. Herschel at once realized that the door was open to new experiments in spectroscopy, and in the same year that William Henry Fox Talbot announced the invention of his calotype process Herschel recorded the spectrum of the midday Sun through a glass prism made by Joseph Fraunhofer. Focused by a lens onto sensitized paper, the sunlight was spread out into a continuous band intersected with the dark lines discovered visually by William Wollaston in 1802 and Fraunhofer in 1814. One important finding from Herschel's early experiments was that the "chemical rays" recorded on photographic paper extended beyond the red and violet limits evident in the "luminous rays" seen by the unaided eye. But no additional "Fraunhofer lines" – now known to indicate absorption at characteristic wavelengths by elements in the solar atmosphere – could be seen than were already discernible by eye.

The spectrum opposite, made by the rival daguerreotype process, was the first to reveal in a photograph Fraunhofer lines not visible to the eye. The photographer was John William Draper, a professor of chemistry and physiology at New York University. His improvements upon the process divulged in 1839 by Louis Jacques Mandé Daguerre in Paris enabled him to take the first photograph of the Moon in 1840 (p 16) and subsequent photographs of the solar spectrum – although no direct images of the Sun. For his first successful spectra in 1842, including the one shown here, Draper used a prism; but two years later he was to switch allegiance to the diffraction grating in his efforts to decipher what he called "the constitution of the sunbeam".

Sir John Herschel was so impressed with the daguerreotype of the solar spectrum shown here, "a joint work of nature and art" sent to him personally by its author, that he wrote a paper on it in the *Philosophical Magazine*, describing it thus: "A Daguerreotype silver plate, about $3\frac{1}{2}$ inches by 3 inches, on which is exhibited the impress of the spectrum in the form of a streak 3.3 inches, or thereabouts in length, and 0.08 inch in breadth, the edges being perfectly rectilinear and sharply defined throughout the whole length until within about a third of an inch from either termination.... The Spectrum itself is extremely remarkable and beautiful."

To the left of this historic spectrum, Draper lists the colours of the "rainbow" not only from violet to orange but from lavender (Herschel's preferred term to thwart the "uncouth appellation" of ultra-violet) to extreme red (today's infrared) – colours, in other words, beyond the limits of human vision. (The "coloured spaces" are of course essentially monochrome save for a faint iridescence when viewing the daguerreotype plate at certain angles: colour photography was still many years in the future.) To the right Draper has labelled features to which he wished to call Herschel's attention. These letters do *not* correspond to those which Fraunhofer assigned to the strongest of the Sun's absorption lines. Draper did utilize Fraunhofer's letter designations but later claimed that he was the first to insist on identifying lines by their wavelengths.

Aside from the intense Fraunhofer absorption lines, Draper noted that the spectrum is "crossed by hundreds of minuter lines so that it is impossible to count them"; indeed Draper estimated that there must be over a thousand all told. (These lines are too faint to be reproducible here.) Three lines in the infrared ("Ex Red"), however, could only be observed photographically. Draper labelled the lines α, β and γ; from their relative position they appear to be three of the Paschen series of hydrogen lines. Another four groups of intense lines (twenty altogether) were recorded for the first time in the ultraviolet although they cannot be seen clearly in the same exposure as the infrared lines. "If on common yellow iodide of silver," wrote Draper, "the attempt were made to obtain all the lines at one trial, it would be found that the blue region would have passed to a state of high solarization, and that all its fine lines were extinguished by being overdone long before any well-marked action could be traced in the less refrangible [red] extremity."

The "more refrangible" ultraviolet lines were discovered simultaneously and independently by Edmond Becquerel, but he failed to capture α, β and γ. When Léon Foucault and Hippolyte Fizeau found the latter lines in 1844, they were so excited that they deposited a sealed envelope documenting and dating their discovery with the Académie des Sciences – but, as Becquerel generously pointed out on Draper's behalf, they had been pipped at the post.

Date:	27 July 1842
Place:	Virginia, U.S.A.
Photographer:	J. W. Draper
Apparatus:	Heliostat, prism spectroscope, telescope of focal length 2 m
Emulsion:	Daguerreotype
Exposure time:	15 min
Source:	Science Museum, London
References:	Becquerel 1842, Herschel 1843, Draper 1878

An Historic Photomicrograph

Medicine and astronomy were the first two scientific disciplines to benefit from the application of photography. In a rather lyrical article entitled "Doings of the Sunbeam" published in *The Atlantic Monthly* in 1863, Oliver Wendell Holmes observed, "While the astronomer has been reducing the heavenly bodies to the dimensions of his stereoscopic slide, the anatomist has been lifting the invisible by the aid of his microscope into palpable dimensions, to remain permanently recorded in the handwriting of the sun himself." For the earliest photomicrographs, including the historic daguerreotype opposite, the Sun did indeed serve as the light source. But artificial illumination using an oxy-acetylene flame or a carbon arc did not lag far behind.

It would be fair to claim that the first photographs of histological significance were those taken by Alfred Donné and Léon Foucault and published in an anatomical atlas in 1845. Donné, professor of microscopy at the Collège de France in Paris, had been the first to obtain what he called "photogenic images" of microscopic objects. On his behalf J.-P. Biot first demonstrated them to the French Academy of Sciences on 17 February 1840. Only by reflected sunlight could any impression of the microscopic specimens be obtained on the fairly insensitive iodized plates of the day. Donné's "microscope-daguerréotype" was constructed, appropriately enough, by the optical instrument maker Soleil. Donné published his *Cours de Microscopie* in 1844, to be supplemented the following year by the photographic atlas whose 86 engravings were prepared after daguerreotypes largely taken by Foucault (later renowned for his pendulum experiment demonstrating the Earth's rotation).

For his monumental atlas containing the first published photomicrographs, Donné claimed both scientific and pedagogic motives. Henceforth, he wrote, "Before drawing conclusions from our observations, we shall let Nature reproduce herself; we shall fix her upon a daguerreotype plate with all her details and infinite nuances. . . We are determined to support each new observational fact on a rigorous representation safe from any illusion or preconceived ideas." Students too would find them indispensable: "Independently of the confidence which the sight of these images cannot fail to inspire, ... these plates will particularly aid the teaching of microscopy; it is so to speak the object itself which will be placed before the eyes and in the hands of the audience."

Photographic techniques were still so new that Donné felt it incumbent upon him to describe the procedure in some detail in his introduction to the atlas – polishing of the plate with pumice and lavender oil, sensitization with solutions of iodine and then bromine (an improvement suggested by J. F. Goddard), exposure in the focal plane of the microscope for 4 to 20 seconds, development in a mercury bath and fixing in gold chloride solution. The solar microscope furnished intense illumination (though Donné was experimenting concurrently with the carbon arc) but incurred one severe problem: despite two internal reflections, the concentrated heat was sufficient to damage the specimens. The solution was provided by a dark blue filter, all the more appropriate since most of the "actinic" power of the daguerreotype lay in the blue and violet. The apparatus was disposed with the microscope vertical and the camera horizontal, a right-angled prism between them. Blood, milk, mucus, saliva, urine and other bodily fluids were photographed at magnifications of 20 to 400 times.

The daguerreotype reproduced here closely resembles Figure 16-*bis* in the atlas although the two plates are not identical. It was published as something of an irresistible afterthought; as Donné wrote in his caption, "It summarizes so well all the degrees of action by water [on blood corpuscles from a frog], the modification of the blood corpuscles under this treatment are so perfectly rendered, that we felt we had to reproduce it here although it was not indicated in the text." Unmodified, the blood cells have a circular nucleus and clearly defined outer membrane. Addition of a small quantity of water to the blood sample makes the nuclei prominent and the surrounding cytoplasm successively fainter. The cell becomes elliptical under the action of water, the nucleus approaches the circumference and the two finally part company. Although invisible opposite, the signature "L. Foucault, juin 1844" is scratched on the original plate.

Date: June 1844
Place: Paris, France
Photographer: J.B.L. Foucault
Apparatus: Heliostat, short-focus solar microscope by Soleil
Emulsion: Daguerreotype plate sensitized with iodo-bromide
Exposure time: Between 4 and 20 sec
Source: Library, Wellcome Institute for the History of Medicine, London
References: Donné 1840, Donné & Foucault 1845, Lécuyer 1945 Gernsheim 1961

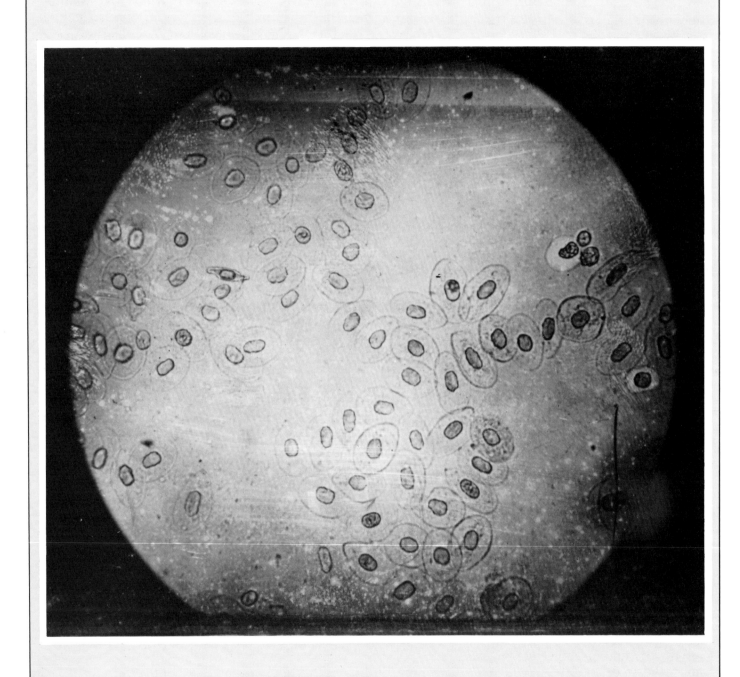

Earliest Photograph of Lightning

Ask an atmospheric physicist or even a photographic historian to guess the date of the first lightning photograph; he will probably surmise that it harks back to the 1880s. He would be astonished to learn that the forerunner of all lightning photography is a daguerreotype made by the Missouri photographer Thomas Easterly. Sadly the original plate was lost, but not before Cramer, Gross and Company in the same town obtained a 10 cm × 13 cm (4 in × 5 in) cabinet photograph of it in 1870.

The Missouri Historical Society reports little documentation on this daguerreotype listed in their files as "Street Scene no. 267". A former director of the Society, however, did unearth an interesting advertisement for Easterly's "Gallery" in St. Louis, Missouri. In Green's St. Louis Directory for 1851, Easterly advertised a display featuring "likenesses of Distinguished Statesmen, Eminent Divines, Prominent Citizens, Indian Chiefs, and Notorious Robbers and Murderers. Also – Beautiful Landscapes, Perfect Clouds, and a Bona Fide Streak of Lightning, Taken on the Night of June 18th, 1847". By implication Easterly had managed to obtain only one photograph of lightning of acceptable quality, and this unique image still merited display four years later.

Evidently the "streak of lightning" recorded by Easterly was an air discharge – that is, an electrical flash from cloud to cloud without branching to the ground. From its exhibition context, of course, we gather that Easterly was rather less concerned with the scientific attributes of his photograph than with its entertainment value. The first direct photographs taken for scientific purposes date from 1882 (W. N. Jennings in Philadelphia), while the earliest spectra were recorded in 1893 (G. Meyer in Germany). But the first major advances in lightning photography came in 1902 with the invention of a special lightning camera by Sir Charles Vernon Boys.

Despite the success of Mach, Rayleigh, Worthington and Boys himself in the realm of high-speed photography, it was not yet possible to obtain lightning photographs with acceptable time resolution by conventional means. The Boys camera circumvented the problem in a novel and ingenious way.

To follow the course of the stroke of lightning as it flashes between points of opposite polarity requires very rapid movement, but not necessarily of the film itself. The moving element in the Boys camera is the lens – indeed, two lenses mounted at opposite ends of a rotating disc.

A typical lightning stroke to the ground consists of a faint stepped leader moving in one direction followed by a rapid and brilliant return stroke. But let us suppose for a moment that lightning is as it appears: a simultaneous illumination of a jagged channel from cloud to ground. A moving lens would then provide no more information than a fixed lens; if it were moving fast enough, it could conceivably blur the image but no more. But if the flash evolves as the lens moves, then each change in position of the lens catches the stroke at a progressively later time. The greater the displacement of the lens from its initial position, the greater that of the relevant portion of the stroke. If a measurable displacement results from comparison of the moving and the fixed lens, how much larger it will be if we have – as in the Boys camera – two lenses moving in opposite directions.

Thus the evolution of a lightning stroke became quantifiable for the first time. The Boys camera continued in use with ever greater modifications for many years, notably by B. F. J. Schonland. Photographic technology now affords such high film speed (in the sense of ASA or DIN rating) that the highest time resolution these days is achieved not with moving lenses but with a moving filmstrip. Lightning flashes are made to streak across the film, yielding at low speeds resolution of the multistroked flash and at high speeds resolution of the individual stroke. Lightning photography is now a very far cry from Easterly's daguerreotype, but we ought to acknowledge this image as a precursor of many more "bona fide streaks of lightning".

Date:	18 June 1847
Place:	St. Louis, Missouri
Photographer:	T. M. Easterly
Apparatus:	Daguerreotype camera
Source:	Missouri Historical Society, St. Louis
References:	Schonland 1950, Salanave 1980, Buckland 1981

Daguerreotype of a Streak of
Lightning taken June 18th 1847
at 9 o'clock P.M. By
J. M. Easterly
St Louis Mo.

Polarization Classic

It is not widely realized that Sir William Crookes was an enthusiastic photographer before he turned to experiments in chemistry and radiometry. His study of polarization phenomena, published in 1853, is the more remarkable for being not only a very creditable first foray into the field on his own account but also one of the earliest truly scientific applications of photography.

Photographs of polarization patterns had already been obtained some ten years earlier by William Henry Fox Talbot (p 12), but they provided no insights beyond those gained from visual observations by Talbot through his polarizing microscope in the previous decade. The earliest surviving photomicrograph taken by polarized light is a calotype by Talbot of a uniaxial crystal, now preserved in the Science Museum, London.

Crookes began experimenting with a combined polariscope and camera early in 1852. His initial purpose, he later claimed, was no more than "the desire to record and retain in a more tangible form the well-known beautiful figures observed when thin slices of some crystals (such as calc spar and nitre) are seen in the polariscope".

The polarizer and analyzer sandwiching the crystal under study were superior specimens of tourmaline, a dichroic crystal, lent by Sir Charles Wheatstone of King's College London. The first satisfactory pictures of the patterns produced by calcite and nitre were obtained on an emulsion of iodized collodion. The camera-polariscope combination was exposed facing skyward for between half an hour and two hours in broad daylight and rotated 90° every few minutes in the interests of uniformity.

Now visual inspection of the polarization pattern revealed 8 or 9 rings, but the collodion plate yielded about 50. It might be thought that this result shows only that the camera must have been more sensitive than the eye – whence the greater number of rings – but remember that Frederick Scott Archer had invented the wet collodion process only a year or two previously, and as yet it was not very sensitive. Crookes at once inferred that the extra rings reflected the difference in spectral response between collodion emulsion and human retina; or as he put it, "The photograph [showed] in a remarkable manner the greater extent of the rings formed by the more refrangible rays over those formed by the visible ones." By more and less refrangible rays, Crookes meant respectively the near ultraviolet and infrared regions of the spectrum.

Next Crookes attempted to duplicate the visual observations photographically by suitable filtering. Sir John Herschel and others had already noted that iodine-based collodion photography, whilst decidedly more sensitive than the calotype or the daguerreotype, failed to reproduce faithfully the relative intensities of natural light and shade. The infidelity was attributed to the contribution of invisible ultraviolet rays, and Herschel proposed the substitution of bromine for iodine to produce a better balance (better for human eyes) between the red and blue rays in the spectrum. In addition Herschel recommended a quinine sulphate bath to obliterate the ultraviolet contribution entirely. Crookes utilized both, arguing that bromine gives a better colour balance (in shades of monochrome!) without being sensitive to the "less refrangible" infrared rays whilst the "more refrangible" ultraviolet rays would be suppressed by the quinine bath.

To his satisfaction the rings were reduced to their visible number; but to his surprise an anomalous pattern was revealed. The photograph opposite, labelled in Crookes' own hand, shows the pattern observed for calcite although a similar anomaly was found for nitre. The black cross appears with its four component "brushes" as usual; the abnormality lies in the rings. In the normal pattern the rings march outward in a smooth pattern, thick and bright near the centre, sharper and fainter with increasing distance. In this abnormal figure the radial regularity is broken, the fourth and fifth rings apparently merging into one diffuse ring.

Crookes surmised that "these abnormal figures may be caused by invisible rays which have hitherto escaped notice, existing within the space enclosed by the visible spectrum." With hindsight the culprit seems more likely to have been the optically active nature of the quinine solution. It is nevertheless somewhat curious that this explanation did not occur to Crookes in view of contemporary experiments (published in 1852) by W. B. Herapath on iodosulphate of quinine. Crystals of this compound exhibit dichroic properties not exploited until eighty years later when Edwin H. Land invented polaroid film.

Date:	1853
Place:	London, UK
Photographer:	W. Crookes
Apparatus:	Camera attached to tourmaline polariscope, exposed to bright sky
Emulsion:	Wet collodion plate
Exposure time:	1 hr (approx)
Source:	Science Museum, London
References:	Crookes 1853, Arnold 1977, Darius 1984

Calc: Spar.

Abnormal.

The Moon through a Giant's Eyes

The stereoscope was invented with exquisite if inadvertent timing by Sir Charles Wheatstone in 1838, just before the advent of photography. Stereoscopic photography did not catch on at once but following publicity by Sir David Brewster around 1850 it became something of a Victorian craze. The underlying idea is quite straightforward: one of our visual cues for three-dimensionality consists in the presentation of slightly different images to each eye. The stereoscopic viewer does exactly that with a pair of 2-D images and thereby tricks the visual cortex into seeing a 3-D simulacrum.

But what had stereoscopy to do with science? Their acquaintance did not run deep, but they met in a few specialized areas. In historical order they are (1) photomicrography: binocular microscopes providing stereoscopic vision were introduced by J. A. Riddell in New Orleans (1851), C.-S. & J.-A. Nachet in Paris (1853) and F. H. Wenham in London (1860); (2) radiography: so-called "Röntgen stereoscopy" was conceived by Ernst Mach in Vienna in 1896 only months after X-rays had been discovered, and in short order the skeleton of a live mouse was rendered in what the experimenters called "astonishing relief"; (3) photogrammetry: the stereocomparator and related instruments were developed at the turn of the century by Carl Pulfrich in Bonn to the great benefit of cartography and surveying.

The earliest scientific application of the technique was associated with the one science least susceptible to the charms of stereoscopy – *viz.*, astronomy. The reason is obvious: the photographer cannot gain a large enough parallax to obtain a stereo pair for any celestial object even if he were to choose opposite sides of the Earth as his baseline. The dome of heaven is perceptually two-dimensional, with no visual cues to distinguish a nearby faint star from a distant bright one.

How then is astronomical stereoscopy feasible? For the vast majority of celestial objects it is not. The Moon, however, is a special case because the common assumption that it always displays the same face to the Earth is nearly but not completely true. The Moon's orbital motion permits us to observe not only the 50% which we would expect from a satellite which rotates exactly once in revolution round the Earth, but also an extra 9% from time to time.

A terrestrial observer sees a slight wagging to and fro on its spin axis, called libration in longitude, which reveals up to $7°.6$ more at eastern and western limbs; and a slight nodding about its orbit, libration in latitude, which reveals up to $6°.7$ more at the poles. The pitch in latitude and yaw in longitude are optical librations caused respectively by the inclination of the Moon's equator to its orbit around the Earth and by its changing speed in orbit, accelerating as it draws closer. Naturally the period of this pitching and yawing is a lunar month. (Other librations are much smaller, diurnal optical librations through parallax by a factor of seven and physical librations through the asymmetric distribution of mass by a factor of a few hundred.)

Thus optical libration – the wagging in yaw and nodding in pitch – produces a natural stereo pair if carefully selected. Warren De La Rue was the first to recognize the latent opportunity, and in 1858 after moving his telescope from the London borough of Canonbury to the clearer atmosphere of Cranford, he turned afresh to lunar photography by the wet-plate process. Six years earlier he had become the first person in England to photograph the Moon, and by now he was routinely turning out exposures of high quality.

Stereo pairs like the one reproduced here attracted comment from Sir John Herschel; they offer a view, he said, "such as would be seen by a giant with eyes thousands of miles apart". De La Rue himself added, "The stereoscope affords such a view as we should get if we possessed a perfect model of the Moon and placed it at a suitable distance from the eyes, and we may be well satisfied to possess such means of extending our knowledge respecting the Moon, by thus availing ourselves of the giant eyes of science." He was later to obtain stereoscopic photographs of sunspots by allowing solar rotation to generate suitable pairs of images.

Stereoscopic lunar views constitute more than a parlour game. They assist in delineating the Moon's surface features and particularly in cartography. De La Rue found, for example, that the lines radiating from Tycho (prominent at bottom, opposite) consist of ridges and furrows. Max Wolf later measured lunar features stereoscopically with Pulfrich's assistance.

It is not widely realized that a viewer is not

absolutely essential to convey the stereoscopic effect. The pair above (north at top) has been reprinted beneath at a size and separation which should give readers a 3-D view with a little practice. First focus on a distant object at eye level, raise the book into the line of vision and pay attention to the central overlapping image without looking at it directly. Myopic readers may find that it helps to remove their glasses. A perfect merge can be accomplished after a few trials.

Date: 29 March 1858
Place: Cranford, Middlesex
Photographer: W. De La Rue
Apparatus: 33 cm Newtonian reflecting telescope, focal length 3 m
Emulsion: Wet collodion plates
Exposure time: 1 to 5 sec
Source: Science Museum, London
References: De la Rue 1859, Fry 1861, Anon. 1868

To Stop a Bombshell

Among the various techniques in the armoury of the scientific photographer, few have evolved to a level of such sophistication as high-speed photography. Yet nearly all the early high-speed attempts must now be presumed lost and with one exception the archives begin with the galloping horses of Muybridge and the shock waves of Mach and Boys.

The exception is an "instantaneous" photograph by Thomas Skaife, best remembered for the pistol camera which he introduced in June 1856 and improved over the next few years. So-called instantaneous photographs at first embraced virtually any photography of movement, as in crowded street scenes or ships afloat, but Skaife's photograph belongs to a different order. Its immediate scientific significance was nugatory, but along with Talbot's spark photograph in 1851 of a page from the *Times* on a rotating drum it presaged great advances in the photography of high-speed movement.

The rare surviving photograph by Skaife shows one of a series he obtained with his "Patent Pistolgraph" of bombshells fired from mortars on Woolwich Common and neighbouring Plumstead Marshes. Accounts from his own pen were published in the *Times* of 29 May, 14 July and 5 August 1858; the subject of the latter, recently rediscovered, is reproduced here. It takes the form of a carte de visite which was evidently sold for many years – first from Vanbrugh House in Blackheath, later from the "Pistolgraph Depôt" in Regent's Park.

In his letters to the *Times* Skaife waxes eloquent about the significance of his pictures of mortar shells and attendant phantoms ("Likeness of a Human Head"). "Epochs of time, inappreciable to our natural unaided organ of vision, [can] be made evident to our senses by a photographic camera as decidedly as the presence of animalculae in blood or water is by a microscope." He goes on to deride a gentleman who, shown the photograph opposite, ingenuously enquired, "But what stopped the ball?" Skaife infers the exposure time from the known projectile velocity (said to be 500 feet per second) and the length of the trail produced by application of what he likes to call an "optical brake": one fiftieth of a second is claimed.

Two months later the editor of the *Liverpool and Manchester Photographic Journal* described Skaife's camera in some detail: "Within the camera, and immediately behind the back combination of a portrait lens, a *square* opening, somewhat larger than the diameter of the lens, is closed by means of a pair of shutters fitting tightly and slightly overlapping one another by means of a small rabbet or groove in the corresponding edges of the shutters. The material of which they are constructed is that known as 'Vulcanite', a combination of caoutchouc with some other ingredient, in extensive use for the manufacture of combs, etc., under a patent of Mr Goodyeare's. . . . Each little shutter is hinged so as to cover one half of the aperture, and the pair can be opened and shut precisely like a pair of folding doors. The hinges consist of wires attached to one edge of each shutter, and these wires are prolonged upward so as to project through the top of the camera. Each wire is armed at its upper extremity with a very small reel or bobbin, with little projecting pins or 'studs'. Now, by turning the bobbin one quarter of a revolution, that is, by bringing any one of the 'studs' to a position at right angles to that in which it was previously, the shutter attached to its wire is completely opened, and being of such trifling weight, this operation is accomplished by a minimum expenditure of force. . . .

"It is only necessary, then, to rotate one of the bobbins a quarter of a turn in order to cause *both* shutters to be *completely* opened, as any movement of one bobbin is immediately conveyed, but in an opposite direction, to its companion, by means of the silken thread or the elastic band, the latter always coming into play when extraneous force is withdrawn; consequently, if a thread be attached to and partly wound round the bobbin, by a very slight jerk of the thread the shutters may be completely opened, and will of themselves close again in a very small fraction of a second of time." Finger action was found to be too slow, and a trigger key connected to rubber bands was soon substituted.

Date:	28 July 1858
Place:	Plumstead Marshes, London
Photographer:	T. Skaife
Apparatus:	Pistolgraph with vulcanite shutters; portrait lens of aperture 2.2 cm, focal length 2.5 cm
Emulsion:	Wet collodion plate
Exposure time:	0.02 sec
Source:	Royal Astronomical Society, London
References:	Anon. 1858, Skaife 1860 & 1861, Gernsheim & Gernsheim 1969

Mitres and Mountains on the Solar Limb

Photographs of solar eclipses were no longer a novelty when Warren De La Rue set out for Spain to record the moments of totality at the 1860 eclipse. G. A. Majocchi had already daguerreotyped the eclipsed Sun in Milan in 1842, albeit without recording corona or prominences. Berkowski in Königsberg (now Kaliningrad) and Father Secchi in Rome fared rather better at the solar eclipse of 1851, and photography would be no stranger at subsequent eclipses.

Whatever photographic success these observers could boast, their images did not promote any scientific advance until De La Rue mounted his Spanish expedition. Two aspects of De La Rue's eclipse effort were entirely new: the use of wet collodion plates and the attempt to settle an astronomical question photographically. The nature of the prominences observed at the periphery of the Moon's occulting limb had long been disputed: whether they represented optical effects in the Earth's atmosphere or else originated in the Sun itself.

Launching an eclipse expedition in 1860 was fraught with difficulties. De La Rue arranged to transport the famous Kew photoheliograph (p 17; preserved in the Science Museum, London), along with a new cast-iron mounting and the apparatus of a complete photographic laboratory. One of the disadvantages of working with collodion is the requirement that the entire photographic process be conducted in one continuous endeavour.

De La Rue set sail from Plymouth in HMS *Himalaya* with the equipment and four assistants, landed at Bilbao two days later and continued by stage-coach to Rivabellosa on the edge of the Spanish rioja region in the province of Logroño. Here he established his observatory on a local threshing-floor. On the day of the eclipse, much anxiety was caused by heavy cloud, which happily cleared in time; by a fire started when a Spanish lad smoking glass for local villagers got carried away; by the encroachment of a crowd of 200 curious Spaniards, eventually contained by the Guardia Civil. But in the event De La Rue obtained 35 usable photographs, including two at totality – "large and exquisitely defined pictures", as John Lee was to describe them two years later when the Royal Astronomical Society accorded De La Rue its Gold Medal.

The pair of collodion plates reproduced here record the eclipsed Sun just after the beginning of totality (upper) and just prior to the end (lower). In De La Rue's words they "depicted the luminous prominences with a precision as to contour and position impossible of attainment by eye observations". The prominences on the Sun's limb were identified by fanciful designations – the cauliflower, the boomerang, the fallen trunk and the mitre on the eastern (left) limb in the upper photograph, for instance, or the mountain at top right in the lower. The apparent "moonspots" are not lunar eruptions, just defects on the surviving plates.

Meanwhile, Father Secchi had established his observation post at Disierto de las Palmas near Castellón de la Plana, 500 kilometres to the southeast. He obtained photographs at totality which could be compared with those of De La Rue, who argued (correctly) that if prominences belong to the Sun then it should be possible to produce an exact coincidence by superposing their outlines on photographs taken at different locations on the path of totality. Despite some difficulties in obtaining comparison prints of equivalent density, De La Rue subsequently found that mountain for mountain and mitre for mitre the Italian observations matched his own. Moreover, his prediction that prominences on eclipse photographs taken at the same locality at different epochs of totality should coincide if they are of solar origin was amply fulfilled.

Photography scored doubly at this historic eclipse. First, comparison with simultaneous optical observations showed that "luminous prominences invisible to the human eye are depicted in the photographs". Second, arguments over the origin of the prominences were photographically resolved: they are indeed excrescences of the Sun itself.

Prominences are now known to be gaseous emanations erupting out from the solar photosphere in a variety of shapes (from surging columns to circular loops), sizes (up to 200,000 km) and lifetimes (hours to months). They consist of material much cooler and denser than the surrounding corona. Curiously, a classification scheme introduced thirty years ago by D. H. Menzel and J. W. Evans harks back to De La Rue's whimsical nomenclature. To them the plumes and whorls of prominences evoke trees, hedgerows, clouds and mounds – a mite more prosaic than cauliflowers and mitres.

Date:	18 July 1860
Place:	Rivabellosa, Spain
Photographer:	W. De La Rue
Apparatus:	Kew photoheliograph of aperture 7.5 cm, focal length 1.3 m
Emulsion:	Wet collodion plates
Exposure time:	1 min
Source:	Royal Greenwich Observatory, Herstmonceux
References:	De La Rue 1862, De La Rue 1864, Norman 1938, Tandberg-Hanssen 1974

Horses in Motion

According to the popular epithet, Eadweard Muybridge (born Edward James Muggeridge) is "the father of the motion picture". If so, the birth of cinematography owes a great deal to what is properly speaking a scientific photograph, one taken to reveal what the eye cannot see. The question which Muybridge set out to answer photographically is perfectly simple: does a galloping horse at any point in its stride lift all four hoofs clear of the ground? The answer can be seen here.

From the early 1870s the above question exercised the mind of Leland Stanford, ex-governor of California and later founder of the eponymous university. Stanford became very interested in the training of horses and wanted to follow their limb movements the better to improve the performance of his recently purchased race-horse Occident. He invited Muybridge, already famous for his photographs of the Yosemite Valley, to photograph Occident trotting on the Union Park race-course in Sacramento, California. "The problem," wrote Muybridge later, "was to obtain a sufficiently well-developed and contrasted image on a wet collodion plate, after an exposure of so brief a duration that a horse's foot, moving with a velocity of more than thirty yards in a second of time [in the event, 38 feet per second], should be photographed with its outlines practically sharp. In those days the rapid dry process ... had not been discovered. Every photographer was, in a great measure, his own chemist..." In May, 1872 Muybridge secured several negatives some of which showed Occident "with all four of his feet clearly lifted, at the same time, above the surface of the ground... The question [is] settled once and for all time in favour of those who argued for a period of unsupported transit."

The matter did not end there, however (fortunately, since none of the 1872–73 photographs survive). Further photographic experiments were conducted at Sacramento in 1876–77, and the resulting "instantaneous" photographs of Occident pulling a sulky (a light two-wheeled buggy) were widely reproduced. The claimed exposure time was less than 1 msec. It was now clear that a horse's foreleg is straight when its hoof strikes the turf. The only surviving photograph from these experiments is heavily retouched – "as is customary at this time with all first-class photographic work", averred Muybridge. His fame rested more on drawings of Occident based on the collodion plates than on the photographs themselves.

The principal attack on the photographic problem was launched at a different site, the Palo Alto stock ranch, mainly in 1878–79. This time a battery of 12 cameras (later 24) spaced 53 cm apart on one side of the track faced a fence hung with white sheeting on the other, numbers and vertical lines marking the sequence. To trip the shutters, either the rims of the sulky's metal wheels made contact with wires laid across the track or – in the absence of a vehicle – the horse itself breasted fine threads strung through the air. In June and July 1878 Muybridge filed patents covering both electrical and mechanical release of his double shutter, a pair of spaced slats held suspended on a taut spring so that the bottom slat covered the lens before exposure and the top immediately following.

The earliest surviving photographs of Muybridge's equine experiments form a sequence of lantern slides reproduced opposite. The horse Abe Edgington draws a sulky driven by Charles Marvin against the calibrated backdrop. The original plates were taken at intervals of 0.04 sec. The best illustrations of "unsupported transit" show a galloping horse with all four legs bunched together under his belly; nevertheless, the fourth photograph makes the point well enough. Similar sequences appeared in *La Nature*, *Scientific American* and other publications as heliographic reproductions and line drawings.

Muybridge analysed the consecutive foot positions adopted by horses walking, trotting, ambling, cantering and galloping and in 1882 presented the results in London first to the Royal Society and then to the Royal Institution. He pointed out how artists had for the most part misrepresented the horse in motion for want of a frozen high-speed record. But despite his comments on the role of photography in the search for truth, designers of hobby-horses have yet to take cognizance of Occident and Abe Edgington!

Date: 15 June 1878
Place: Palo Alto Farm, California
Photographer: E. J. Muybridge
Apparatus: Scoville cameras from NYC, lenses by
 J. H. Dallmeyer, guillotine shutters by A. Brown
 electrically released by trip-wires
Emulsion: Wet collodion plates
Exposure time: approx 0.5 msec
Source: Science Museum, London; Kingston-upon-Thames
 Library, Surrey
References: Muybridge 1882, Mozley 1972, Haas 1976

Cometary Stimulus for Celestial Cartographers

This remarkable photograph of the Great Comet of 1882 wrought a considerable influence on the evolution of astronomical photography, but not for the obvious reason. By 1881 it was possible to obtain excellent photographs both of comets and of their spectra. What really attracted attention in this photograph, *a posteriori*, was the rich stellar background.

The Great Comet of 1882 (formally Comet 1882 II) was first sighted by W. H. Finlay at the Royal Observatory in South Africa. Over the next few weeks it evolved into so arresting an object even to the naked eye that Sir David Gill, His Majesty's Astronomer at the Cape of Good Hope, resolved to photograph it. An "ill-defined mass of golden glory", according to Gill's description, it possessed a "brilliant white head" and a tail like "entangled bright cords, or scattered locks of wool". Indeed, its luminous intensity was so great that on the evening of 17 September 1882 it could be traced to the very edge of the solar disc across which it transited to become visible in the dawn sky the following day. Comet 1882 II was subsequently shown to belong to the Kreutz group of Sun-grazers (see p 202) with a perihelion distance of only 1.2 million kilometres and a period of 760 years.

Gill had had some previous experience of lunar photography on wet collodion plates, but the dry plates he wanted to use were new to him. He sought the advice of a professional photographer, E. H. Allis, from the neighbouring village of Mowbray. With a doublet lens by Ross in an ordinary portrait camera clamped to the Cape's equatorially mounted Grubb telescope, Gill took his first exposure on 19 October. In thirty minutes he recorded a bright coma around the nucleus and a 15-degree tail.

That first attempt had a certain curiosity value, but it was left to Gill's subsequent exposures to make astronomical history. As the comet receded from perihelion, it began to change dramatically, its tail lengthening to over 20° and its nucleus splitting into several distinct condensations like "very small beads on a thread of worsted". Quite unexpectedly it also developed an anti-tail, a faint projection *ahead* of the cometary nucleus which we now believe to result from the viewing geometry. Perhaps to capture this anomalous sunward tail, Gill took five further photographs, all of longer exposure than the first.

In the top (positive) photograph on the facing page, the multiple head is lost in the resplendent coma, but in compensation both the bright straight gaseous tail and the fainter distended dust tail are clearly visible. Fortunately the original negatives still exist; after photographic amplification they yield a striking view of the anti-tail (bottom, as negative). From Gill's point of view the comet was upstaged by the wealth of background stars, visible down to magnitude 8.5. The idea of charting the heavens photographically germinated almost at once, and a week later he ordered a special lens from the London maker John H. Dallmeyer for the purpose. "The point which has struck me is this," wrote Gill, "that if we can get over the distortion in a *reasonable degree* [stars at the edge of the field appear elongated], so as to get sharp or nearly equally sharp pictures of stars over a field of say 10° square, here is a very easy way of making star maps for working purposes."

Thus originated the first catalogue of stellar positions entirely based on photographic measurements, the *Cape Photographic Durchmusterung*. Initiated in 1885, it was completed in 1891 with the help of the indefatigable Dutch astronomer J. C. Kapteyn. Yet more was in store: in 1886 Gill wrote to Rear-Admiral Ernest Mouchez, Director of the Paris Observatory, proposing an international conference to organize "a programme which has for its immediate object the formation of a complete photographic library of the heavens on a scale that approaches the limits of our powers, both as to the magnitude of the stars photographed and the precision with which the relative places are defined upon the plates."

The famous Astrographic Congress took place in Paris in 1887 and duly launched the mammoth *Carte du Ciel* project in which eighteen observatories world-wide would collaborate on photographing and cataloguing the sky. This cartographic effort carried on for some eighty years and although overtaken by faster sky surveys with better emulsions it remains a tribute to the historical initiative of Gill and Mouchez.

Date:	13 November 1882
Place:	Royal Observatory, Cape of Good Hope, South Africa
Photographer:	D. Gill
Apparatus:	Equatorially-mounted portrait camera with Ross doublet lens of aperture 6.4 cm, focal length 28 cm
Emulsion:	Dry gelatino-bromide plate
Exposure time:	80 min
Source:	Royal Astronomical Society, London; Photolabs, Royal Observatory, Edinburgh (bottom)
References:	Gill 1887, Gill 1911, Gill 1913

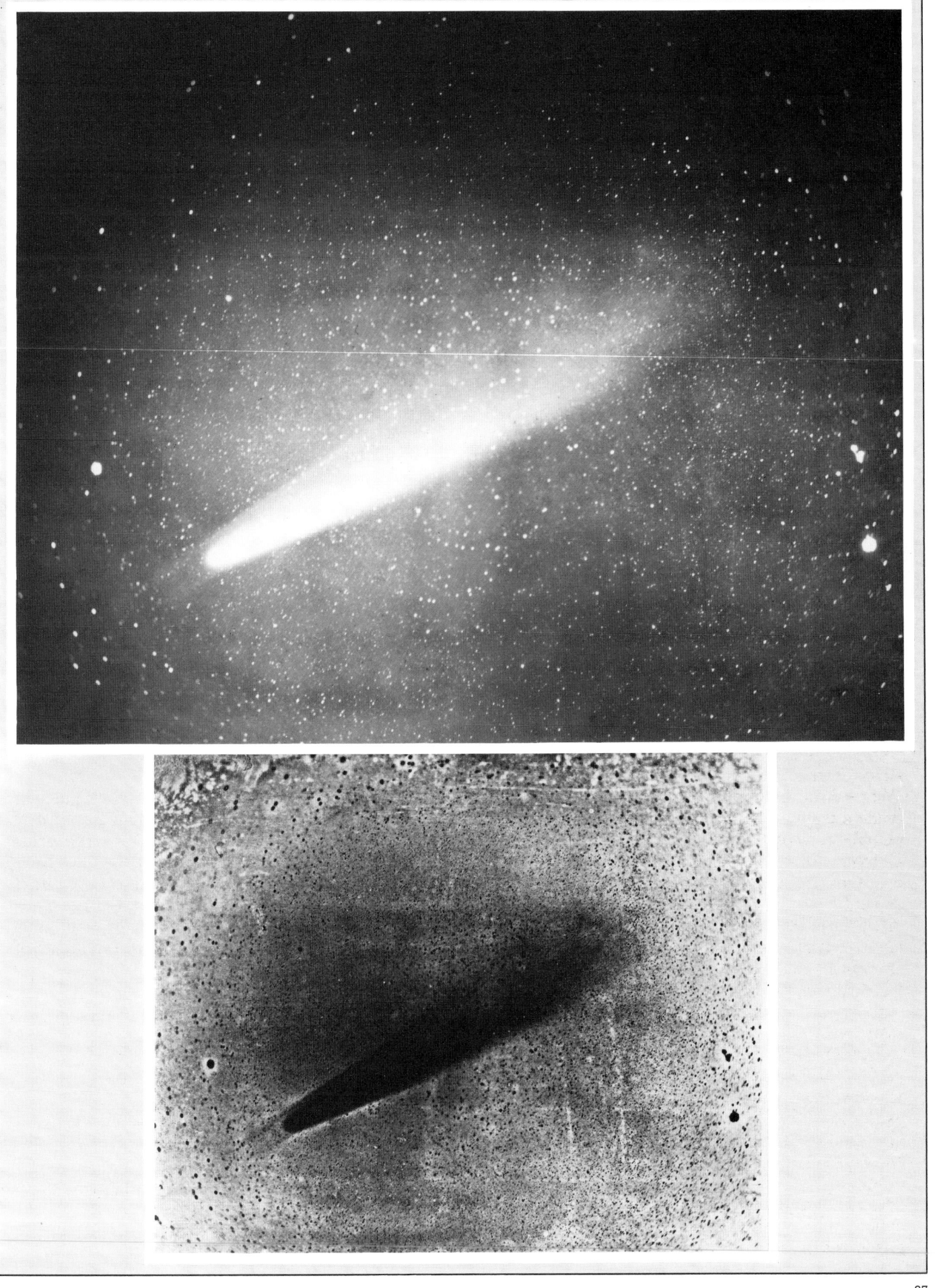

Geometric Man

As a graphic depiction of a running man, the picture opposite may pass muster; but as a photograph it at first seems scarcely credible. It is, however, one of the most intriguing photographic results obtained by Etienne-Jules Marey shortly after construction of the Station Physiologique on grounds in the Parc des Princes placed at his disposal in 1881.

A decade before he designed a movable film system, Marey wrestled with the problem of recording motion on a fixed plate without losing the crucial information in a welter of images. He was satisfied with neither his recent photographic gun (p 19; it supplied tiny silhouettes devoid of spatial information) nor Muybridge's battery of cameras (which admitted more than one camera viewpoint). Abandoning the photographic gun, Marey first opted for a simple box camera with rotating shutter, the subject being taken against a black ground.

Now at first glance the means of avoiding a confusion of superposed images is straightforward enough: merely adjust the shutter speed to prevent overlap and ensure a wide enough field. As soon as one demands higher time resolution, however, the problem becomes apparently insuperable. Marey nevertheless circumvented it by means of what he called geometric (or partial) chronophotography.

In geometric images like the one shown here, the photograph is reduced to the barest desired essentials by blacking out unwanted portions of the subject. As the adjacent photograph shows, a runner is dressed in black, even his face covered, with white stripes along his limbs. (To attain sufficient reflectivity for the short exposures, Marey prescribed sticks of black wood bearing a row of nails with brilliant metallic heads; later he adopted silver lace.) Other photographs show the man walking, running or jumping in a costume half-black, half-white.

Whereas use of a fixed plate previously restricted exposures to ten per second, partial photography facilitated as many as a hundred per second. The rotating shutter, a disc with a rectangular slit, is not made to rotate any faster; it is simply provided with more slits – ten in this case. Note that every fifth partial image registers thicker than the others. Marey commented, "It is often advantageous to give one [but obviously two here] of the windows a diameter twice that of the others; there results a greater intensity of one of the images and that facilitates timing estimates as well as supplying reference points for comparison of the movements of lower and upper limbs."

Marey recognizes a kind of "uncertainty principle" in geometric photographs such that space and time cannot be inferred with equal precision. The more detail required in body position, the greater the number of lines to be applied and the longer the time interval required between exposures to avoid jumbled images. Conversely, the greater the number of images required per second, the more skeletal the lines must be made. The runner here is photographed 60 times a second – a good compromise.

The fixed-plate chronophotographic camera used for this study employed a disc of 50 cm radius with slits 3 cm wide. Rotating six times a second, it must have given an exposure of about 1/600 sec though in other cases the rate was faster and the exposure time shorter (1/900 sec). Geometric photographs were pursued until 1888 when moving film (pp 46–47) ushered out the era of the fixed plate.

Date: 1883
Place: Parc des Princes, Paris
Photographer: E.-J. Marey
Apparatus: Chronophotographic apparatus with rotating
 shutter, fixed plate
Emulsion: Dry gelatino-bromide plate
Exposure time: 2 msec (each image)
Source: Musée Marey de Beaune (Collège de France
 Collection), France
References: Marey 1883, Marey 1895, Frizot 1977

Images successives d'un ouvrier

Watershed in Celestial Photography

To terrestrial observers the Great Nebula in Orion appears the brightest of the diffuse nebulae and as a result has always been a favourite subject for astrophotographers. Indeed it was the first nebula ever photographed – by Henry Draper on his 28 cm Clark refractor in September 1880. Noteworthy a feat though it was, Draper's photograph did not have so great an impact as the one shown here, taken by Andrew Ainslie Common on his home-ground 91 cm reflector in January 1883.

At a meeting of the Royal Astronomical Society in March 1883, the President asked Common to circulate his Woodburytype enlargement of the nebular photograph, in his view "by far the best I have ever seen". In his address Common presciently commented, "We are approaching a time when photography will give us the means of recording in its own inimitable way the shape of a nebula and the relative brightness of the different parts in a better manner than the most careful hand-drawings [doubtless a reference to E. S. Holden's 1878 monograph on the central parts of the Orion Nebula] ... As these stars appear on negatives taken with exposures of from 37 to 60 minutes, and the time of exposure can easily be extended to hours, it may be ... quite possible to get stars invisible to the eye in the same telescope used for photography."

Thus this was the first astronomical photograph to rival the best visual observations in the details recorded. The emulsion proved far superior to the drawing, even in the hands of a skilled observer. As Agnes Clerke was later to write in her sonorous prose, "Photography may thereby be said to have definitely assumed the office of historiographer to the nebulae, since this one impression embodies a mass of facts hardly to be compassed by months of labour with the pencil, and affords a record of shape and relative brightness in the various parts of the stupendous object it delineates, which must prove invaluable to the students of its future condition."

Common persevered over the next year, obtaining photographs of the Orion Nebula and others with exposures up to 90 minutes, as well as photographs of Jupiter and Saturn. When presenting Common with the Gold Medal of the Royal Astronomical Society in 1884, the President (E. J. Stone) remarked, "The success of these long exposures with this powerful instrument has opened out a new field of research by which the accumulating effect of the light of faint stars, too faint even for observation to the eye, have [sic] been registered upon the photographic plate. It is indeed difficult to over-estimate the interest with which the results which Mr Common may obtain in this direction will be watched by astronomers." We should note the implication here: it is not only for their ability to capture wisps of vanishingly faint nebulosity that the photographs are praised, but also for the opportunity they offer to reach stars of fainter magnitude.

It comes as a surprise to learn that the telescope on which this historic photograph was taken not only survives but remains in active service. Edward Crossley purchased Common's 3 ft (91 cm) reflector in 1885; a decade later he donated it to the Lick Observatory on Mount Hamilton, whose director was none other than E. S. Holden. The cognomen "the Crossley reflector" has clung tenaciously, obliterating its rightful title. On the other hand, virtually all of Common's original instrument has been rebuilt or replaced in the course of a century's use.

The year 1882–1883 marked an astronomical watershed; as E. E. Barnard of Lick Observatory later remarked, it signalled the "waking up of celestial photography". The two harbingers of this awakening were Gill's plates of the Great Comet of 1882 (pp 36–37) and Common's of the Orion Nebula. From a contemporary standpoint, it is sobering to reflect that this historic photograph was the work of an amateur astronomer. As Stone reflected in his presidential address, the amateur "untrammelled by the necessity of continuing observations,... having the power of taking up any subject he pleases, pursuing it so long as he believes in the possibility of success, without fear or responsibility of charges of wasted time and wasted means" possessed priceless advantages over his professional confrères.

Date:	30 January 1883
Place:	Ealing Observatory, near London
Photographer:	A. A. Common
Apparatus:	91 cm reflecting telescope with adjustable plateholder
Emulsion:	Dry gelatino-bromide plate
Exposure time:	37 min
Source:	Science Museum, London
References:	Common 1883, Common 1884, Clerke 1893

Shock Waves

The first benefit which the physical sciences reaped from high-speed photography was the visualization of shock waves. Adapting the schlieren technique devised by August Töpler, Ernst Mach photographed and measured supersonic waves in the wake of rapidly moving projectiles (shown here), as well as sound waves generated by sparks and jets of compressed air.

Mach, an extraordinarily inventive and wide-ranging physicist and philosopher, had already experimented on shock waves by means of electric sparks. Waves produced by a pair of sparks were made to displace soot on a sheet of glass, much the way acoustic waves produce Chladni patterns. When in 1884 Mach finally obtained the new dry plates, so much more sensitive and practical than their wet collodion predecessors, he turned to photography with the aid of the schlieren technique.

Schlieren originally referred to the streaks seen in imperfectly annealed glass, and by extension came to mean irregularities in the air (or any fluid medium) made visible by Töpler's method – a method in turn based on an optical test by Léon Foucault. In essence the method allows the eye to see, or the camera to record, waves which have been deflected into or out of the line of sight by shock waves, convection currents or other inhomogeneities. A light source sends a beam through the test medium and then a lens brings the image of the source to a focus, where a slide or knife edge shows up contrasts of density and thus of refractive index in the medium.

Mach's preliminary experiments (1884) with a target pistol revealed no shock waves on account of the subsonic muzzle velocity. At Mach's behest P. Salcher and S. Riegler at the Royal Imperial Naval Academy in the Austrian port of Fiume (now Rijeka, Yugoslavia) undertook experiments with larger projectiles at higher velocity and achieved the first photographs by 1886. Mach's theory that the waves should become visible only above the speed of sound, 343 metres per second in dry air at room temperature, proved correct.

Both parties then turned to guns of larger calibre at artillery ranges, Salcher at Pola on the Adriatic and Mach with his son Ludwig at Meppen in the county of Hanover. They found that the greater bore (cannons of 9 cm at Pola, 4 cm at Meppen) produced in the leading wave or bow-wave a sharper hyperboloid, its vertex somewhat farther ahead of the shot, than did the small arms. But at the same velocity the oblique trailing waves still formed the same angle to the direction of travel – independently of the size of the projectile. In December 1886 Mach formulated the crucial equation according to which the sine of what we now call the Mach angle is equal to the inverse Mach number. (The Mach number is simply the ratio of the projectile speed to the speed of sound – whence Mach one, Mach two and so forth.)

"Really good results," wrote Mach later, "could be obtained only by the most careful conduct of the experiments in a laboratory especially adapted to the purpose." When the Machs returned to their laboratory at the University of Prague, they gradually improved their apparatus in which the bullet was illuminated by the brief, bright spark discharge of a Leyden jar. From the experimenter's point of view the trick is to time the flash exactly right. In the final version of the apparatus, a projectile shot through a small cylinder with an open tube set into the side. The rush of air down the tube blew a candle flame just far enough to complete a circuit which set off the spark. To delay the spark until the bullet was crossing the camera field, one had only to lengthen the tube. Larger condensers produce sparks of longer duration and tend to blur the image of the speeding bullet; so Mach employed "incredibly small" sparks.

Such sophistication of design had not yet been achieved by the winter of 1888 when these photographs were obtained. Not a candle flame but the projectile itself completed the circuit to discharge the jar and illuminate the bullet by providing a fleeting short-circuit between two wires in the field of view, one connected to each terminal in the jar. The vertical white lines crossing the field are these wires, made of copper 0.5 mm thick. Experiments were conducted on projectiles differing in shape and in composition (lead, aluminium, brass) before the "troublesome" wires were replaced.

The two photographs here are reproduced from plates 1 cm across – probably the earliest original plates still extant according to the Ernst-Mach-Museum. They contrast the different shock waves generated by brass bullets of different form, sharp (34 mm long, weighing 18 g) and blunt (23 mm long). Both display a *hyperboloidal* leading wave which looks merely hyperbolic in cross-section because the three-dimensional shell is too thin to reflect much light except when seen edge-on. Similarly, the trailing waves, which always point at a more rakish angle than the leading wave, are really cones seen in cross-section. Those behind the blunt bullet flare outward from the casing. The intermediate (trailing) waves arise regardless of the smoothness of the shell, and Salcher attributed such waves to friction in the same fashion that wind produces ripples on a lake. When irregu-

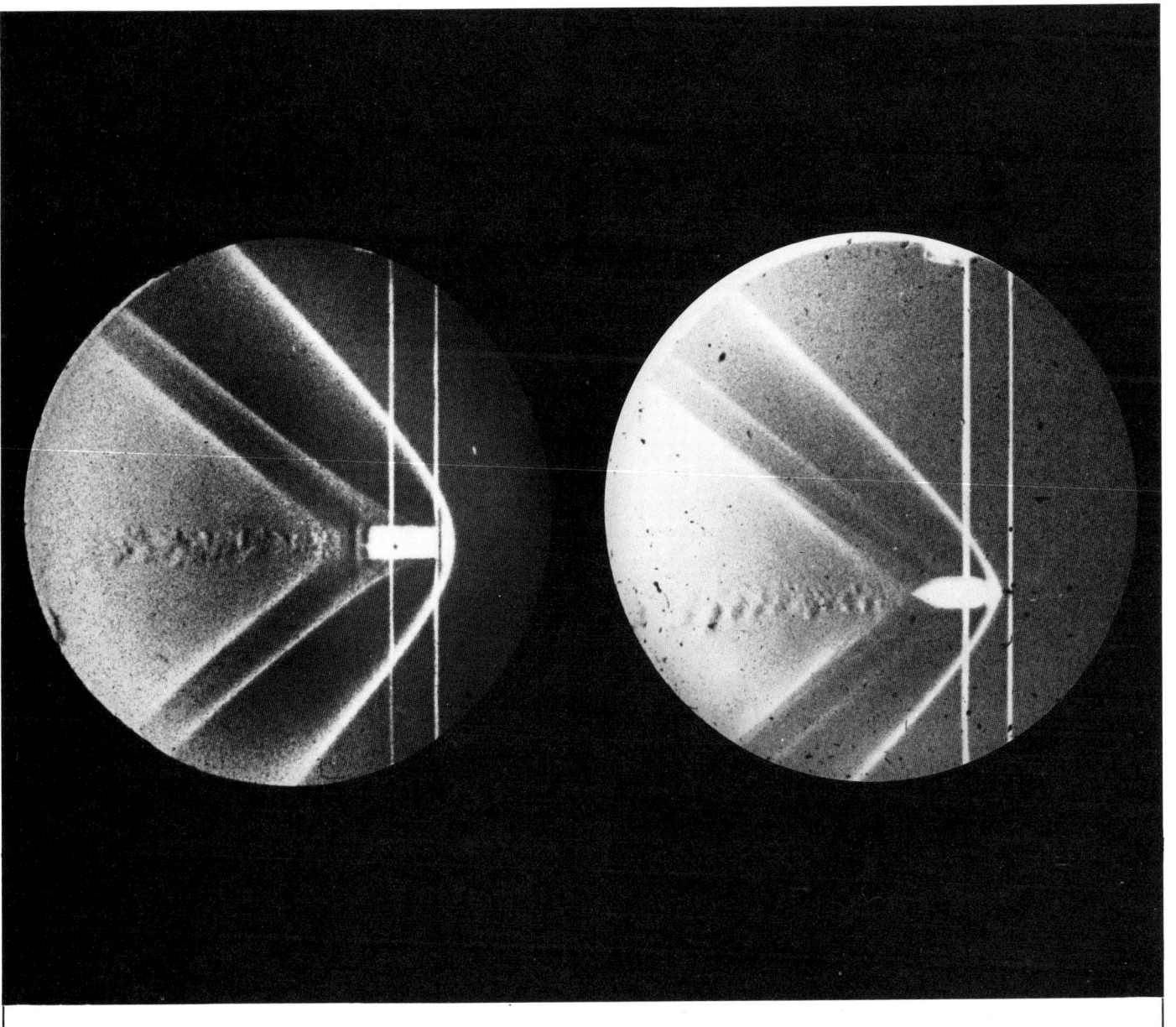

larities are present, on the other hand, they always provide a point of departure from which intermediate waves stretch out.

Note that contrary to what some scientists anticipated, a vacuum does not form behind the speeding bullet. Instead the bullet leaves a cylindrical trail of air turbulance, "little clouds ... filling the flight path like a string of pearls" in the words of J. Castner. Immediately behind the blunt bullet with its higher air resistance, or drag, longitudinal waves of large amplitude stand out clearly. The greater resistance is also responsible for the more intense leading wave (left). Mere air movement cannot generate the turbulent trail, but an abrupt rise in temperature through frictional heating would have just this effect.

These experiments provide several lessons for the student of ballistics. A single report is heard when a subsonic projectile is fired, but at supersonic speeds the report is double: one arriving at the speed of the projectile and a second following at the speed of sound. The old myth that wounds are inflicted by compressed air ahead of the missile was laid; the damage is caused by the penetrating metal itself. Finally, sharper bullets yield fewer eddies and lower drag. Artillerists should take note, commented Mach sardonically, since "To shoot in the shortest time possible as many holes as possible in one another's bodies [is] the most important affair of modern life."

Date:	Winter 1888
Place:	Physical Institute, German University of Prague
Photographers:	E. Mach & L. Mach
Apparatus:	Brass bullets at 520 m/sec approx; spark from Leyden jar triggered by copper wires
Emulsion:	Schleussner's extra-sensitive dry plates
Exposure time:	2 μsec approx
Source:	Ernst-Mach-Institut, Freiburg, West Germany
References:	Mach & Salcher 1889, Mach & Mach 1889, Mach 1910, Blackman 1972

Photographic Capture of a Comet

The full flower of astronomical photography can be traced back to its memorable blossoming in the early 1880s, and it could be only a few years before it claimed a major share of discoveries. Indeed in 1891 the asteroid 323 Brucia became the first to be found photographically. The following year saw the first photographic discovery of a comet – formally Comet 1892 V – by the famous American astronomer Edward Emerson Barnard. Only a month earlier, in September 1892, he had made what proved to be the last *visual* discovery of a satellite – Jupiter V, or Amalthea.

By the 1890s photographs of comets were of course no rarity; the earliest harked back to Donati's comet of 1858, recorded with a short-focus camera by an English commercial photographer named Usherwood. But the rule of the game had always been first to spot the comet visually and then to attempt a photograph. Of Comet 1892 V, on the other hand, Barnard was to write, "Nothing whatever was known of its existence until it was shown on the photographic plate. It was then looked up in the sky and observed with the micrometer [i.e., visually through a telescope] . . . Its history is complete, and until better evidence is forthcoming [a rebuke to some unsubstantiated earlier claims] it will stand as the first comet whose original discovery was made by photography."

It is remarkable that the comet, the fuzzy needle in the middle of the stellar haystack on the facing page, is centred as if it were the target of the photograph. In fact, sheer serendipity was responsible because at the time Barnard was recording this star field in the constellation Aquila as part of his monumental photographic survey of the Milky Way. Working at Lick Observatory on Mount Hamilton, Barnard sat at the guiding eyepiece of the telescope throughout the long exposure, making fine adjustments whenever necessary to achieve perfectly sharp stellar images. In over four hours the relatively nearby comet moved appreciably against the background of distant stars, and consequently the streak represents not simply the image of a comet but a trail along its direction of motion. The trail is shown at near right enlarged about ten times.

Confirmation of the suspected comet was immediately sought, both visually and photographically. Barnard had recorded the comet with a 6-inch portrait lens, but he sought and found it visually in a telescope of twice the aperture. To determine its orbit, photographs were taken on succeeding nights until 8 December. From 40 observations the orbit of Comet 1892 V was calculated in 1974 by D. K. Yeomans to reach perihelion (closest approach to the Sun) at 1.5 times the Earth's distance and to return every 6.5 years. Yet through inadequate observational data or an unhappy encounter in the outer reaches of the Solar System, Barnard's comet has never been recovered.

Date: 12 October 1892
Place: Lick Observatory, California
Photographer: E. E. Barnard
Apparatus: Willard portrait lens of aperture 15 cm, focal length 79 cm
Emulsion: Dry bromide plate, Cramer "Lightning"
Exposure time: 260 min
Source: Royal Astronomical Society, London
References: Barnard 1893, Norman 1938, Brandt & Chapman 1981

45

To Catch a Falling Cat

No cat ever somersaulted more controversially than this one. The brilliant photographer and scientist Etienne-Jules Marey first displayed this unbroken filmstrip at the 29 October 1894 meeting of the Academy of Sciences in Paris under the bemused gaze of President Loewy and fellow Academicians. The old adage has it that cats always land on their feet, but before the advent of high-speed photography no one could quite see how they managed to do so. Some claimed that cats give themselves a shove in the right direction at the moment of falling, in this instance pushing the experimenter's hands; others, that they use air resistance.

The camera, in Marey's capable hands, proved both hypotheses wrong. Rotated in a zoetrope, which can be considered a primitive Victorian predecessor of the cineprojector, the images take on continuity of movement at about 10 images per second. (Marey claimed 60 images per second for the original filmstrip, but in this case the rate must have been nearer half that figure.) Even the frozen sequence here shows what really happens: the cat flings its hind paws out with its forepaws retracted to rotate its head and shoulders and then reverses the procedure, extending its forepaws whilst tucking in its hind ones, its tail twisting all the while in the *opposite* direction to the rotation. The beret-clad experimenter overhead (not Marey himself) is looking on with satisfaction as the agile cat executes a perfect landing.

Marey had considerably refined his "chronophotographic" apparatus by the time he captured this falling cat. The double-action mechanism shown schematically at right was operated by a hand crank, but through a novel design the film was fed through at a uniform rate. A special device arrested the film at the moment of exposure. The sensitized film consisted of a continuous strip spooled about two bobbins. (Curiously, the widespread modern practice of attaching the leading end of a roll of film by means of a vertical slit in the bobbin originated in this apparatus.) The shutter was comprised of two perforated discs rotating at different speeds, exposure occurring whenever the rectangular apertures coincided.

At first sight, the falling cat seemed to confound the "theorem of areas," better known as the principle of conservation of angular momentum. Indeed, Guyou – the speaker after Marey – started by saying that "this spontaneous turning of the animal appears impossible." Was this to be another case where scientists proved that aerodynamically bees cannot fly? The theorem of areas was vigorously discussed for the next few meetings by Messieurs Guyou, Lévy, Picard, Deprez, Appell, Lecornu and others. The theorem was not refuted but they agreed that it had been misinterpreted in the past.

The popular press in the form of *Paris-Photographe* took up the story and it eventually came to the ears of the great mathematician Giuseppe Peano, who dismissed the paw movements as irrelevant and asserted stoutly that the whole manoeuvre depended on the animal's tail. Rather maliciously he proposed a further experiment with a tail-less cat (the Manx variety).

The latest if not the last word belongs to Thomas R. Kane of Stanford University, who thinks little of the tail theory and less of explanations based on bodily rotation. "The torso of the cat bends, but does not twist," he states categorically. With M. P. Scher, Kane formulated a set of equations describing the dynamics of a cat's fall. The model is founded on bending of the feline spine forward and backward, to and fro. Is Kane right? We can only borrow a line from T. S. Eliot: "The cat himself knows but will never confess."

Date: 1894
Place: Collège de France, Paris
Photographer: E.-J. Marey
Apparatus: Chronophotographic apparatus with rotating
 shutters, spooled film
Emulsion: Gelatino-bromide film
Exposure time: < 1 msec (each image)
Source: Science Museum, London
References: Marey 1894, Marey 1895, Peano 1895, Kane & Scher
 1969

X-rays: Photography of the Invisible

The discovery of X-rays by Wilhelm Röntgen stands as a major landmark in the history of scientific photography. It was by no means just a "lucky accident", for with the proliferation of Crookes vacuum tubes (since 1879) and fluorescent screens (since 1878) the apparatus was available and the time ripe. But as always, in the sagacious remark of Louis Pasteur, chance favours the prepared mind. Indeed, only two days after Röntgen's first public demonstration, Hugo Münsterberg of Harvard University wrote, "There were many galvanic effects in the world before Galvani saw by chance the contraction of a frog's leg on an iron gate. The world is always full of such chances, [but] the Galvanis and Röntgens are few."

The famous first photograph through living flesh – shown opposite – depicts the ringed hand of Röntgen's wife Bertha. The date "22 Dec 1895" is scrawled at upper right. But still earlier radiograms were made of inanimate objects, the oldest surviving plate being the exposure through the closed door of Röntgen's laboratory reproduced at near right. The plate is inscribed in Röntgen's hand at lower right: "20 Nov 1895, 3te Platte". (Both hand and door appear here as negatives.) The metal door knob and streaks of lead-based paint come out as white striations because the "white lead" absorbs a greater proportion of the incident X-rays.

Although conflicting stories on the actual discovery abound, Röntgen's biographer Otto Glasser plumps for the rather melodramatic account by British physicist Silvanus P. Thompson: "November the eighth, 1895, will ever be memorable in the history of Science. On that day a light which, so far as human observation goes, never was on land or sea, was first observed. The observer, Prof. Wilhelm Conrad Röntgen. The place, the Institute of Physics in the University of Würzberg in Bavaria. What he saw with his own eyes, a faint flickering greenish illumination upon a bit of cardboard, painted over with a fluorescent chemical preparation [crystals of barium platinocyanide]. Upon the faintly luminous surface a line of dark shadow. All this in a carefully darkened room, from which every known kind of ray had been scrupulously excluded. In that room a Crookes tube, stimulated internally by sparks from an induction coil [in other words, an evacuated cathode-ray tube excited by electric discharge], but carefully covered by a shield of black cardboard, impervious to every known kind of light, even the most intense... Nothing visible until the hitherto unrecognized rays, emanating from the Crookes tube and penetrating the cardboard shield, fell upon the luminescent screen, thus revealing their existence and making darkness visible... The discoverer, interposing his hand between the source of the rays and his bit of luminescent cardboard, *saw* the bones of his living hand projected in silhouette upon the screen. The great discovery was made."

Rarely has a scientific discovery taken the world by storm to such a degree. Between preliminary publication on 28 December 1895 in the *Proceedings* of the Würzburg Physical Medical Society and first public announcement on 23 January 1896 in a lecture to the Würzburg Society, the news spread round the globe. First Austria picked up the story (*Wiener Freie Presse*, 5 January 1896), then England (the *Standard*, 7 January), America (*New York Herald* and *Electrical Engineer*, 8 January) and France (*Le Matin*, 13 January). Nor did the major technical journals – *Nature, Science, Comptes Rendus, Il Nuovo Cimento, Lancet, British Medical Journal* – lag behind by more than a week or two. Within that first year alone over fifty books and a thousand articles had been published on the Röntgen rays, as the anatomist A. R. von Kölliker diplo-

22 Dec 1895

matically proposed they be called. The term X-rays, advanced at once by Röntgen himself, gradually displaced its many rivals in general currency.

In 1901 Röntgen was awarded the first ever Nobel Prize for Physics – fitting recognition for a discovery which anticipated major advances in physics (such as X-ray crystallography) and medicine (such as angiography). As Lord Rutherford reflected in 1919, it "marks the beginning of a new and fruitful epoch in physical sciences in which discoveries of fundamental importance have followed one another in almost unbroken sequence."

Date:	22 December 1895 (above); 20 November 1895 (opposite)
Place:	University of Würzburg, Germany
Photographer:	W. C. Röntgen
Apparatus:	Crookes tube under table, hand placed on table supporting plate (above); closed door between tube and plate (opposite)
Emulsion:	Dry gelatino-bromide plate, probably by Schleussner
Exposure time:	Between 3 and 10 min
Source:	Deutsches Museum, Munich
References:	Glasser 1933, Glasser 1959, Fuchs 1960, Nitske 1971

Skeletal Radiogram

The catalogue of objects subjected to radiography in the year following the discovery of X-rays (1896) includes many curious items: booby-trapped bombs, the digestive system of dogs, Egyptian mummies, metal castings, paintings, parchment, porcelain, precious stones, reptiles, typewriters,... But above all the human body – teeth, kidney stones, fractured limbs and so forth – was viewed by the "searchlight of photography" as the *Lancet* dubbed X-rays.

The earliest surviving radiogram of the whole human body is thought to be the one assembled by Ludwig Zehnder and reproduced opposite. Wilhelm Röntgen had appointed Zehnder as his assistant when he took up an appointment as physics professor at Giessen (north of Frankfurt), and their collaboration continued in Würzburg until 1890. Zehnder then left for a post in Freiburg and was thus absent when X-rays were discovered in November 1895. The two men corresponded, however, and in February 1896 Röntgen sent technical details to help Zehnder obtain his own radiogram. Zehnder was later to spend another spell as Röntgen's assistant, from 1899 until his resignation in 1904.

Zehnder decided to obtain a series of radiograms from which he could put together an entire skeleton. The mosaic on the facing page is composed of nine sections taken on six different photographic plates through three subjects. First the chest of a boy of 14 was recorded, but he suffered radiation burns – not the first such case, contrary to the contention of biographer Nitske. With greater caution Zehnder then radiographed pelvis, lower arms and hands (note the crippled left thumb), legs and feet of a 23-year-old soldier. The head belonged to his assistant at Freiburg, Kempke; for some reason Zehnder taped a bullet behind his ear. (It must be said that the attribution according to the Deutsches Museum is slightly different. The soldier would have provided chest, pelvis and lower limbs; another man, the hands; and Kempke, the head as before.) Röntgen saw the composite at a Swiss scientific meeting and requested two copies, one for his institute and another to present to the Kaiser.

For the record, a letter written in 1933 to Otto Glasser by pioneer American radiologist Dayton C. Miller claims that he obtained "the first X-ray life-size portrait of the human body" by means of a seven-plate composite as early as March 1896, and moreover sent Röntgen a copy in April. Apparently this radiographic record has not survived.

Nor has the original of the better-known radiogram by another American pioneer, William J. Morton: the first of a complete adult body in a single exposure. Reproduced at near right from the *Electrical Engineer*, New York, it pictures a woman of 30 fully dressed save for a corset; her hat-pin, necklace, bracelet, rings and buckled boots with nailed heels are clearly visible. She occupied a sheet of sensitive film nearly 2 m by 1 m, placed 1.3 m from a Crookes tube. A facetious poem published in *Life* magazine a year earlier by Lawrence K. Russel describes her perfectly:

She is so tall, so slender, and her bones –
Those frail phosphates, those carbonates of lime –
Are well produced by cathode rays sublime,
By oscillations, amperes and by ohms.
Her dorsal vertebrae are not concealed
By epidermis, but are well revealed.

Around her ribs, those beauteous twenty-four,
Her flesh a halo makes, misty in line,
Her noseless, eyeless face looks into mine,
And I but whisper, "Sweetheart, je t'adore."
Her white and gleaming teeth at me do laugh.
Ah! Lovely, cruel, sweet cathodagraph!

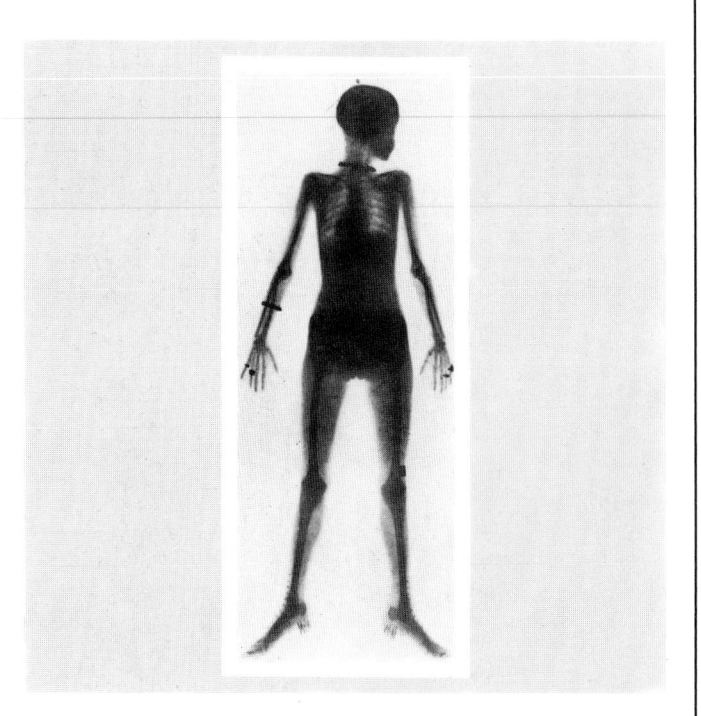

Date:	August 1896 (opposite); April (?) 1897 (above)
Place:	Freiburg, Germany (opposite); New York, N.Y. (above)
Photographer:	L. Zehnder (opposite); W. J. Morton (above)
Apparatus:	Crookes-tube X-ray machine
Emulsion:	Dry plates, each 46 cm × 51 cm (opposite); Eastman Kodak film, 2 m × 1 m (above)
Exposure time:	15 min except hands (5 min) and head (60 min) (opposite); 30 min (above)
Source:	Deutsches Museum, Munich (opposite)
References:	Glasser 1959, Grigg 1965, Nitske 1971

Aerodynamic Abstractions

One important application of photography conceived by the fertile mind of Etienne-Jules Marey seems to have been largely forgotten today, even by those to whom it is most relevant. His lifelong study of movement by graphic and photographic methods included significant work in aerodynamics and more generally hydrodynamics.

Marey's interest in aerodynamics stemmed from studies of birds and insects in flight as early as 1868 although the first photographs of bird flight date from 1882. In addition to chronophotographs revealing pigeons, seagulls, pelicans and other birds in flight through a succession of juxtaposed images on a fixed plate, Marey constructed three-dimensional models of flapping wings and a zoetrope to study flight at leisure. The locus traced out by a wing-tip was also recorded on a fixed plate by attaching a tiny metal reflector to buzzards and crows subsequently photographed against a black ground (cf. pp 38–39). After 1888 Marey utilized moving filmstrips to study birds and especially insects, whose flight he considered analogous to sculling.

The germination of Marey's aerodynamic experiments emerges clearly from the pages of *Le Vol des Oiseaux*, published in 1890. In chapter 13, he enunciates this proposition: "From the point of view of the resistance encountered, it is immaterial whether the solid body be in movement in calm air or whether it be immobile in flowing air" – not so indisputable a statement then as it appears now. Marey suggested two reasons for building powerful wind tunnels to study how air resistance affects flight. First, the atmosphere fails to provide steady winds of known velocity. Second, granted the complexity of the aerodynamic problem, a purely mathematical approach would be premature – witness the unreasonable results it calculated for physical work done in flight. "It is thus to the observation of Nature, or better still to experiments conducted under real flight conditions, that we must always turn to understand the significance of different feats of aerial locomotion."

Stimulated by the apparatus designed by H. Müller to visualize how a wing-beat displaces air, Marey invented his own smoke machine. In place of Müller's single column of smoke from burning cotton seen by daylight (or else phosphorescent vapours on a dark ground), Marey devised a combined camera and wind tunnel with multiple threads of smoke. In a pamphlet printed for the Paris Exhibition of 1900, Marey described it thus:

"In a large canal having walls of plate glass and before a dark background a draft of air is created by means of a ventilator. In order to regulate the current [i.e., to eliminate turbulence] it is filtered through a very fine silk gauze. At the top of the canal, we set free, by means of a series of little tubes, fillets of smoke [usually from burning tinder] which descend parallel to one another like the three cords of a lyre. Now, if we place in the interior of the canal obstacles of different forms, we immediately see the threads bend on these obstacles, slide over them, and form behind them eddies of varied forms." To avoid the convection currents associated with most sources of illumination, Marey exposed the film by magnesium flash.

The results of thirty different experiments with smoke streams are documented in the photographs opposite. The top row shows what happens when the smoke encounters a thin slip of mica at increasing inclination to the streams, and in the last image three parallel slips. The second row repeats the first with an important difference: an electric vibrator causes the smoke to oscillate ten times a second and thereby makes velocity measurement possible. The streams slow down when encountering the obstacle but accelerate alongside. The remaining rows indicate the effect that shape has on the interaction. Wherever a configuration appears to repeat, the second is taken by the light of burning magnesium ribbon rather than an "instantaneous" flash.

These experiments with jets of smoke yielded a double legacy. On the one hand, turbulent flow around airfoils suspended in wind tunnels is still tested by means of smoke streams, at least for low velocities. On the other, the fascination of these abstract patterns was not lost either on the Italian Futurists, whose manifesto reverberated through the decade following Marey's experiments, or on the visionary German artist Max Ernst.

Date:	*circa* 1900
Place:	Collège de France, Paris
Photographer:	E.-J. Marey
Apparatus:	Smoke-stream generator with 58 tubes, electric vibrator; illumination by magnesium flash or ribbon
Emulsion:	Dry gelatino-bromide plate
Exposure time:	0.02 sec or 3 sec
Source:	Musée Marey de Beaune (Collège de France Collection), France
References:	Marey 1890, Marey 1901, Marey 1902, Frizot 1977

Classic Study of the Splash

It is widely but erroneously believed that the first photographs of splashing droplets were taken by Harold Edgerton soon after he designed the first modern stroboscope in the 1930s. It is true that his coronet of droplets produced by milk splashing on a plate has become a latter-day classic, but certainly "Papa Flash" has always given due credit to his predecessor A. M. Worthington. For over thirty years, Worthington investigated splash phenomena in his capacity as professor of physics at the Royal Naval Engineering College in Devonport, and these studies culminated in 1908 in his engaging book *A Study of Splashes*.

Worthington first applied photography to his splash research in 1894 in the wake of even earlier photographic experiments by Lord Rayleigh. Previous attempts to secure splash photographs failed because "plates sufficiently sensitive to respond to such extremely short exposures were not obtainable." Although he published two learned transactions under the auspices of the Royal Society, he felt compelled to disseminate his photographs more widely in order to share with the public "some of the delight that I have myself felt, in contemplating the exquisite forms that the camera lens revealed, and in watching the progress of a multitude of events, compressed indeed within the limits of a few hundredths of a second, but none the less orderly and inevitable, and of which the sequence is in part easy to anticipate and understand, while in part it taxes the highest mathematical powers to elucidate." All the same, Worthington's "instantaneous" photographs were intended not for illustrated magazines but for scientific study. "So little seems to be known about the actual behaviour of real, as opposed to imaginary fluids," he lamented, "that we cannot but think that trustworthy information about the motions that follow very simple initial conditions may prove of real value, and not of merely curious interest."

No photograph of Worthington's apparatus has come down to us, but it would surely have gratified Heath Robinson. Over a bowl of liquid (generally milky water, occasionally petrol or glycerine) a droplet sits suspended on a watch glass supported by a horizontal rod armed with a spring to catapult it aside when the current to the electromagnet holding it in position is switched off. On the same circuit is a similar lever-spring arrangement below a metal timing-ball released simultaneously with the droplet so as to fall between two magnesium terminals connected to oppositely charged Leyden jars, thus unleashing a spark to illuminate the bowl into which the droplet is falling. Instead of trying to photograph successively the stages of a single splash, Worthington adjusted the moment of exposure to record different stages of repeated, identical splashes. Timing is effected by raising or lowering the rod bearing the timing ball.

In the particular series of splash photographs assembled (by Worthington himself) on the facing page, a falling stone sphere 3.2 cm in diameter is substituted for the droplet. When smoothly polished, the sphere seems to draw water round it like a fluid sheath even before it is completely submerged (Series C, no. 3). Only a diminutive jet ensues.

Roughened with sandpaper, a sphere 1.5 cm in diameter dropped from about the same height produces dramatically different results (Series D). The liquid now shuns the sphere on impact and diverges into what we would today call a "coronet", or what Worthington termed a "basket splash". The points on the crown merge, the crown thickens and abruptly "from the depths of the crater there rises with surprising velocity [an] exquisite jet" (nos. 8–10). Increasing the height of fall for the same sphere (Series E) causes the crown to grow until the crater walls close together in a bubble of "exquisite delicacy".

Immediately under Series E a row of nine photographs depicts the splash of a rough sphere falling from higher still (140 cm) as seen above and below the water level. A surprising change occurs: the upward jet makes little headway, being supplanted by a downward jet diving into the air pocket in pursuit of the sinking sphere. In the two bottom photographs the air column is broken up by the downward jet, and a powerful seething effect is thereby generated at the surface – an effect even visible to the unassisted eye.

Date: *circa* 1908 (some earlier)
Place: Royal Naval Engineering College, Devonport, Devon
Photographers: A. M. Worthington & G. B. Bryan
Apparatus: Illuminating spark timed by falling sphere between terminals, concentrated by concave mirror
Emulsion: Thomas A1 Ordinary plates
Exposure time: <3 μsec
Source: Science Museum, London
References: Worthington & Cole 1897, Worthington & Cole 1900, Worthington 1908

From Ben Nevis to the Cloud Chamber

The path leading to this photograph of particles streaming from a radioactive sample of radium sounds with hindsight highly improbable. C. T. R. Wilson spent a climbing holiday in September 1894 on the peak of Ben Nevis in the Scottish Highlands, where he became fascinated by the interplay of sunlight and cloud. He was determined to duplicate the optical phenomena under controlled conditions in the laboratory.

Over the next two years Wilson designed a chamber in which to generate mist by the simple expedient of expanding moist air. He soon discovered that expansion of damp air by a quarter of its volume produced no droplets in the absence of dust particles although greater expansion generated heavy fog. X-rays had just been discovered by W. C. Röntgen (November 1895); and investigating their effect on his cloud chamber, Wilson stumbled upon a still more intriguing phenomenon. Following a one-quarter expansion, they produced droplets of condensation in large numbers when they traversed his apparatus.

It seemed that charged particles generated by the passage of X-rays provide nuclei about which a water-drop can form from the supersaturated air. Wilson came to realize that he had inadvertently constructed a particle detector and he spent the next fifteen years perfecting it. Early in 1911 he tested the effect on his improved cloud chamber not only of X-rays, but of alpha, beta and gamma rays, and concluded that the tracks "of ionizing rays of any kind through a moist gas may be made visible by condensing water upon the ions set free".

The form of the cloud chamber, wrote Wilson of his 1911 version, "is cylindrical, with flat horizontal roof and floors, its diameter being 7.5 cm, and its height between 4 and 5 mm before expansion and about 6.2 mm after expansion. The expansion is effected by the sudden downward displacement of the floor of the cloud-chamber; this is constituted by the flat top of a hollow brass piston open below...The clouds are viewed through the roof of the cloud-chamber, which is of glass, coated below with a uniform layer of clear gelatine [as is the floor]. Besides serving as a cement to attach the glass roof of the cloud-chamber, the gelatine lining avoids altogether . . . the deposition of dew on the inner surface of the glass. In addition it forms, when moist, a conducting layer which may be maintained at a constant potential...

"The potential difference applied between the roof and floor . . . amounted to 8 volts. Any ions set free before an expansion were thus exposed to a field of about 16 volts per centimetre, and had at the most about 0.5 cm to travel. The only ions 'caught', on expansion, were thus those which had been produced within less than 1/40th of a second before the expansion, and such as were set free in the short interval after the expansion during which the supersaturation exceeded the limit necessary for condensation under the ions." In the summer of 1911 another chamber double the size was built, and this apparatus is preserved at the Cavendish laboratory.

For analysis purposes the droplets marking particle tracks had to be photographed before they dispersed. The shower of tracks in the photograph opposite betokens the passage of alpha particles, helium nuclei emitted from a small quantity of radium on the metal tongue of a spinthariscope (left). As Wilson recalled in his Nobel lecture of 1927, "The very beautiful sight of the clouds condensed along the tracks of the alpha-particles was seen for the first time." The narrow streaks indicate concentrations along the loci of particles released after the expansion and before the diffusion of the charged particles in their wake. The broader rays show the loci of particles already traversing the chamber before expansion. These tracks are consequently older and there has been sufficient time for the air molecules ionized by the passage of the alpha rays to diffuse.

The cloud chamber proved instrumental in many discoveries in atomic physics for a good half-century, even after use of nuclear emulsions to detect particles became widespread in the 1940s. Little wonder that Lord Rutherford was moved to extol it as "the most original and wonderful instrument in scientific history".

Date: 1911
Place: Cavendish Laboratory, Cambridge
Photographer: C. T. R. Wilson
Apparatus: Cloud chamber illuminated by mercury spark;
 Beck "isostigmar" lens at f/5.8
Emulsion: Ilford Monarch plate
Source: Science Museum, London
References: Wilson 1911, Wilson 1912, Gentner et al. 1954

General Relativity: The Acid Test

When Albert Einstein framed the theory of general relativity in his epochal paper of 1915, the scientific world was staggered – but not only because he had had the effrontery to supplant the Newtonian view of the Universe with his own. The great beauty of Einstein's theory lay in its predictive power, and the 1915 paper proposed three astronomical tests by which general relativity would stand or fall. Let it be said at once that every test from the first (involving the motion of the innermost planet Mercury) to the very latest (a pulsar in a binary system) has vindicated general relativity. That fact does not of course prove that the general theory is right, only that no test has ever been devised capable of overthrowing it.

The test which aroused greatest public excitement was the search for deflection of starlight at the 1919 solar eclipse. Einstein had argued that gravity is a manifestation of the curvature of space-time, but a curvature immeasurably small in normal terrestrial circumstances. The effects remain minute even in the case of the Sun, 333,000 times more massive than the Earth, but do lie within reach of careful measurement. The particular effect Einstein predicted was that light from distant stars should be bent in the solar gravitational field, the star-dots in the Sun's immediate vicinity appearing ever so slightly splayed out with respect to their standard positions. Sunlight scattered in the Earth's atmosphere normally obliterates all adjacent stars, but they become visible when the Moon totally eclipses the Sun.

Sir Frank Dyson, who had been Astronomer Royal since 1910, was planning a double expedition to sites favourable for viewing the eclipse of 29 May 1919 even before World War I ended. Arthur Stanley Eddington, Plumian Professor at Cambridge, and E. T. Cottingham were to sail with the Oxford astrographic telescope to the island of Príncipe off the western coast of Africa; C. R. Davidson and A. C. D. Crommelin, with the Greenwich equivalent plus a smaller telescope to Sobral in Brazil, the hope being that the weather would favour at least one observing station. The Príncipe expedition set up camp on a cocoa plantation at Roça Sundy whilst the Sobral team chose the racecourse of the local Jockey Club. Clouds created anxiety at both sites on the morning of the eclipse day, and Príncipe even suffered a freak thunderstorm. Indeed, thin cloud persisted at Sundy throughout totality but 7 of their 16 plates showed measurable star images. At Sobral the clouds parted at the last moment, and most of the 19 plates from the 13-inch astrographic telescope (seen at near right facing its coelostat) plus 8 from the 4-inch proved usable. One

of the latter is shown opposite, the seven measured stars indicated by short lines.

Now the gravitational deflection at the Sun's limb was predicted by Einstein to be 1.75 arcseconds – the equivalent of trying to measure an acorn from a mile away. Any number of small errors could have masked the measurement, and the two teams took care to photograph a test field away from the Sun in addition to the star field around it, both at the May eclipse and at a few months' remove when the Sun had shifted. The first plate Eddington measured agreed with Einstein's prediction – the greatest moment of his life, he later claimed. Further painstaking plate reductions yielded 1.61 ± 0.30 arcsec from the astrographic telescope at Príncipe, 1.98 ± 0.12 arcsec from the 4-inch instrument at Sobral. "Thus the results," states the final report, "can leave little doubt that a deflection of light takes place in the neighbourhood of the Sun and that it is of the amount demanded by Einstein's generalised theory of relativity."

Date: 29 May 1919
Place: Sobral, Brazil
Photographers: C. R. Davidson & A. C. D. Crommelin
Apparatus: 20 cm coelostat → 10 cm telescope
Emulsion: Ilford Special Rapid plate
Exposure time: 28 sec
Source: Royal Greenwich Observatory, Herstmonceux
References: Dyson *et al.* 1920, Chandrasekhar 1979,
 Earman & Glymour 1980

Stonehenge: The Avenue from the Air

Aerial photography dates from the first escapade in 1858 by the inventive French photographer Nadar, aloft near Paris in a balloon filled with the cumbersome apparatus required to take a wet collodion plate. Arguably the first scientific application of aerial photography, however, was realized some 60 years later by Osbert Guy Crawford, a pilot in the Royal Flying Corps shot down and captured by the Germans in World War I. Dubbed "the discoverer of aerial archaeology" by Leo Deuel, Crawford was working for the Ordnance Survey as Archaeology Officer when in 1922 he first identified patterns of pre-Roman lynchets (rectangular cultivation banks) from aerial photographs of Wiltshire.

Emboldened by this signal success, Crawford started poring over other aerial photographs from among the thousands routinely made by the Royal Air Force. Stonehenge, the putative megalithic astronomical observatory, soon came to his attention and precipitated a remarkable discovery. The parallel banks of the Stonehenge Avenue, whose orientation had suggested an astronomical alignment to William Stukeley as early as 1740, leapt out from the photos – not just the well-known stretch running outward from the circular ditch past the Heel Stone, but the entire length of it not a trace of which was visible from the ground. Crawford rephotographed the extended Avenue he had discovered on R.A.F. photos from 1921, and portions of the eastern branch are displayed opposite (north is to the right).

Let us focus on the mystery of Stonehenge for a moment; it was Einstein who once said that "the most beautiful thing we can experience is the mysterious", and Stonehenge provides it in full measure. The site, occupied from 3100 to 1000 BC, consists of the remnants of concentric circles of standing stones and stoneholes or postholes. At the centre stands the Altar Stone guarded by a horseshoe of five trilithons (a trilithon is comprised of two uprights topped with a lintel) and encircled by 60 bluestones and then 30 Sarsen stones. Then come three concentric circles of holes, now filled in, the whole surrounded by a bank and a ditch. (See the modern aerial view at near right – orientation as facing page.) The main functions of Stonehenge as an observatory were purportedly twofold: to use the 56 Aubrey holes, the outermost circle, to predict eclipses; and to mark the extreme positions of sunrise and moonrise in the course of the year. Could the Neolithic farmers who built Stonehenge – not the Druids as folklore would have it – really have mastered the complex behaviour of Sun, Moon and Earth? Or do latter-day archaeoastronomers read too much into the myriad chance alignments of concentric holes and stones?

In a recent review of astronomical interpretations of Stonehenge, R.J.C. Atkinson concluded. "There is only *one* built-in alignment which can be accepted with confidence, namely the axis of the first straight stretch of the Avenue directed upon the first-gleam of solstitial sunrise at the end of the third millennium BC." With such a significant alignment, the Avenue seemed to have good cause for pursuing a straight course. Yet after a direct run northeast, the aerial perspective reveals that it branches eastward and later curves down toward the village of West Amesbury.

"All this is absolutely new and was never before suspected," declared Crawford in the *Observer* in July 1923. "The utter absence of . . . surface indications where the lines appear on the air-photo is remarkable, but in some ways not unwelcome; so much greater will be the triumph of air-photography if digging reveals the flanking ditches." Three trenches dug two months later confirmed the prehistoric ditches on either side of the Avenue. In the words of Deuel, "Aerial archaeology had triumphed. It had made the unseen seen and had shown that archaeological features lost beyond hope of recovery were suddenly given a new lease of life."

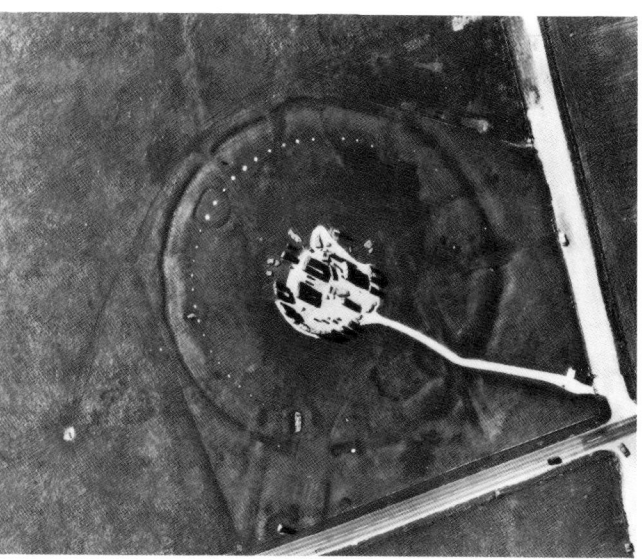

Date:	28 May 1924 (opposite)
Place:	Amesbury parish, Wiltshire
Photographer:	O. G. S. Crawford
Apparatus:	Airborne camera at 762 m
Exposure time:	6 msec
Source:	Air Photographs Collection, National Monuments Record (opposite); Aerofilms Ltd., Borehamwood, (above)
References:	Crawford 1924, Crawford & Keiller 1928, Deuel 1971, Atkinson 1979

Imaging the Brain

The discovery of X-rays in 1895 made it possible to image the skull of a live subject without resorting to surgery. Röntgen's rays passed straight through the soft tissue of the brain, however, and it was not until thirty years later that cerebral angiograms revealed the brain as shown in these photographs. Today such techniques as computer-assisted tomography, positron tomography and nuclear magnetic resonance imaging trace the distribution of tissue, blood and water – but the first clinical success (leaving aside the traumatic injection of air into the brain) belongs to cerebral angiography and in turn to Egas Moniz.

Moniz was a renowned Portuguese neurologist who set out "to make the diagnosis of the localization of the majority of [brain] tumours through the alteration of the normal arterial pattern of the cerebrum" by injection of a contrast agent. That idea as such was hardly new: as early as 1896 Viennese doctors studied the circulatory system in the hand by injecting a corpse with "Teichmann's mixture", a toxic amalgam of petroleum, quicklime and mercuric sulphide. The goal of Moniz, on the other hand, was to perform angiography on a living patient and to develop it into a clinical tool.

Two difficulties had to be overcome: finding a non-toxic substance capable of serving as an effective contrast medium and injecting it into the circulatory system in such a way that good photographs could be taken before it was heavily diluted by the blood flow. The latter problem was eventually solved by exposing the internal carotid artery, injecting the contrast agent, immediately placing a ligature on the artery, then releasing it a split second before taking the radiogram.

The first problem was solved only after extensive experiments on rabbits, dogs and human corpses with the clinical assistance of Almeida Lima and Almeida Dias. In the last months of 1925, Moniz made his first experiment on the skull of a cadaver. Filling some short segments of rubber tubing with bromides of lithium, strontium, ammonium, sodium and potassium in solution, he fixed them to a stiff card, placed them inside a dried skull and radiographed it (below left). The bore of the tubes was selected to be equivalent to that of a cerebral artery. Strontium bromide was then chosen for further work and eight different concentrations from 10% to 80% were tested (below right). Numbers 1 and 8, made of lead, were used for orientation.

Attempts at cerebral angiography by means of strontium bromide injections into living subjects were carried out on six patients with limited success, and the last patient died. Moniz then switched to sodium iodide, which had also performed well in prior tests despite its mild instability. The first two patients of the iodide series produced meagre results but use of the ligation technique described above yielded an excellent angiogram of the third.

"At that unforgettable hour, the afternoon of 28th of June 1927," wrote Moniz later, "all our attention was concentrated upon the first arteriogram. We remember with pleasure the work done ... the culmination of an obsession to realize a long-standing project. On the film [negative reproduced opposite] the cerebral vessels were seen, but deformed through the presence of the tumour. The internal carotid artery was pulled forward ... The sylvian artery was displaced upward from its normal position." The patient whose brain provided this historic angiogram was a blind man aged 20 whose pituitary tumour provoked severe headaches and vomiting. Injection of 5 cc of a 25% solution of sodium iodide produced of itself no ill effects.

Within the next decade another thousand diagnoses by means of angiography had been successfully conducted and the technique had been applied by Reynaldo dos Santos, Moniz and others to obtain arteriograms of other parts of the body. Ironically, Moniz was to share the 1949 Nobel Prize for Medicine on the strength of originating the technique of prefrontal lobotomy, a practice later discredited. Just as Einstein never received a Nobel award for relativity theory (only for his work on the photoelectric effect), the lasting contribution of Moniz to cerebral angiography went unrecognized at the time.

Date: 28 June 1927
Place: Santa Marta Hospital, Lisbon, Portugal
Photographer: E. Moniz, University of Lisbon
Apparatus: Radiography of subject injected with 25% solution of sodium chloride
Exposure time: 0.25 sec
Source: A. Coito, Santa Maria Hospital, Lisbon
References: Oldendorf 1980, da Silva 1982, Veiga-Pires & Grainger 1982

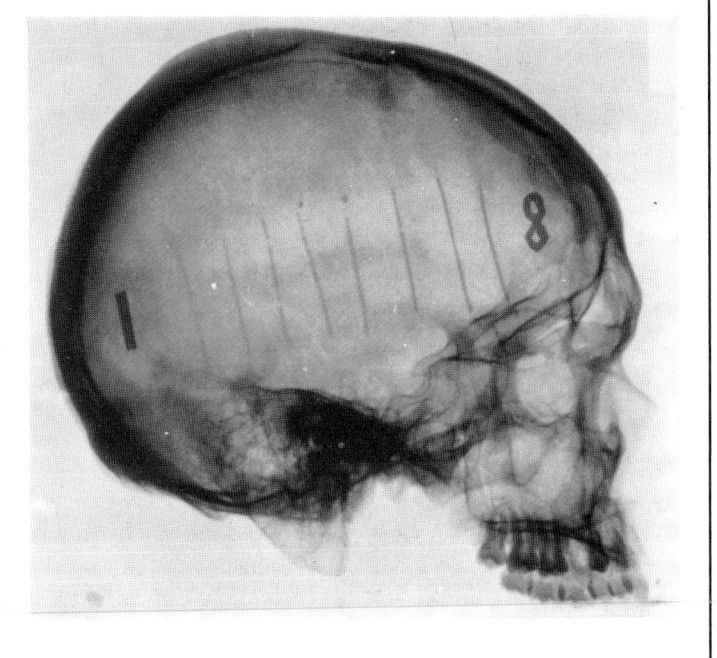

Electrons: Waves or Particles?

Among the great questions of 20th-century physics, the debate over the fundamental nature of radiation and matter ranks high. Radiation demonstrably travelled in waves, yet Erwin Schrödinger's theory of quantum mechanics suggested that light behaved as a collection of particles (photons). Matter clearly must be composed of particles, yet Louis de Broglie saw that a frequency could be associated with a given fundamental particle as though it were a wave.

Could light really be treated as particles and matter as waves? The first attack on this problem came from Clinton J. Davisson and Lester H. Germer. In their famous experiment, a hot filament in an "electron gun" directed a narrow beam of electrons onto a rotatable target consisting of a single crystal of nickel. A shielded collector mounted on a rotating arm allowed electrons scattered off the target to be detected by means of an electrometer. The distribution of scattered electrons turned out to be just what would have been expected had the source produced X-rays rather than particles. "*Are electrons waves?*" asked Davisson rhetorically. "The easiest way of answering this question is to ask another. *Are X-rays waves?* If X-rays are waves, then so also are electrons."

The identical question was addressed simultaneously and independently by the Professor of Natural Philosophy at the University of Aberdeen George P. Thomson (later Sir George), son of J. J. Thomson who discovered the electron. For Davisson and Germer's slow beam of electrons (difficult to control), Thomson substituted fast electrons streaming from a cathode-ray tube; for reflection from a thick target, transmission through a thin film; for the galvanometer, a photographic plate. The immediate stimulus came from a Cambridge experiment in which electron scattering in helium produced haloes. These observations later proved mistaken, but they generated the right enquiries if for the wrong reasons!

In Thomson's first experiment with the assistance of his student Alexander Reid, electrons were fired through a celluloid film a few millionths of a centimetre thick and detected by a photographic plate 10 cm behind it. A film any thicker would risk scattering the incident electrons several times before re-emergence and could thereby smudge the pattern on the plate. To avoid scattering by air molecules, the whole apparatus was evacuated. At low voltages (2500 volts) only a diffuse disc appeared but at higher voltages (up to 16500 volts) the disc resolved itself into a central spot surrounded by concentric rings "recalling in appearance the haloes formed by mist round the Sun". Higher energies yielded sharper rings.

It certainly appeared that the electrons in cathode rays were being diffracted by the film, but celluloid created a loophole in the argument since its atomic structure was not yet accurately known. So G. P. Thomson turned to metal lattices of known crystalline structure, starting with gold. For these experiments a larger apparatus was constructed, a suspended slide arrangement allowing the pattern to fall either on a fluorescent screen or on one of two positions on a photographic plate. Tubes projecting above and below were used to evacuate the apparatus by means of a mercury-vapour pump.

Thomson later wrote that the gold foil "at once gave rings which agreed quantitatively with the theoretical expectation for a face-centred cubic lattice of side 4.06 Å." The very photographs he first took are shown opposite. "You will notice," wrote Thomson of these patterns, "that there are two, put side by side, with different voltages as measured by the spark gap, the equivalent spark gap of the induction coil. You see the larger rings associated with the lower energy."

Experiments on a variety of thin films all pointed to a remarkable conclusion. "The detailed agreement shown in these experiments with the de Broglie theory [according to which a moving particle behaves as a group of waves whose velocity and wavelength are governed by the speed and mass of the particle] must, I think, be regarded as strong evidence in its favour. This means accepting the view that ordinary Newtonian mechanics (including the relativity modifications) are [*sic*] only a first approximation to the truth, bearing the same relation to the complete theory that geometrical optics does to the wave theory. However difficult it may seem to accept such a sweeping generalisation, it seems impossible to explain the results obtained except by the assumption of some kind of diffraction." The dualism between waves and particles had become inescapable, and these epochal experiments earned Davisson and Thomson the Nobel Prize for Physics in 1937.

Date: October 1927
Place: University of Aberdeen, Scotland
Photographer: G. P. Thomson
Apparatus: Cathode-ray tube at 57000 volts (left), 34000 volts (right); evacuated camera
Source: Science Museum, London
References: Thomson 1928, Thomson 1962, Goodman 1981, Russo 1981

SPARK GAP **20·7** mms *10·7 mms*

Probing the Living Heart

The routine clinical application of cardiac catheterization, in which a narrow tube is inserted directly into the human heart to measure variations in blood pressure, owes its origin to a daring exploit. Applied to animals, the method had been used successfully in the 19th century by Claude Bernard and by E.-J. Marey; but when Werner Forssmann in 1929 decided to attempt a human catheterization, he met considerable opposition. In retrospect he was bound to be praised for acting with the courage of his convictions or roundly condemned for his foolhardiness.

After seven years' training at the Friedrich Wilhelm University in Berlin, Forssmann failed to find a suitable job and was obliged to take up an internship at the Auguste Viktoria Home in Eberswalde. Here he began to reflect on the inadequacy of heart diagnosis by the long-standing techniques of percussion and auscultation, and even by the more recent ones of radiography and electrocardiography. Many pathological and physiological problems would be solved, thought Forssmann, if only one could find "a safe route of access to the heart that would not affect the complicated balance of pressure in the thorax, not disturb the involuntary reflex tracts, and not necessitate altering the important vital functions through anaesthesia."

Surgery thus being out of the question. Forssmann was inspired by the classic French experiments on animals to consider catheterization. When he proposed experimenting on a patient, his surgical director Richard Schneider flatly refused. In his autobiography Forssmann recounts the exchange. "There's another way to prove it's not dangerous," pursued Forssmann; "I'll experiment on myself." Schneider replied in horror, "I'm afraid I must also forbid that . . . You may be sure that my no is final and absolute."

Forssmann was not to be deterred. He persuaded a nurse to become his accomplice, and she agreed under the misapprehension that she would be the subject of this historic operation. "Of course I had no intention of going through with this," wrote Forssmann, "but it was the only way to get the instruments." He lashed her firmly to the operating table on the pretext that some patients collapse on the application of even a local anaesthetic. "In the twinkling of an eye I had anaesthetized my left elbow . . . When my anaesthetic began to take

effect I quickly made an incision in my skin, inserted a Deschamps aneurism needle under the vein, opened it and pushed the catheter about a foot inside." Then he released the nurse.

Despite her fury at being deceived and the violent intervention of one of his colleagues, Forssmann managed to reach the X-ray room. "I had a mirror placed so that by looking over the top of the screen I could see in it my thorax and upper arm . . . I pushed the catheter in further, almost to the two-foot mark. Now the mirror showed the catheter inside the heart, with its tip in the right ventricle, just as I'd envisioned it. I had some X-rays taken as documentary evidence."

Franz Loogen's more recent account of the first heart-probe differs in anecdotal detail but culminates at the same point: "Forssmann insisted in having a photographic record, as he was afraid that no one would believe him. This picture appeared in his original publication in 1929 in the *Klinische Wochenschrift*, entitled 'Die Sondierung des rechten Herzens'."

In fact half a dozen radiographs were taken and the originals have recently been unearthed in an office at the University of Düsseldorf where Forssmann became Chief Surgeon shortly after sharing the 1956 Nobel Prize for Medicine with André Cournand and Dickinson Richards. (After 1940 they revived the technique pioneered by Forssmann but until then little appreciated. Today it is a standard feat in the clinical repertoire.)

It is significant that the catheter (arrowed opposite) runs through the *left* subclavian vein round to the *right* atrium of the heart. The left atrium receives blood via the pulmonary circulation (from the lungs); the right atrium, via the systemic circulation (from the body generally – including the cephalic vein used by Forssmann). Not for another quarter century would it be possible to conduct catheterization of the left side of the heart.

Date: Summer 1929
Place: Auguste Viktoria Home, Eberswalde (nr. Berlin)
Photographer: W. Forssmann
Apparatus: Large X-ray machine (plates 39 cm × 29 cm)
Source: H. Schadewaldt, Institute for the History of Medicine, University of Düsseldorf
References: Forssmann 1929, Forssmann 1974, Snellen *et al.* 1981

The Philosopher's Stone

The transmutation of one element into another haunted the imagination of the alchemists for centuries, but their dream could not be realized by chemical means. Their quest for the philosopher's stone came to naught because the transformation can be wrought only be nuclear means. In this photograph a nitrogen atom undergoes artificial transmutation to oxygen under bombardment by a stream of alpha rays (helium nuclei).

The first suspicion that nuclear disintegration was feasible arose from experiments performed by Sir Ernest (later Lord) Rutherford at the University of Manchester at the end of the First World War. A source of alpha rays was placed in the middle of a nitrogen-filled chamber with a fluorescent screen at one end. The length of the chamber was such that any interactions between the alpha-ray particles and nitrogen atoms ought to take place before the former reached the screen. Yet Rutherford observed scintillations on the screen which he considered could only arise if secondary emission from fragmented nitrogen atoms took place. The emitted particles were inferred to be protons, Rutherford's enduring term for hydrogen nuclei.

"We must conclude," wrote Rutherford, "that the nitrogen atom is disintegrated under the intense forces developed in a close collision with a swift alpha particle, and that the hydrogen atom which is liberated formed a constituent part of the nitrogen nucleus ... The results as a whole suggest that if alpha particles – or similar projectiles – of still greater energy were available for experiment, we might expect to break down the nucleus structure of many of the lighter atoms." Rutherford and other scientists repeated his controversial experiments, with similar results, until Patrick Blackett clinched the interpretation with photographs taken in a Wilson cloud chamber.

Of 400,000 tracks on 23,000 photographs which Blackett took up to 1925, only eight indicated suspected disintegrations – and of these four were discarded on technical grounds. Blackett then substantially improved his apparatus, automating the cloud chamber and introducing a double camera to take a pair of photographs at right angles. The experiment was repeated with argon-oxygen-hydrogen and nitrogen-oxygen-hydrogen mixtures. Another four disintegrations emerged from 1,100,000 tracks on 18,000 photographs – a lower yield but of superior quality.

For the classic photograph opposite a radioactive source containing lead, bismuth and polonium was placed in a chamber containing 50% nitrogen, 45% hydrogen and 5% oxygen. The image resembles a shabby broomstick, the bristles being short (4.8 cm) or long (8.6 cm) according to the range of the alpha rays. The crucial feature is the oblique leftward streak (at top), the track of a proton ejected from the nucleus of a nitrogen atom by an energetic alpha ray. The recoil nucleus, now transmuted to oxygen, carries on a short distance toward upper right.

In more modern terms the reaction would be described as the capture of a helium nucleus (He-4) by a nitrogen nucleus (N-14), yielding a brief-lived fluorine isotope (F-18) which immediately decays to oxygen (O-17) with the emission of a proton (H-1) and the release of energy. This photograph of the reaction was highly valued because nearly the whole length of the proton track is visible – quite literally a track in a million.

Date: circa 1930
Place: Cavendish Laboratory, Cambridge
Photographers: P. M. S. Blackett & D. S. Lees
Apparatus: Cloud chamber with thorium source, automatic
 cameras at right angles
Source: Science Museum, London
References: Blackett 1929a, Blackett 1929b, Blackett & Lees
 1932, Segrè 1980

69

The Discovery of Pluto

The search for Planet X, the outermost inhabitant of the Solar System, has fired popular imagination for over a century. The orbit of Uranus, seventh of the nine known planets in the Sun's retinue, displayed certain irregularities best accounted for by postulating the existence of a transuranian body. In due course Neptune was discovered visually by Johann Galle in 1846 at the Berlin Observatory, armed with Urbain Le Verrier's mathematical prediction of its approximate position. Even so, Uranus continued to display certain positional deviations not attributable to any other known body in the Solar System including Neptune – and the new prey to be hunted was a transneptunian planet.

The hunt began visually well over a century ago, but it soon became evident that to find a faint planet beyond Neptune astronomers would have to resort to photography. Percival Lowell, William H. Pickering and others in the first quarter of this century spared no effort to track the object down; but to no avail until Vesto M. Slipher, Director of the Lowell Observatory, resumed the search in 1929 with the help of a new recruit, Clyde W. Tombaugh, and a new telescope equipped with a 33 cm photographic objective lens.

Tombaugh began the search on 6 April 1929, exposing his first plate for one hour in the constellation Gemini and proceeding gradually eastward along the ecliptic, the path of the Sun's apparent motion through the sky. It looked a daunting task: where Gemini intersects the Milky Way, one of Tombaugh's 36 cm \times 43 cm plates would have held 300,000 star images. (Today's more sensitive plates would hold tenfold more.) The strategy consisted in obtaining a matched pair of plates of each region in the search area advocated by Lowell, plus one additional plate for double-checking, and alternating their images in a blink comparator to test for movement of a suspect planet. Such a search breeds many false leads, including asteroids and variable stars and even random clumps in the emulsion. Blinking of plates is a tedious procedure, and even outside the rich fields of the Milky Way it typically took Tombaugh three days of blinking (or about 20 hours) to scrutinize one pair of plates.

A self-avowed perfectionist, Tombaugh photographed by night and blinked by day or whenever it was cloudy. On the morning of 18th February he started on a recently photographed pair in western Gemini, its scattering of stars only moderately dense. In mid-afternoon, he recalls, "I suddenly spied a 15th-magnitude object popping in and out of the background. Just $3\frac{1}{2}$ mm away another 15th-magnitude image was doing the same thing, but appearing alternately with respect to the other, as first one plate and then the second was visible through the eyepiece. 'That's it!' I exclaimed to myself. The change in position – only 3 or 4 mm in six days – was much too small for an ordinary asteroid near opposition. But were the images real or spurious? At once I laid out the 8-by-10-inch plates that had been taken by our Cogshall camera simultaneously with the 13-inch exposures. Although nearly at its limit of visibility, there were the images exactly in the same respective positions!"

The discovery pair shown opposite are dated 23 and 29 January 1930, only nine months after the last painstaking search had been initiated. Subsequent photographs confirmed the reality of the new planet and three weeks later the news hit the headlines. The name Pluto was chosen to join his brothers Jupiter and Saturn and in the first two letters to commemorate the fulfilment of the prediction by Percival Lowell. With the advantage of hindsight, images of Pluto turned out to have been recorded on many prediscovery plates by Lowell and others, but one can judge from the small plate segment reproduced here just how easily its point image is lost among the background stars.

The fever of the hunt abated only a little. Some astronomers thought Pluto too faint and insufficiently massive to be Lowell's Planet X, attributing Pluto's discovery to little more than a "happy accident". Tombaugh pursued the search for another 13 years, but no other planet materialized. It is true that Pluto was discovered to have a planet-sized satellite in 1978 (see p 180), but Tombaugh remains the only person this century able to declare with Keats, "Then felt I like some watcher of the skies/When a new planet swims into his ken."

It is not as if the watchers have been idle, but the perennial search for a Planet X, this time transplutonian, has never borne fruit. If there is a tenth planet it must be very dark (unlike Pluto, whose surface is glazed with methane frost), very small or very distant.

Date: 23 and 29 January 1930
Place: Lowell Observatory, Flagstaff, Arizona
Photographer: C. W. Tombaugh
Apparatus: 33 cm telescope
Emulsion: Cramer Hi Speed
Exposure time: 60 min
Source: Lowell Observatory
References: Tombaugh 1960, Tombaugh & Moore 1980, Hoyt 1980

January 23, 1930 January 29, 1930

The Unrecognized Neutron

In a sense nuclear physics was born with the discovery of the neutron, a fundamental component of the nucleus carrying zero charge. In 1920 Ernest Rutherford anticipated that a neutral particle with the same mass as a proton would be discovered, but subsequent experiments did not at first bear him out. In 1928, however, W. Bothe and his student H. Becker discovered that bombardment of the light metal beryllium with alpha rays (helium nuclei) emitted by polonium produced a strongly penetrating neutral gamma radiation.

In 1932 Irène Curie, with her husband Frédéric Joliot, decided to study this unexplained penetrating radiation. Using a source once again of polonium, the element discovered by Irène's parents Marie and Pierre Curie in 1898, they bombarded a beryllium target so placed that the resulting radiation would pass through the cloud chamber whose round window is shown opposite.

The source of the gamma rays found by Bothe and Becker was orientated at the seven o'clock position, in the same direction as the oblique white streak. The thick white line at bottom indicates a paraffin-coated mica screen placed in front of the chamber window, and the oblique streak reveals a proton knocked out of the paraffin. (The incoming radiation, being neutral, leaves no tracks.)

The Joliot-Curies conjured up an unlikely interpretation in terms of the Compton scattering effect previously observed for electrons. Being light particles, electrons can easily be made to recoil upon collision; but protons are 1836 times more massive. As Emilio Segrè remarks, "If one billiard ball hits another one, they easily recoil; but if an automobile is hit with a billiard ball, it will not be set in appreciable motion." Meanwhile, they sent this photograph to the Cavendish Laboratory, along with their tentative explanation which was received with incredulity by Rutherford.

According to Segrè, the Joliot-Curies' paper also reached the young Italian physicist Ettore Majorana, who expostulated, "What fools! They have discovered the neutral proton and they do not recognize it." Majorana was right: very soon James Chadwick at the Cavendish Laboratory repeated the experiments and concluded that the radiation must consist largely of particles with the mass of the proton but zero charge. So the correct interpretation of the photograph opposite is that a neutron from below strikes a hydrogen nucleus in the paraffin screen and displaces a proton which recoils to upper right leaving a typical ionization track.

Chadwick's discovery of the neutron was not in fact made on a cloud-chamber photograph. His ionization chamber was connected to a valve amplifier whose output was recorded on an oscillograph, and its deflections in turn *were* recorded photographically on bromide paper.

For nuclear physics 1932 was an *annus mirabilis*: the simple picture of an atomic world populated only by electrons and protons was irrevocably shattered by the discovery of three new particles: the neutron, the positive electron or positron (p 74) and the deuteron. The last of these later proved not to be itself a fundamental particle since it consisted of a proton bound by the strong nuclear force to a neutron. The existence of a heavy isotope of hydrogen – deuterium – whose nucleus was comprised of this proton-neutron pair was made spectroscopically. So it could be said that photography played some role in the discovery of all three.

Date: January 1932
Place: Institut du Radium, Paris
Photographers: I. & F. Joliot-Curie
Apparatus: Cloud chamber at 1500 gauss with polonium & beryllium source, paraffin target
Source: Science Museum, London
References: Chadwick 1932, Curie & Joliot 1932a, Curie & Joliot 1932b, Segrè 1980

Discovery of the Positron

The discovery photograph of the positron, its broken trail curving upward through a lead plate in the cloud chamber, must have been more widely circulated than any other in particle physics. It was first published (as a negative) in *Physical Review* seven months after the discovery, and it created a sensation in the scientific world.

For a short but blissful period, physicists could have convinced themselves that the fundamental constituents of matter formed the tidy trinity to which schoolchildren are first introduced: the negative particle (electron, discovered 1895), the positive particle (proton, announced 1911) and the electrically neutral particle (neutron, discovered 1932). Hard on the heels of the identification of the neutron by Chadwick, however, came a set of tracks which bespoke another particle still, apparently identical to the electron save for its opposite charge. This was the first antiparticle, and whilst it is now taken for granted that to every particle found there corresponds a counterpart with equal and opposite charge, the concept had not taken root at the time. History is not always a faithful shadow of chronology, and here is a case in point: the concept of anti-particles *could* have anticipated, even promoted, their discovery since Paul Dirac had shown mathematically that the theory of electrons also predicts positive "holes". Yet not until the "positive electron" was announced was it realized that the mathematical hole bore a physical reality. "The discovery of the positron was wholly accidental," reflected its discoverer Carl Anderson in 1961. "Despite the fact that Dirac's relativistic theory of the electron was an adequate theory of the positron and despite the fact that the existence of this theory was well known to nearly all physicists, it played no part whatsoever in the discovery of the positron."

In the summer of 1932 Carl Anderson and his supervisor Robert Millikan set up a Wilson cloud chamber at Caltech to photograph cosmic rays. This penetrating radiation from outer space had been known ever since the balloon flight of Victor Hess in 1912, and had already been observed in a cloud chamber by D. Skobelzyn in 1927. What Anderson brought to the experiment was a far more powerful electromagnet (15000–24000 gauss), capable of deflecting correspondingly more energetic particles (4 or 5 billion electron volts). Out of 1300 photographs of cosmic-ray tracks, 15 presented strong evidence for the existence of a new particle.

Naturally the Caltech physicists were cautious. In the absence of the lead plate (horizontal bar through centre of picture), the track could just as well have been an electron tracing a downward path. But the greater curvature of the arc above the plate implies a loss of kinetic energy – and the electron could hardly have *increased* its energy after ploughing into the 6 mm lead barrier. So the particle track must start at the bottom of the picture and in view of the magnetic field configuration must carry a positive charge. (It may seem odd that a cosmic-ray particle should be travelling *upward*, but the natural direction of motion can be reversed by scattering.) Furthermore, the possibility that the track be made by a proton is ruled out by its length and curvature, as well as its linear density. The number of droplets per unit length is a good guide to the mass of the particle. Slower, heavier particles (such as protons) produce more abundant droplets of condensation, and the meagre train in this picture argued for a particle as light as an electron.

The inescapable conclusion was that Anderson had found a new particle. At the end of the discovery paper he commented that if nature allowed for *positive* electrons, it should also cater for *negative* protons – but this satisfying symmetry was not to be experimentally confirmed for another 24 years.

Confirmation of the positron was soon provided in abundance by P. M. S. Blackett and G. P. S. Occhialini using the first cloud chamber to be triggered by Geiger counters. Only six months after the epochal discovery by Anderson, they were able to account satisfactorily for the origin of positrons in terms of "pair formation", whereby the gamma rays of a cosmic-ray shower spontaneously generate pairs of electrons and positrons. Employing much the same apparatus with which they *almost* discovered the neutron (pp 72–73), the Joliot-Curies demonstrated a similar phenomenon in the laboratory only a few months later.

Date: 2 August 1932
Place: California Institute of Technology, Pasadena
Photographer: C. D. Anderson
Apparatus: Cloud chamber at 15000 gauss
Source: Science Museum, London
References: Anderson 1933, Anderson 1961, Hanson 1963, Sekido & Elliot 1984

Last Gape of the Tasmanian Tiger

The search for a living example of the thylacine, or Tasmanian tiger, lacks none of the drama – the claimed sightings, the characteristic spoor, the tangle of anecdote and rumour – of the hunt for the Yeti or the Sasquatch. There is nevertheless a fundamental difference: the thylacine is a Tasmanian animal whose existence at least is unimpeachable up to the 1930s, and its legacy of bones, pelts and indeed photographs amounts to more than circumstantial evidence. To date, however, no solid evidence has emerged to contradict the probability that the thylacine is now extinct.

A carnivorous marsupial related to the kangaroo, the thylacine is distinguished by several remarkable features. Its tawny fur with thick dark stripes down flanks, rump and tail at once suggests the tiger although the two species are as different as cats and dogs. Nor is it much closer to a dog or hyaena, for that matter, despite its other popular cognomen of "Tasmanian wolf". For one thing, its long, tapering tail is stiff like that of a kangaroo and incapable of wagging from side to side; for another, the female bears a pouch to carry its young. (Curiously enough, the male too possesses a vestigial pouch, apparently to protect his scrotum.) Yet unlike the kangaroo's pouch, the thylacine's opens from the rear, not the front (top), presumably because the kangaroo maintains an upright stance whereas the thylacine lopes about on all fours and might otherwise injure its young on rough undergrowth. Even if it is not quite such a zoological farrago as the platypus from neighbouring Australia, the thylacine does combine a bizarre variety of characteristics. Indeed its generic name, *Thylacinus cynocephalus*, signifies "pouched dog with a wolf head".

In one respect – its gape – the thylacine more closely resembles a snake than anything else. Its jaws can open to an angle of 120° or more; although outdone by, say, a python, no other animal could match it. The pair of frames from a film made in the 1930s (facing page) constitutes the last surviving photograph taken of the last known thylacine, and the only one to show its famous gape. (Gamekeeper David Fleay obtained a superior photograph in 1933, but the original has evidently been lost.)

Until the last certifiable member of the genus (opposite) died in Beaumaris Zoo on the Domain in Hobart on 7 September 1936, the thylacine reigned as the largest carnivore among the marsupials. From nose to tip of tail it measured up to 2 metres, in height 55 cm and in weight 20 kg. It is thus larger than the fierce little Tasmanian devil, the quoll, or even the various dasyures of Australia, where palaeontological evidence shows that the thylacine too once roamed.

Trappers and hunters have been largely responsible for the thylacine's demise. A century ago Tasmanian sheep-farmers considered thylacines as serious a menace as dingoes (wild dogs) were thought in Australia. In view of their ravages, wrote one farmer, "It behoves sheep owners to make common cause against the common foe, to form themselves into tiger districts and to subscribe to a fund from which to offer a sufficiently high reward for tiger heads." A bounty was placed on their head, £1 per carcase, by an act of State Parliament on 29 February 1888. Thousands were snared, shot or poisoned over the next few decades, and a mange-like disease contributed to their rapid decline. The last confirmed shooting of a wild thylacine occurred in north-west Tasmania on 13 May 1930. The death in captivity of the last known Tasmanian tiger shown here was marked by neither regret nor gloating, and passed all but unnoticed.

Bounties were eventually set upon its head once again, this time not to kill but to recover a single live specimen, and much effort has been devoted to the search. Nearly five decades later, after at least seven full-scale expeditions, 300 alleged sightings (the latest in 1982, but reported only in January 1984) and innumerable forays by wildlife enthusiasts, photographers and zoologists, their pains still go unrewarded.

Date:	*circa* 1935
Place:	Beaumaris Zoo, Hobart, Tasmania
Photographer:	Unknown
Apparatus:	8 mm movie camera
Source:	State Library of Tasmania, Hobart
References:	Pocock 1926, Griffith 1972, Beresford & Bailey 1981

Meson of Mistaken Identity

This cloud-chamber photograph of a particle track is considered to have been in its day the most convincing proof of the existence of a new particle – variously called the mesotron, the mu meson, or today simply the muon. To label it the discovery photograph would be to exaggerate somewhat. Such particles had appeared previously in cosmic-ray showers – a multitude of particles generated as cosmic radiation ploughs into the upper atmosphere – and had puzzled physicists as to their identity.

At first it was argued that the primary radiation impinging on the atmosphere must consist of electrons and that the particles observed at sea level capable of penetrating lead must be electrons accelerated to high energy. This contention did not square either (on the macroscopic scale) with the east-west asymmetry in cosmic-ray flux or (in the cloud chamber) with the observed behaviour of the penetrating particles, which unlike electrons suffered scant energy loss through radiation. Nor did energetic protons fit the bill since their capacity for producing ionization is greater than that observed for the penetrating particles. One way out of the difficulty could be found in the idea that the penetrating radiation consisted of fundamentally new particles with a mass intermediate between those of the electron and the proton.

At least two teams of researchers, J. C. Street and E. C. Stevenson at Harvard University and S. H. Neddermeyer and C. D. Anderson at Caltech, must be credited with pinning down the new particle. Both teams dealt with the low yield at sea level by designing coincidence circuits to take photographs in a cloud chamber only when external and interior Geiger counters agreed that a sufficiently energetic particle had been detected. Both inferred the mass of the particle from its ionization density – measured by counting droplets condensed along its track – as a function of the applied magnetic field strength.

A photograph "of special interest" published by Neddermeyer and Anderson in 1938 (the one opposite) was taken in a cloud chamber filled with helium and argon. They were fortunate enough to record for the first time a penetrating particle at the end of its range after it had swept down the copper tube of the internal Geiger counter (centre). Barely visible on the original image is a hint of the particle's decay into a positron where its track seemingly stops short. On the left is a direct image; on the right, a mirror image useful for stereoscopy. "It is clear," argued the Caltech physicists, "that the track cannot possibly be due to a particle of either electronic or protonic mass." The new particle was positively charged, and its mass was estimated to be 240 times that of an electron. In fact, the modern value for the muon is 207 times the electron's mass.

A curious historical sidelight is provided by the story of the muon's initially mistaken identity. Swayed no doubt by the tidy prediction of a positive electron by Dirac and its experimental confirmation by Anderson (pp 74–75), experimenters aware that the Japanese physicist H. Yukawa had predicted a particle with just the order of mass of the one discovered leapt to the wrong conclusion. Yukawa's particle was subsequently (1946) identified with the pi meson, or pion, by Cecil Powell and his energetic group at Bristol.

Date: 1937
Place: California Institute of Technology, Pasadena
Photographers: S. H. Neddermeyer & C. D. Anderson
Apparatus: Helium-argon cloud chamber at 7900 gauss,
 controlled by Geiger counters
Source: Science Museum, London
References: Neddermeyer & Anderson 1938, Neddermeyer &
 Anderson 1939, Rochester & Wilson 1952,
 Gentner *et al.* 1954

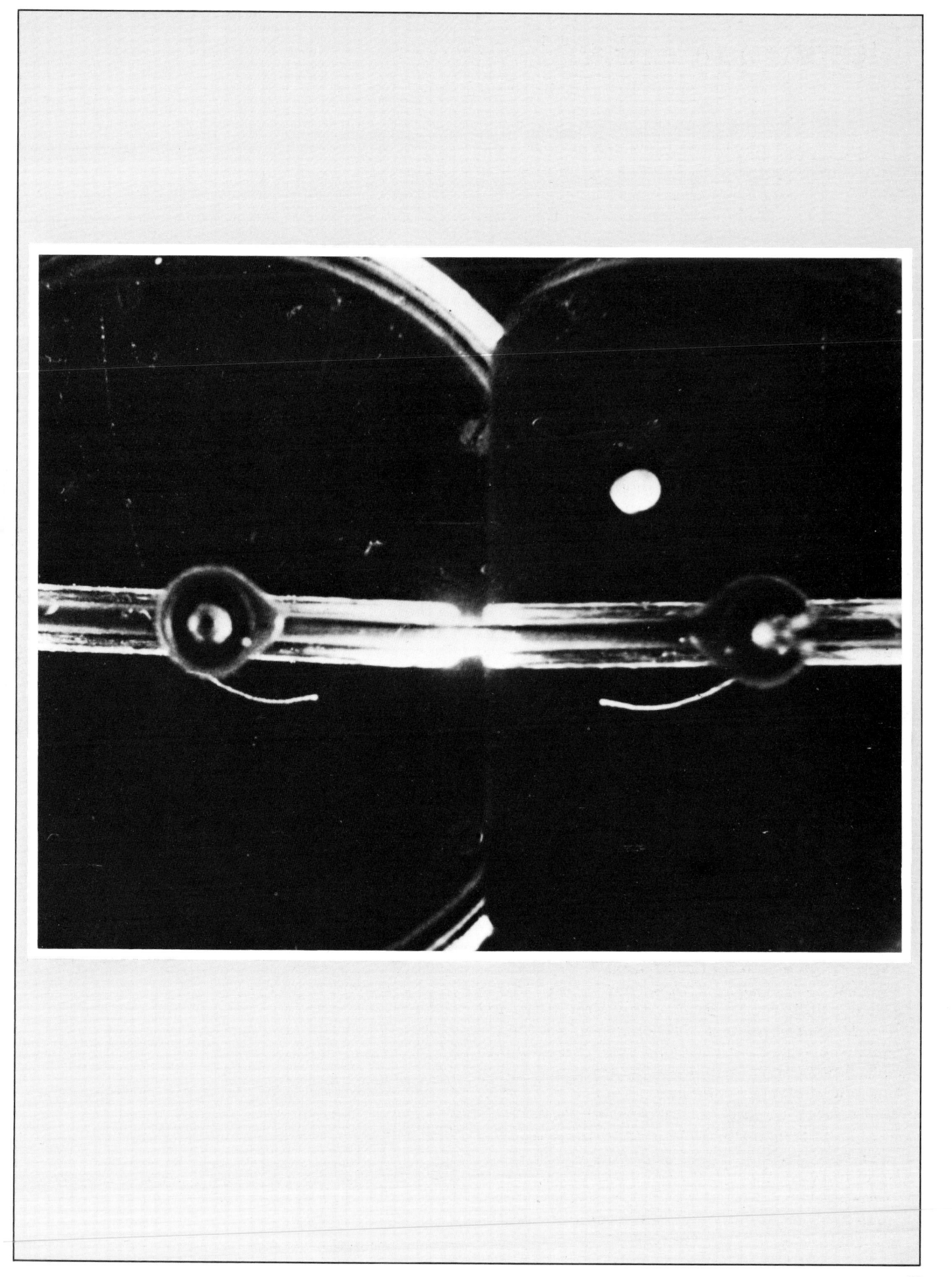

The Virus Verified

For several decades viruses were to the biologist what atoms had long been to the physicist: entities which could not be seen on account of their small size but which proved exceedingly fruitful in accounting for observed phenomena. But these convenient fictions were photographically converted into observable fact, atoms by the field-ion microscope in the early 1950s and viruses a decade earlier by the electron microscope. The earliest photomicrographs to reveal unmistakably the structure of the viral strain designated T2 are reproduced on the facing page.

Viruses are tiny particles which attach themselves to cells, highjack their genetic mechanism to reproduce more viruses and then destroy the host cells by dissolving the cell walls and pouring out freshly made viral material (a phenomenon called lysis). Those viruses which infect bacteria are called bacteriophages, literally "bacterium eaters". That bacteriophages are particles capable of lysing a bacterial cell was already known to Salvador Luria and Thomas Anderson when they joined forces at RCA in November 1941. So was the fact that Ernst Ruska, the inventor of the electron microscope, had recently observed particles shaped like spermatozoa in a phage suspension. But the crucial photographs demonstrating the head-and-tail structure of viruses belong to Luria and Anderson, aided not only by the quality of their apparatus but also by the acquisition of very highly concentrated stocks of bacteriophage.

A bacteriophage T2 particle, at first termed "anti-coli PC" by Luria and Anderson, typically possesses a head 60 to 80 microns (millionths of a metre) in size and a tail 120 to 130 microns long and 20 microns thick. The first electron micrograph to show one clearly is pictured opposite above. Added to a culture of the gamma or PC strain of the common colon bacillus *Escherichia coli*, bacteriophage T2 particles attach themselves to the cell wall after a few minutes and infect the bacillus (opposite below). Lysis will occur about twenty minutes later with the ejection of more than a hundred new viral particles. Different bacteria are susceptible to different viruses, and for that matter not all viruses are virulent. So it is also possible for viruses to refrain from bacterial attack or else to integrate themselves with the bacterium without at once replicating and destroying their host.

Let us now jump two decades and resolve the T2 bacteriophage as something more than an out-of-focus tadpole. In the 1962 electron micrograph, the virus reveals itself as a complex structure with a polyhedral head, a cylindrical tail with an outer sheath ringed like a screw thread and at its end a base plate to which short rods (difficult to discern) and six kinked tail fibres are attached. The head contains DNA (some viruses carry RNA) and both head and tail consist of a protein envelope called a capsid. One can see why viruses have been called "mobile genes".

Phage particles land on a hapless bacterium like spaceships docking. "The long tail fibres attach first, followed by the short rods," writes Anderson. Rather like a hypodermic syringe, attachment of the rods "causes the tail sheath to contract, which drives the needle [normally concealed by the base plate and lower sheath] into the bacterial wall which somehow induces the DNA contained in the head to pass through the needle into the bacterium. There the DNA takes over the synthetic machinery of the bacterium [which] lyses to release the daughter particles into the medium where each of them can encounter a fresh bacterium to repeat the life cycle." The infecting phage particles adsorbed onto the bacterial wall remain stuck fast, their delivery complete and their role ended.

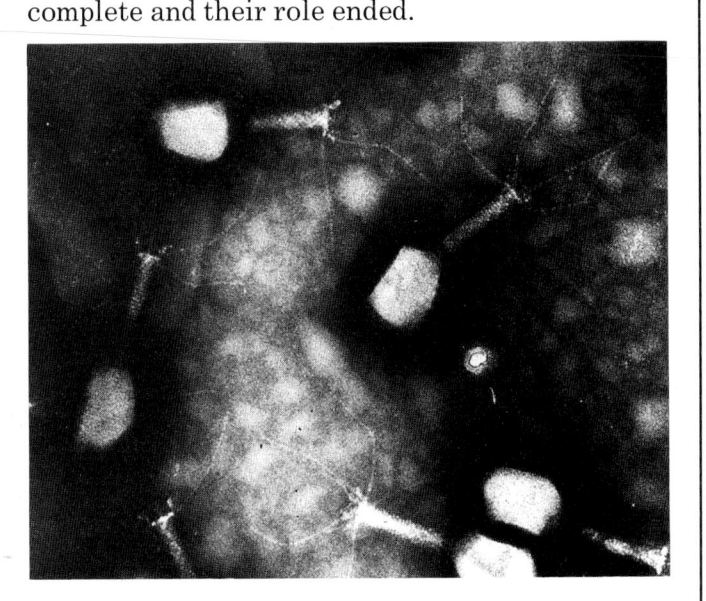

Date:	2 March 1942 (opposite); 29 March 1962 (above)
Place:	RCA Research Laboratories, Camden, New Jersey (opposite); Institute for Cancer Research, Philadelphia, Pennsylvania (above)
Photographers:	T.F. Anderson & S.E. Luria
Apparatus:	RCA Model B electron microscope (opposite); Siemens Elmiskop I (above)
Emulsion:	Kodak Lantern Slide glass plates (opposite); Ilford Special Lantern Plates, Contrasty (above)
Source:	T.F. Anderson, Fox Chase Cancer Center, Philadelphia
References:	Luria & Anderson 1942, Luria *et al.* 1943, Cairns *et al.* 1966

Cell under the Electron Microscope

Cytology, the study of biological cells, is as old as the microscope and can be said to date from the studies of Robert Hooke and Antoni van Leeuwenhoek in the seventeenth century. Many important details of cellular structure, however, lie beyond the highest resolution of the optical microscope and could not be observed until the advent of the electron microscope three centuries later. Of the photographs here the famous biologist George Palade once remarked that they "mark the beginning of the electron microscope era in cell biology".

This electron micrograph of a cell from a chick embryo was taken in the James B. Murphy Laboratory of Pathology at the Rockefeller Institute, New York by Keith Porter, the late Albert Claude and Ernest Fullam only a decade after the invention of the electron microscope. Naturally biologists did not wait a decade before submitting tissue samples to microscopic scrutiny, but previous attempts had been hampered by the destructive character of the electron beam, by the difficulty of obtaining sufficiently thin specimens or by the degradation of the fixative employed. Improving on conventional practice, the American researchers coated the glass slide on which a tissue culture was to be grown with a thin polyvinyl film called "formvar" which made it much easier to transfer the culture to the wire mesh of the electron microscope. Exposure to vapours from a 2% solution of osmium tetroxide (OsO_4) for 45 minutes effected fixation. The tissue culture was then washed for 30 minutes in distilled water.

The famous composite of five electron micrographs taken of a chick embryo fore-gut is reproduced opposite. It must be said that the optical microscope is also capable of revealing, if not nearly so clearly, some of the cell components: the nucleus (large black blob, blurred through excessive thickness of the specimen at this point), nerve fibres (three jagged branches traversing the picture), dark Golgi bodies and filamentary mitochondria responsible for respiration (near the nucleus). On the other hand, the ground substance displayed two new features: a granular appearance due to fine particles and a lace-like texture which later became known as the endoplasmic reticulum.

Both these findings deserve further attention. The fine particles were at once associated with so-called microsomes, small particles recently isolated by Claude from other specimens of chick embryo.

In these microsomes, Claude had in fact discovered ribosomes, the RNA-rich particles where protein synthesis takes place. (Their role in translating the genetic code into a chain of amino acids – a protein – was not actually established until much later.) It is not the fine granules, however, but the vesicle-like bodies in the endoplasmic reticulum which constitute the ribosomes.

The endoplasmic reticulum occurs in both animal and plant cells and comprises a maze of tubules and sacs of membraneous tissue responsible for transporting proteins and lipids (fatty organic molecules) around the cell. The very fineness of this "delicate lace-work extending throughout the cytoplasm" somewhat alarmed Claude, who warned in a subsequent paper that it might be no more than an artefact of the preparation procedure. The filamentary structure nevertheless proved to be genuine; Palade and his associates were later to study its structure and biochemistry in some detail.

Summarizing their paper, Porter and his colleagues concluded, "The detail of cell outline... revealed in electron micrographs is in excess of that which can be seen with the light microscope. In part responsible for this is the far greater resolving power of the electron microscope... But also important is the fact that the cells are thin enough for differential penetration of electrons with a minimum of multiple scattering [except in the nucleus] and a consequent fair definition of cellular components." A quarter century later Palade singled out other contributing factors: "In retrospect, it is clear that the high quality of the micrographic evidence, ... the high contrast, and the sharp definition of the structures studied were due to a combined effect of fixation and staining of cellular membranes by OsO_4, [and of] prolonged fixation and subsequent washing." Indeed, it was the first time that such a preparation technique successfully introduced the thinly spread cultured cell into electron microscopy.

Date: 6 July 1944
Place: Rockefeller Institute for Medical Research, New York
Photographers: K. R. Porter, A. Claude & E. F. Fullam
Apparatus: RCA electron microscope, type B; specimen fixed
 in OsO_4
Emulsion: Eastman Kodak 548-G
Source: K. R. Porter, University of Colorado, Boulder
References: Porter *et al.* 1945, Palade 1971, Florkin 1972

Unholy Trinity

The event signalled by this photograph, the birth of the atomic age, has been accorded historical stature equal to that of the Industrial Revolution. Trinity, the code name for the first atomic explosion, was the culmination of the top-secret Manhattan Project dedicated to the development and assembly of atomic weapons. Whether the notorious mushroom cloud symbolizes the eventual harnessing of what President Eisenhower liked to call "the peaceful atom", or alternatively "Death, Shatterer of Worlds" in the words of Robert Oppenheimer quoting the *Bhagavad-Gita*, it must be acknowledged an outstanding scientific achievement.

The scientific basis for the bomb was a chain reaction produced by nuclear fission, the energetic break-up of a heavy atom; the technological basis, the assembly of a critical mass of sufficiently pure uranium or plutonium at the moment of detonation. (A critical mass is that which can just initiate a self-sustaining fission reaction.)

A chain reaction can occur in, say, neutron bombardment of uranium because the neutrons split the heavy nuclei, producing barium, krypton and other fission products plus a surplus of neutrons which in turn split more nuclei to yield further neutrons ... However, the neutrons do not necessarily behave as they are bidden: they may simply escape (below the critical mass), they may be absorbed without fission (notably at intermediate velocities by the uranium isotope U-238) or they may encounter the wrong atom (if the uranium sample contains impurities). The most direct path to a fission chain reaction must therefore be to isolate a critical mass of the uranium isotope U-235, much more susceptible to fission than U-238, from the mixture of isotopes occurring in nature. U-238 is unfortunately 140 times more abundant than U-235. The first atomic pile, in which lumps of uranium oxide were interspersed with graphite acting as a "moderator" to slow the neutrons down and increase the probability of reaction with U-235, was constructed by Enrico Fermi and his colleagues in 1941 and a successful chain reaction was achieved in December the following year.

That fission could be harnessed to generate atomic power on the one hand or a devastating weapon on the other was realized virtually at once. The technological obstacles to either were daunting, however. Laborious attempts at isotope separation were made using the mass spectrograph, the centrifuge, gaseous diffusion, liquid thermal diffusion. But another option was also explored: U-239 produced through the capture of neutrons by U-238 nuclei will decay to neptunium (Np-239) and then plutonium (Pu-239). Plutonium, the first element to be synthesized in the laboratory, behaves like U-235 in response to slow neutrons but has the advantage of being created from the more abundant isotope U-238. No isotope separation is necessary.

For the first bomb a plutonium core was chosen, with an initiator – a metal ball with radioactive polonium core and beryllium shell – to provide fast neutrons when the implosion device crushed them together under the onslaught of a spherical shock wave. (A controlled chain reaction in an atomic pile calls for slow neutrons; but a bomb thrives on fast neutrons.) Ground zero was a timber tower in the middle of the Los Alamos desert, the bomb perched on top at a height of 30 metres. The detonator was armed by Trinity project director Kenneth Bainbridge by remote key control shortly before 5:30 local time on 16 July 1945 – when in a blinding false dawn an atomic blast equivalent to 18 kilotonnes of TNT was unleashed.

To record Trinity, over fifty cameras were placed at positions 0.7, 9, 29 and 38 kilometres from ground zero. Eight of the various films were badly fogged by X- and gamma-rays, and the nine best of the remainder were used for measuring. Most of the 100,000 exposures were obtained with cinecameras. The still camera responsible for the exposure opposite makes a strange bedfellow among the innovative cameras with rotating mirrors and prisms specially designed at Los Alamos. In the experiment log the photograph is described thus: "Overexposed but shows ball of fire and branches" – a superposition of the first five seconds of Trinity. The top of the mushroom cloud will by this time have reached 500 m.

The transition from ball of fire to cloud of smoke takes place after about one second has elapsed, by which time many of the most interesting phenomena have already occurred: blisters on the fireball, spikes running down the guywires, the groundstrike and consequent rise of a skirt of dust, the passage of the blast wave (a *visible* shock front). Trinity ultimately rose to some 12 km, leaving a crater 400 m wide. By thermonuclear standards (pp 96–97) it was an explosion of low yield, but at the time it was the most powerful man-made explosion in history.

Date:	16 July 1945
Place:	Jornada del Muerto, Alamogordo, New Mexico
Photographers:	J. E. Mack & B. Brixner
Apparatus:	Still camera at f/2000, 9140 m from ground zero
Emulsion:	Kodak Commercial film
Exposure time:	5 sec
Source:	Los Alamos National Laboratory, New Mexico
References:	Mack 1945, Butler 1962, Wiener 1983

TIME EXPOSURE
0 TO 5 SEC.
N

100 METERS

The Chicken and the Egg

It is a fact of nature that eggs emerge blunt end foremost. For many years it was taken for granted that birds must naturally form an egg that way, perhaps creating a soft spheroid first and gradually deforming it into an ovoid by the peristaltic movement of their uterine muscles. Now it is true that several physiologists since the great seventeenth-century Fabricius of Padua realized that the egg rotates *in utero*, thereby confuting the peristaltic theory, but confusion abounded well into the twentieth century.

The problem of the chicken and the egg was at last approached photographically in 1946, when J. R. G. Bradfield of the Department of Zoology at Cambridge University contacted John A. Fairfax Fozzard, an experienced radiographer at the School of Anatomy. Fozzard took a dozen lateral radiograms of domestic hens (the Rhode Island Leghorn breed) at various stages of incubation in April 1946, to be followed by further series in May and November and again in April 1948. From these a clear visual sequence could be pieced together, each cycle lasting 26 hours from one laying to the next.

After some $6\frac{1}{2}$ hours the outline of a round form in the hen's abdomen becomes just discernible (radiogram at upper left, facing page). Not until 12 hours can the egg's oval asymmetry be descried, its pointed end toward the cloaca (upper right: $12\frac{3}{4}$ hours). At $23\frac{1}{2}$ hours the egg is sharper (centre), still "pointing" downstream but at about $24\frac{1}{2}$ hours the egg starts to rotate horizontally (edge-on view at near right) until by $25\frac{1}{2}$ hours (bottom, facing page) it is pointing the other way, ready to be laid. The X-rayed chicken opposite displays its vertebrae clearly, with its lung at upper left, the arch of its pelvis at top, its cloaca at right and plenty of grit in its gizzard (the dots at lower centre). For part of this sequence Fozzard was awarded the Rodman Medal of the Royal Photographic Society in 1946.

Why should birds behave in this extraordinary fashion? Obviously there must be some natural advantage to the blunt-laid egg, and in a tongue-in-cheek article in the *British Medical Journal* (entitled "De formatione ovi et pulli" in imitation of Fabricius and William Croone) H. A. Harris advanced one theory. The uterine contractions of a hen are surprisingly forceful, he argued, and the blunt-end-foremost arrangement stands a better chance of avoiding rupture of either egg or uterus. However, Bradfield found the alleged peristalsis to be without foundation. Instead, the shell gland holding the egg is extruded through the cloaca where the egg is deposited before the gland retracts.

So the ingenious explanation offered by D'Arcy Thompson for the egg's form – that muscular contractions propelling an egg down the oviduct account for its shape – has been radiographically refuted. Is there some other reason why hen eggs are ovoid? If the ovoid is supposed to have such exceptional tensile strength, why are some birds' eggs spherical, like the tawny owl's? Are all birds equipped with an internal rotation system to guarantee their eggs a blunt exit? We know that chickens rise to their feet at about the time rotation takes place, enabling the egg to drop to a deeper position (see below), but the mechanism of rotation remains elusive. Nor is it clear four decades on just why nature does not save itself a lot of trouble and form the egg the "right" way round in the first place. Perhaps the resurrection of these remarkable radiograms will spark further research.

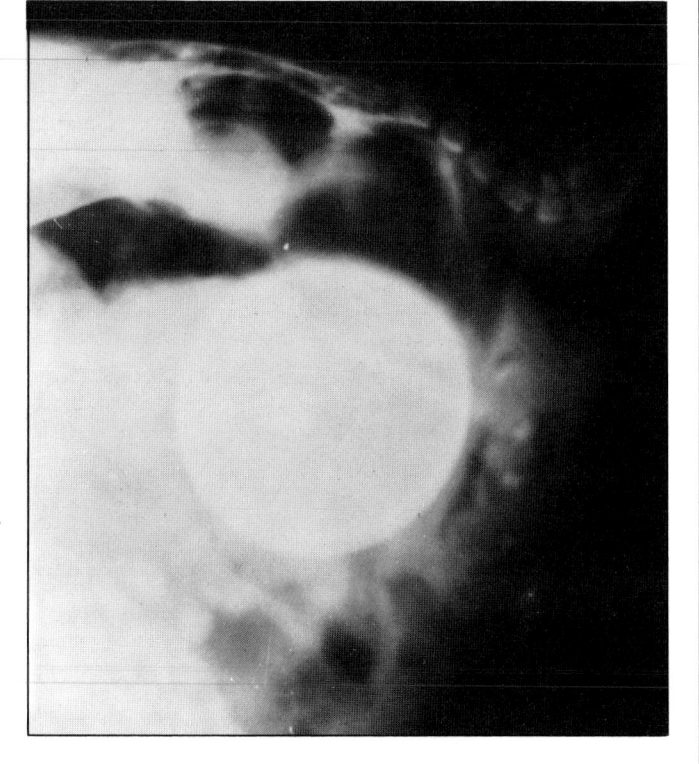

Date:	3 and 4 April 1946 (facing page)
Place:	School of Anatomy, Cambridge
Photographer:	J. A. F. Fozzard
Apparatus:	Coolidge X-ray tube at 60 kV, 1 m from chicken
Exposure time:	0.05 sec (facing page); 0.2 sec (above)
Source:	Photographer
References:	Thompson 1942, Harris 1948, Bradfield 1951

The Unseen Sun

A cloudless sky may appear perfectly transparent at optical wavelengths, but to ultraviolet light and X-rays the atmosphere looks as opaque as a brick wall. Opposite above is a set of spectra providing our very first glimpse of ultraviolet (UV) radiation from the cosmos, and below the first X-ray image acquired beyond the obscuring layer of ozone. In both cases the vehicle was a rocket and the target naturally enough the brightest, closest star: the Sun itself.

Nuclear physics was not the only field to benefit, somewhat inadvertently, from World War II (p 84). Solar spectroscopy and upper-atmosphere research were both given a powerful shot in the arm by the V-2 rockets captured from Germany. In principle they could reach over 160 km in height though in practice satisfactory UV spectra could be obtained after the rocket had passed beyond the upper limit of the ozone layer at 50 km. To fire it to maximum height would gain a dubious advantage: the spectrum might stretch further into the hard ultraviolet but the rocket would have farther to plummet, and in those early days neither deceleration jets nor parachutes were employed to slow the fall. For the historic flight which returned these spectra, the rocket was lofted to 107 km and then artificially blown apart on the descent (at 35 km) to counteract the streamlining, as undesirable a feature on the way down as it was welcome on the ascent. As a result the spectrograph, lodged in the tail-fin of the rocket, survived with no more than a minor dent – by contrast with the preceding V-2 flight where the recovery team found little save a 25-metre crater!

Unlike modern rockets and satellites, the V-2 was not locked onto its target by means of pointing sensors, and rays of sunlight might come in at any angle. Naval Research Laboratory scientists circumvented this difficulty through the use of spherical beads of lithium fluoride, one for each spectrograph. Two spectrographs were designed effectively back to back since after the stabilized, fuel-burning portion of the flight the rocket could spin in any direction whatever and the two beads, each feeding light to its corresponding spectrograph, would be able to cope with a Sun appearing at nearly any angle. (An inertial guidance system operated during the initial trajectory with an autopilot to adjust carbon vanes in the exhaust.) The spectrographs were both evacuated and each was endowed with an aluminium-on-glass diffraction grating, motorized shutters to control the exposures and an armoured canister for the film, whose advance was also motor-controlled.

The historic flight took place on 10 October 1946, but it took another six days to locate the wreckage in the New Mexican desert. The best of the solar spectra – that is, extending furthest into the UV – is the bottom one, taken at an altitude of 55 km. A higher one (88 km) turned out to be much weaker because of an unfavourable orientation of the Sun. The spectrographs were designed to be sensitive to UV radiation from 1100 to 3400 Å; to record wavelengths shorter than the observed cut-off around 2200 Å, longer exposures at greater height would be necessary. Absorption lines from a dozen metals can be seen, as well as the important magnesium doublet around 2800 Å where the bright continuum is severely interrupted by these huge absorptions.

The crude image of the Sun opposite below is the first photograph at X-ray wavelengths. (North is at top and west to right.) It was acquired with a lensless pinhole camera aboard an Aerobee-Hi rocket with a peak height of 220 km. The pinhole was covered with a thin nitrocellulose film called Parlodion to prevent visible and ultraviolet rays from interfering with the X-ray image. Possessing *two*-axis stabilization, the rocket was able to rotate around the Sun-camera axis with the result that discrete features are drawn out into arcs. Nevertheless, it was possible to deduce the origin of solar X-rays in the corona above bright plages, as well as the size and intensity of the X-ray Sun. It is instructive to compare this dismal if historic image with the outstanding photographs taken routinely by Skylab (pp 148–149) only thirteen years later.

Date: 10 October 1946 (above); 19 April 1960 (below)
Place: White Sands Missile Range, New Mexico
Photographers: R. Tousey & C. V. Strain (above); T. A. Chubb & H. Friedman (below)
Apparatus: Grating spectrograph in V-2 rocket (above); pinhole camera in Aerobee-Hi rocket (below)
Emulsion: Kodak 103-O film, UV-sensitized (above); Ilford Industrial G X-ray film (below)
Exposure time: 3.6 sec (above); 286 sec (below)
Source: R. Tousey, Naval Research Laboratory, Washington, D.C.
References: Baum *et al.* 1946, Strain 1947, Blake *et al.* 1963, Tousey 1967

89

Strange Particles

The inconspicuous inverted V below right centre in this photograph of a cloud chamber heralded a whole new class of elementary particles. At the vertex of the V no track is visible: so the in-coming particle must be uncharged. This, then, is the discovery photograph of the neutral V-particle, first of the so-called strange particles.

With their equipment at Manchester University, G. D. Rochester and C. C. Butler took some 5000 photographs before encountering evidence for the first neutral and later the first charged V-particle. The cloud chamber consisted of a cylinder 30 cm in diameter and 19 cm deep containing argon and oxygen in the ratio 4:1. The lead plate (central band) sandwiched between sheets of chromium-plated brass serves its usual purpose: to examine the effect that the heavy metal has on the cascade of energetic particles and especially to see what decays it induces. As in other counter-controlled devices (e.g., p 78), a photograph is taken only when triggered by a strong shower of cosmic rays.

Before claiming the existence of new particles, Rochester and Butler had to demolish alternative explanations. After all, a straightforward collision in the gas could be responsible – but then one would expect all the more collisions in the dense lead plate (3 cm thick) and they are not observed. Electron pair formation is ruled out on account of the wide angle of the fork ($67°$), and decays of pions or muons on the grounds of the energies involved. Nor can we be witnessing the chance superposition of two unrelated tracks in the chamber since the photograph is one of a stereoscopic pair which together confirm that the tracks are copunctal. Even the possibility that the V be re-interpreted as the track of a particle coming from *below* and disintegrating into one charged and one neutral particle can be ruled out of court. So we must be dealing with a spontaneous decay on the (invisible) trajectory of a neutral particle.

Detailed arguments based on the assumption that the decay products (the two prongs of the fork) are pions or muons showed that the new particle must have a mass on the order of a thousand times the electron's mass, or about half a proton. Discouragingly, however, no confirmatory sightings were forthcoming for another two years. Then Carl Anderson and his research group in Pasadena came up with another 30 cases of "forked tracks"; a year later the Manchester team improved their chances of detection by transporting the cloud chamber to the top of the Pic du Midi in the French Pyrenees, where they bagged 43 more V-particles. Soon still more new particles were discovered, this time by means of photographic emulsions. All these heavy mesons complicated a picture that theoreticians in the late 1940s thought to be coming clear (apart from the place of the muon and the neutrino in the scheme of things), and they were thus dubbed "strange" particles a few years later.

Cosmic rays could not be relied upon to generate quantities of "strange" particles since the energy required exceeded 1000 million electron volts. The chance that a relatively small detector would be operating at the right time and place to record such an energetic shower was not high. Fortunately, the era of the cyclotron, capable of accelerating particles artificially to the energies where collisions could be counted upon to produce "strange" particles, lay close at hand. The so-called Cosmotron which began operation in 1953 at Brookhaven National Laboratory, New York was soon revealing V's and associated particles by the score.

Particle accelerators at Brookhaven, Stanford, CERN and elsewhere have almost entirely replaced cosmic-ray detectors in the search for new fundamental particles. Considered with modern eyes, the cosmic-ray shower opposite looks amusingly quaint. Today it is recognized that there are two types of neutral V-particle, the one inferred from this historic photograph being called the neutral K-meson $K°$ with a mass 966 times that of an electron. The visible decay products are a positive and a negative pion.

Date: 15 October 1946
Place: Physical Laboratories, University of Manchester
Photographers: G. D. Rochester & C. C. Butler
Apparatus: Stereoscopic photographs at f/4 of counter-controlled cloud chamber at 3500 gauss; Siemens SF4 flash tubes
Emulsion: Kodak R55
Source: Science Museum, London
References: Rochester & Butler 1947, Rochester & Wilson 1952, Segré 1980, Sekido & Elliot 1984

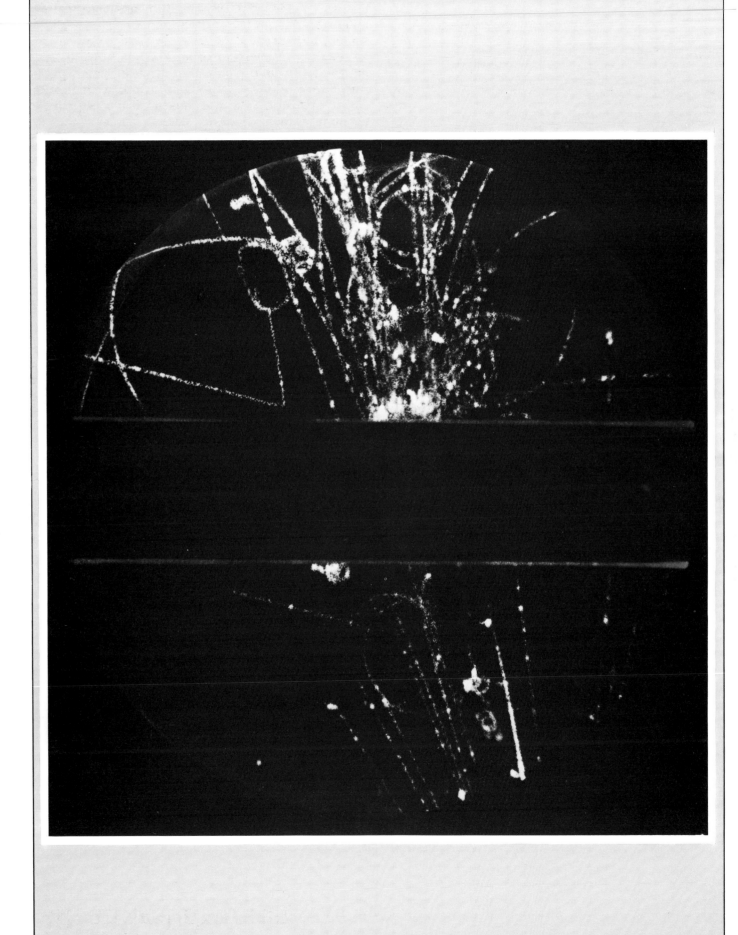

The First Hypernucleus

The starburst opposite reveals the disintegration of a heavy cosmic-ray particle at the point where it collided with a silver or bromide nucleus in the photographic emulsion. To physicists accustomed to evaluating photomicrographs of cosmic-ray tracks, it is nothing very unusual. Far more remarkable is the smaller starburst at bottom right: here lay the discovery of hypernuclei.

Cloud chambers dominated nuclear physics for several decades, but they were not the only kind of detector. Photographic emulsions too revealed the passage of charged particles. The first photomicrographs of particle tracks were taken in 1914, but not until about 1935 was it possible to produce emulsions tailor-made for nuclear physics. Considerable research and development by Ilford Limited and others perfected nuclear emulsions over the next decade. Many physicists utilized the new emulsions, but perhaps no others were so productive as the group led by Cecil F. Powell at the W. H. Wills Physical Laboratory of Bristol University.

Thanks to Powell, the two Polish physicists Jerzy Pniewski and the late Marian Danysz were able to secure a place for their photographic plates on one of the Bristol balloon flights. When they saw the results, they realized from the length of the track between disintegrations A and B that this particular event was highly significant. The incident particle arrives along p and disintegrates in a shower of more than twenty fragments at A. The fragment h gives every appearance of disintegrating in turn at B after the "very long" time of 3 millionths of a microsecond. If starburst B represents spontaneous decay, then the track would be expected to be much shorter – corresponding to a lifetime briefer by a factor of a hundred million.

The obvious escape routes from the quandary are all but blocked. One could claim that track h has nothing to do with disintegration B and that the end of one just happened to coincide with the occurrence of the other. However, the chances are about 10 million to 1 against such a coincidence. Alternatively one could claim that if p could strike a nucleus in the emulsion at A, then h could do so at B. But there is a difference: despite all the other rays of the star at A, one of them does carry on in the same direction as p albeit with reduced kinetic energy. The fragment h, on the other hand, stops dead as if it had miraculously shed all its kinetic energy at once.

We are thus left with a genuine delayed disintegration. Abrupt excitation of the protons and neutrons in an ordinary nucleus should lead to very rapid decay. The implication drawn by Danysz and Pniewski from the delayed decay was that a hyperon – one of the "strange" particles (pp 90–91) – whose decay time matched the survival time of h must be bound into an ordinary nucleus. (They also suggested the alternative possibility that a pion caught in a bound orbit about the nucleus might be responsible but other observations in the year of publication [1953] ruled out that scenario.)

By good fortune another delayed disintegration came to light in a similar balloon flight in the same year conducted by D. A. Tidman and his colleagues at Imperial College. The chance superposition of B on the end of track h, which had looked so unlikely before, now became extremely improbable. Like the Poles, the British physicists thought that the presence in a nucleus of what they called a neutral V-particle, now known as a lambda hyperon, provided the most plausible explanation. Free hyperons had been recognized for some years but until the cosmic-ray evidence of the 1952 balloon flights nucleus-bound hyperons had not been suspected. Hypernuclei had been discovered and they in turn led some 30 months later to the adoption of strangeness as a new quantum number.

Date: 1952
Place: Balloon at 28 km
Photographers: M. Danysz & J. Pniewski
Apparatus: Nuclear emulsion exposed to cosmic rays
Emulsion: Ilford G5
Source: J. Pniewski, University of Warsaw, Poland
References: Danysz & Pniewski 1953, Tidman et al. 1953, Powell
 et al. 1959, Sekido & Elliot 1984

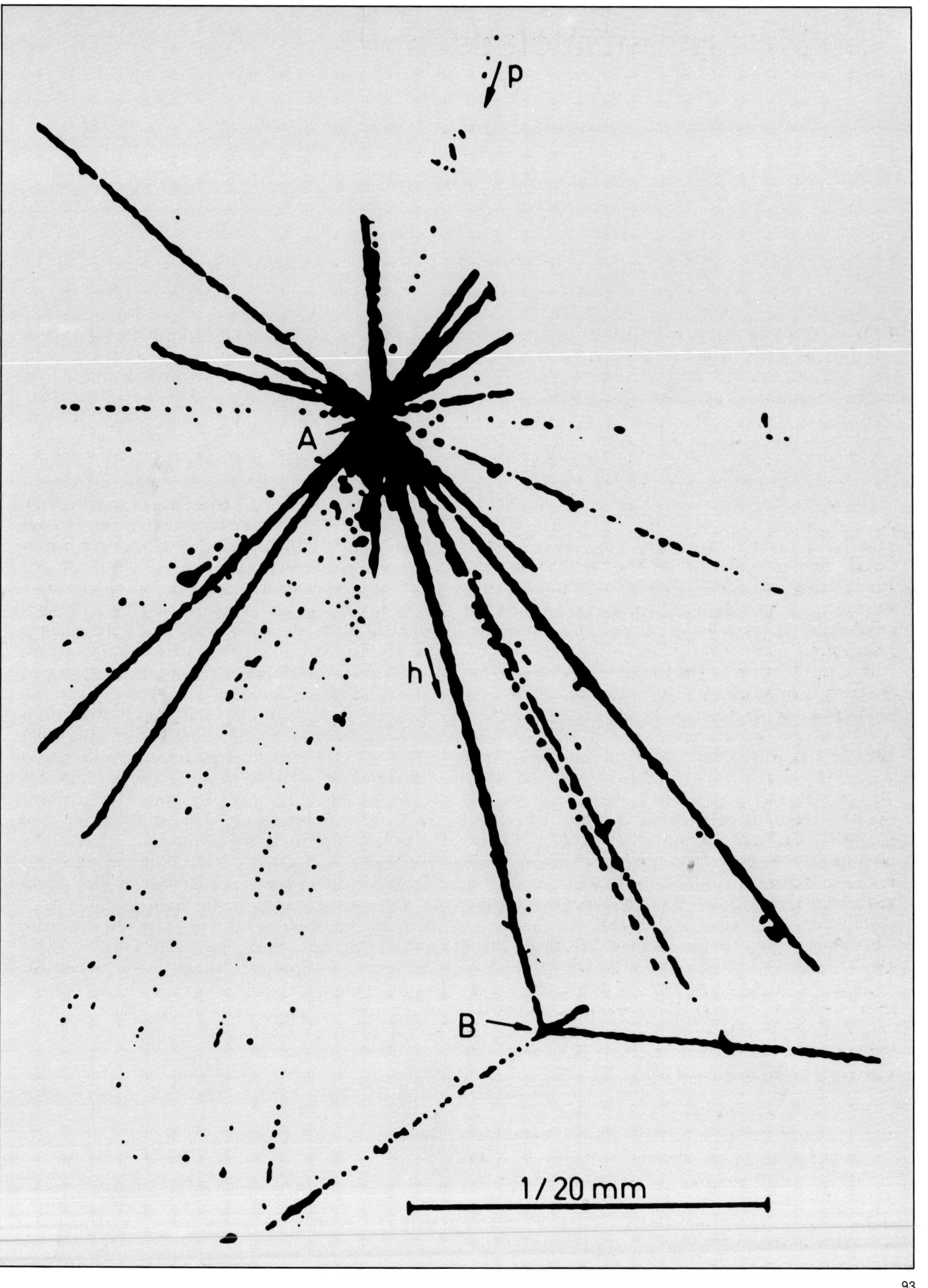

1/20 mm

Spiral Staircase of Heredity

Visually unappealing but conceptually exciting, these diffraction patterns – created by beaming X-rays through a sample of DNA – are nevertheless among the most important scientific photographs ever taken. They presented the first unequivocal photographic evidence for helical structure in the A (left) and B (right) forms of DNA, the basis of all living matter, and were soon to trigger recognition of the double helix by Francis Crick and James Watson.

Molecular biochemistry yoked together the chemistry and geometry of deoxyribonucleic acid (DNA) to account for the bearer of the genetic code in terms of its structure. That line of attack could readily be pursued because a crucial analytical tool was available: X-ray diffraction (p 15). The first X-ray diffraction photograph of DNA in the form of a dry film was taken by William Astbury and Florence Bell in 1938. Indistinct though the pattern was, they estimated the spacing of the component molecules from its periodicity, inferred the molecular weight and proposed a structure. The first biochemist to appreciate the genetic significance of DNA was not Astbury, however, but Oswald Avery experimenting on pneumococcal virus in 1943.

No one else took up the torch until, at a meeting of the Faraday Society in May 1950, Maurice Wilkins of the Biophysics Unit at King's College obtained a vial of exceptionally pure DNA from Rudolf Signer. His original intention was to use the DNA for optical studies, but Raymond Gosling of the Physics Department at King's approached him for a sample to X-ray. Dry sheets of the gel yielded poor diffraction patterns; but when strong, fine fibres drawn out of the gel by Wilkins were substituted, extraordinarily good results were obtained at high humidity after a long exposure. DNA was later shown to occur in different para-crystalline forms: structures A ("crystalline"), B ("wet") and more rarely C (or Z). The A pattern obtained by Gosling and Wilkins, shown at left, was in its day the best ever produced from DNA and confirmed the crystalline structure which Astbury had strongly suspected. But Astbury's early work had suffered doubly: his DNA film was a confusing mixture of forms A and B and less concentrated than Wilkins' filaments of pure A; and dry films produce blurred, weak patterns. Jim Watson later claimed that this A pattern, projected by Wilkins at a meeting in Naples in May 1951, first incited him to tackle the structure of DNA.

Wilkins was already contemplating some sort of helical structure when Paris-trained X-ray crystallographer Rosalind Franklin arrived at King's. Abetted by a new X-ray tube and camera, she and Gosling soon obtained many more photographs, plus some unexpected results. Increased humidity gave not merely a better pattern but a quite different one (a B form, as opposite at right) – and one still more suggestive of helical structure. Franklin's interpretation oscillated, however. At one stage she wrote in her notebook that the structure must be either "a big helix or a smaller helix consisting of several chains"; not much later Watson quotes her as denying that there was any shred of evidence to support a helical form for DNA. By May 1952 she had gone off on an "anti-helical tangent" in the words of historian Robert Olby and two months later even wrote a mock obituary for helical DNA in the "crystalline" (A) form!

Ironically, in May 1952 she had obtained the excellent X-ray diffraction pattern of the "wet" (B) form, no. 51 in her notebook, which was to provide Watson and Crick with the key to the double helix. The apparatus had been much improved over that used by Gosling and Wilkins the previous year – a fine-focus X-ray tube designed by Werner Ehrenberg and Walter Spear of Birkbeck College to replace the war-surplus Raymax tube with its more diffuse beam; an airtight vessel maintained at high humidity by bubbling hydrogen through a salt solution rather than water; a smaller lead shield (central white disc); a superior Phillips microcamera.

How do we interpret exposure 51 (right), made with a single DNA fibre from calf thymus? Inside a blurred diamond, short stubby arcs of varying intensity define the shape of a cross. The diffraction pattern is not that of "real space", but it is a reliable transformation of it. From the intense outer arcs, top and bottom vertices of the diamond, a spacing of 3.4 Å between nucleotides can be inferred; from the innermost arcs, exactly one tenth the distance to the outer arcs, a distance of 34 Å between repetitions of the pattern. (Nucleotides are the molecular subunits of nucleic acids; each nucleotide of DNA contains the sugar ribose linked to a phosphate group, a phosphorus atom surrounded by four oxygen atoms, the group in turn connected to a purine or pyrimidine base.) To the attuned mind, in the words of H. F. Judson, "The pattern shouted helix" – each full twist occurring every 34 Å and containing ten nucleotide pairs spaced 3.4 Å apart. Properly interpreted, the pattern even divulged the diameter of the helix (20 Å).

Poised on the brink of discovery, as we appreciate with hindsight, Franklin failed to capitalize on exposure 51 until ten months later. By then Wilkins

had already shown the pattern to Watson, visiting from Cambridge. "The instant I saw the picture my mouth fell open and my pulse began to race," Watson recollected; he grasped at once the fact that "the black cross of reflections which dominated the picture could arise only from a helical structure." By early 1953 no one seriously doubted the existence of a helix; Linus Pauling among others even devised a triple helix.

The geometric insight which was to change the face of molecule biochemistry flashed upon Watson and Crick. One structure fitted the diffraction pattern perfectly: an intertwined double helix, spiralling chains of sugars and phosphates, each strand being linked to its neighbour by pairs of complementary bases (one purine and one pyrimidine) joined by a weak hydrogen bond. Gauging the correct structure proved far more than an arid exercise in geometry. The rules of base pairing ordain that, granted the sequence of bases attached to one coil of the double helix, the sequence attached to the other coil follows ineluctably. The bases are complementary, like photographic negatives and positives, and to envisage self-replication nature has only to separate the strands. Each parent strand then passes on its genetic coding inversely

– in intaglio, so to speak – by pairing with a new strand. The net result is two pairs of offspring helices identical to the parental pair.

When Crick, Watson and Wilkins shared the 1962 Nobel Prize, the presentation speech honoured a discovery which "opens the most spectacular possibilities [for] unravelling of the details of the control and transfer of genetic information". Decades later the spiral staircase of DNA, its rungs a pair of bases, still leads to unexplored heights – not least the possibility of cloning through recombinant DNA.

Date:	June 1950 (left); 2 to 6 May 1952 (right)
Place:	Biophysics Research Unit, King's College, London
Photographers:	R. G. Gosling & M. H. F. Wilkins (left); R. E. Franklin (right)
Apparatus:	Raymax X-ray tube, bunch of 35 DNA fibres (left); Ehrenberg-Spear X-ray tube, Phillips camera, single DNA fibre (right)
Exposure time:	4 hr (left); 62 hr (right)
Source:	M. H. F. Wilkins, King's College
References:	Olby 1974; Portugal & Cohen 1977; Judson 1979; Watson, ed. Stent (1981)

Arms for Oblivion

The energy unleashed in an atomic bomb, based on nuclear fission, seems stupendous enough. Yet that of a thermonuclear bomb, based on nuclear fusion, is typically a thousand times greater. When Operation Ivy detonated the first thermonuclear device on a Pacific atoll, it removed one island completely from the map.

Fusion and fission seem to be the source of much popular confusion. In fission, the nuclei of heavy atoms are split into lighter fragments; in fusion, nuclei of lighter atoms combine to form heavier ones. The difference in mass between the reactants and the products is a measure of the energy released. To produce a fusion reaction, extremely high energies (as in cyclotrons) or correspondingly high temperatures (as in the cores of fission bombs) must be attained. Since temperatures of at least 10 million degrees are required, a fusion bomb is often referred to as a thermonuclear device. It is also called a hydrogen bomb or H-bomb, being composed of hydrogen or one of its heavier isotopes, deuterium (H-2) and tritium (H-3). Both fission and fusion bombs are *nuclear* weapons; an "atomic" (fission) bomb is something of a misnomer.

The feasibility of a thermonuclear bomb had been discussed as early as 1941 by physicists Edward Teller and Enrico Fermi. In the late 1940s factions determined to build the so-called "Super" fought to win political and financial support in the teeth of those who condemned the device as a "weapon of genocide". The explosion of a fission bomb by the Soviet Union in 1949, the removal from Los Alamos of opponent Robert Oppenheimer, the implacable determination of Teller and other factors conspired to give the proponents of the Super their head. On 30 January 1950 President Truman announced a crash programme for its development.

The detonation on 8 May 1951 of a fission bomb code-named George, one of four exploded in the area of Eniwetok Atoll in Operation Greenhouse, provided the first measurements of a fusion reaction triggered by the fission device. But two crucial developments were required before the first true thermonuclear bomb could be successfully exploded: the UNIVAC electronic computer and the so-called Teller-Ulam configuration. Rapid as they are, shock waves still travel too slowly to bring the nuclear core of a fission bomb to a density and temperature high enough to set off a thermonuclear reaction before the contents explosively disperse. In the spring of 1951 Stanislaw Ulam proposed to Teller that the X-rays released in copious amounts by a fission bomb could themselves be used to trigger any amount of nuclear fuel.

The Super project, incorporating the Teller-Ulam configuration, achieved a workable fission-fusion bomb the following year. It had long been obvious that a practical hydrogen bomb would never be built using hydrogen, deuterium or tritium in their normal gaseous state; such a bomb would be unmanageably large. Instead, the core of this first device consisted of liquid lithium deuteride and lithium tritide, compounds which on detonation would rapidly break down into deuterium and tritium, which combine at high enough temperatures to form helium with the release of neutrons. The neutrons in turn will bombard the lithium nuclei (Li-6, the lighter and rarer isotope) to produce *more* tritium (and helium) – fresh ammunition for the reaction with deuterium. The core container was beryllium whose nuclei react to a fusillade of neutrons by producing two for every one which strikes home. This deluge of neutrons not only contributed to the lithium reaction but helped to accelerate the twin fission bombs acting as triggers.

These triggers consisted of plutonium and fissile uranium (U-235) surrounding the thermonuclear core. A small linear accelerator provided the neutrons which set off the fission bombs – triggering the triggers, so to speak. Surrounding the fission bombs was a shield of common uranium (U-238) to redirect part of the X-ray flux from the explosion inward to the core. Similarly an outer shell of beryllium reflected neutrons fleeing from the fission reaction back into the thermonuclear furnace. The entire bomb occupied a cylinder only 1.2 m long and 0.5 m in diameter. It was dropped over the island of Elugelab in the historic Mike shot shown opposite.

Whereas Trinity (the first fission bomb; p 84), detonated on a tower in clear weather, yielded 18.3 kilotonnes, Mike (the Super) was exploded at ground level under a partly overcast sky to give 10.2 *mega*tonnes (TNT equivalent). Here we see Mike's mushroom cloud climbing to 35 km and standing on a 20 km stalk or stem, but the spread of a "skirt" half-way up the stem is lost in cloud. As the first high-yield surface explosion, Mike unexpectedly gave rise to five flashes of artificial lightning, propagating upward from sea level – certainly the *mot juste* since in less than a second Elugelab had been wholly obliterated.

Date:	1 November 1952
Place:	Elugelab, Eniwetok Atoll, Marshall Islands, Pacific Ocean
Photographers:	H. E. Edgerton, K. J. Germeshausen & H. E. Grier
Apparatus:	Speed Graphic camera, hand-held in C-47 aeroplane
Source:	Los Alamos National Laboratory, New Mexico
References:	Anon. 1954, Glasstone 1962, Uman *et al.* 1972, Danckwerts 1982

Tripod Fish Photographed

Although underwater photography dates back nearly a century, the camera began to cull information from the deep sea only relatively recently. Marine biologists benefited from the work of two deep-sea photographers above all: Harold Edgerton at the Massachusetts Institute of Technology and John D. Isaacs at the Scripps Institution of Oceanography. Both devised ingenious cameras to be operated by remote control in the inhospitable environment at very high pressure, near-zero temperature and darkness unrelieved by any sunlight.

A very few such photographs were taken not by means of a baited camera or a sequence of automatic exposures but by the occupants of a pressurized submersible. For the photograph opposite Harold Edgerton, renowned for his invention of the high-speed electronic flash, joined forces with Lt. Cmdr. Georges S. Houot in his bathyscaphe FNRS 3 to photograph the Mediterranean floor off Toulon. Houot and his colleague P. Tailliez observed this "tripod fish", properly speaking a *Benthosaurus*, on their first dive to the bottom at 3000 metres. The first successful photograph, shown here, dates from a subsequent dive; according to Edgerton, the depth was 1600 m.

The bathyscaphe is rendered buoyant by filling the hull with petrol, which is lighter than water, and is made to sink by opening a valve to admit seawater into the central air lock. To avoid distortions introduced by viewing through the Plexiglas porthole of FNRS 3, Edgerton positioned his camera outside the bathyscaphe in a watertight housing of stainless steel capable of withstanding the huge pressures – nearly 200 times atmospheric pressure at the bottom of the Mediterranean Sea off Cap Cépet. A two-element optical corrector is placed in front of the camera. Four electronic flashlamps operated by a 24-volt battery provide illumination. The resulting photographic haul was immense, many creatures including the *Benthosaurus* being photographed in their natural habitat for the first time.

Marine biologists had previously surmised that the two long ventral fins plus the tail-fin (caudal fin) serve as feelers. This photograph shows that, on the contrary, they act as stilts and enable the "tripod fish" to prop itself up on the seabed, immobile as it stands waiting for food. When disturbed, it leaps away – "like a frightened cricket" in the words of Houot – to land on its stilt-like appendages and begin a new vigil.

Benthosaurus grallator (the fish pictured opposite) is found not only in the Mediterranean but in the Atlantic, the Caribbean and the Gulf of Mexico. A related species *Bathypterois viridensis*, also termed a "tripod fish" in popular parlance, has slightly shorter appendages and prefers shallower depths. A *Benthosaurus* is generally no more than 30 cm long, and its colour is a mottled black. Its life history is little better known today than when it was first photographed *in situ* perched on the seabed.

Date:	August 1954
Place:	Trench in Mediterranean Sea off Cap Cépet
Photographer:	H. E. Edgerton, Massachusetts Institute of Technology
Apparatus:	Camera at f/11 in pipe of stainless steel; 4 flashlamps (200 J)
Exposure time:	0.03 sec
Source:	Photographer
References:	Edgerton 1955, Edgerton & Hoadley 1955, Sears Foundation 1966

66

Defects in a Crystal Lattice

The photographic confirmation of a speculative idea is nowhere better illustrated than in this first picture of a crystal dislocation. As soon as the electron microscope had attained sufficiently high resolving power, it was employed to observe directly the lattices of large molecular crystals. In so doing it vindicated theoretical predictions made over twenty years earlier.

The historic analysis of crystal defects by Sir Geoffrey Ingram Taylor originated in a design project on aeroplane engine shafts at the Royal Aircraft Factory (now Establishment), Farnborough. "A young man called A. A. Griffith came to work with me," reminisced Taylor in a 1971 interview with G. K. Batchelor, "and as a result of many discussions he developed the theory of the Griffith crack to account for the fact that metals are much weaker than consideration of atomic forces would lead one to expect. The fact that though metals may be less strong than expected they get stronger in plastic strain was not in agreement with Griffith's theory and this awkward fact simmered in my mind for twenty years till I realized that a physical idea I had had from the first could be expressed mathematically using as a model Volterra's elastic dislocations."

That mathematical model was embodied in two papers on "the mechanism of plastic deformation of crystals" published in 1934. They dealt theoretically and empirically with the stress-strain curves of single metallic crystals (aluminium, copper, gold, iron) and rock salt. The stress-strain curve monitors how a crystal responds to tensile stress as it undergoes elastic stretching, then plastic deformation and finally fracture. The behaviour of the crystal as it is subjected to a shearing force can be modelled by picturing a regular atomic lattice whose crystal planes slide past each other.

A perfect crystal ought to manifest strong resistance to shear, but faults in normal crystals reduce their strength (as Griffith had tried to explain). Although intrinsically weaker than might be expected, metals respond to greater stress, somewhat paradoxically, with greater resistance; and Taylor argued that this increase in strength was caused by a larger number of faults per unit volume. These faults were interpreted as crystal dislocations capable of propagating through the lattice but not amenable to repair. Like knots on a string, dislocations cannot be removed except at the edges of the crystal.

Taylor's work on dislocations in crystal lattices in 1934 can be likened to predictions about the nature of stars which Eddington imagined would be made by astronomers on a cloud-bound planet. Despite the vast improvement in resolution of the electron microscope over the optical variety, direct visualization of crystal lattices was not achieved until 1955, when J. W. Menter at Tube Investments Research Laboratory began studying crystals with lattice dimensions commensurate with the resolution then available (about 10 Å).

Menter prepared crystals of copper and platinum phthalocyanine in an alcohol suspension and applied a drop to the grid of a transmission electron microscope – the Siemens Elmiskop 1, the premier instrument of its day. When the supporting fluid had evaporated, he photographed the crystals in the hope that the periodic lattices would strongly diffract the electron beam and enhance visibility of the crystal planes. His choice of metallic compounds was dictated both by the large spacing of the molecular layers in the lattice and by their thermal stability and consequent resistance to the depradations of the powerful electron beam.

As the photomicrograph opposite shows, Menter's experiment was successful. A platinum phthalocyanine crystal is viewed edge-on to one of its planes. The spacing of 12.0 Å measured from the 70,000 × photomicrograph is corroborated by X-ray diffraction measurements. The more recent electron micrograph on p 187 may be considered effectively the face-on equivalent.

After the sheer fact of seeing crystal lattice planes for the first time, the most exciting element of this photograph is the presence of a single-edge dislocation. The diagram underneath marks its location. Menter considered that although we see only a projection of the crystalline structure in the path of the electron beam it is likely that this dislocation line continues throughout the thickness of the crystal. In other samples, the electron micrographs revealed different crystal defects.

This electron micrograph is only a static record; for the dynamic reality, we must again turn to pp 186–187. But at least the concept of dislocations has changed from mathematical convenience to physical reality. As John Tyndall once wrote, "The brightest flashes in the world of thought are incomplete until they have been proved to have their counterparts in the world of fact."

Date: 1955
Place: Hinxton Hall, Cambridge
Photographer: J. W. Menter
Apparatus: Siemens Elmiskop 1 electron microscope (80 kV) with fine-focus condenser
Emulsion: Ilford Special Contrasty Lantern plate
Source: Science Museum, London
References: Taylor 1934, Menter 1956, Nabarro 1967, Batchelor 1975

The Sky in Colour

It took 120 years before photography had progressed to the stage where celestial objects could be captured in colour. The first cosmic colour photograph, picturing the Veil Nebula in the constellation Cygnus, was obtained on relatively fast colour film but without the benefit of modern techniques of hypersensitization. It is in retrospect quite remarkable that such a high-quality result was attained. In fact, the colour slide is still for sale with no historical fanfare whatever from the Caltech Bookstore.

From the astronomer's point of view, the failings of colour emulsions obtainable until about 1960 were (1) poor sensitivity, (2) high reciprocity failure, (3) loss of colour balance on long exposures and (4) contrast shifts. (By reciprocity failure, photographers mean the saturation effect in which an emulsion does not absorb proportionately more light with a longer exposure.) When Super Anscochrome film rated 100 ASA for normal exposures became available, it surpassed its colour rivals in sensitivity although in retrospect it was a case of a tortoise beating a snail. Anscochrome's nominal speed of 100 dropped to 7 ASA, for example, in the exposure of four hours required to capture the Crab Nebula in colour. On the other hand, the supposedly faster High-Speed Ektachrome also available at this period and rated 160 ASA would have dropped to a miserable 3.4 for the same exposure.

The colour balance of conventional tripack colour reversal film is designed for "standard conditions" – not for exposures of long duration at low light level. The changes introduced by extended exposure times are all the more pernicious for being difficult to pinpoint. Studio photographers can always guard against colour shifts by comparing their latest exposure with the original subject. But as William Miller, then Research Photographer at Hale Observatories, pointed out in his pioneering paper on colour astrophotography, "We do not know what nebulae and galaxies should look like in colour, for we have never seen and probably never shall see them visually in their true colours." The reason is simply that of the two components of the retina, cones and rods, it is the former which respond to colour but the latter which predominate in nocturnal vision. Bright point sources – stars like Antares, for instance, a red giant – can appear distinctly coloured. To nebulae and other extended objects, however, telescopic observers are effectively colour-blind. Somehow the emulsion must be induced to mimic a visual response even if we cannot double-check it by eye.

The problem is aggravated by the fact that the three layers of the emulsion in a modern subtractive colour process do not share the same reciprocity failure. The uppermost blue-sensitive layer, the middle green and bottom red layers do not diminish in sensitivity at the same rate. Here, then, lies the source of the shifts in colour balance and intensity.

One solution to this problem is the cold camera. At suffiently low temperature significant reductions in reciprocity failure can be achieved, with a corresponding gain in speed and reduction in colour shift. Arthur Hoag adopted this approach in 1961 but few followed his lead until the next decade. Another solution is to say, effectively, that if one cannot lick the problem one can always compensate for it – and this was the attitude which Miller decided to take.

Miller resorted to colour filters, and experimented to discover whether they are best introduced at the time of exposure on the telescope or in the course of processing. Certainly the latter plan, corrective measures applied when duplicating exposed film, works better than none at all; but Miller found that an accurate colour balance could be maintained only over a narrow range of photographic density. Use of a colour filter – preferably no more than one, to avoid ghost reflections – during exposure turns out to be "definitely superior" to the post-operative alternative. Subsequent filtering can help when need be to repair any vestigial imbalance. Regardless at which time the filter is applied, it is vital to expose a sensitometer control strip for each frame, in Miller's words "the *alter ego* of its accompanying photograph", to determine the required colour correction. A further correction for scattered background light may be necessary.

Not all celestial objects are depicted equally well on a colour emulsion; its three layers of primary colours tend to paint with a broad brush. Among brighter stars, the cooler ones register reddish and the hotter ones bluish. But nebulae present a more severe challenge: subtleties of colour discrimination which would not tax a human eye under normal lighting conditions cannot always be faithfully recorded by the photographic film (no colour *plates* at this epoch). Under some circumstances, a blue hue and a green one would both appear blue. High-Speed Ektachrome proved to be less culpable in this respect than Super Anscochrome.

Despite the foregoing comments on the preferability of colour correction during exposure, the wispy outlines of the Veil Nebula (part of the

Cygnus Loop) seen here were photographed without a filter – as were all the earliest of Miller's colour exposures. Correction was applied when duplicating the image by means of two Wratten filters, 50Y (a yellow filter whose blue density is 0.50) and 10M (a magenta filter whose green density is 0.10). As usual, to enhance a particular colour the photographer must apply a filter of complementary colour.

The Veil Nebula, NCG 6992, is part of a supernova remnant spawned in a huge stellar explosion perhaps 70,000 years ago. (That is I. S. Shklovskii's estimate; others contend that it is younger.) Its distance being only 800 parsecs (2600 light-years), the Cygnus Loop of which the Veil forms a part spans fully $3°$ – six times the size of the full Moon! Its delicate filaments emit radiation from atoms of hydrogen, as well as ionized nitrogen, oxygen and sulphur, but this optical emission is a drop in the Loop's energy bucket. Most of the gas in the Loop has a temperature of several million degrees; so the majority of its radiative output lies in the X-ray region. When Miller obtained this photograph, however, identification of the Cygnus Loop with a

powerful X-ray source lay thirteen years in the future.

Astronomical photography today, colour and monochrome, has been revolutionized by the advent of faster emulsions, cooled cameras, hyper-sensitization (pre-exposure baking in nitrogen and hydrogen) and various enhancement techniques. The three-colour *additive* process which saw the very birth of colour photography has been revived to excellent effect. One of its foremost practitioners, David Malin of the Anglo-Australian Observatory, remarks of Miller's *subtractive* process that his "original results are difficult to better with modern materials".

Date: 26 August 1957
Place: Palomar Observatory, California
Photographer: W. C. Miller
Apparatus: 1.2 m Schmidt telescope at f/2.5
Emulsion: Super Anscochrome roll film SA 100
Exposure time: 120 min
Source: California Institute of Technology, Pasadena
References: Miller 1959, Miller 1961, Miller 1962, Malin 1980

The Moon's Averted Face

In these days of Viking and Voyager, it is extremely difficult to remember the enthusiasm with which the world greeted the first glimpse of the Moon's far side. As the first celestial body to yield its secrets to reconnaissance by space vehicles, the Moon raised scientific and political temperatures when Luna 3 directed its miniature camera to the face normally hidden from terrestrial observers.

Placed into orbit 4 October 1959 by the Soviet Union, Luna 3 was the 21st successful launch since the inauguration of the space age by Sputnik 1 exactly two years earlier. Several potential lunar probes had failed to reach orbit, Luna 1 had missed the Moon completely and Luna 2 had crash-landed near the crater Archimedes. In its fly-by on 7 October at over 65,000 km, Luna 3 obtained a 40-minute sequence of photographs which enabled astronomers to map about 70% of the far side.

It may seem astonishing in retrospect that the photographs relayed back to earth originated not in a television camera but on 35 mm film exposed, developed, fixed, washed and dried aboard the satellite. The camera used either of two lenses, one with a focal length of 20 cm shooting at f/5.6 and the other 50 cm at f/9.5. The negatives were scanned with a light beam and the signals broadcast earthward where they were stored on magnetic tape.

Reconstruction from the tapes proved very laborious on account of emulsion defects, radio interference and the intrinsic low contrast of the far side at "full phase". At the Sternberg Astronomical Institute in Moscow, Yu. N. Lipsky resorted to various methods to recover detail from the "noisy" images, including superimposition of several frames, unsharp masking to compensate for the large range in photographic density and an electronic enhancement technique. Some idea of the difficulties may be gauged from the reproduction at the near right of the *best* unretouched high-resolution image.

The best global image assembled from Luna 3 data after image processing must surely be the one opposite (north at top). It is a composite of two enhanced full-disc images prepared in 1960 by Ewen A. Whitaker of the Lunar and Planetary Laboratory at the University of Arizona.

Three independent Soviet teams set about mapping the far side, and even at this crude resolution managed to compile an atlas of 498 features – 251 definite, 190 probable and 57 uncertain. The half dozen dark maria – lowland basins filled with dark basaltic material which reminded Galileo of seas – which can be seen at lower left in the photograph fall on the limb of the Moon and are just visible from the Earth despite some foreshortening. The most prominent new feature, the blob at upper right, was named the Moscow Sea. The oblique streak roughly at centre was confidently called the Soviet Mountains, but later mapping missions by the five American Lunar Orbiters obliterated this spurious range.

What secrets, then, had the "orbèd maiden" been hiding? It is striking how different the near and far sides look when photographs more modern than those reproduced here are compared. True, both are peppered with craters, traversed by mountain ranges and scored with bright ray systems. But the large dark maria which undeniably dominate the near side contribute little to the opposite hemisphere. It is a curious fact that a quarter of a century later we have yet to find a reliable explanation for the asymmetry between the lunar faces.

Date:	7 October 1959
Place:	Luna 3, 65000 km from Moon
Apparatus:	Camera at f/5.6 with 20 cm lens; reconstruction from magnetic tape
Emulsion:	35 mm film prepared for high-temperature processing (2-image enhanced composite)
Exposure time:	Automatic control
Source:	E. A. Whitaker, Lunar and Planetary Laboratory, Arizona
References:	Barabashov *et al.* 1961, Lipsky 1961, Kopal & Mikhailov 1962, Whitaker 1962

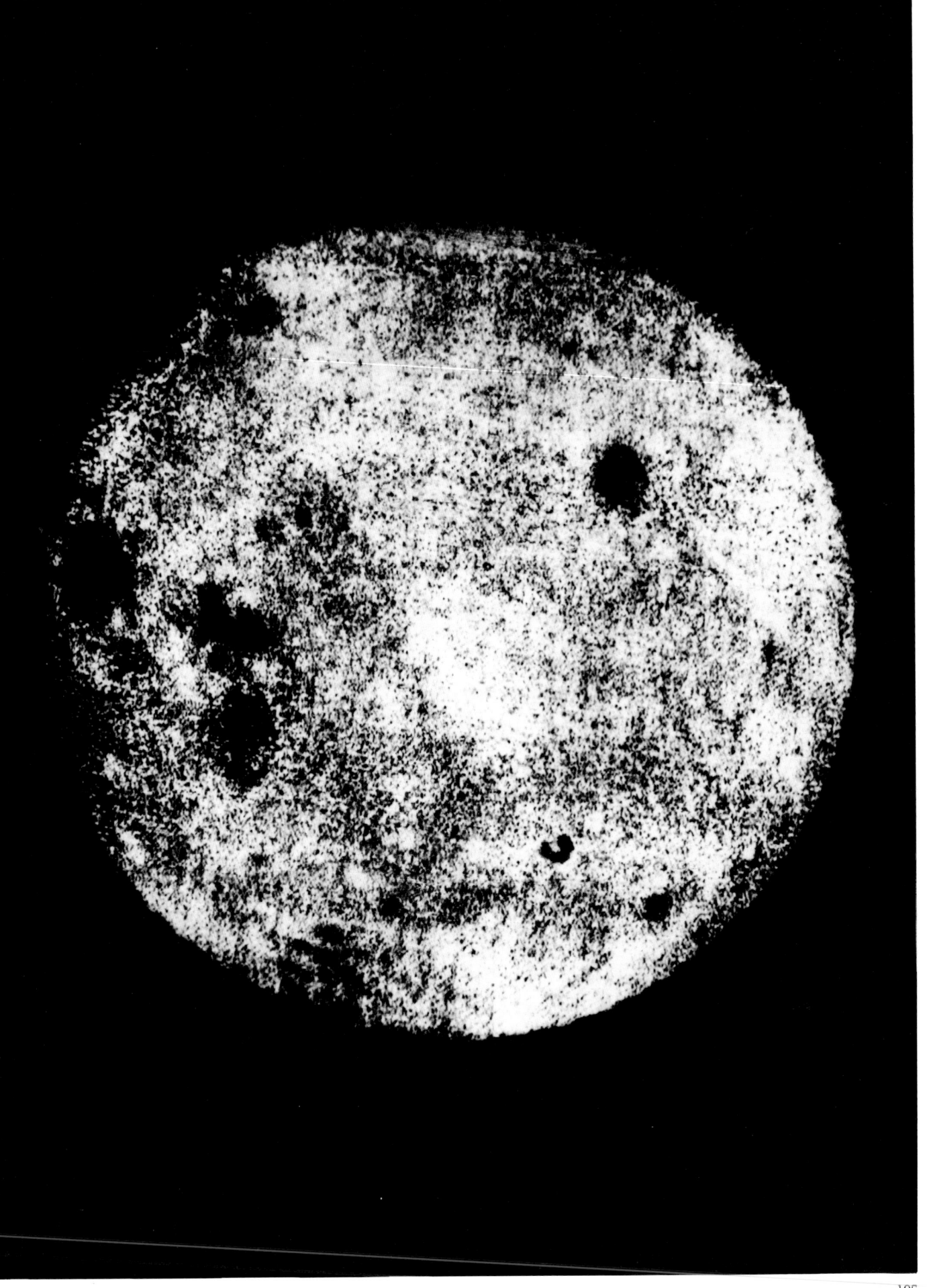

First Images of Atoms

The idea that ordinary matter consists of fundamental units called atoms is as old as Leucippus and Democritus, but for 2400 years they remained a theoretical construct. Matter behaved as though the theory were tenable, but even with the most powerful microscopes it was not possible to see a single atom. The resolution of the best optical microscope falls short by a factor of several thousand, and until very recently the electron microscope failed to reveal atomic detail. But with the invention of the field-ion microscope by the late Erwin W. Müller of Pennsylvania State University, atomic resolution came at last within our grasp.

The principle of the field-ion microscope was adumbrated by the prototype field-emission instrument designed by Müller in Berlin as early as 1936. The idea was quite novel: the specimen, far from being the passive subject of the probing microscope, itself participates actively in the process. The specimen is treated as the cathode of what is effectively a television tube, its fluorescent screen behaving as the anode. A high voltage applied to the pointed tip of the cathode forces the specimen to emit (negative) electrons which fly straight to the (positive) screen where they duplicate the image of the cathode at a considerable enlargement. A partial vacuum ensures that the electron stream is not unduly scattered and attenuated en route.

It turned out, however, that electrons are not the ideal imaging medium for a field-emission microscope; at best one can attain a resolution of 25 Å, a figure equalled or surpassed by the electron microscope. After years of experimentation Müller reversed the sign of the applied field and in 1951 produced the first field-*ion* microscope. Here a smaller specimen is held at a higher, positive charge and a tenfold improvement in resolution can be achieved. Another important difference is that the ions originate not in the specimen itself but in the immediately adjacent tenuous gas in the partially evacuated glass tube. Engineering details took another decade to perfect, but by 1960 the field-ion microscope had achieved its optimum resolution.

An image of the kind that the field-ion microscope was at last capable of producing after a quarter century of painstaking development is shown on the facing page. It is a tungsten crystal surface magnified about 10 million times with a resolution of about 3 Å. Each luminous spot is an

atom, and the pattern of the crystal lattice is remarkably clear.

The ions producing the image originate not in the tungsten tip itself but in the rarefied gas adsorbed onto the tip surface. The gas atoms – helium in this case – hop around the tip until they become ionized, losing an electron and in so doing becoming positively charged; then they fly out from the tip in a straight path to the negatively charged screen.

If there are any inhomogeneities in the needle tip, of course, they will be reflected in the surface-hugging gas atoms or molecules; so it is vital that the tip be smoothly curved, free of pits and ridges. Happily the enormous field strength (typically 500 million volts per centimetre) completes the smoothing process crudely initiated by chemical etching and annealing of the fine tip point. The surface atoms migrate to form a lowest-energy configuration, and any bulges disappear under the influence of field evaporation – the *sine qua non* for perfect tip surfaces. Each tip is itself submicroscopic in size, hemispherical, chemically pure and as smooth as field evaporation can render it. Its temperature is kept extremely low, perhaps 20 de-

grees above absolute zero, since the resolution improves as the temperature drops.

Another image from the 1960 era of field-ion microscopy is shown at left, this time an iridium crystal magnified about 5 million times. (Higher magnifications can be obtained by increasing the screen distance or reducing the tip size at the expense of the intensity of the image.) The dark spots mark crystal planes, their edges limned by atoms. The superposed square pattern defines "zone lines", a polarization effect.

Heavier metals, such as the two whose crystal structure is displayed here, were the first to be imaged and remain the preferred candidates for studies of crystalline defects and dislocations. But the range of suitable specimens now embraces nearly all metals from beryllium to uranium, as well as metallic alloys and some organic molecules.

Date: *circa* 1960
Place: University Park, Pennsylvania
Photographer: E. W. Müller, Pennsylvania State University
Apparatus: Field-ion microscope with helium as "imaging gas"
Source: T. T. Tsong, Field Emission Laboratory,
 Pennsylvania State University
References: Müller 1965, Hren & Ranganathan 1968, Müller &
 Tsong 1969, Tsong 1978

Plate Tectonics and the Puerto Rico Trench

What does one expect to see at the bottom of the ocean? "Mud" seems a plausible answer; after aeons of effluvial deposition by continental rivers and decomposition of marine organisms, there is good reason to expect plenty of mud. Yet the photograph opposite shows massive rocks at the bottom of the Puerto Rico Trench, a steep, narrow rift in the ocean floor off Florida: 8.4 km deep, 1550 km long but only 120 km wide. To gain a sense of scale, note that the photograph covers an area about 1.5 metres across.

Photographs of the ocean bottom have become plentiful, but only a quarter century ago the camera had revealed just a few random snatches of its physiognomy. Harold Edgerton, one of the pioneers of underwater photography, designed fundamental apparatus for deep-sea applications: watertight cases capable of withstanding pressures of over 100 million pascals (15,000 pounds per square inch), optical correctors to counteract distortion, electronic flash for illumination, sounding devices to position the camera at the correct height. Without diminishing the contributions of Edgerton's predecessors in the field, we must recognize that marine geology and biology owe a great debt to his photographic ingenuity.

Edgerton joined forces with geologists from Woods Hole Oceanographic Institution aboard the *Chain* to study the character of sites in the Atlantic Ocean. To obtain photographs of rocky outcrops, boulders and gravel on the north wall of the Puerto Rico Trench, Edgerton forwent the traditional techniques of camera positioning by means of a towed sled (Cousteau's preferred method) or a trigger hung below the camera. Instead he employed a sonar transducer, popularly called a "pinger".

A pinger sends pulses simultaneously to the mother ship and to the ocean bottom. The latter pulse is reflected and eventually reaches the mother ship as well, where the delay between arrival of the two signals pinpoints the pinger's position. The pulse, only a millisecond or shorter, pings at a frequency of 12 kilocycles. For this photograph the pinger indicated a depth of 3800 fathoms (about 7000 m) – in 1960 one of the deepest sites ever recorded.

Exposed rocks imply fairly recent geological activity, and this photograph could have fuelled arguments for sea-floor spreading. Bear in mind, however, that the theory of continental drift proposed by Alfred Wegener in 1915 lay dormant at this time, largely in disrepute. To drive crustal plates about the surface of the Earth, huge forces need be mustered. At the time when Wegener advanced his theory to account for gross climatic changes over a large historical span, no good evidence of mantle convection currents had as yet supplied a reasonable mechanism.

Even in 1960 after magnetic studies had lent support to the notion of crustal mobility, the theory of continental drift languished for lack of sufficient data. It was revived in the form of sea-floor spreading within the next decade, the idea being that crustal plates are borne about by convection currents in the fluid interior. They diverge at mid-oceanic rises where fresh crust is created by rising magma; they converge at subduction zones marked by mountains and trenches where old crust is sucked downward.

Photographs of the Puerto Rico Trench would have fitted this picture of geological activity beneath the oceans very well indeed. But the opportunity was missed, and this picture becomes historic only with hindsight.

Date:	1 March 1960
Place:	Puerto Rico Trench, Atlantic Ocean
Photographer:	H. E. Edgerton, Massachusetts Institute of Technology
Apparatus:	Stainless steel camera at f/11 plus flash; positioned by pinger
Source:	Photographer
References:	Edgerton & Hoadley 1955, Edgerton & Cousteau 1959, Hersey 1967, Edgerton 1979

Turning-Point in Lightning Spectroscopy

Excellent specimens of lightning photography have been taken this century – both direct images (cf. p 25) and spectroscopy, where the light is dispersed into its component wavelengths. But this slitless spectrum, obtained by placing a finely ruled transmission grating in front of an aerial camera, ushered in what one physicist called "a new era of lightning spectroscopy". It could be said that our knowledge of the lightning spectrum was changed at a stroke.

Spectrographs equipped with a prism or a diffraction grating are made to produce a "rainbow" of light running in any chosen direction. Light passing through the slit of a conventional spectroscope forms an image of the slit in all the colours which the grating or prism is capable of passing or to which the recording medium (generally photographic film) is sensitive. Natural lightning poses a problem for the slit spectrograph in that there is no guarantee that the bolt will obligingly appear in front of the narrow slit. It is thus far more likely that a reflection of the flash, rather than the stroke itself, will be recorded.

To pinpoint the stroke spectroscopically, it is more rewarding to resort to a slitless spectroscope where the incoming light is dispersed parallel to the horizon. That prescription, of course, will show up an air-to-ground stroke as a sequence of parallel images varying in intensity according to wavelength (as opposite), but would be most inconvenient for a cloud-to-cloud stroke where the direct image and its multiple spectral duplicates would become hopelessly confused. In the photograph shown here, the stroke is captured at an appropriately vertical angle, and the result may be seen as a three-dimensional graph: position as the ordinate, wavelength as the abscissa and intensity provided at any desired point.

The earliest successful slitless photograph of lightning still extant was recorded by E. C. Pickering in 1901 at Harvard College Observatory. Use of a prism, however, limited the spectral range since glass transmits a very limited band of wavelengths. Sir William Crookes used to circumvent this difficulty by substituting quartz, but a still more effective alternative is the diffraction grating of either the reflecting or the transmitting variety. Gratings had their own problems: the earlier ones concentrated most of the incoming light into the zero order, where being undispersed it does the spectroscopist no good whatever.

Progress in the manufacture of diffraction gratings facilitated far more efficient use of available light in several ways. First, the technique of "blazing" a grating shapes the grooves to concentrate the light into any desired order, usually first or second order. In the second place, optical manufacturers in the 1950s (above all Bausch and Lomb) began to achieve high quality and uniformity even over large gratings – and at lower cost to boot. The successful production of replica gratings, duplicated in plastic from the ruled master grating and mounted on a glass substrate, proved a great boon to spectroscopy.

In the wake of these improvements Leon Salanave, then with the Institute of Atmospheric Physics at the University of Arizona, took this crucial photograph. His lightning spectrograph consisted of a modified aerial camera plus a prism-grating combination yielding a dispersion of 25 Å mm^{-1} in first order. The replica transmission grating, made by Bausch and Lomb, covered the whole telephoto lens (aperture 8 cm). Not only is there a variation in intensity with wavelength running from the near ultraviolet at far left (3800 Å) to the red region at far right (6200 Å); there is also considerable variation from top to bottom of the stroke, with knots or hot spots salient at certain points. (The bright knots could also be simply a geometric effect rather than an enhancement in flux or temperature.)

The multiplied images of the (single) stroke look stronger or weaker according to the atoms responsible for line emission at that wavelength. All the brightest lines are attributable to singly ionized atmospheric nitrogen (that is, nitrogen atoms minus one electron), but other prominent lines belong to neutral nitrogen and to neutral or ionized oxygen. If the spectrum had run on a bit further to the right, the H-alpha line of hydrogen would have been conspicuous; the hydrogen originates in the dissociation of water vapour by the electric spark. Water vapour also makes its presence known directly toward the right-hand ("red") end of the spectrum, where it is manifest as a broad dark band intersected by lines of ionized nitrogen. Just as bright lines denote *emission*, dark bands indicate molecular *absorption*. The faint features toward the left-hand ("blue") end result from molecular emission by the cyanogen radical CN and the nitrogen radical N_2^+ although they were not recognized when the photograph was first published.

Writing of the historic significance of this photograph, Salanave comments, "The importance of these slitless spectra, dating from 1960 on, lies in the fact that from them (after time-resolution into individual strokes) channel temperatures near peak luminosity could be reliably determined for the first time." The highest temperatures occur not as the stepped leaders snake downward (or upward, according to the polarity) but on the return stroke. Typical peak temperatures lie between 24,000 and 28,000 K, about five times hotter than the surface of the Sun.

Date: 9 September 1960
Place: Tucson, Arizona
Photographer: L. E. Salanave, San Francisco State College, California
Apparatus: K-18 Aero-Tessar camera of aperture 8 cm, focal length 60 cm; Bausch and Lomb replica transmission grating
Emulsion: Eastman Kodak Royal Pan
Source: E. P. Krider, Institute of Atmospheric Physics, University of Arizona
References: Salanave 1961, Krider 1973, Salanave 1980

Hurricane Esther

TIROS 1 returned the first television image of the Earth's weather on 1 April 1960. In view of the date, it was at first widely regarded as a hoax; but as TIROS continued to supply 32 pictures per orbit (every 98 minutes), meteorologists soon took it seriously, and it radically affected ground-based weather forecasting. Another nine TIROS satellites followed in succession, each an improvement on the last, over the next five years.

Observations from space naturally supplement ground-based data, but it was only a matter of time before a satellite would take the lead and give advance warning of occurrences undetected on terra firma. That historic moment belongs to TIROS 3 as long ago as 1961. TIROS had been no quicker than Earth-bound weathermen to spot Hurricanes Anna, Betsy, Carla and Debbie; but the first inkling of Esther's gestation arrived by satellite.

NASA has always been fond of acronyms, and TIROS proves the rule; it stands for Television Infrared Observation Satellite. The character of the payload nevertheless changed significantly in the course of the TIROS programme, let alone its successors the ESSA and NOAA series. The first seven TIROS satellites recorded their pictures on magnetic tape, ready to relay to ground on command, whereas the eighth was capable of transmission in "real time" (live). A polar orbit was selected for the later satellites so that they could view the whole Earth turning beneath from their vantage point at 700 km or higher in the case of TIROS 9 (p 118). The orbits of TIROS 1 to 4, however, were inclined at 48° to the Earth's equator.

In addition to various infrared sensors, TIROS 3 bore two identical slow-scan television cameras, each with a 2.3 cm vidicon tube and wide-angle (104°) lens, in what looked like an oversize polygonal hat-box. The resulting image covered an area about 1200 kilometres square, with a 50% overlap between successive pictures. Launched on 12 July 1961, it survived 230 days but managed to relay 35,000 pictures (24,000 usable frames) before the system, then deteriorating, had to be shut down. (The spent satellite is still in orbit.) Power was provided by over 9000 solar cells glittering on the top and eighteen sides of the hat-box satellite.

The first hurricane to be imaged by satellite was not unnaturally seen by TIROS 1: Hurricane Anna was picked up off northeastern Australia only nine days after launch. As another historic picture, it deserves to be reproduced at right; but Hurricane Esther (facing page) generated far more excitement

than any of her predecessors. It looked like a dangerous typhoon and one of the two primary tracking stations for TIROS, Wallops Island off the coast of Virginia, lay square in its path. A telex dated 19 September 1961 from the NASA archives is illuminating: "HIGH WINDS PRECEDING HURRICAME/ ESTER/FORCED THE STOWING OF THE WALACQ [Wallops Island] ANTENNAS. THE WALACQ CDA STATION WAS CLOSED DOWN AND POWER WAS TURNED OFF LATER IN THE DAY IN RESPONSE TO WARNINGS ON HURRICAME /ESTER/" (original spelling retained!).

In the event, despite its grim cyclonic appearance, Esther merely footled about off the east coast of America before petering out in the Atlantic Ocean. The early warning did afford enough time to launch a cloud-seeding experiment using silver iodide – but its efficacy even today remains little more reliable than the rain dance.

Date: September 1961 (opposite); April 1960 (above)
Place: 700 km over Atlantic (opposite), Pacific (above)
Apparatus: Wide-angle vidicon with f/1.5 Elgeet lens aboard TIROS 3 (opposite), TIROS 1 (above)
Source: National Aeronautics and Space Administration, Washington, D.C. (opposite); National Oceanic and Atmospheric Administration, Washington (above)
References: Anon. [Spreen] 1966, Cortwright 1968, Schnapf 1982

Launching the Redshift Controversy

Quasars fit rather well Sir Winston Churchill's description of Russian foreign policy: "a riddle wrapped in a mystery inside an enigma". They may resemble ordinary galactic stars on a photographic plate, but their spectra reveal that they inhabit the farthest reaches of the observable Universe. (See pp 218–219.) Despite their small size they emit prodigious quantities of radiation. The nearest and apparently brightest of the quasars is 3C 273, discovered in a radio survey at Cambridge. The correct interpretation of its spectrum (below) by Maarten Schmidt in 1963 changed our whole picture of the cosmos.

Like many extragalactic radio sources, 3C 273 appears double. After its position had been accurately fixed by a lunar occultation, its optical counterpart was also found to consist of two components, a star-like blue object and a faint jet. Jets were not a new phenomenon in galaxies, but two other features decidedly were: the peculiar photometric colours of 3C 273 and its bizarre spectrum. A handful of similar "quasi-stellar radio sources", or quasars, were studied for two years before the riddle of their spectra was solved.

In February 1963 Schmidt abruptly realized that the as yet unidentified spectral lines included a pattern which strongly resembled the hydrogen Balmer series. That this pattern had not been recognized earlier might seem surprising, but the reason is simple enough. The wavelengths of the lines were far removed from their laboratory values

and could only be understood if the quasar 3C 273 were receding from the Earth at 47,500 km per sec, 16% of the speed of light. If this recession were interpreted to mean that quasars are participating in the expansion of the Universe, 3C 273 would have to lie about 1000 million light-years distant and its light must consequently have started its journey 1000 million years ago. Moreover, to appear as bright as it does it must be emitting radiation at a rate a hundredfold greater than that of normal galaxies – and yet must possess a volume little more than that of the Solar System on the grounds of its variability on the order of a few months.

So outrageous does this interpretation appear that it sparked the long-running "redshift controversy" over the question whether the enormous displacement of the spectral lines toward the red region of the spectrum could be wholly attributed to the recession velocity. If not, the cosmological distance and egregious energy output could have been exaggerated. Even in their first paper on quasars 3C 273 and 3C 48, Caltech astronomers Jesse Greenstein and Maarten Schmidt considered a gravitational explanation for the redshift – but this line of thinking raised more spectres than it laid.

The spectrum below is the very one with which Schmidt made his momentous discovery. The fuzzy spectrum of the quasar is sandwiched between two sharp-lined comparison spectra of hydrogen, helium and neon used to measure wavelengths in

the target. Red lies to the right. The quasar spectrum consists of a darker upper and a lighter lower band because the source was trailed (in the interests of uniformity) for 30 minutes over one half of the slit and ten minutes over the other half. The darkest line in the quasar spectrum (toward the right) is the H-beta line of hydrogen at its redshifted wavelength 5632 Å instead of its normal wavelength, 4861 Å. For the sake of contrast a photographic negative of the spectrum is displayed here; the dark features are consequently broad, bright emission lines. The presence of some spectroscopically "forbidden" lines suggests that similar low-density conditions to those found in emission-line nebulae must exist in some part of the quasar.

Some 1550 quasars are now known but as the nearest, 3C 273 has been the most extensively studied. Its radiation has now been measured not only in the radio and optical regions but also at infrared, ultraviolet, X-ray and gamma-ray frequencies. The energy distribution turns out to be quite smooth. Although variability is encountered in radio, optical and X-ray regions, there seems to be no straightforward correlation among them. The best current model of 3C 273 posits a central black hole of more than 2500 million solar masses accreting matter from a dense disc of gas at a rate equivalent to 25 Suns per year.

In the Halley Lecture for 1978, cosmologist Martin Rees commented that in a sense quasars were discovered too soon. "In 1963 they did indeed seem qualitatively different from anything hitherto known. The associated energy problems did seem to demand some new physics, and many bizarre ideas were proposed . . . Only later, through the discovery of pulsars and compact X-ray sources, did we recognize the existence of compact objects capable of converting gravitational energy, very efficiently, into non-thermal radiation. These now serve as small-scale prototypes for what might be going on in quasars. Had quasars been discovered in (say) 1973, when these other concepts were already familiar, I would guess that a consensus would have quickly emerged that models involving evolution towards a massive black hole, and subsequent accretion onto it, were an acceptable best buy." Quasars may not yet be fully understood, but neither are they so exotic as to hover hopelessly beyond the reach of contemporary physics.

Date:	29 December 1962
Place:	Palomar Observatory, Pasadena, California
Photographer:	M. Schmidt, California Institute of Technology, Pasadena
Apparatus:	5 m telescope; prime-focus spectrograph at 195 Å per mm
Emulsion:	Kodak IIa-D, prebaked 19 hr at 64°C
Exposure time:	30 min (top half, central strip), 10 min (bottom half)
Source:	Photographer
References:	Schmidt 1963, Greenstein & Schmidt 1964, Rees 1978, Ulrich 1981

Discovered in a Flash

The Carlsbad Caverns provide a spectacular natural habitat to innumerable bats. The dominant species is the Mexican freetail bat (*Tadarida brasiliensis mexicana*). Every night they wheel outward to hunt for food up to 65 kilometres away and return by dawn with their prey. Indeed, the Mexican freetail probably holds the world record for distance covered.

Tadarida brasiliensis mexicana is a relatively small, dark brown or grey bat with long, narrow wings and a wingspan of about 30 cm. Stiff curly hairs extend from its toes. It dwells in caves by preference to buildings over a large swath of the Americas from Brazil in the south to Ohio in the north, and in areas of greater seasonal variation (including New Mexico) it migrates south for winter. Although at times the Carlsbad Caverns house some ten million bats, other caves in Texas and elsewhere harbour even greater populations. The great exodus begins shortly after sunset in a huge cloud emerging from the cave mouth with a sound which bat researchers Roger Barbour and Wayne Davis liken to the "roar of a white-water river". Outgoing and incoming speeds are typically 55 kilometres per hour but *Tadarida* can exceed 90 in mid-flight.

Equipped with strobe lights and a special triggering unit, Harold Edgerton and California scientists P. F. Spangle and J. K. Baker set out to photograph these bats at the cave entrance. A photomultiplier was set up to detect the expected passage of a bat 3 metres away. Signal detection triggered three electronic flash lamps at the focus of a metallic reflector to provide a very bright, brief spotlight. The camera shutter, on the other hand, was not triggered but simply left open until a flash occurred, when it was immediately closed and a new film loaded.

One curious feature of the Mexican freetail bat is its long and apparently useless tail. Other bats have membranes anchored by their tails, and these membranes remain spread even when they come to rest. The Mexican freetail, on the contrary, unfurls its tail membrane only in flight, using hind limbs to extend and retract the membrane. In flight, the "free tail" is no longer in evidence.

The photographs reproduced here reveal the Mexican freetail's behaviour in flight. Clearly the unfurled membrane assists in aerial manoeuvres such as diving and braking. But the photograph opposite indicates another function: the tail acts as a scoop to sweep up insects in mid-air. The bat then clutches the prey against its body until it can land for a meal. Small moths form the greater part of a Mexican freetail bat's diet, but in the photograph on the facing page it is about to seize a mealworm flicked into the air as bait by the photographer.

Bats maintain their body temperature with difficulty. The need to conserve heat accounts for the tendency of bat colonies to hang in dense clusters, generally fluttering about and crawling over each other to generate extra warmth. The area of body exposed is a crucial factor: the larger the surface area, the greater the heat loss. Herein lies the advantage of a retractable tail membrane: it is an asset for soaring through the air without becoming a liability when hanging in the cave.

Date: *circa* 1965
Place: Carlsbad Caverns, New Mexico
Photographer: H. E. Edgerton, Massachusetts Institute of Technology
Apparatus: Camera at f/11, focal length 15 cm, plus FX-33 flash units
Emulsion: Kodachrome
Exposure time: 0.07 msec (flash duration)
Source: Photographer
References: Edgerton *et al.* 1966, Barbour & Davis 1969, Edgerton & Killian 1979

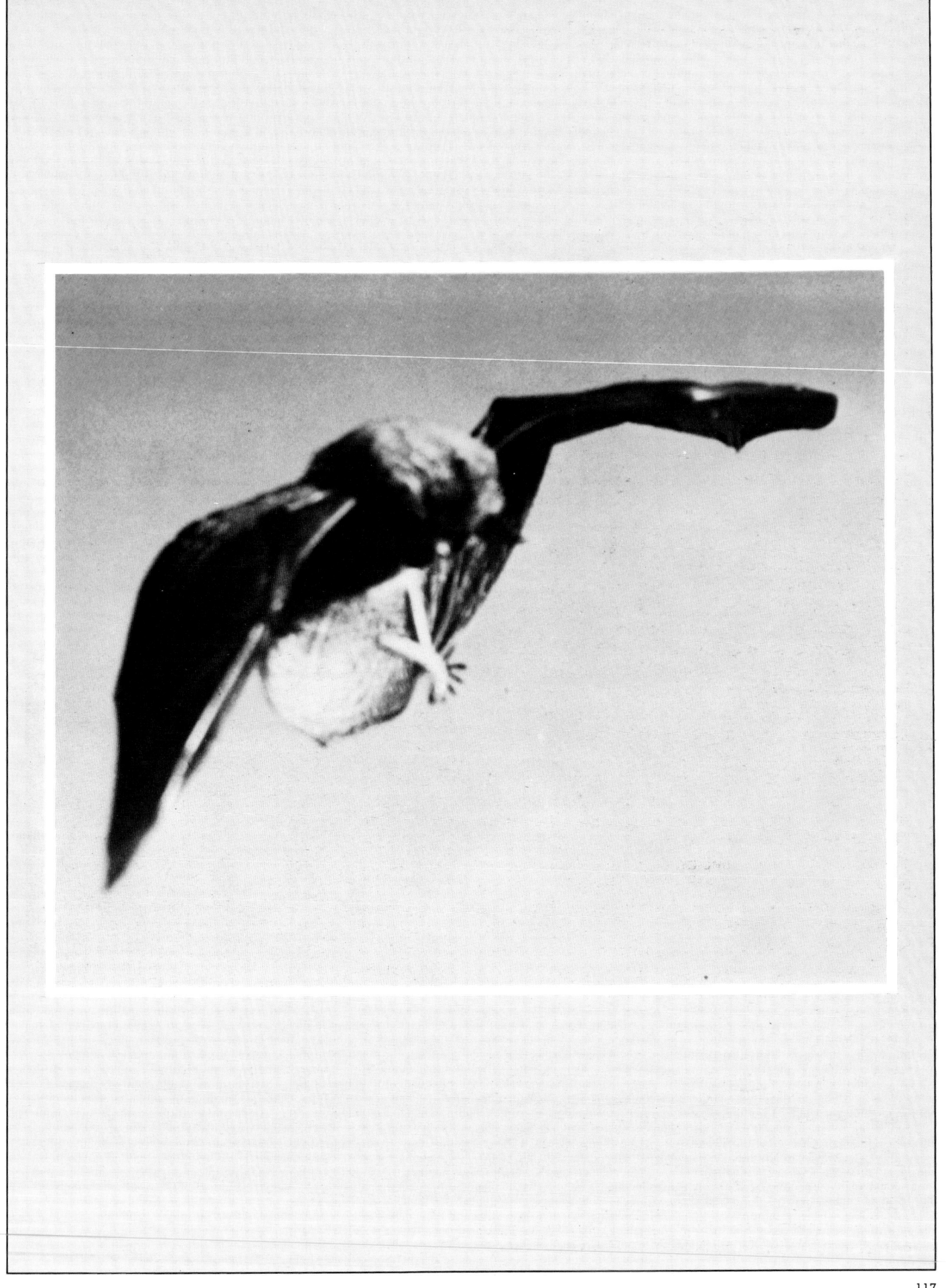

The World's Weather

To provide a synoptic view of the world, its meteorology, its climate, its geomorphology, its sea currents, must be the greatest boon which remote-sensing satellites have provided. Earth-bound scientists have been collecting pieces of a jigsaw puzzle for centuries without ever being rewarded with a display of the complete product. Here is the first global view of the Earth's weather – quite a fine mosaic when one remembers that it shows the handiwork of 1965 technology.

TIROS 9, launched 22 January 1965, recorded this historic image three weeks later. In common with TIROS 3 (pp 112–113) it carried two of the usual wide-angle television cameras instead of the Automatic Picture Transmission system inaugurated by TIROS 8. In shape it still resembles a polygonal hat-box. In most other respects, however, it differed radically from its predecessors. The cameras were

mounted not on the baseplate, but at either end of the hat-box. It sounds as though one camera must be gazing earthward whilst the other points into outer space, but in fact terrestrial coverage was shared between them by inducing rotation on an axis normal to the orbital plane: the satellite effectively rolled along its orbit in what came to be known as a "cartwheel mode". Each camera was triggered in turn when pointing directly downward. The orbit was changed to a more eccentric ellipse so that at apogee TIROS 9 was not 800 but 3000 km distant. For the first time a Sun-synchronous, polar orbit was selected to provide truly global coverage.

The television tubes, a pair of 1.3 cm vidicons with 500 scan lines per frame, could feed their data either to an FM transmitter for relay to a convenient ground station or to a magnetic tape recorder capable of storing up to 32 pictures per orbit.

The cameras' field of view was 107°. Some confusion could arise about the IR in TIROS. Although about half the TIROS missions also carried a scanning infrared radiometer, their television cameras operated in the visible region, not in the infrared.

A full day is depicted by combining the 480 television pictures which TIROS obtained in its 12 polar orbits. Note the two monsoons at right, one just off Ceylon and a better defined one farther south. An oblique jet stream traverses most of North Africa right of centre, while the residue of a storm is gradually dispersing at centre in mid-Atlantic. At least two severe cold fronts appear to be afflicting North America. (Land masses have been artificially outlined to assist in identification.) It is instructive to compare the views of Australia at extreme right and, twenty-four hours later, at extreme left. The eastward movement of a storm

just off the coast in the earlier image has carried it some 800 km into the South Australian Basin.

TIROS 9 was turned off after more than three years' operation though it still rolls lifeless along its designated orbit. Global coverage of the world's weather now occurs on a routine basis, and synoptic images have come to be taken for granted along with the evening news.

Date: 13 February 1965
Place: TIROS 9 in polar orbit
Apparatus: Pair of wide-angle vidicon cameras with f/1.5
 Elgeet lenses; computer reconstruction
Source: National Oceanic and Atmospheric Administration,
 Asheville, North Carolina
References: Cortwright 1968, Allison 1980, Schnapf 1982

Life before Birth

To penetrate the mother's womb and photograph the living embryo in its natural environment once seemed an almost insuperable task. Tiny cameras attached to endoscopes have been probing inside most crevices in the human body for over a century, but the results often proved dismal and hard to interpret. Here, however, Lennart Nilsson obtained for the first time a clear, haunting image of a foetus *in utero* at the age of fifteen weeks (picture opposite).

A Swedish gynaecologist shown this photograph when it first appeared gasped, "This is like the first look at the back side of the Moon!" Certainly the publication in *Life* magazine of Nilsson's photographs documenting the evolution of the embryo from a fertilized egg to an energetic foetus in the amniotic sac caused a sensation. Since then Nilsson has photographically explored the human body with a variety of techniques, reaping a visually spectacular harvest at each stage.

Most of the embryos photographed by Nilsson were surgically removed from their mothers' wombs for a variety of reasons; to obtain a representative image of each stage of development demanded the co-operation of several hospitals, time and sheer luck. The two photographs reproduced here, on the contrary, were taken (albeit some years apart) of *living* foetuses inside the womb with the aid of an ultrawide-angle lens plus miniature flash on the tip of an endoscope.

In the photograph on the facing page the foetus – nearly four months old – has assumed the recognizable shape of a human baby, the organs, skeleton and musculature already forming and the skin beginning to thicken. The eyes are still sealed shut. Only a few weeks earlier the nostrils would have been a pair of forward-pointing holes in the face, but now they point downward in their final configuration. Fine hairs can be distinguished following the whorled ridges of the skin; these are called "lanugo", a soft down which will for the most part be shed before birth. At this stage the size of the foetus from crown to rump is 11 to 13 cm.

The photograph on this page, taken perhaps a decade after the one opposite, documents a baby girl in the amniotic sac six weeks later. By now she will be essaying her first feeble kicks and her sense of hearing will have been activated. Her nails and eyebrows are already growing, and her genitalia are complete save for the hymen. From navel to placenta run the coils of the umbilical cord. The foetus will by this time have increased to 18 or 20 cm from crown to rump, or 25 cm in overall length.

Unlike the majority of scientific photographers, Nilsson remains extremely reluctant to divulge the photographic details of his work. One can only marvel at the remarkable depth of field he is able to obtain with the "special equipment" he has designed with very wide fields of view and very short focal lengths. He frequently resorts to the scanning electron microscope with which he has obtained photomicrographs at very high resolution.

Whether these photographs have really furthered scientific knowledge has occasionally been disputed. But whatever their lasting value to embryology or to obstetrics, their impact on public awareness of human ontogeny cannot be denied.

Date: March 1965 (opposite)
Place: Karolinska Institute, Stockholm
Photographer: L. Nilsson
Apparatus: Endoscope with 110° lens of short focal length plus flash
Source: Barbro Dal, Bonnier Fakta, Stockholm
References: Nilsson *et al.* 1974, Nilsson *et al.* 1977, England 1983

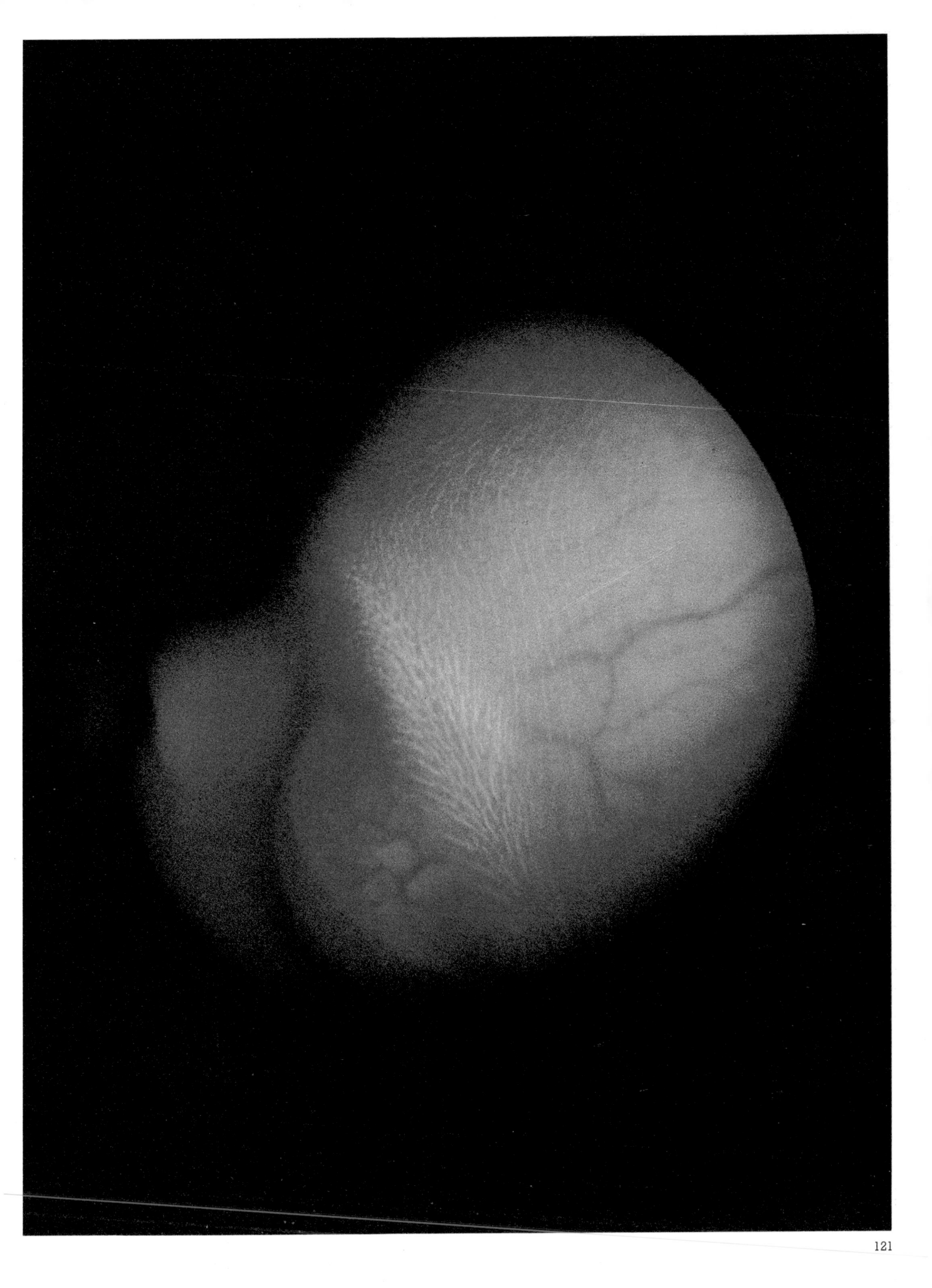

Craters on Mars

The idea of impact craters on Mars once seemed about as likely as cyclones on the Moon. Very few scientists anticipated that the first space probe would be greeted by a crater-pocked surface. Here we see the earliest image among the twenty-two returned by Mariner 4 to show undisputed craters.

Since its companion probe Mariner 3 failed, Mariner 4 became the first of this satellite series to transmit photographs. Whereas previous space probes to the Moon had relayed their images live, those returned by Mariner 4 from Mars were first stored on a tape recorder and later transmitted at the incredibly slow rate of one frame in 10.5 hours. The camera consisted of a Cassegrain telescope with mirrors of polished beryllium, not glass, coupled to an electrostatic vidicon tube claimed in its day to be "the most successful electro-optical transducer for the space invironment and the missile launch requirements". Each image was formed from an array of dots (pixels) 200×200, and each pixel was assigned a value on a brightness scale of 64 levels. Between telescope and vidicon was mounted a rotating shutter bearing two blue-green and two orange-red filters.

The rendezvous with Mars occurred on 15 July 1965 after a journey of 525 million km with one mid-course correction. The first image was taken at 17,000 km; the closest, at 12,000 km. The rapid fly-by viewed only 1% of the surface, and it is not surprising that it generated a rather exaggerated view of Mars as a dead world.

Some scientists hailed Frame 9 (opposite), some Frame 11, as one of the most important scientific photographs ever made – an assessment largely assigned to oblivion by the later crop of images from Mariner 9 and the Viking orbiters. Of Frame 9, Bruce Murray of the Mariner 4 science team has said that it "was the first picture available to the TV Experiment Team that clearly showed a cratered, lunarlike surface, even including a characteristic central peak and some evidences of polygonalization of the craters. Many scientists before that time had considered the surface of Mars to resemble more closely that of the Earth than that of the Moon. Picture no. 9, portending a complete rearrangement of Mars on the family tree of the Solar System, must be regarded as one of the high points of discovery of the space age, if not of the 20th century. Because of the speed with which photographic data can be disseminated, and the universal under-standing of pictures, the entire world truly shared in the excitement of this discovery."

The shock of the Moon-like landscape ought perhaps not to have been so great. Some tentative predictions of impact craters had been independently published by Ralph Baldwin, Ernst Öpik, Clyde Tombaugh and Fred Whipple. The density of craters, however, turned out to be far higher than expected – not because it was overlooked that a planet adjoining the asteroid belt would receive a fair peppering by meteorites of all sizes, but because it was assumed that most traces of this bombardment would have been erased by erosion and tectonic activity. The one man who wholeheartedly believed in a cratered Mars was Dean McLaughlin – but his craters would have owed more to volcanic eruptions than to stray asteroids. Volcanoes, of course, were eventually found on Mars (p 136) but Mariner 4 gave no hint of them. Nor, for that matter, did these first close-up pictures of Mars lend the slightest support to protagonists of its supposed canals.

Indistinct though it may appear, this image has in fact been dramatically enhanced. In its original form it looked like little more than an unevenly fogged plate. After geometric correction, photometric calibration and removal of fiducial marks and blemishes, the picture looked cleaner but no clearer. What transformed the "fogged plate" into an historic scientific photograph was a technique called contrast stretching whereby the darkest of the grey smudges was designated black and the palest white.

The image covers an area of 253 by 225 km on the edge of Mare Sirenum overlapping with a swath of Atlantis toward bottom left (southwest). About 20 craters are visible on this ancient plain, typical of the southern hemisphere of Mars. Just how ancient is still hotly debated, but the estimates range from 1.8 to 3.8 thousand million years – about three quarters the age of the planet.

Date: 15 July 1965
Place: Mariner 4 at 13,000 km from Mars
Apparatus: 3.8 cm Cassegrain telescope, vidicon tube with orange filter; computer enhancement
Exposure time: 0.2 sec
Source: National Aeronautics and Space Administration, Washington, D.C.
References: Anon. 1967, Nicks 1967, Cortwright 1968, Carr 1981

123

The Invisible Rainbow

Somewhere in *King John* Shakespeare averred that to "add another hue unto the rainbow … is wasteful and ridiculous excess". It seemed a safe enough figure of speech at the time, but in fact that is exactly what Robert Greenler succeeded in achieving for the first time in the mid-1960s. The additional colour is actually present in all rainbows but invisible to human eyes.

What is a rainbow in the first place? Aristotle and Seneca got the explanation wrong; Roger Bacon observed that the angle between incident solar rays and reflected rainbow rays is constant; Theodoric of Saxony and Qutb al-Din of Arabia realized that every droplet produces its own bow. But the first successful attempt at a geometric analysis is due to René Descartes, who in 1637 showed that sunlight is refracted by one side of a spherical raindrop, partly reflected at the other side, and refracted again upon re-emerging into the air. The geometry for many parallel incident rays favours re-emergence at a particular angle, 42°, and thus to see the primary bow we must look 42° away from the antisolar direction. The secondary bow, when visible, lies on the arc of a circle 51° from the antisolar point. In 1666 Sir Isaac Newton was able to account for the colours, not just the angles, of the bows: rays of shorter wavelength (toward the blue) are refracted through a larger angle than rays of longer wavelength (toward the red). The primary bow displays an outer red arc running through the colours of the spectrum to an inner violet arc; the secondary bow reverses the order. The full explanation of the rainbow is surprisingly subtle, and only very recently have physicists been able to account for all its characteristics.

Now between the red outer arc of the primary bow and the red inner arc of the secondary bow apparently lies nothing – nothing, that is, except a band of sky perceptibly darker than elsewhere, named for Alexander of Aphrodisias who first described it 1800 years ago. But it occurred to Robert Greenler, Professor of Physics at the University of Wisconsin, that there was no reason to suppose that the bow cuts off sharply at the red arc just because our visual sensitivity approaches its long-wave limit. The Sun emits infrared rays and neither the atmosphere nor water absorbs all of them; so with the right apparatus an infrared bow ought to be observable. (Atmospheric absorption militates against ultraviolet bows.)

Infrared film may seem the obvious answer, but it alone will not suffice because it is sensitive to both infrared and visible (even blue) light. To circumvent this difficulty, Greenler neatly isolated a band of infrared by combining film and filter with overlapping sensitivity curves. (The long-wave tail of the former overlapped the short-wave tail of the latter to create a bandpass centred at 8650 Å.) This stratagem paid dividends at once and in September 1966 Greenler succeeded in photographing the infrared rainbow opposite in the spray from a perforated garden hose supported on top of the ladder at bottom right. Primary and secondary bows are clearly discernible, and if they are not in "colour" it is only that unlike certain species of snake human beings cannot see into the infrared.

Four years later Greenler recorded the first *natural* infrared rainbow (below). "When the film was developed," he writes, "I saw for the first time an infrared rainbow that had hung in the sky, undetected, since before the presence of people on this planet." The double bow arcs down into the trees, their leaves salient in the infrared, and below the primary bow can be seen at least two supernumerary arcs, an interference phenomenon very occasionally seen beyond the violet arc of visible rainbows. The traditional seven colours of the rainbow have conscripted a new member, albeit one incomprehensible to the human retina.

Date:	September 1966 (opposite); summer 1970 (above)
Place:	Milwaukee, Wisconsin
Photographer:	R. G. Greenler
Apparatus:	Kodak 87C infrared filter; 35 mm camera at f/2 (opposite), f/2.8 (above)
Emulsion:	Eastman Kodak IR 135 film
Exposure time:	0.04 sec (opposite); 0.1 sec (above)
Source:	Photographer
References:	Greenler 1971, Nussenzweig 1977, Greenler 1980

Infrared Premonition

Medical diagnosis depends both on visible symptoms and on those unseen but accessible with the right detector. Breast cancer was perhaps the first clinical condition to benefit greatly from thermography, with cerebrovascular disease – illustrated here – soon to follow. A thermograph measures the far infrared heat radiation emitted by a body and images different temperatures by monochrome or colour contrasts. Here is one of the earliest false-colour thermograms to reveal an alarming asymmetry in the heat radiation emitted by the cerebral hemispheres – alarming because it forecasts a probable stroke in the subject.

Infrared radiation was discovered by means of a temperature probe, not a photographic plate; yet the entire history of the subject leans heavily on photography. Infrared photography is sometimes distinguished from thermography in that the former relies on the behaviour of radiation reflected or scattered at infrared wavelengths (pp 124–125, for example) whereas the latter records radiation emitted by the subject. For the purposes of thermography, the photographer may choose to take his picture in total darkness.

Medical practitioners have for centuries taken cognizance of the significance not only of higher or lower body temperatures but of the distribution of temperature anomalies over the skin. The back of a doctor's hand makes a poor sensor, however, whilst thermocouples and even radiometers proved of limited utility. What doctors have always needed is a remote scanner to provide two-dimensional maps of the heat distribution.

It is quite likely that potential military applications of thermography spurred the development of infrared scanners, and by the mid-1940s their resolution was sufficient to detect heat patterns over the human body. Another decade passed before they could be harnessed for diagnostic purposes, early detection of breast cancer being the first clinical application. Since then thermograms have increased in scan speed, improved their temperature and spatial resolution and incorporated false-colour coding to facilitate interpretation. (The eye is more sensitive to differences in colour than to shades of grey.)

In its most primitive form the thermograph (the T-1 model) required 45 minutes to complete an exposure but by the mid-1960s the time had been cut to 4 minutes (on the M1-A). The spectral range covers 2 to 16 microns, which for "black bodies" – perfect emitters and absorbers of radiation – corresponds to temperatures of maximum emission 200 to 1500 K. The human body does behave virtually as a black body: a perfect emitter has an emissivity of 1.00 and human skin comes very close at 0.99. So normal body temperature – 310 K or 37°C – falls within range.

The photographer or rather thermographer of the head opposite, R. Bowling Barnes, died in 1981; but his son described this widely used example of diagnostic thermography as follows. "[This] colour image of a man's face [shows] the tell-tale lack of thermal symmetry at and above the eyes which indicates arterial blockage and a high risk of stroke in the subject. The dark arch [above] this individual's right eyebrow is now recognized as a clear warning sign. A sinister capability, we discovered very soon about the thermograph, is its ability to reveal this 'mark' on the face of the unsuspecting victims of arterial disease. I recall many unhappy moments when a casual 'snapshot' taken of a visitor or friend showed what our eyes could never have seen about the individual's future." Each gradation in colour from indigo (nearly black) to red signifies a temperature rise of 0.25 C°.

Skin temperatures are largely determined by local blood flow, and it is for this reason that thermography proves so useful in diagnosing a wide variety of vascular disorders. Most strokes are caused by a reduction in blood supply to the brain through the carotid artery, and at the time this image was taken E. H. Wood at the University of North Carolina showed that a 50% blockage should be thermographically detectable. Strokes tend to occur only when a 75% blockage has developed; so a timely thermogram can be a life-saving exercise.

Date: *circa* 1967
Place: Stamford, Connecticut
Photographer: R. B. Barnes, Barnes Engineering Company, Stamford
Apparatus: M1-A thermograph (scanning radiometer); false-colour reconstruction
Emulsion: Polaroid film
Exposure time: 4 min (scan time)
Source: R. B. Barnes, Jr.
References: Wood 1965, Barnes 1968, Uematsu 1976

The First Optical Pulsar

Pulsars were first recognized at radio frequencies when Jocelyn Bell Burnell noticed "a bit of scruff" which cropped up on observations made at Cambridge in 1967. The scruff turned out to be an astonishingly regular signal of celestial origin. After "little green men" and other straw-clutching explanations had been eliminated, it was realized that the source must be a rotating neutron star. Only two years later the first *optical* signals were detected from what was long to be the pulsar of shortest period: NP 0532 in the Crab Nebula.

It is no accident that the Crab Nebula happens to be the remnant of a supernova explosion, indeed one of historic significance. The filamentary nebulosity which we see today is the residue of a star which exploded in 1054 AD in the constellation Taurus where it was noticed by Chinese and Japanese astronomers. That star is NP 0532, a very compact object in which a mass equivalent to the entire Sun is compressed into a sphere perhaps 20 km in diameter. This extremely high density is characteristic of neutron stars, the rapidly rotating cores of degenerate matter created by catastrophic expulsion of the surface layers of those supernovae initially no greater than 1.7 solar masses. (Too high a mass will inevitably lead to a black hole; too low, probably to a white dwarf.)

Optical pulsations were sought in May 1968 in the first pulsar to be discovered, CP 1919, but to no avail. The Crab pulsar was not discovered until 18 November 1968 (at radio frequencies), and it was recorded photometrically on 24 November – but by a sad irony the Cambridge photometrist, unaware of the discovery, did not analyze his data until much later. So the palm for discovery of the *optical* pulsations went to the team of W. J. Cocke, M. J. Disney and D. J. Taylor at the Steward Observatory in Arizona. The discovery occurred on 16 January 1969 in "real time" as the trio gazed at a computer-linked cathode-ray tube and inadvertently recorded their excitement in unbridled expletives on a recorder accidentally left running. The signal consisted of a main pulse 4 msec long plus a smaller intermediate pulse, the whole train repeating 30 times a second. Only three weeks later their paper appeared in *Nature* with the comment, "The source of the pulsations should be apparent as a point image on a high-resolution photograph of the Crab Nebula."

The first astronomers to take up the photographic challenge were Joseph C. Miller and E. Joseph Wampler of Lick Observatory. They devised a stroboscopic apparatus: a rotating shutter placed between the 3 m telescope and a television camera consisting of an image intensifier coupled to an SEC vidicon tube. The shutter (p 17) was a disc with six slots rotating about 10 times a second so that the same phase of the pulsar would be recorded through each slot. The faint chopped signal could then be integrated for 10 seconds to record separately the signal at maximum (top, opposite) and minimum (bottom). The field of view across each frame spans about one minute of arc. In terms of light emission, maximum must be at least fifty times minimum and in all probability considerably more.

The television frames recorded by Miller and Wampler achieved two important results: they pinpointed the identity of the optical pulsar and they confirmed photographically the optical variations previously observed photometrically. All normal exposures must present some sort of average brightness between the "on" and "off" images shown here.

As a mechanism for pulsing behaviour, most astronomers have adopted the "searchlight" or "lighthouse" model. Early observations of the Crab pulsar revealed its light to be circularly polarized and thus testified to the presence of a magnetic field. The field lines would be wrapped about the star by its rapid rotation, and the only escape route for charged particles would lie through the magnetic poles. Now if the rotation axis of the star does not coincide with the magnetic polar axis – as indeed it does not in the case of the Earth, by about 15° – then we can see how rotation could sweep the beam-emitting pole into and out of our line of sight like a searchlight. Without committing ourselves to an emission mechanism for the light, we can nevertheless understand how the geometry could generate flashes. If the light beam is quite narrow, this model would neatly account for the paucity of optical pulsars: only those whose magnetic axis coincides however briefly with our line of sight would be visible.

NP 0532 is no longer the fastest celestial rotator, having been displaced by PSR 1937 + 214 and PSR 1953 + 29 with pulse periods twenty and five times shorter respectively. But of the 330 pulsars discovered to date the Crab pulsar remains the youngest and moreover the only one known to blink at radio, optical, X-ray and gamma-ray frequencies.

Date: 3 February 1969
Place: Lick Observatory, Santa Cruz, California
Photographers: J. S. Miller & E. J. Wampler
Apparatus: 3.1 m telescope, rotating shutter; Westinghouse SEC camera plus image intensifier with S-25 photocathode
Exposure time: 10 sec (integration time)
Source: Lick Observatory
References: *Cocke et al.* 1969, Miller & Wampler 1969, Ostriker 1971, Smith 1977

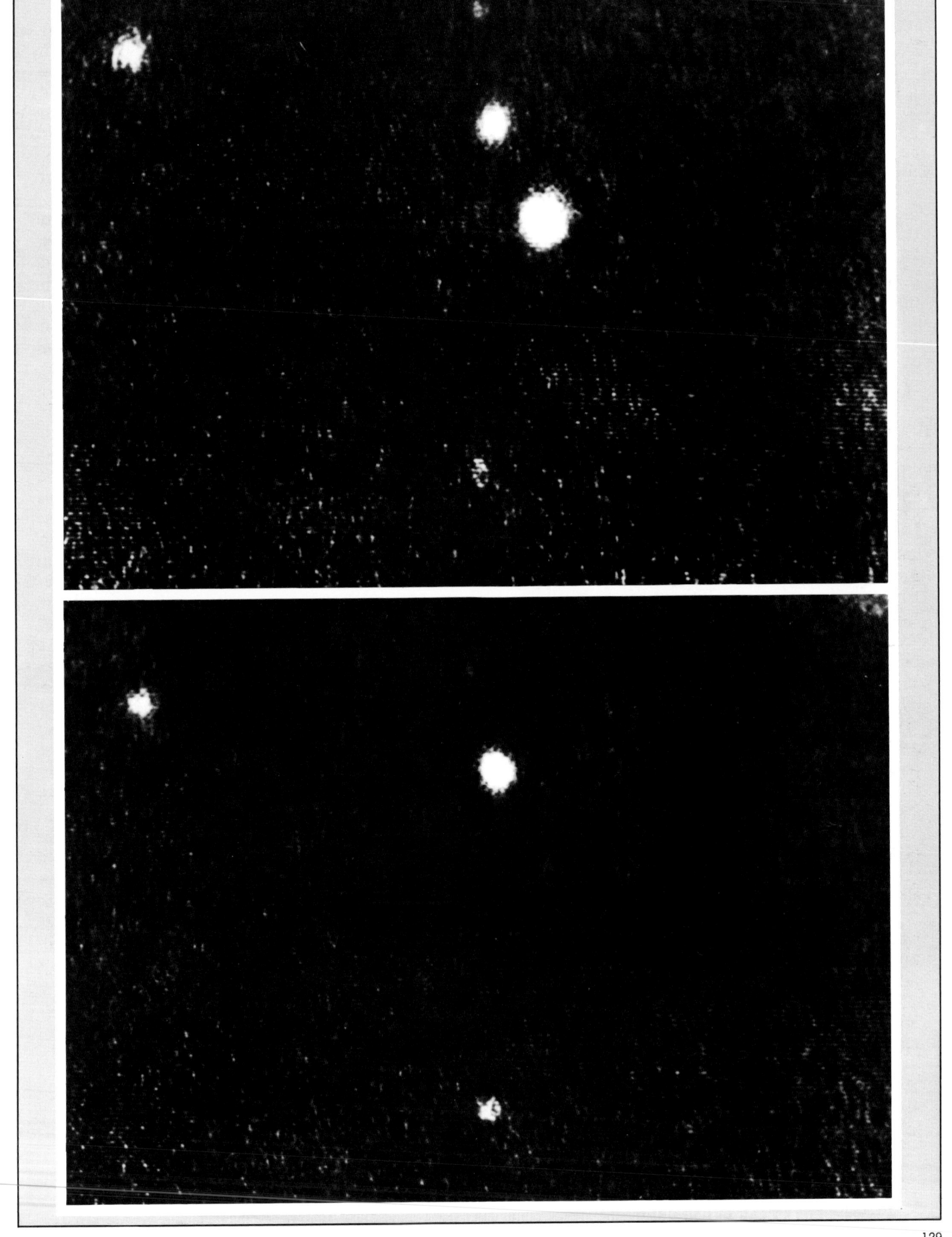

The Finding of Lost City

"Goe, and catch a falling starre," urged John Donne and many a poet and songwriter since. American meteoriticists took him literally and, armed with photographs from an automatic meteor patrol network, homed in on Lost City, Oklahoma. The stony meteorite on this page is the very same that produced the spectacular fireball opposite. It marks the first time that photography successfully pinpointed the landing site of a chunk of rock from space.

The photograph was no coincidence. The fireball was recorded on a winter's night in 1970 by four cameras in the Prairie Network, a set of sixteen stations set up in the broad, flat prairieland of the American mid-west (Illinois, Iowa, Kansas, Missouri, Nebraska, Oklahoma and South Dakota). Operated by the Smithsonian Astrophysical Observatory from 1963 to 1975 with a subsidy from NASA, the Prairie Network logged over 2700 meteors (excluding bright meteor showers) from at least two stations. (Triangulation works best with three stations or more, but photographs from only one station are practically worthless.) In thirteen years of scanning the sky nightly, however, the Lost City meteorite proved to be the single photographic recovery.

Each station functioned automatically, with a twilight photometer to start the four aerial cameras, one directed to each cardinal point. Save for a blind spot at the zenith, the whole sky was covered at every station by the f/6.3 Planigon lenses, each with an 85-degree field of view. A cloud detector ensured that only sufficiently clear skies were recorded. Plate-glass windows in the roof of the tiny huts, 2 metres square, protected the optics in case of rain, but there were no sliding shutters whose mechanism could jam. The unmanned stations ran without supervision until it came time to reload the film magazines. The rolls of film were 22 cm wide and 120 m long!

The spectacular fireball shown here, brighter than full Moon and accompanied by a sonic boom, occurred over northeastern Oklahoma and registered on the films of two Oklahoma stations and two in Kansas. The dashed trajectory results from a chopping camera shutter which allows the meteor's velocity and rate of deceleration to be determined. In the background can be seen trails produced in the fixed camera by stars in the constellations Canis Major, Orion and Taurus, photographed over several hours. The meteor looked a good candidate for a surviving meteorite because of its low initial velocity (14.2 km per sec; it can be as much as five times faster), its very low terminal velocity (3.5 km per sec) and terminal height (19.5 km), and its relatively long duration (9 sec).

Now it is well established that successfully recovered meteorites are often associated with brilliant fireballs, so it might be thought that the converse holds too. Sadly, it does not. Before the Prairie Network project, it was believed that faint meteors are generated by low-density objects of cometary origin which burn up completely in transit whereas bright meteors (fireballs) are caused by more massive objects with a correspondingly greater chance of survival to produce a meteorite fall. But the Prairie Network soon began to turn up a horde of fireballs consumed in mid-air, and Richard McCrosky and other Smithsonian scientists were forced to conclude that the majority of all meteors, fireballs included, originate in friable cometary débris.

Several factors conspire to determine the point of impact. Aside from the triangulated position and velocity inferred from the trajectory, the meteorite hunter needs to take account of the body's density and shape (to calculate the aerodynamic drag coefficient), the air density and local winds. A radiosonde flown over Oklahoma City provided the latter, but in the absence of first-hand information one could only assume that the body itself was spherical and of normal meteoric density (3.4 gm per cc). The predicted fall lay a few kilometres east of Lost City, Oklahoma.

The recovery itself has elements of the fantastic. Prairie Network manager Gunther Schwartz heard about the fireball on the evening news, arranged for the film to be collected and processed at once, set in motion a pre-planned aerial sweep to obtain micrometeoritic particles in the atmosphere, and the following morning began the drive of 700 km

from his home town in Lincoln, Nebraska to Lost City. Icy conditions and heavy snow prevented him from reaching his destination until four days later. By this time the meteorite could well be hidden by fresh snow. Yet as he drove eastward from Lost City, Schwartz abruptly spotted a black rock lying in the road, only 600 metres from the predicted site. Its fusion crust confirmed that it was indeed a chunk of meteorite. Three more fragments were later recovered – 17 kg in all.

The Lost City meteorite, pictured left, is a bronzite chondrite dated by chemical and radiogenic means at 4800 to 5500 million years old. It is the second meteorite whose orbit prior to terrestrial encounter can be calculated from photographic observations. The orbit has low inclination and an eccentricity small enough to keep aphelion (greatest distance from the Sun) inside the orbit of Jupiter. We must not jump to the conclusion that it originated in the asteroid belt, however, since both Jupiter and the Earth may have severely modified its primaeval orbit.

Date:	3 January 1970
Place:	Hominy, Oklahoma
Apparatus:	T-11 camera at f/6.3
Emulsion:	Eastman Kodak Tri-X (panchromatic)
Exposure time:	3 hr (trajectory 9 sec)
Source:	C.-Y. Shao, Smithsonian Astrophysical Observatory
References:	McCrosky 1970, McCrosky et al.1971, McCrosky et al. 1976–77

Spying on the Gene

It is one thing to work out in principle how DNA (pp 94–95) transmits genetic information, quite another to photograph the act of transmission. For the first time this electron micrograph revealed genes in action: central fibres of DNA spinning out thin fibrils of RNA in a delicate tracery. The function of this particular type of gene, taken from cells of a spotted newt, is to manufacture ribosomes which in turn synthesize proteins out of amino acids.

The genetic code dictates how DNA is transcribed into RNA and how RNA is translated into protein. In a eukaryotic cell (one with a well defined nucleus) like the female reproductive cell, or oöcyte, of a common spotted newt, transcription takes place inside the nucleus and translation in the cell body outside. Three kinds of RNA are synthesized – messenger RNA, transfer RNA and ribosomal RNA (seen opposite). If the cell is viewed as a protein factory, DNA passes on instructions for making the RNA tools which ribosomes utilize in the manufacture of protein from amino acids. For a shop-floor view of the protein factory – "the first time that active genes of known function were visualized" – we must thank Oscar Miller and Barbara Beatty, then working at Oak Ridge National Laboratory.

To a large extent it is a breakthrough in technique which enabled Miller and Beatty to record the genes in an oöcyte nucleus in action. The oöcyte is happily a large cell, up to 2 mm across, so that its nucleus is readily isolated with jeweller's forceps. Immersed in distilled water, the granular outer layers soon disperse and the fibrous core begins to unwind. The unravelled cores are fixed in formalin and centrifuged onto a carbon film over an electron microscope grid. But the crux of the exercise is to spread the cores evenly over the film prior to microscopy, without degrading the delicate patterns. After much experimentation Miller and Beatty hit upon the ideal solution: use a carbon surface made hydrophilic (where water spreads easily) by electric discharge, add a few drops of "Kodak Photo-Flo" to reduce surface tension (which generates distortion in the course of drying) and stain electrostatically with a solution of phosphotungstic acid.

The spectacular electron micrograph which resulted appears on the facing page. (It may well be familiar from the covers of *Science* and *New Scientist*.) Miller suspected, and enzyme tests confirmed, that the stems of these fern-like shapes consist of DNA plus protein, the fibrils of RNA plus protein. The gene as such assumes no obvious geometric pattern; it is simply the DNA content of each fern, or properly speaking "matrix unit". Homing in on the transcription site, we see on closer scrutiny that the axial fibre of the "stem" is composed not of solid lines but of a sequence of granules. These are molecules of RNA polymerase, the enzyme which catalyzes transcription of DNA. By means of cells radioactively labelled as tracers, it was shown that transcription into RNA, or more accurately a molecular precursor of ribosomal RNA, occurs only in the matrix units. Successive stages of RNA synthesis can be traced from narrow tip to broad base of each matrix unit, longer fibrils being further advanced on the road to ribosomal RNA. The axis of each "fern" is 300 Å or less in diameter and its length 2.4 microns on average. (The micrograph opposite is about 8 microns wide.)

As Miller was to write later, "Many of our pictures bear an almost uncanny resemblance to diagrams of transcription and translation that have been published over the years." What promoted his success where others had been frustrated? Aside from the experimental technique outlined above, the choice of oöcyte nuclei was providential on account of their large size, the unusually high number of free nucleoli known to be sites for the genesis of ribosomal RNA and the fact that their growth is accompanied by a deluge of RNA synthesis. Each matrix unit, each gene, carries perhaps a hundred RNA polymerase molecules simultaneously transcribing the precursor molecules of ribosomal RNA. The wittiest description of Miller's remarkable micrographs was provided by Robert Perry: they show genes caught *in flagrante transcripto*.

Date: 11 March 1969
Place: Oak Ridge National Laboratory, Tennessee
Photographers: O. L. Miller, Jr. & B. R. Beatty
Apparatus: Siemens Elmiskop I electron microscope at 60 kv
Emulsion: Kodak Projection Slide glass plate
Source: O. L. Miller, Jr., University of Virginia
References: Miller & Beatty 1969, Miller *et al.* 1970, Miller 1973, Miller 1981

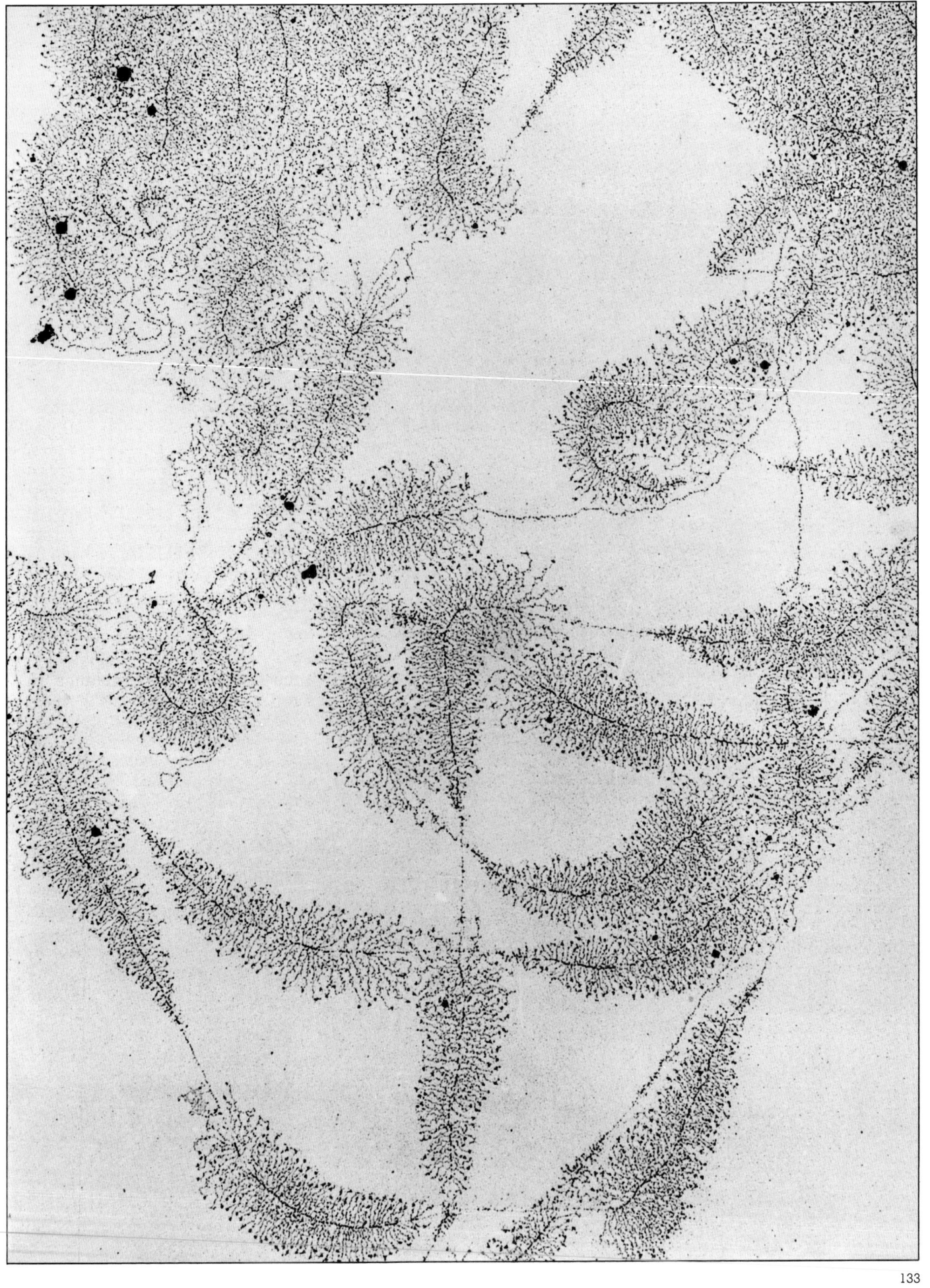

Forces United in Neutral Currents

These photographs of particle tracks in a bubble chamber record a crucial experimental result which should prove a landmark on the road to the "grand unification" which physicists since James Clerk Maxwell have sought in vain. By unification they mean the drafting of a theory which establishes the underlying common ground between the forces of nature, a theory which reduces two independent forces to two manifestations of a single force. By *grand* unification they mean the theory which, one day, will link together coherently all four known forces – in order of decreasing strength the strong nuclear force, electromagnetism, the weak nuclear force, and gravity.

Whereas the strong nuclear force binds the nucleus together, the weak nuclear force governs such processes as the beta decay of a radioactive nucleus. Our modern picture of forces requires that they operate through the exchange of mediating particles, quanta of radiation. The heavier the particle, the shorter its range of influence and the higher the energy of the particle accelerator required to reveal its existence. Photons of zero rest mass mediate the electromagnetic force. Mesons, from the pion at 275 electron masses up to much heavier particles, mediate the strong nuclear force over a range the size of an atom. Other mesons just discovered at CERN (1983) – intermediate vector bosons at 80–90 proton masses, or some 150,000 electron masses – mediate the weak nuclear force over a range a thousand times smaller.

In the teeth of opposition from established physicists, Abdus Salam with John Ward and Shelley Glashow independently broached the idea in 1956–58 that three particles should mediate the weak force, two electrically charged bosons W^+ and W^- and an electrically neutral "heavy photon" Z^0. At sufficiently high energies (above 100 GeV), the distinction between electromagnetic and weak interactions disappears and the "electroweak" force operates as a single unified force. The theory was modified and improved, assuming its virtually final form in 1965 at the hands of Salam and Ward and of Stephen Weinberg independently.

The first observational tests stemmed from a prediction made by their unified electroweak theory. Although the reaction probability is extremely small, it should be possible to observe neutrinos scattering off nucleons (protons or neutrons) or off electrons through the invisible mediation of the heavy Z^0 particle. By analogy with the charged-current interaction which takes place in radioactive beta decay (for example) involving *charged* bosons, these reactions involving exchange of the *neutral* boson are called neutral-current interactions or simply neutral currents. Weak interactions requiring exchange of charged mediators had been known for well over half a century albeit without being described as such; weak interactions calling for neutral mediators had never been remotely suggested by nuclear experiments. If verified, neutral currents would become the first new type of interaction discovered since the earliest days of nuclear physics.

The exciting discovery of neutral currents was achieved at CERN by introducing a beam of neutrinos into the giant bubble chamber Gargamelle, where interactions yield charged particles whose tracks become visible as bubbles in the superheated heavy liquid – in these experiments freon (CF_3Br). The pressure in the chamber is abruptly released; the liquid starts to boil, the first bubbles appearing along particle tracks; a phalanx of flash tubes illuminate the chamber to serve eight cameras variously positioned; then the freon is recompressed in anticipation of the next exposure.

Two candidates for the discovery photograph are reproduced here. The one below, showing the elastic scattering of an antineutrino on an electron without transfer of charge, takes priority in publication. (Neutrinos or their antiparticles serve equally well in seeking the desired reaction.) After scanning 375,000 photographs, the research team landed only this one electron event. Here the (anti)neutrino arriving from the left side remains invisible since uncharged, but reveals its presence by knocking out an electron which carries on in nearly the same direction as the neutrino beam. The curvature of the track in the applied magnetic field and the characteristic spiral clearly identify the particle as an electron. That this photograph

reveals neutral currents was definitely confirmed in a paper published three years later.

The photograph above was taken about the same time as the one at left and it prompted what is often cited as the discovery paper. This time the neutrino beam (again directed to right) strikes a neutron, yielding a negative pion track above – which further interacts to produce gamma rays – and a proton track below (long arc decelerated in the heavy liquid). Absence of a secondary electron or muon stamps the reaction as the work of neutral currents.

Date:	October 1971
Place:	CERN, Geneva
Photographers:	Aachen – Brussels – CERN – Paris – Milan – Orsay – UC London Collaboration
Apparatus:	Gargamelle bubble chamber fed by Proton Synchrotron, illuminated by 21 flash tubes (100 J)
Emulsion:	Kodak Plus X film
Exposure time:	1 ms (flash duration)
Source:	P. Musset, CERN, Geneva (above); D. H. Davis, University College London (opposite)
References:	Hasert *et al.* 1973a, Hasert *et al.* 1973b, Sciulli 1979, Mulvey 1981

Scaling Mount Olympus

Mariner 4 surprised planetologists with its revelation in 1965 that Mars possessed a crater-scarred surface (pp 122–123). Four years later, Mariners 6 and 7 confirmed that the craters were ancient impacts and found some other types of terrain. When Mariner 9 was successfully placed into orbit around Mars on 14 November 1971, its cameras were intended to map the dead world just as soon as the planet-wide dust storm with which its arrival coincided had cleared.

But Mars was not so dead as first painted. The dust storm, which had been brewing up since 22 September 1971 when Mariner had already travelled two thirds of its journey, uniformly obscured the face of Mars on the earliest pre-orbital calibration images. As the dust began to settle, however, four dark spots emerged – evidently surface features whose elevation allowed them to poke their head above the sinking cloud level. The pre-planned observation sequence was reprogrammed for closer inspection of the dark smudges, and within a week of Mariner's arrival they were dimly perceived as the rims of craters so far above ground level as to contradict the notion of primaeval meteorite craters. The photograph which clinched the volcanic hypothesis and thereby resurrected Mars from the company of such inert bodies as the Moon and Mercury was taken on 27 November and is reproduced opposite at top.

This image provides an oblique view of the feature first mapped as Nix Olympica ("Snows of Olympus") by Giovanni Schiaparelli in 1877. Despite the gravelly texture of the early image processing and the continued presence of unsettled dust, Nix Olympica could be nothing other than a volcanic caldera. Harold Masursky, leader of the team working on Mariner 9 television science, has been quoted as saying, "We were driven to the conclusion that these four features [Nix Olympica and the adjacent trio of craters Ascraeus Mons, Pavonis Mons and Arsia Mons] were big volcanoes – and that turned out to be the great switchover point in our thinking about Mars." Volcanoes signify geological activity, and it was not long before supporting evidence – most memorably the fault valleys of Phoenicis Lacus – began to accumulate.

On earlier Mariner imagery, Nix Olympica had featured as no more than a bright ring. But as the dust shroud lifted, a huge mountain properly deserving the name Mount Olympus was revealed, and it was duly rechristened Olympus Mons. Towering at a peak of 26.4 km above "sea level", thrice the height of Mount Everest, it has a caldera (top image) 90 km across and a base spanning about 600 km, thrice the width of the largest terrestrial

volcano Mauna Loa. Indeed, no other contenders have yet toppled Olympus Mons from its position as the largest known volcano in the Solar System.

Our best picture of Olympus Mons has been assembled from images taken by the two Viking orbiters, launched four years after Mariner 9. On the mosaic opposite below (north at top) the gargantuan structure can be fully appreciated. The caldera appears as a dark spot, slightly off-centre. Around it the radial ridges of once-molten lava define the volcano's flanks, terminating abruptly in a black-limned escarpment. Beyond this precipitous perimeter stretches a still larger aureole which one author has likened to rough elephant hide. The total area covered by Olympus Mons and its encircling textured annulus amounts to some three million square kilometres, virtually the size of India.

The steep escarpment presents something of a puzzle. In places it rises sheerly 10 km above the broad plateau on which the volcano sits; elsewhere it forms a complex of ridges, flows and faults. What sustains it – or what depressed the surrounding plateau? Either a truly olympian tectonic process is involved or else landslides or other erosive processes must be invoked. To support the sheer mass of a giant like Olympus Mons, the crust of Mars must be considerably thicker than the Earth's. Michael H. Carr has suggested that the crust may reach 300 km in parts, in contrast to the terrestrial subcontinental maximum of 100 km, but argues that the crust under Olympus Mons should be closer to half that value. Not only does Mars have a thicker crust than the Earth; it shows no signs of the plate tectonics which govern the creation of so many of our volcanic mountains.

The nature of the outlying aureole is no less enigmatic. Ancient ash flows furrowed by wind erosion, wrinkling of the crust under stress, subterranean ice deposits and a fossil volcanic shield have all been conjectured to account for it. Olympus Mons has been well photographed but is far from being well understood.

Date:	27 November 1971 (above); 1976–80 (below)
Place:	Mariner 9 at 9250 km over Mars (above); Vikings 1 and 2 (below)
Apparatus:	High-resolution TV cameras, field $1°.1 \times 1°.4$ (above) and $1°.5 \times 1°.7$ (below); computer enhancement
Source:	Jet Propulsion Laboratory, Pasadena, California (above); H. Masursky, U.S. Geological Survey, Flagstaff, Arizona (below)
References:	Quam et al. 1973, Hartmann & Raper 1974, Carr 1981, Beatty 1982

Rivers on a Dry Planet

The long-standing question of water on Mars has taken many twists and turns. With no better justification than in the case of lunar "maria", 19th-century astronomers begged the question by naming features *fons* (fountain), *fretum* (strait), *lacus* (lake), *mare* (sea), *palus* (swamp) and *sinus* (bay). The misrepresentation was exacerbated by Giovanni Schiaparelli and Percival Lowell, whose claimed sightings of *canali* (channels or canals) were construed as evidence of an artificial irrigation system. Spectroscopically, however, water remained elusive until 1963 when it was weakly detected by Hyron Spinrad and co-workers. Mariner 4 (p 122) apparently quashed any lingering myths about water beyond trace amounts.

Mariner 9 re-opened the whole issue with a vengeance. "Of the many spectacular achievements of the Mariner 9 mission, none was more surprising than the discovery of channels on the martian surface," wrote geologist Michael Carr. It turns out that sinuous channels forcibly suggestive of water flow abound on Mars, Nirgal Vallis (opposite) being the first one seen. But where is the liquid water which presumably must once have filled the channels? In its liquid state, water has no right to exist at the low pressures and temperatures which obtain on Mars. A pail of water deposited by a visiting astronaut would freeze at night or evaporate on a midsummer day. It is estimated that the atmosphere contains a total of 1.3 cubic kilometres of water, sufficient to provide the odd cloud of condensed vapour but hardly enough to cover all the river-beds meandering over the surface. As William Hartmann and Odell Raper put it, "It seems to require a miracle to get large volumes of water on the surface of Mars and it seems to require another miracle to keep the water there long enough to erode a river channel."

To escape from the dilemma, other agents were postulated to produce the channels – such as lava or liquid carbon dioxide – but to no avail. All the evidence pointed to water-cut channels like terrestrial gullies or arroyos, not to lava channels like lunar rilles. As for liquid carbon dioxide, the atmospheric pressure would have to be five times greater. The only solution lies in accepting that water did once flow freely on the martian surface and explaining why it is no longer there.

The palaeoclimatology of Mars has been the subject of considerable speculation, some of it wild, much of it contradictory. William R. Ward calculated that the Sun and other planets induce huge variations in the obliquity of Mars' equator to its orbit. Whereas in the Earth's case this obliquity scarcely changes from 23.4 degrees even though the pole precesses like a spinning top with a period of 26,000 years, the martian obliquity of 25.1 degrees oscillates with the polar precession period of 175,000 years, reaching a maximum of plus or minus 10 degrees every 1.2 million years. The 175,000-year period is in turn modulated by the rotation of the line joining aphelion and perihelion, the line of apsides, to produce a net period of climatic variation every 51,000 years.

The significance of all these oscillations is that at times the poles receive more solar heat, at times less – at maximum obliquity one third more insolation and at minimum one third less than they do now. The poles, an amalgam of dry ice (CO_2) and water ice (H_2O) interlarded with dust, release their pent-up water at times of higher obliquity. The entire planet must undergo a change in climate on the three timescales given above, possibly to the point of blanketing the atmosphere with clouds and initiating a hot greenhouse effect as on Venus. Other speculative scenarios differ: a face of unbroken white cloud might reflect so much sunlight that the net result would be global cooling rather than heating. Variation in the energy output of the Sun itself is yet another possibility, but one which would also have to be reconciled with our own geological record.

Nirgal Vallis seen here snakes through Mare Erythraeum for 400 of its 800 km length, ranging from 1.8 to 4.0 km in width. It is a runoff channel of intermediate size. *Broad* channels probably originate in permafrost abruptly melted by local volcanic heating; *narrow* dendritic channels are attributable to sporadic rainfall. *Intermediate* runoff channels, on the other hand, have too wide a distribution to support the notion of local heating and run too deep to have come from rainwater. Sapping of groundwater from aquifers or permafrost is the probable source. Tributaries of such channels typically end in box canyons, quite unlike the dendritic runoff channels. "An episode of climatic warming is a more likely cause for their formation," conclude Harold Masursky and his colleagues at the U.S. Geological Survey.

Date: 19 January 1972
Place: Mariner 9 at 1666 km over Mars
Apparatus: Low-resolution TV camera ($11° \times 14°$) with Zeiss f/2.35 lens; computer enhancement
Source: Jet Propulsion Laboratory, Pasadena, California; NASA
References: Hartmann & Raper 1974, Sharp & Malin 1975, Gornitz 1979, Carr 1981

Ghost Craters from Orbit

Some meteorite craters stand out from the terrestrial landscape, like the Barringer Crater in Arizona. Others, reduced with time to mere fossils by the forces of erosion, may be all but invisible to groundlings yet emerge with great clarity from an aerial perspective. These ghost impressions of large, ancient meteoritic impacts are called astroblemes. Here is a remarkable instance of a potential astrobleme discovered on Landsat imagery and by a happy chance confirmed almost simultaneously by field work at the site.

This bull's-eye in Brazil (650 km west of the capital Brasilia) is known as the Araguainha Dome after the Araguaia, an important tributary to the Amazon. The ground at its centre is raised over a circular area some 10 km across and is surrounded by broken depressions forming a ring apparently 5 km wide. The inner zone consists of deformed Devonian sandstone 350 to 400 million years old and, at the centre, an intrusion of compacted broken igneous rock from still earlier (Precambrian) times. The oil company Petróleo Brasiliero SA (familiarly Petrobras) thought that the dome might harbour an oil deposit, but drillings in 1962 yielded nothing.

Let Robert Dietz, a geologist now at Arizona State University, take up the story. "In my search for astroblemes I came across a geological map of this feature prepared by Petrobras and I also obtained some thin-section rock slides from them. Although it was evident to me from the thin sections that the rocks were shocked [the quartz crystals displayed shock lamellations] and hence the Araguainha Dome was a definite astrobleme, I sent the slides to Bevan French at NASA-Goddard Space Flight Center in Greenbelt, Maryland, for definitive petrological study. As he was in fact studying the slides [through a microscope], Nicholas Short strode in and exclaimed, 'Look, here is a beautiful astrobleme in Brazil.' Bevan French replied, 'Yes, I know; I am looking at shocked samples from that site.' (Being at Greenbelt, Short was the first qualified scientist to see the Landsat photos from Brazil.)"

Landsat, or ERTS 1 as it was formerly known, was launched 23 July 1972 into a near-circular polar orbit from which – granted clear skies – its sensors could survey the whole Earth in the course of 18 days. A swath along the ground 185 km wide was scanned by six detectors simultaneously in each of four wavelength bands covering the optical region and the near infrared. The data were digitized for transmission to one of three tracking stations. The image containing the Araguainha Dome has been specially processed in false colour at the EROS Data Center using two optical bands and one in the near infrared. A portion of this image 300 km on a side is reproduced here (north at top), its best resolution being about 80 m. Healthy vegetation appears pink; clouds, white as usual.

The pattern of the Araguainha bull's-eye on the right doubles its size as previously estimated on the ground. Indeed it looks rather more than double with its several concentric rings, but the dark outer annulus simply reflects thick vegetation growing in soil near the bottom of the domed peak. The whole region is typical of tropical savannah, with grassy plains and low scrub occasionally interrupted by clumps of woodland.

Despite their presumed production in giant explosions, the association between astroblemes and meteoritic impacts is considered in many quarters to be *sub judice*. Evidence for powerful shock waves there may be – shatter cones, high-pressure forms of silicates, impact melts, crystal deformations – but actual meteoritic débris is absent. What particularly distinguishes astroblemes is the occurrence of shatter cones – cones of rock with common orientation pointing farther from the vertical with increasing radial distance from the impact site. At present nearly 100 astroblemes are known (and another 100 suspected) at 30 of which shatter cones have been found. Meteoroids or comets which evaporate explosively before striking the ground may produce the scars now counted as astroblemes. All the same, it is unsettling to be certain that murder has been committed without being able to locate the body.

Date: 20 October 1972
Place: Landsat, 900 km over Araguainha Dome, Mato Grosso, Brazil
Apparatus: Multispectral scanner; false-colour computer processing
Source: EROS Data Center, National Oceanic and Atmospheric Administration, Sioux Falls, South Dakota
References: Dietz & French 1973, Short et al. 1976, McCall 1979

Spaceship Earth

It is ironic that this image, never the subject of painstaking measurement, can probably claim to be the most influential scientific photograph ever taken. The graphic portrayal of our native spaceship from outside has dramatically altered our conceptual position in the Universe. It drives home more pungently than all the philosophers and astronomers pontificating since the Copernican revolution that "The world's a bubble; and the life of man/Less than a span."

That the space programme should have spawned so few full-disc colour images of the Earth seems in retrospect rather odd. The first full-disc images date back to 1967. Lunar Orbiter 5 shot a nearly full globe in black and white from lunar orbit at 350,000 km on 8 August; DODGE captured its colour counterpart from Earth orbit at over 30,000 km on 25 July. DODGE (for Department of Defence Gravity Experiment) was launched to test a technique for stabilizing satellites; photographs of the Earth were taken simply to confirm its orientation. In fact the "first colour portrait of an angry Earth", as *Life* magazine called it, was assembled from three monochrome images through red, green and blue filters. Another satellite sometimes receives undue credit for the first colour image, this time dating from 18 November of that same bumper year: ATS 3 (for Applications Technology Satellite) was first and foremost a communications satellite, pictures taken by the spin-scan colour camera on board being once again an incidental by-product.

These early images, however, rate as damp squibs beside the spectacular photographs of Earth obtained by astronauts in the course of the Gemini and Apollo missions. Yet the images returned from Earth orbit were of necessity fragmentary, and nearly all those brought back from lunar forays pictured partial phases. The unique full-disc image taken during the Apollo missions is shown here. It was a hand-held snapshot by astronaut Harrison "Jack" Schmitt at 35,000 km en route to the Moon for the last lunar mission, Apollo 17. The visible hemisphere is dominated by Africa (banded with ochre desert, dark savannah and cloud-pocked rain forest) and Antarctica (brilliant at the height of summer).

With creditable prescience, Fred Hoyle anticipated the impact of just such an image in a lecture in 1948: "Once a photograph of the Earth, taken from outside, is available, we shall, in an emotional sense, acquire an additional dimension ... Once let the sheer isolation of the Earth become plain to every man whatever his nationality or creed, and a new idea as powerful as any in history will be let loose."

Two decades later Hoyle picked up the thread of this speculation during a postprandial speech in Houston: "Well, we now have such a photograph, and I've been wondering how this old prediction stands up. Has any new idea in fact been let loose? It certainly has. You will have noticed how quite suddenly everybody has become seriously concerned to protect the natural environment. Where has this idea come from? You could say from biologists, conservationists and ecologists. But they have been saying the same things as they're saying now for many years. Previously they never got on base. Something new has happened to create a worldwide awareness of our planet as a unique and precious place. It seems to me more than a coincidence that this awareness should have happened at exactly the moment man took his first step into space."

Many others have reacted similarly to visualization of the world from this previously unattainable perspective. Moonbound astronauts from Apollo 8 in 1968 to Apollo 17 in 1972 exclaimed not only at its beauty but at its minuteness and seeming fragility. "I think that all of us subconsciously think that the Earth is flat or at least almost infinite," mused William Anders of Apollo 8. "Let me assure you that, rather than a massive giant, it should be thought of as [a] fragile Christmas-tree ball which we should handle with considerable care." To Apollo 10 astronaut Thomas Stafford the Earth from cislunar space is "a boy's blue glass marble"; to astronomer Donald Clayton, "our green and blooming spacecraft" – much the same view as held by the late Buckminster Fuller; to poet Archibald MacLeish, "no longer the World but a small, wet, spinning planet in the solar system of a minor star off at the edge of an inconsiderable galaxy. ..." It is easy to dismiss these responses as so many pretty phrases, but the change wrought in the human outlook is almost palpable.

Date:	7 December 1972
Place:	Apollo 17 lunar module, 35,000 km from Earth
Photographer:	H. H. Schmitt
Apparatus:	Hasselblad 500EL with 250 mm lens at f/11
Emulsion:	Kodak SO-368, type 2485
Exposure time:	4 msec
Source:	Hasselblad UK Ltd.; NASA
References:	Hoyle 1960, Clayton 1975, Ordway 1975, Hallion & Crouch 1979

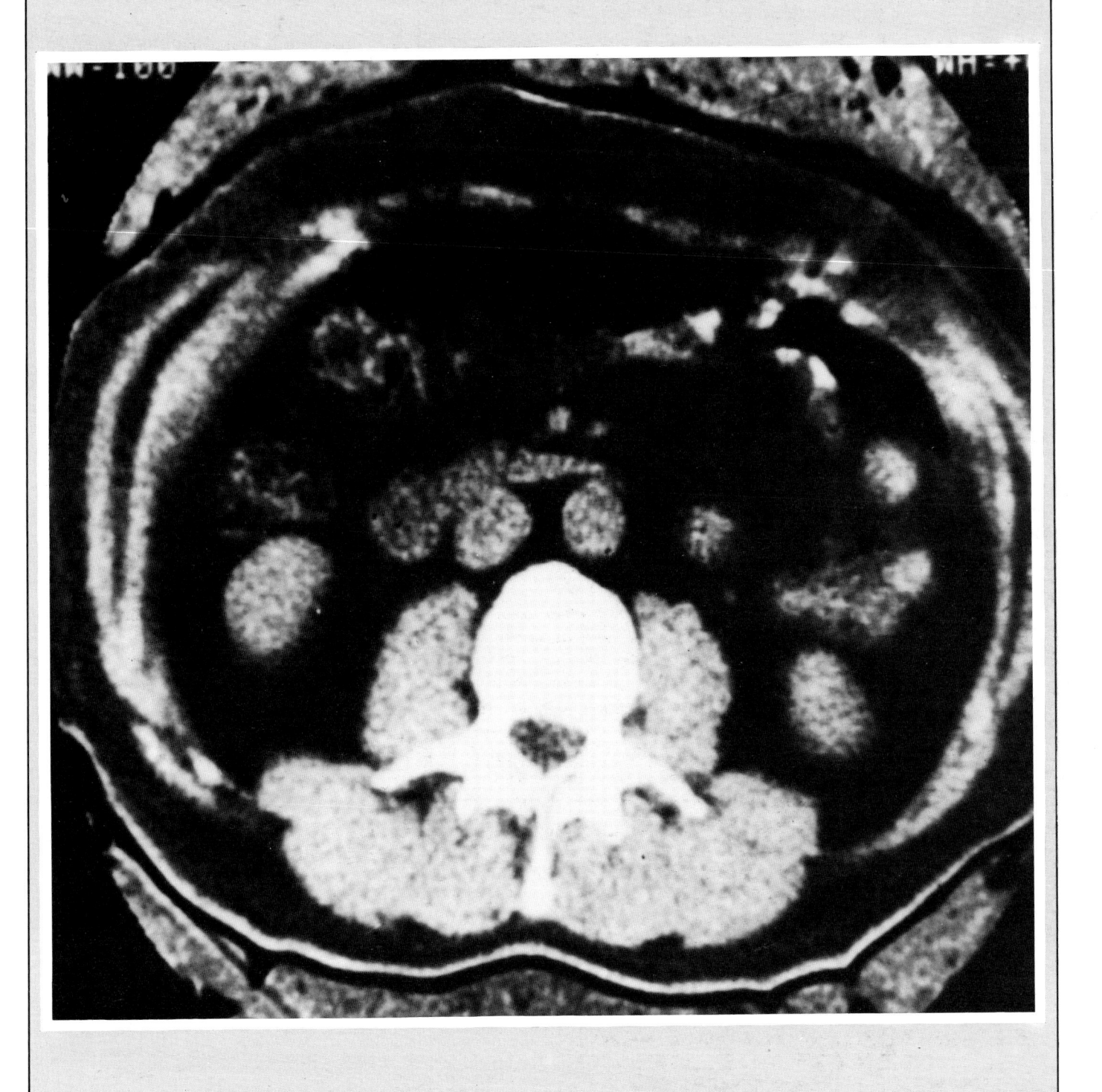

Spoor of the First Centauro

The cosmic rays of highest energy, up to 100 billion billion electron volts, hold a special interest not only for cosmic-ray researchers but for all nuclear physicists. Such huge energies far exceed the upper limit of even the most powerful particle accelerators operating today. For example, the proton-antiproton collider at CERN, the European Centre for Nuclear Research near Geneva, can achieve collision energies of 540 billion electron volts (GeV, G for "giga-") or even 900 GeV under certain conditions. Somewhere nature is manufacturing cosmic-ray particles with energies well over a millionfold greater.

The Earth's atmosphere can be relied upon to intercept these energetic particles in mid-flight. The primary particle will encounter a molecule, flinging off charged and neutral pions whilst the narrowly bunched main component of heavy fragments (the "hadron core") carries on in the same direction. Charged pions decay to provide the muon component (see pp 78–79) measured at ground level; neutral pions vanish in a burst of energetic electrons and gamma rays. The characteristics of this "air shower" allow the energy of the original incoming particle to be inferred.

One of the most bizarre discoveries in the history of cosmic rays emerged in 1973, when the first "Centauro event" was recorded. What is so odd about such events is that the hadron core (typically a hundred protons, neutrons and other heavy particles) is recorded without its expected gamma-ray accompaniment, the implication being that neutral pions are not produced. The primary particle must be a very strange beast indeed. Tentative explanations involve an exotic new nuclear particle containing the missing "top" quark (cf. the charmed quark of pp 176–177) or perhaps a glimpse of the gluon which binds quarks together to form hadrons.

Most cosmic rays of very high energy are not detected photographically because they are so rare: at the 100 billion GeV level, only five events per sq km per century. The output generally appears instead as an oscilloscope trace. In the observations at the Mount Chacaltaya Observatory, however, a sandwich of photographic and lead plates acts as the detector. The photographic plate consists of a nuclear emulsion overlaid with very sensitive X-ray film whose purpose is to detect the arrival of energetic particles. The resulting black spots in the X-ray film act as markers indicating where to seek the microscopic particle tracks in the nuclear emulsion.

A single detector sandwich, however, leaves too many interpretative loopholes. The emulsion chamber is designed with a *dual* detector, an upper sandwich over a target layer of petroleum pitch to encourage nuclear interactions and a lower one separated from the target layer by an air gap giving the reaction products space to fan out. The upper detector acts as a shield to trap electrons and gamma rays from an air shower; the associated hadrons plough straight through it but cannot traverse the target layer unmolested. Miniature showers instigated in the target layer and detected in the lower sandwich are selected for study. These showers have been called "C-jets" for the carbon content of the target layer.

The first Centauro event left its traces on X-ray film (opposite) in the emulsion stack of the lower detector. The event has the hallmarks of an air shower rather than a C-jet; yet the lead plates of the upper detector ought to have captured all the air-shower components save for the hadron core. From the concentration of some 40 or 50 spots within a circle of diameter 0.6 cm – the line at bottom is graduated in mm – we can infer a total energy of 330,000 GeV (or 330 TeV, T for "tera-"). According to normal expectations the films in the upper chamber should be utterly blackened with spots from energetic particles – but normality is confounded: the films are all but blank. Like the mythological Centaur, half man and half horse, this nuclear event does not allow us to guess the appearance of the interaction in the upper chamber from that in the lower and vice versa. (Let those deceived by the claim that Centauro events were named from a coincidental resemblance between the first record and the constellation compare the photograph opposite with any star chart!)

In this event it is estimated that at the point of interaction 50 m above Mount Chacaltaya (itself 5220 m above sea level) an unidentified cosmic-ray particle interacted to yield 74 hadrons (and no pions), 6 of which reached the emulsion chamber. CERN researchers have lost no time in hunting for Centauro events despite the relatively low energies attainable in the collider. Two groups have now sought but not found them. Important discoveries must lie in wait at higher energies.

Date: 1973
Place: Mount Chacaltaya Observatory, Bolivia
Photographers: Brazil-Japan Collaboration on Chacaltaya
 emulsion-chamber experiment
Apparatus: Two-storey emulsion chamber no. 15
Emulsion: Sakura N-type X-ray film (lower chamber)
Source: Y. Fujimoto, Waseda University, Japan
References: Lattes *et al.* 1980, Waldrop 1981, Alpgård *et al.*
 1982, Arnison *et al.* 1983

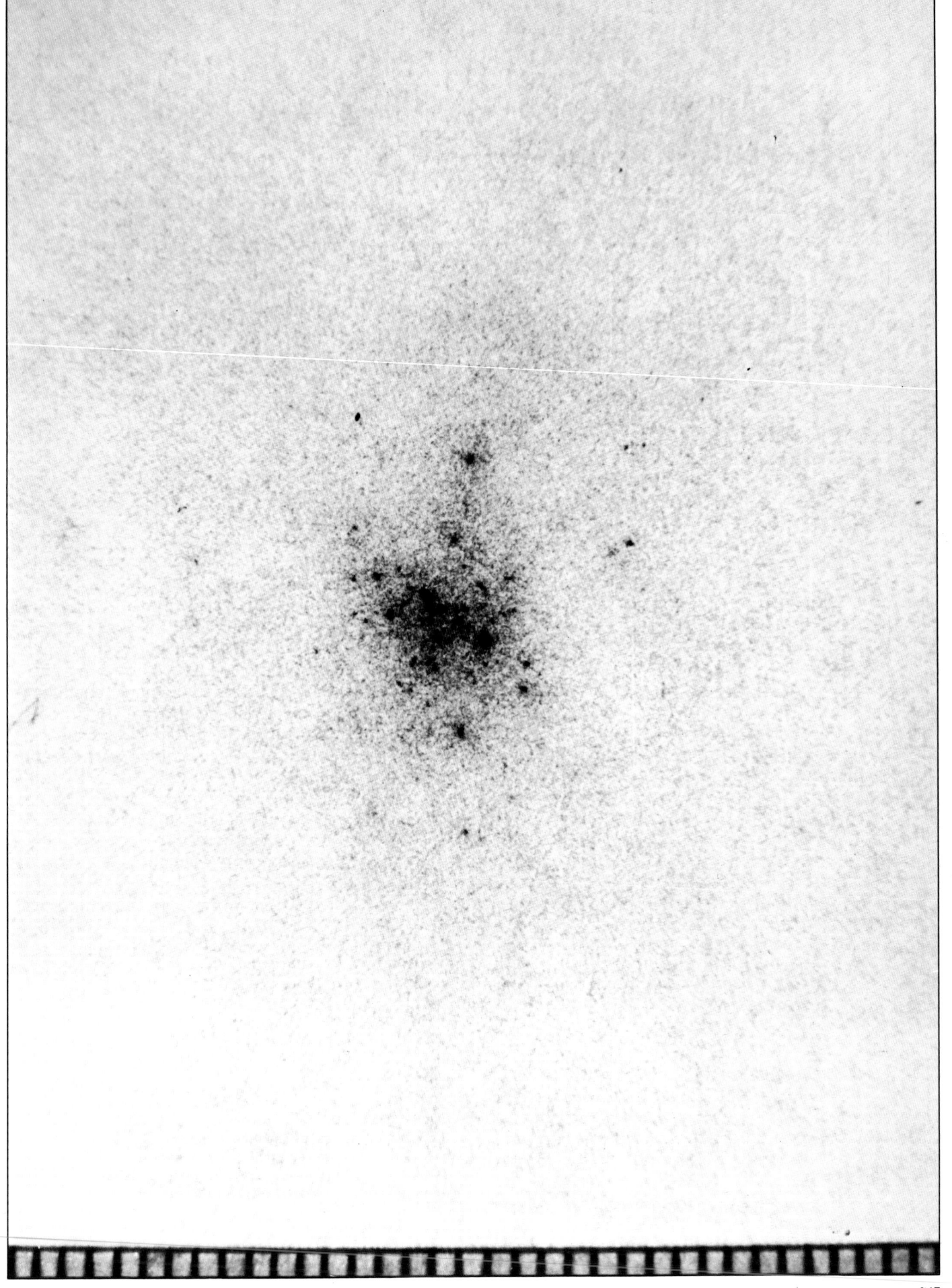

X-ray Sun at Eclipse

Just how different the Sun would appear at X-ray wavelengths was adumbrated by the first pinhole image of the X-ray Sun obtained by a rocket payload in 1960 (p 89). What a contrast it is, nevertheless, when compared with the Skylab image opposite, covering much the same wavelength range but providing far greater resolution. Skylab consisted of an orbiting laboratory manned for a total of 171 days by three crews in 1973–74. Observations made with the solar telescopes on its Apollo Telescope Mount caused a revolution in our knowledge of the Sun.

This image looks like many other X-ray portraits of the corona but in fact it occupies a unique place in the history of solar physics. It was taken by one of the two X-ray telescopes aboard Skylab at the very moment when the shadow of a solar eclipse was sweeping across Africa. For the first time it became possible to piece together a synoptic view of the Sun and its enveloping corona at a variety of wavelengths, enabling us to trace the coronal streamers seen in ground-based eclipse observations back to the surface of the X-ray Sun. This "surface" in fact lies in the inner coronal region (well above the photosphere) where the electron temperature is on the order of a million degrees K. For the ground-based counterpart to this image, see p 151 where the orientation remains close to that on the facing page (north at top). No other eclipse can lay claim to such thorough coverage across the spectral range.

X-rays cannot be focused by ordinary lenses. The S-054 X-ray spectrographic telescope with which this image was acquired employed grazing-incidence optics and six filters covering the X-ray spectrum from 3.5 to 60 Å. The field of view was 0.8 second of arc. The telescope could be operated manually or automatically, and was functioning in the latter mode to record this photograph. Along with the rest of Skylab, it was destroyed on 11 July 1979 in the course of re-entry into the atmosphere.

The 60,000 X-ray images obtained by Skylab of the solar corona – half of them by the S-054 instrument – reveal two new features glimpsed but scarcely appreciated in prior observations. One was the existence of coronal holes, large dark areas seemingly devoid of X-ray flux, where the electrons are less dense and the temperature is lower. (A huge hole is visible at the north pole in the solar image opposite, snaking down toward the equatorial region.) Empty they are not, however: it was soon realized that the solar wind streams from them, bearing energetic particles which affect our own magnetic field. The solar wind prefers holes because they are magnetically streamlined; that is to say, field lines around a hole stretch out radially instead of interrupting the flow by virtue of their usual complex pattern of arches and loops. In principle, the position of holes can be inferred from the streamers on ground-based eclipse photographs, but not without difficulty since they are then viewed at right angles (edge-on).

The other feature is the presence of bright points dotted all over the face of the X-ray (and the ultraviolet) Sun, even inside coronal holes. Bright points betray intense X-ray emission. By comparing the X-ray image with either ground-based and airborne eclipse photographs or else images from Skylab's own white-light coronagraph (allowing for a solar mask twice the diameter of the Sun), we find an answer to the long-standing question of the solar roots of polar plumes. Bright points in coronal holes prove indeed to be the source of polar plumes, the short jets of outflowing gas seen in the polar regions.

The brightest regions opposite are all seething with solar activity: they are associated with sunspots in the photosphere, plages in the chromosphere and solar flares. Streaks and striations delineate the shape of the local magnetic field, sometimes bound in tight loops where the field is concentrated, sometimes arched over great distances. Colour filters tint the monochrome X-ray image when it is reproduced on 35 mm film, and the scarlet Sun opposite has appeared elsewhere in orange.

Date:	30 June 1973
Place:	Skylab, 435 km over Earth
Photographers:	American Science & Engineering, Cambridge, Massachusetts
Apparatus:	S-054 X-ray telescope under automatic control; false-colour processing
Emulsion:	Kodak SO-212 (antistatic back coating added, front gelatine layer removed)
Exposure time:	64 sec
Source:	J. M. Davis, American Science & Engineering, Inc.
References:	Haggerty *et al.* 1975, Tousey 1977, Vaiana *et al.* 1977, Eddy, ed. Ise 1979

In Pursuit of the Corona

The Sun is wreathed in a huge, tenuous cloud of extremely hot gas called the corona, so much fainter than the brilliant photosphere that it becomes visible only when the Moon has blotted out the Sun in total eclipse. Alternatively, the corona can be observed by satellite, unimpeded by the Earth's atmosphere. In either case what the eye or camera records depends very much on the degree of solar activity at the time of observation.

The Sun oscillates between relative quiescence and flaring activity on some multiple of an 11-year cycle. The corona, produced by the flux of energetic particles streaming from the Sun, serves as a good barometer (and thermometer) of solar activity. Seen at solar minimum, the corona resembles a halo distended at the equator and accompanied by short straight plumes at the poles. At solar maximum the corona manifestly expands, abandoning its sober symmetry and projecting streamers far out from the solar limb.

In fact streamers exist at both maximum and minimum though they become more pronounced with increasing solar activity. Streamers act as tracers of the solar magnetic field and vary in brightness and orientation according to the vagaries of the Sun's field and charged particles hurtling along the field lines. These particles form a solar wind measurable not only at the Earth's distance but out to the maximum distance yet reconnoitred by a spacecraft (Pioneer 10, now past the orbit of Pluto).

How far can we trace streamers photographically before having to resort to flux counters on isolated spacecraft? One might have thought that the record would be held by Sun-observing satellites such as Skylab (pp 148–149), a superb manned space station for solar studies before its sad demise. Skylab traced the solar corona from 1.5 to little more than 6 solar radii; it suffered somewhat from scattered light. SOLWIND, an unmanned solar watchdog (p 202), can record the corona from 3 to 10 solar radii. (The solar radius is 700,000 km.)

Surprisingly, the laurels go not to an orbiting satellite – able to scrutinize the corona at any time – but to an aeroplane. Even cruising at 12,000 m, observers in aeroplanes suffer the same handicap as ground-based observers: light scattering by the atmosphere condemns them to coronal observations only during solar eclipse. (It is true that coronagraphs occlude the Sun to render the inner corona visible even outside eclipse, but the outer corona remains beyond reach.) Nevertheless, airborne eclipse expeditions manned by a Los Alamos research team have managed to photograph the corona from 1.2 to 12 solar radii, and even beyond: they contend that they have data for the 1980 eclipse (pictured opposite below) out to 20 solar radii, or 14 million km.

The photographs on the facing page testify to their success. Taken from a U.S. Air Force jet chasing the shadow of the 30 June 1973 eclipse over central Africa, the upper one forms an exact Earth-based counterpart to the Skylab photograph on p 149. Four exposures on fine-grain film were digitized so that they could be manipulated by computer. Initially the intensity gradient is so great that it appears impossible to see the bright inner corona and the faint outlying streamers on a single print. But then a computational filter is applied to compensate for the radial gradient and a spatial filter to adjust for the azimuthal variation. Each of the four exposures is thus doubly filtered and then combined to produce this remarkably detailed composite. North is at top, west to right.

Note how much brighter the streamers appear in the equatorial than in the polar regions. If the occulting disc looks suspicious, it should: it is not the Moon but an artificial disc 30% larger to blot out the innermost corona and alleviate to a small extent the radial density problem. Some of the streamers are flung out radially, others obliquely, even colliding with their neighbours – but it is largely the effect of projection. In 1973 solar activity was waning, and the equatorial concentration of streamers conforms to expectation. For comparison, consider the lower photograph, obtained with the same equipment and techniques (but 32 negatives instead of 4) in 1980, near sunspot maximum. Streamers here radiate from the polar regions as well. This enhanced photograph has its own colour counterpart on p 205; each could claim to be the best of its kind.

Date: 30 June 1973 (above); 16 February 1980 (below)
Place: NC-135 jet, 11.5 km over Africa (above), Indian Ocean (below)
Photographers: C. F. Keller & W. Matuska
Apparatus: Camera at f/6 with telephoto lens, polaroid & colour filters; computer enhancement
Emulsion: Kodak Panatomic X (above); Kodak 2475 (below)
Exposure time: 50 sec (above); 0.2, 1.0, 3.0 sec (below)
Source: C. F. Keller, Los Alamos National Laboratory
References: Martinez 1978, Keller & Liebenberg 1981, Mulkin 1981

A Satellite for all Seasons

Satellite imagery can expand our vision in several dimensions: in space, in time, in wavelength. These false-colour microwave images of the polar regions, the Antarctic opposite and the Arctic below, provide the first synoptic view of their seasonal changes. The persistent cloud cover which hinders optical observations looks transparent to microwaves.

NASA initiated its Nimbus series of meteorological satellites in August 1964; and whilst the contemporaneous TIROS series and later ESSA series are now closed chapters, the Nimbus satellites continue up to the present day. Although it would no longer be true now, it was possible as late as 1979 for a satellite expert to claim that the Nimbus project "has matured to become the [American] nation's principal satellite programme for remote-sensing research". (The last to be launched was Nimbus 7, in 1978.) Nimbus 5, responsible for the images shown here, was launched 11 December 1972 in a near-circular polar orbit with an altitude of 1100 km. It was equipped with three infrared and two microwave radiometers; the Electronic Scanning Microwave Radiometer (ESMR) supplied these remarkable images.

Microwaves overlap in wavelength with the infrared region on the shortward side and ordinary radio waves on the longward side; some authors define them as running from 1 mm to 30 cm. The name is liable to breed misunderstanding: far from being measured in micrometres (microns), they could be said to occupy the "centimetric" band. In the case at hand, the ESMR mapped the polar regions at 1.55 cm. It was the first time that the ESMR had formed part of a satellite payload, and it was to be employed again on Nimbus 6.

The ESMR instrument does not actively transmit microwaves and measure the return signal, as do some scanners; instead it passively measures the so-called "brightness temperature" of the microwave emitter. The brightness temperature will be some fraction of the physical temperature – the two temperatures are equal for a perfect emitter, or "black body" – according to the characteristics of the surface. Ideally the brightness temperature refers only to the surface of the emitter but in some cases it indicates an average of microwave radiation from different depths. Microwave emission originates in the top few millimetres of soil, water and fresh ice; the top few centimetres of older ice; and the top few metres of dry snow.

The colour-composite images here show marked contrasts in brightness temperature between various surfaces. During Antarctic summer opposite at left, for example, the interior snow registers a chill blue, but the water north of 60° S appears even colder (white). The range of false colours is selected by the investigator to emphasize the features he is studying, and in this case the code specifies lowest temperatures (below 150 K) white and highest temperatures (above 240 K) magenta. For a sense of scale and orientation, note that the land mass of Antarctica extends almost to 65° S at upper right and that the southern tip of South America lies off-stage at bottom right.

At the beginning of July (Antarctic winter, opposite right), the shelf of pack ice encircles continental Antarctica in a thick belt. In area, sea ice in winter is typically six or seven times as great as in summer; but in some regions (e.g., the Amundsen Sea at top) the ice scarcely seems to change all year. The interior now looks as white as snow, or indeed as the outlying ocean, but the similarity is an artefact of the image processing. The brightness temperature of the water remains lower than that of the ice cap, but both are so cold as to be off-scale according to the colour calibration.

Familiar land masses are easier to recognize in the Arctic images below: the tongue of Greenland, bottom centre, with Iceland to the right. Farther right lies Scandinavia, particularly salient in summer (left image); in the bottom right-hand corner the United Kingdom is clearly discernible in winter (right image). Only the largest icebergs will be visible (see Antarctic summer) because the resolution is no better than 30 km. The Arctic Ocean looks uniformly cold in winter but the picture in summer is considerably more complex. As in the Antarctic, the deluge of fresh data on the ice caps calls for revision of existing atlases.

Date: 1973–74
Place: Nimbus 5, 1100 km over Antarctic (opposite above),
 Arctic (below)
Apparatus: ESMR radiometer; false-colour computer
 reconstruction
Source: National Space Science Data Center, World Data
 Center A for Rockets and Satellites, Maryland
References: Gloersen *et al.* 1974, Gloersen & Salomonson 1975,
 Zwally & Gloersen 1977

Antarctic summer

Antarctic winter

Arctic summer

Arctic winter

Ultraviolet Veils of Venus

Our nearest planetary neighbour, Venus, emulates the Earth in size and mass but little else. The featureless white cloud deck observed from Earth consists of sulphuric acid droplets suspended in a dense atmosphere of carbon dioxide. The ultraviolet cameras of Mariner 10, flying past en route to Mercury, revealed a very different picture: planet-wide swirls of cloud which move round the globe in under five days.

Illusory observations persuaded many an early astronomer that the clouds of Venus did possess some visible markings. Perhaps wishful thinking, perhaps optical aberrations, led Francesco Bianchini to see continents and oceans, Percival Lowell long narrow lines which he judged natural unlike the "artificial" canals of Mars, and other observers dark spots, bright points and even the spokes of a wheel. In fact, faint shading can be discerned with an ultraviolet filter, as F. E. Ross discovered in 1926; but not until Mariner 10 did unambiguously defined cloud structure appear in the atmosphere of Venus. The most reliable ground-based observations, carried out at the Pic du Midi Observatory by C. Boyer, H. Camichel and P. Guérin in the 1960s, identified a faint horizontal "Y" (⤳) lying along the planetary equator. They deduced the retrograde rotation of the atmosphere with a period of 4 days – a pre-Mariner achievement which deserves to be better remembered.

In its fly-by past Venus, Mariner 10 initially recorded images with blue and orange-yellow filters and detected the usual blank face. After encounter on 5 February 1974, the twin vidicon cameras switched to their ultraviolet (UV) filters and treated scientists and journalists at the Jet Propulsion Laboratory (JPL) to the swirling cloud patterns seen opposite, relayed in "real time" – live – from the Mariner spacecraft. Over the next eight days 3400 frames were acquired, representing 64 global views of Venus. The mosaic here, stitched together from digitally enhanced television images, was taken one day after closest encounter. Thus it provided the highest resolution available until the arrival of Pioneer Venus in 1978 (p 182).

The eight-day sequence afforded our first clear insight into the planet's atmospheric dynamics. It nicely corroborated the four-day retrograde rotation of the atmosphere claimed by the French astronomers a decade earlier. When the long-disputed rotation period of Venus was at last established by radar (in 1967) as 243 days in the retrograde direction, the notion that the atmosphere was spinning in the same sense but 60 times faster must have looked highly suspicious – yet it was borne out by Mariner 10. Of course, the spiralling pattern of UV markings represents the circulation of only the upper cloud layer. Lower down, the winds drop from their measured equatorial value of about 100 m per sec – which would correspond to a rotation period of 4.4 days – to 10 m per sec at an altitude of 10 km and to the merest breeze at ground level.

Details in the pattern gradually migrate poleward from the equator, the smallest resolvable markings here being 10 to 20 km wide. By implication there are at least two major flow régimes occurring simultaneously: one zonal, producing the ⤳-feature, and one meridional, carrying the mottles toward the poles. The meridional pattern looks very much like the circulation proposed for the Earth's atmosphere, not very successfully, by George Hadley in 1735. The atmosphere of Venus, on the other hand, may indeed obey a Hadley régime whereby heated "air" (mostly carbon dioxide) rises at the equator and falls at the cooler poles. Hadley cells may be broad but they do not run deep: current meteorological models picture a series of global cells nested one below the other.

On the composite UV image opposite, the circulation is effectively frozen. With north at top, it would appear on subsequent images to move from right to left. The equatorial ⤳ is not particularly evident here, though the indigo streak adjacent to the polar ring at lower right would constitute one arm of it, and indeed the UV features vary on scales large and small from one rotation to the next. The most enduring feature appears to be the bright ring of cloud about the south pole.

Like their martian predecessors, the images of Venus required special computer processing to extract the best results. An image-processing team at JPL used simple cosmetic treatment to remove spikes in the data, "radiometric decalibration" to restore true relative brightness, filtering to compensate for attenuation of high frequencies by the cameras, and contrast enhancement to improve the subjective result. For the final version of the picture, members of the Division of Astrogeology at the U.S. Geological Survey retouched the image, which was then tinted blue for the cover of *Science*. To an astronaut orbiting Venus, of course, the ultraviolet eddies would be invisible; he would see only a yellowish disc devoid of spiralling clouds.

Date: 6 February 1974
Place: Mariner 10 at 720,000 km from Venus
Apparatus: Cassegrain telescope at f/8.4, vidicon camera with
 3550 Å filter; false-colour photomosaic
Source: J. E. Guest, University of London Observatory; NASA
References: Murray *et al.* 1974, Soha *et al.* 1977, Dunne &
 Burgess 1978, Hunten *et al.* 1983

First View of a Stellar Surface

The textbooks have always insisted that it is impossible to see the surface of any star except the nearest one, the Sun itself. The argument looks watertight – the diffraction limit sets an insuperable bound on the size of disc resolvable whilst the turbulent atmosphere in turn prevents us from approaching the diffraction limit – yet astronomers at Kitt Peak National Observatory found a loophole. Opposite is a false-colour digital reconstruction purporting to represent our first look at another star.

The star is Betelgeuse, or Alpha Orionis, at over 500 light-years not among the nearest stars but certainly one of the brightest and largest. The crucial measure is its angular diameter, greater than that of any of its nearer rivals. This red supergiant seemed a good candidate for a technique called speckle interferometry pioneered by Antoine Labeyrie around 1970, in which information smeared out by the fluctuating atmosphere is rescued through short exposures. Stars twinkle, and what Labeyrie and his enthusiastic followers have done is to capture and correlate the twinkles, or "speckles".

Interferometers come in many varieties – the classic Michelson, amplitude, intensity, speckle – but they work on a common principle: two slightly different beams of light from a given source interfere with each other to produce a pattern yielding information not obtainable from either beam individually. In the case at hand, turbulent atmospheric cells, typically 10 to 25 cm in size, cause rays of starlight at different phase to strike different parts of the telescope mirror (or lens) at the same moment. Averaged over only a few seconds, the interference pattern produced at the eyepiece (or on a photographic plate) would become completely smeared out.

But if the "seeing disc" of the star (the diffraction disc first described by Astronomer Royal George Airy) can be captured in a few hundredths of a second in a narrow waveband, the speckles can be used to resolve details normally beyond our grasp. To tackle Betelgeuse, Roger Lynds, Pete Worden and Jack Harvey took very short monochromatic exposures of highly magnified stellar images with a motor-driven camera coupled to an image intensifier on the 4-metre telescope at Kitt Peak. These images were then digitized, processed by computer, and added to produce a complete picture. The technique of speckle interferometry is usually employed to measure angular diameters or to resolve close double stars (pp 162–163), but this time it was harnessed to turn out an image.

The two narrow-band filters were centred on the "green" wavelengths 5100 Å and 5180 Å – the first in a region of the spectrum nearly free of absorption lines to reveal the stellar surface, or photosphere; the second in a band of strong absorption by titanium oxide to probe higher up in the atmosphere. After individual processing for each filter, the composite speckle images were digitally subtracted one from the other.

Betelgeuse does appear to have surface structure, but *caveat emptor*! In their paper the Kitt Peak astronomers cautiously remark, "We cannot be absolutely certain with available data that the structures we note on the reconstructed image truly represent features on the star." Indeed, Worden published a subsequent study with Susan Wilkerson which confirmed the star's angular diameter and demonstrated marked limb darkening (a decrease in brightness toward the limb, also found in the Sun) – yet failed to reveal significant surface structure. On the other hand, an independent team did succeed in obtaining an image of Betelgeuse comparable with the first reconstruction. At best one can believe only the grossest features of the reconstruction, perhaps one third the star's diameter, the finer variations being no more than an artefact of the image processing. Overall the variations probably reflect temperature differences produced by convection on a huge scale.

Date: 28 March 1974
Place: Kitt Peak National Observatory, Arizona
Photographers: C. R. Lynds, S. P. Worden & J. W. Harvey
Apparatus: RCA image intensifier with two 100-Å bandpass
 filters, motorized camera on 4 m Mayall telescope;
 false-colour computer reconstruction
Emulsion: Kodak Tri-X
Exposure time: 0.008 sec (20 exposures in each filter)
Source: Association of Universities for Research in
 Astronomy, Inc., KPNO
References: Lynds *et al.* 1976, McDonnell & Bates 1976,
 Wilkerson & Worden 1977

The Microscopic Frontier

Under the heading "Most Powerful Microscope", the Guinness Book of Records trumpets the achievement of Lawrence Bartell and Charles Ritz in photographing the electron clouds of atoms magnified a staggering 260 million times. Indeed, the images produced by their two-stage holographic microscope represent an extreme limit of magnification and resolving power unsurpassed in photographs from any other source.

Holography in general, and electron-wave holography in particular, were conceived by the fertile mind of the late Dennis Gabor in 1948, long before it could be practically realized. In a nutshell, holography is a technique for recording the pattern produced when light scattered from an object interferes with an unscattered reference beam and for reconstructing an image of that object from the interference pattern. At first, however, a technical stumbling block impeded experimentation: the requirement that the interfering light waves be *coherent*, travelling in step with little tendency to disperse. The invention of the laser in 1960 provided the ideal source of monochromatic, coherent light.

In the special case of electron-wave holography, the obvious requirement is an electron laser but unfortunately there is no such animal. Thus the interference pattern must be generated in another fashion. Drawing on long experience studying electron diffraction in gases, L. S. Bartell in the Department of Chemistry at the University of Michigan devised a two-stage microscope. The first stage is an electron-diffraction apparatus used to generate the hologram, and the second a laser diffractometer to reconstruct the image. The crucial principle on which Bartell's holographic microscope was founded is simply this: electron waves are scattered strongly by the nucleus, weakly by the enveloping electron clouds. So the compact nucleus provides a "reference" beam with which the scattered "object" beam from the orbiting electrons can interfere.

With ironic timing Gabor spoke of the history of the electron microscope at an international congress in Canberra in August 1974, and lamented, "I am still waiting for somebody who will realize high-resolution electron holograms." Perhaps he had had no opportunity to update the published text or else had considered the holographic microscope too far removed from its electron counterpart, but in April of the same year he had seen his hopes realized by Bartell and Ritz and had written back with hearty congratulations. "You can imagine how thrilled I was," he wrote; he had been "waiting for something like this for many years."

Within the past decade holography has indeed been applied to electron microscopy by combining views from different angles, but Bartell's approach is rather different. In the holographic microscope each atom or molecule produces its own hologram, and the holograms and subsequent images lie one over the other in perfect registration. So the micrographs we see do not picture individual particles but rather an ensemble of identical particles exactly superposed. In other words the hologram is an average electron diffraction pattern and the reconstructed image an average atom or molecule.

An interesting photographic sidelight on the atomic holograms is worth relating. After attenuation by a heart-shaped rotating mask, the interfering beams build up a holographic negative on a 10 cm × 13 cm plate which is then rephotographed on direct positive film. "Such film," writes Bartell, "is not noted for its optical perfection, and the uniformity of its optical thickness suffers when the preserving fixative is painted over the film. Therefore, we made a large number of holograms, selected those which, by accident, were on optically uniform portions of film, and made reconstructions without *fixing* the emulsions at all!" A helium-neon laser plus f/15 lens then effects the reconstruction.

The first atom to be imaged was argon (upper picture, longer exposures toward the right) and the first molecule arsenic pentafluoride or AsF_5 (shown at lower left, with its holographic progenitor at right). The inner "fine structure" results from instrumental diffraction effects and does not pretend to portray electrons whirling in orbit. But the outermost ring of the molecular image certainly is significant: it depicts the shell of five fluorine atoms round a central atom of arsenic. At a magnification in this case of 70 million, one can measure the bond length with no more sophisticated instrument than a ruler.

Date:	1975 (above); 1977 (below)
Place:	University of Michigan, Ann Arbor
Photographer:	L. S. Bartell
Apparatus:	Two-stage holographic microscope using 3 mW He-Ne laser
Emulsion:	Electron Image Plate → Polaroid film (above); Process Plate → Kodak 131-02 holographic plate (below)
Source:	Photographer
References:	Bartell & Ritz 1974, Bartell 1975, Bartell & Johnson 1977

Infrared Breakthrough in Geology

The revolution in remote sensing which began with multispectral imagery from such Earth-resources satellites as Landsat has spilled over into conventional aerial photography. The computer endows a geologist with the powers normally wielded by a spectroscopist and enables him to determine gross composition from afar. The trick is to decide which combination of colours, or colour ratios, uniquely distinguishes a particular kind of rock – to discriminate among reflecting surfaces which from aeroplane or satellite look visually indistinguishable.

Here the rich mining district of East Tintic, Utah is observed in the infrared (IR) with an airborne scanner, the results digitized and fed into a computer to generate a series of false-colour reconstructions. Useful diagnostic photographs have been prepared from narrow bands in the *visible* spectrum, but this image obtained entirely in the *infrared* has yet to be surpassed.

The choice of a spectral region in the middle infrared, 8 to 14 microns, for this historic study was dictated by the excellent transparency of the atmosphere in this waveband (so long as one avoids the ozone absorption band at 9.6 microns) and the fact that silicon-oxygen bands dominate it. To a geologist the latter point strikes home: oxygen and silicon are the two most abundant elements in the Earth's solid crust and silicon dioxide (SiO_2) overrides all other compounds in the composition of most igneous and sedimentary rocks (around 60% by mass). Pure quartz consists solely of SiO_2.

The East Tintic Mountains offer a good testbed for IR imagery. Palaeozoic sedimentary rocks, faulted and folded over the last 500 million years, are overlaid in places with Tertiary igneous rocks perhaps a tenth their age. These later volcanic rocks contain more or less silicon according to whether they are or are not dominated by quartz-bearing rocks, the extremes being coded orange and violet respectively in the lithologic map on this page. The earlier sedimentary rocks may be silicon-dominated (quartzite and sandstone, coded crimson) or calcium-dominated (limestone and dolomite, coded green).

The colours on the lithologic map here are coded for different compositions by design. The crucial question is whether the (false) colours on the IR image opposite are coded naturally. Compare the two images in the light of the foregoing remarks: the answer is resoundingly affirmative. By and large, quartz-dominated rock looks reddish and quartz-weak rock bluish or greenish. Widespread vegetation growing on the fertile alluvial soil also appears green.

In the colour-composite image opposite, the letters signify noteworthy features: A, B, F, J and M are all rich in silicates and do indeed look red. K, N, O and P, either silicon-poor or if silicate rocks like latite and monzonite then quartz-poor, duly appear turquoise or green. Mining areas G and H stand out quite starkly. Purple (I) denotes clays. Orange areas at right (Q) mark mining and milling operations, as well as ponds. Black areas were too hot or too cold to record well in the middle IR.

This image of East Tintic also represents a tour de force in image processing. Only three of the six mid-IR channels in which data were taken are employed for the final image, but a great many colour combinations were tried first. *Ad hoc* techniques of colour and contrast enhancement were developed, and many subsequent images have benefited from the analysis of East Tintic.

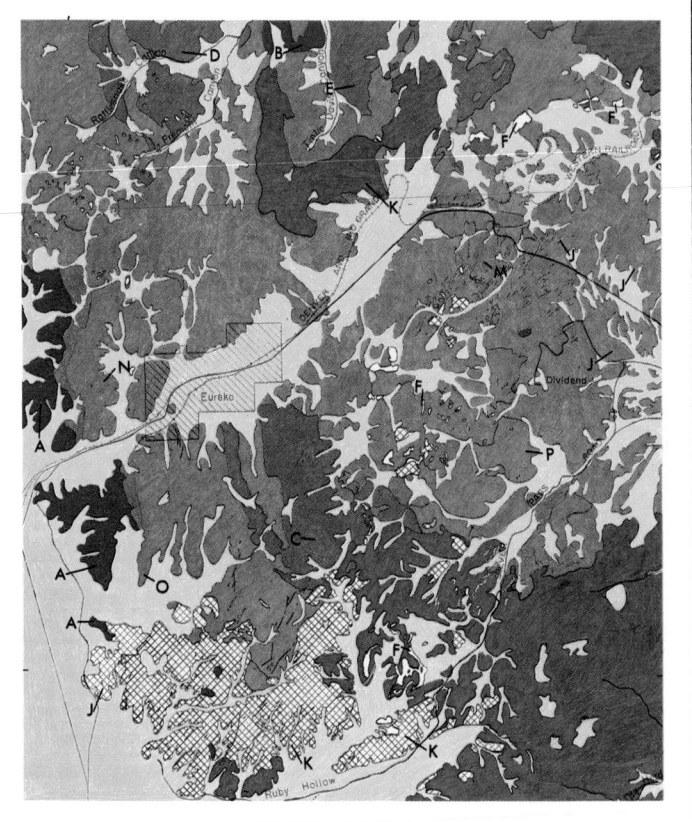

Date: 4 November 1975
Place: NASA C-130 aeroplane, 5.5 km over East Tintic Mountains, Utah
Photographers: A. B. Kahle & L. C. Rowan
Apparatus: Bendix multispectral scanner; computer processing and reconstruction
Source: H. N. Paley, Jet Propulsion Laboratory, Pasadena, California; NASA
References: Kahle *et al*. 1980, Kahle & Rowan 1980, Goetz & Rowan 1981

The Spoils of Speckle

The scintillations produced by the passage of starlight through the Earth's turbulent atmosphere can be transformed into an interference pattern invaluable to astronomers. From such patterns they have been able to deduce the angular diameter of stars, surface features on a red giant (pp 156–157) and data on binary stars so close as to be inseparable on a photographic plate. The separation and relative position of two components in the stellar system Eta Orionis (opposite) are revealed by the interference pattern "transform" (see below), along with the presence of a previously unresolved yet highly luminous third companion.

The raw material of speckle interferometry consists of interference patterns, frozen in time in a narrow wavelength band and examined at high magnification, like those of the variable star 57 Cancri reproduced at near right. *Each* of the two patterns derives from *both* stars of the binary system; they appear on the same frame through the simple expedient of shifting the telescope slightly between exposures. Note how well the two speckle patterns correlate even at a cursory glance.

Although credit for invention of the technique must be vested in Antoine Labeyrie and his French colleagues, the American astronomer Harold McAlister is the doyen of binary-star speckle interferometry. Working primarily on the 4-metre Mayall telescope at Kitt Peak, he photographs 50 to 100 speckle patterns with short exposures through a narrow-band filter centred on 5500 Å ("yellow" light). These patterns are consecutively run through an optical processor in which a laser beam traverses each of the images in turn to build up a second pattern comprising the "Fourier transform" of the first. For a double star, the composite transform is a set of fringes from whose orientation and spacing the relative position and separation of the two components can be respectively inferred.

In the composite transform of Eta Orionis on the facing page we see two sets of fringes. The fine set of close to a hundred fringes originates in a pair of stars which can be discerned visually under conditions of good seeing (minimal atmospheric turbulence), their separation being about 1.6 seconds of arc. The broad set of three fringes (running from the one to the seven o'clock positions) testifies to a third star never before resolved although betrayed spectroscopically by regular oscillations in the line spectrum of the primary star over a period of 9.2 years. The angular distance between the brightest component and the previously hidden component, fortunately at its maximum here, still amounts to only 0.044 arcsec – and even that is not the smallest separation resolved to date.

Eta Orionis is quite a curious system: a visual triple system whose brightest component is itself a spectroscopic triple. The fringe structure seen here refers only to the two brightest components of the visual triple (narrow fringes) and the brightest member of the spectroscopic triple (broad fringes), the other two members – an eclipsing binary of 8-day period – remaining unresolved. All told, Eta Orionis is at least a quintuple system with a total mass over 50 times that of the Sun.

The new data supplied by speckle interferometry make it possible to calculate the distance of Eta Orionis, the absolute magnitudes and the masses of its components. Four out of the five stars turn out to be intrinsically very luminous, hot and massive – although the system appears only moderately bright because of its distance, over 1300 light-years. "This is the first time," comments McAlister, "that masses and luminosities have been directly determined for such intrinsically bright stars."

Date:	16 December 1975 (opposite); 2 December 1976 (above)
Place:	Kitt Peak National Observatory, Arizona
Photographer:	H.A. McAlister, Georgia State University
Apparatus:	Speckle-interferometer camera on 4 m Mayall telescope, 200 Å filter centred at 5500 Å; optical processor for composite transforms
Emulsion:	Kodak Tri-X
Exposure time:	0.02 sec (50 exposures [opposite])
Source:	Photographer
References:	McAlister 1976, McAlister 1977, Labeyrie 1978, McAlister 1985

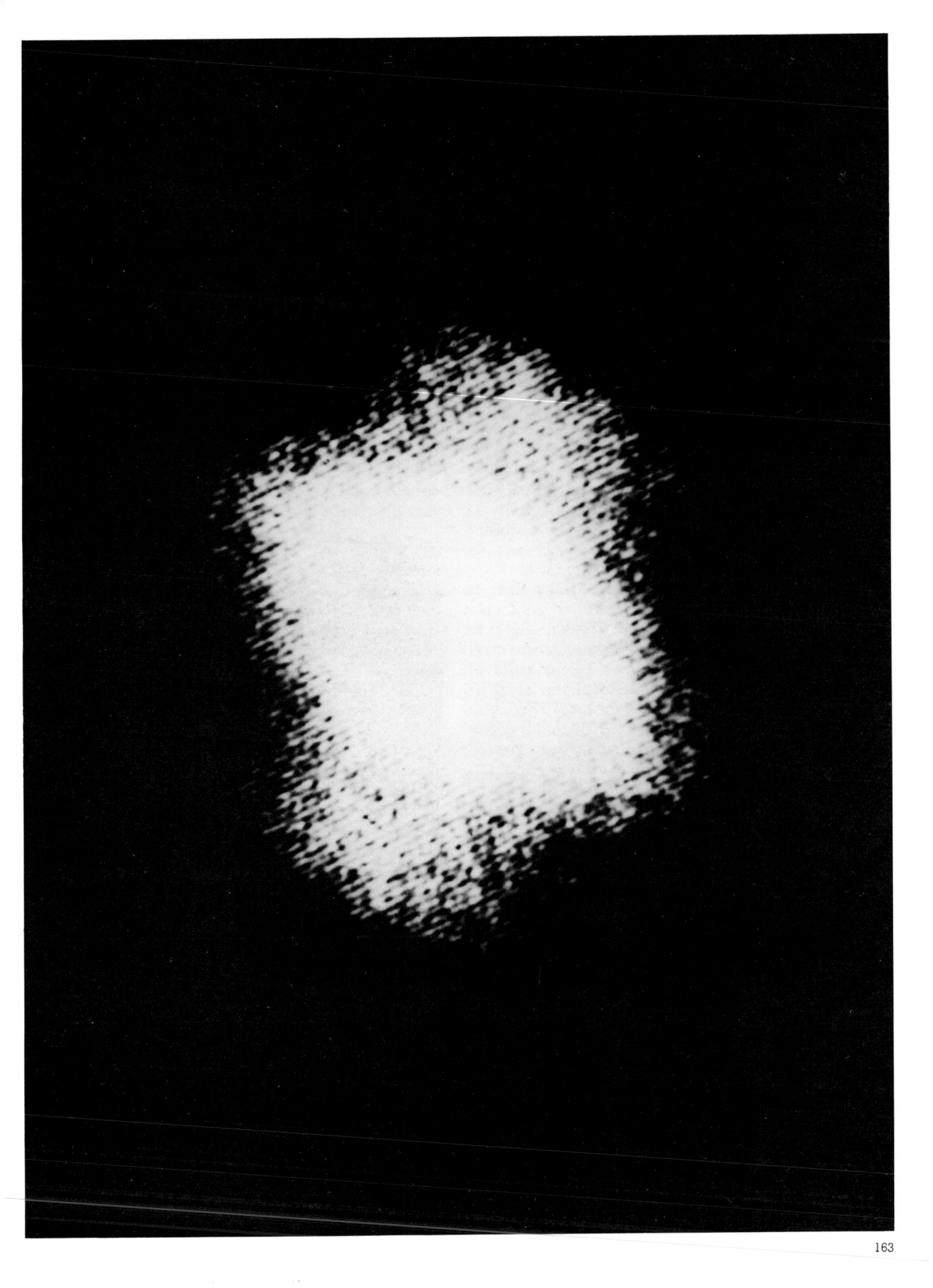

The Faintest Threshold

Astronomy more than any other science has instigated and in turn benefited from research into imaging at low light levels. Contemporary techniques developed largely by and for astronomers, such as image intensification and photon counting, are jostling each other to push back even further the faintest threshold of observation. It comes as a surprise that photography, the most traditional form of imaging, can still hold its own among them.

It seems only logical that instruments capable of recording the arrival of a single photon of light must *de facto* be the means of capturing the very faintest images. In the real world, however, the crucial factor is not so much detection as discrimination – the capability of distinguishing image from background, signal from noise. It is in this discriminatory ability that conventional photography, assisted by unconventional processing techniques, scores most successfully.

Contrast enhancement of faint photographic images can be achieved with a technique announced in 1978 by its inventor David F. Malin of the Anglo-Australian Observatory. Called "photographic amplification", the technique relies on the fact that whereas background fog is distributed throughout the thickness of the emulsion, faint images preferentially affect grains lying near the surface. Images so faint as to be totally invisible to the eye and not even detectable by normal densitometry can be recovered from these upper layers by Malin's method.

Normal printing techniques would encourage grains throughout the emulsion to contribute to the final image, and any latent detail in the top layers would be swamped by the contribution of extraneous photons from lower down. Malin advocates using a vacuum-contact printer with a *diffuse* light source so that, in his words, "Fog grains at lower levels are not resolved and add a uniform neutral density which has no effect on the image. The signal-to-noise ratio is thus improved." For the technique to work successfully, it is essential that modern fine-grain emulsions (such as the Kodak IIIa range) be used and that the plates be taken under optimum conditions. Atmospheric haze, after all, will be enhanced by the very same process which amplifies interstellar nebulosity!

Some astronomers remain slightly incredulous whilst others have reacted with enthusiasm. Photographic amplification has been utilized to great advantage in the study of supernova remnants, comet-shaped dust globules, nebulosity associated with star clusters, and external galaxies – notably in the discovery of shells around certain elliptical galaxies. One elliptical galaxy to which Malin's technique has made a spectacular contribution is M89 (M for Charles Messier, who discovered and catalogued it in 1781), also called NGC 4552.

Pictured opposite, the relatively nearby galaxy M89 could have been taken as the prototype of normal elliptical galaxies until just a few years ago. Its detection at radio frequencies by D. S. Heeschen in 1970 led to classification as an "active" galaxy, but unlike others of the ilk it does not display emission lines in its spectrum. Commenting on this curious inconsistency in 1971, M. J. Disney and R. H. Cromwell suggested that an exceptional amount of interstellar dust and cool gas might be obscuring emission from the nucleus. Although it raises as many questions as it answers, Malin's amplified photograph does reveal plenty of low-contrast material associated with M89 and helps lift it still further from the category of normalcy.

A jet of matter shoots southwest and two concentric shells plus hints of a third encompass the main body of the galaxy (north is at top and east to left). One model for active galaxies pictures such shells and jets as the current manifestation of successive explosions from the nuclear region in aeons past. Moreover, R. D. Ekers and also R. A. Sramek found variations in radio flux, attributed in other active galaxies and quasars to an expanding cloud of relativistic electrons. The variations point to a "small" source only about 50 times the size of our Solar System and a "slow" rate of expansion around 1500 km per sec.

The shells could be composed of outflung gas, but are now thought to be remnants left over from a galactic coalition. "Normal" elliptical galaxies display just the central ellipsoid of stars whereas merged galaxies may disclose wispy appendages under photographic amplification. The envelope of M89 is rendered visible here by superimposition of three amplified (contrast-enhanced) plates. If you have trouble discerning the northeast arc (upper left), all that is visible of the outermost shell, it is hardly suprising: at 29 mag per square arcsecond it is claimed to be the faintest image ever recorded.

Date:	28 March 1976, 26 February & 24 May 1977
Place:	U.K. Schmidt Telescope, New South Wales
Photographer:	D. F. Malin, Anglo-Australian Observatory
Apparatus:	1.2 m UKST
Emulsion:	Kodak IIIa-J (3 plates amplified, superimposed)
Exposure time:	70, 64 & 32 min respectively
Source:	Photographer
References:	Malin 1978, Malin 1979, Allen 1982

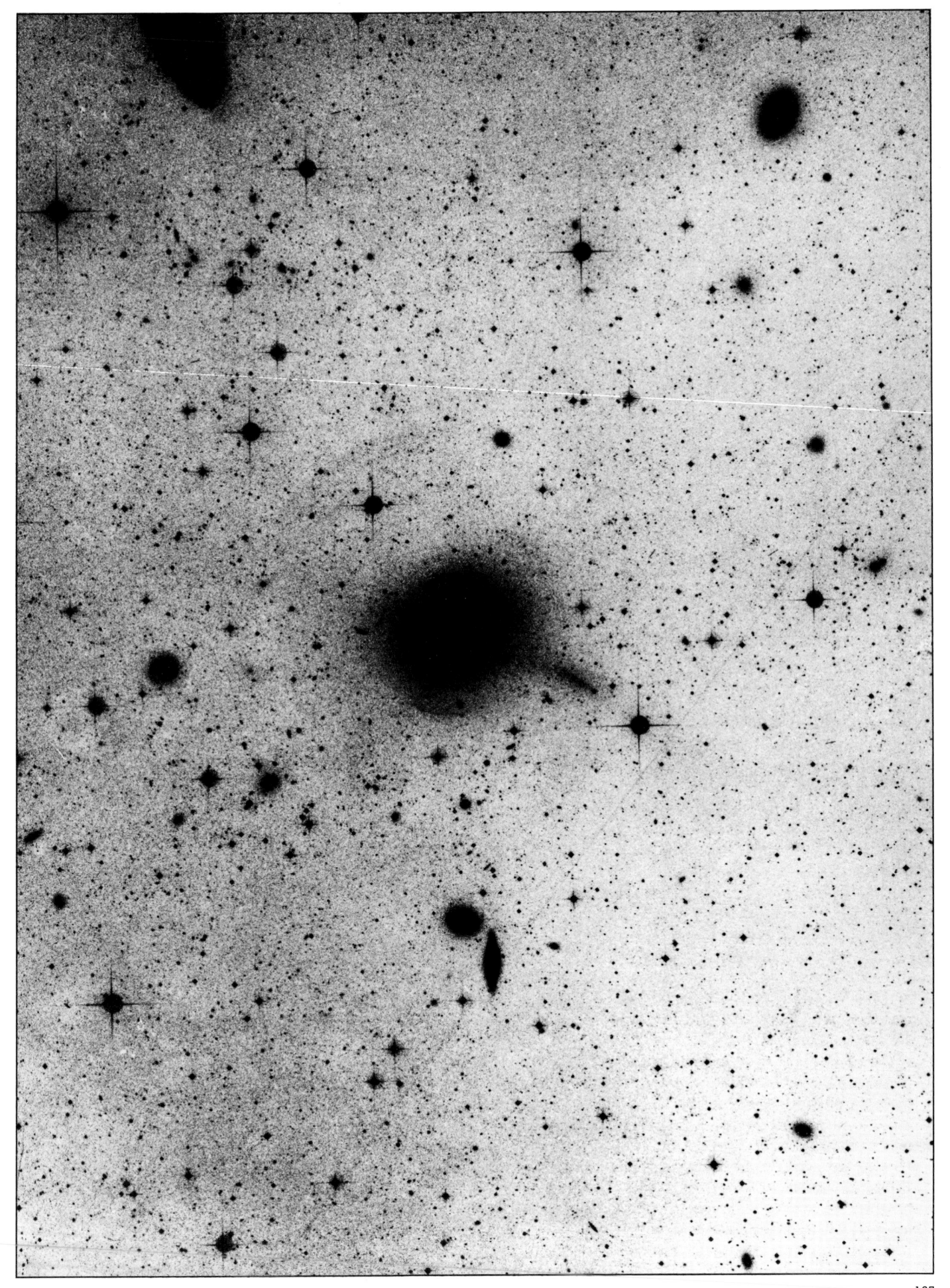

Martian Sploshes

In a global survey lasting four years, the pair of Viking orbiter satellites provided superb photographic coverage of Mars. Although Mariner 9 had embarked on a similar mission in 1971 (p 136), it lasted only $11\frac{1}{2}$ months and transmitted 7300 images against the 55,000 returned by the two Vikings. Perhaps it is not too surprising, then, that some martian landforms had to await Viking for proper scrutiny – notably the rampart craters exemplified by Yuty on the facing page.

Viking 1 orbiter, responsible for this image, achieved orbit about Mars on 19 June 1976. The first function of the orbiters' cameras was to vouchsafe their respective landers a trouble-free landing site (pp 168–169), but thereafter their mission turned to surface geology and atmospheric dynamics. In conception the Viking cameras were the progeny of their Mariner forebears, but with an important difference. Instead of pairing a wide- with a narrow-angle camera as on Mariner, each Viking orbiter bore two identical telephoto cameras shuttered alternately every 4.5 seconds for efficient operation. Recall that the earliest Mariner to reach Mars (p 122) yielded images of 200×200 pixels covering an area of 55,000 sq km at best and displaying surface features on a brightness scale of 64 levels. By contrast, Viking could image 1800 sq km with a raster of 1050×1182 pixels on a brightness scale of 128 levels – in other words, *very* much higher resolution (40 metres) with twice the discrimination in shading. But there is a price to pay: with 10 million bits of data comprising each frame, live transmission as from the Viking landers was out of the question. Each of the Viking orbiters therefore carried a digital tape recorder.

Yuty Crater, the first of its type to be discovered, differs markedly from the impact craters of other bodies in the inner Solar System, in particular Mercury and the Moon. There a typical large crater displays a central peak, a raised rim with terraced walls, a surrounding ejecta blanket, a spattering of secondary craters and occasionally long radial streaks called rays. Lesser craters may lack the central peak and terraces, and the smallest possess bowls in place of flat floors. Many martian craters share these characteristics except for the nature of the ejecta blanket. Instead of a continuous jumble of débris out to a distance of one crater diameter beyond the crater rim, tongues of material appear to have flowed outward from the impact site. The escarpment which outlines the flowing deposits of ejecta gave rise to the name "rampart crater".

Rampart craters were in fact first recognized by J. F. McCauley on images taken by Mariner 9, but he attributed their lobate edges to wind erosion. These craters were not intensively studied, nor was their relatively widespread distribution appreciated, until the arrival of Viking. Note the multiple layers of ejecta deposition around Yuty Crater, successive flows like the overlapping petals of a flower. One investigator evocatively refers to such impacts as "splosh craters". The partly buried crater to the left of Yuty itself provided an inadvertent clue to the nature of the flow. The smaller, older crater remains quite clearly visible so that the flow, however dense it may have been, must have been fairly thin – more like a mud flow or an avalanche than a ground surge. Moreover, the flow is halted and even deflected by the rim of neighbouring Wabash crater (bottom). Yuty, 18 km in diameter, was named after a village in Paraguay; Wabash, after a town in Indiana.

Although trapped atmospheric gases could have lubricated the flows following meteoritic impact, perhaps melted and vaporized ground ice is a more likely agent. The steep scarps limning the outer ramparts may have been built up as material continued to reach the limit at which the flow ceased and the groundwater refroze. A terrestrial avalanche produces comparable ridges at its outer extremities.

Such lobate flows are typical of fresh crater ridges on Mars of diameter 15 km or greater located within $\pm 40°$ from the equator. Inside the crater walls, on the other hand, there is little to distinguish martian craters from those of Mercury and the Moon. However, the transition from a bowl shape to a flat floor takes place at a diameter of 5 km and above on Mars, and of twice that size on its cratered counterparts.

Date:	22 June 1976
Place:	Viking 1 orbiter, 1877 km over Mars
Apparatus:	Vidicon camera, telephoto lens of focal length 47.5 cm; computer enhancement
Source:	J. E. Guest, University of London Observatory; NASA
References:	Carr *et al.* 1977, Spitzer 1980, Carr 1981, Mouginis-Mark 1981

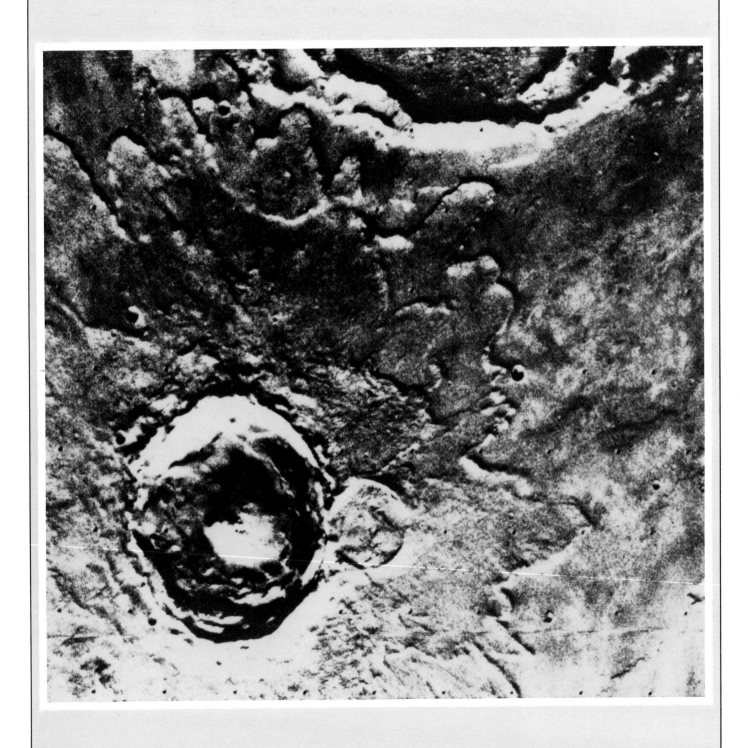

First Colour Landscape of Mars

The first colour photograph taken by the Viking 1 lander on the surface of Mars ranks as one of the century's classics. The subject may be only a rock-strewn landscape under a salmon-pink sky, but it represents a colossal photographic achievement.

Four weeks and four days earlier, the Viking 1 spacecraft had entered orbit about Mars. The orbiter began relaying images at once, and it soon convinced scientists at mission control in the Jet Propulsion Laboratory (JPL) that the site previously selected for landing – Chryse Planitia (Plains of Gold) – looked too rugged to risk. After a scramble to find a safer alternative, a second site was chosen due west of the first and still within the Chryse basin. On 20 July 1976, only minutes after landing – excluding the 19 minutes' relay time from Mars to JPL – the Viking lander camera returned a photograph of the lander footpad with adjacent dust and pebbles. It would transmit another 2500 images before its demise on 11 November 1982 – the last of the four Viking cameras, two orbiters and two landers, to die.

The Viking lander cameras scaled a new peak in the technology of space photography. Designed by the Itek Corporation, they are called "facsimile" cameras after a much older technique for telegraphing pictures. An image is built up line by vertical line and transmitted to the antennas of America's deep-space tracking network without any intermediary recording. Incoming light reflected from the scene being scanned bounces off a mirror through a lens to one of twelve photodiodes. The mirror nods forward to construct a line; then the whole cylindrical camera assembly rotates clockwise to begin the next one. The field of view at any instant from the viewpoint of the photosensor is 2.4, or for colour 7.2, minutes of arc. A colour photograph is created from a set of three images using red-, green- and blue-filtered photodiodes.

It is a measure of how much we had still to learn about Mars at the inception of the Viking mission that the *genuine* first colour photograph (top) was released in the "wrong" colours eight hours after its arrival. Several days later, sheepish members of the JPL imaging team released the *official* first colour photograph (bottom). "We failed to appreciate ... the many subtle problems which, uncorrected, could produce major changes in colour," wrote Thomas Mutch and Kenneth Jones later. "When the first colour data from Mars were received on Earth, we immediately used the same normalization techniques to calibrate the image. The result was surprising and disquieting. The entire scene, ground and atmosphere alike, was bathed in a reddish glow. Unwilling to commit ourselves publicly to this provocative display, we adjusted the parameters in the calibration program until the sky came out a neutral grey. At the same time, rocks and soil showed good contrast; the colours seemed reasonable.... But to our chagrin the sky took on a bluish hue during reconstruction and photoreproduction. The media representatives were delighted with the Earth-like colours of the scene."

Subsequent analysis confirmed that the unearthly "reddish glow" was closer to the reality on account of dust particles suspended in the atmosphere. To duplicate the view as a human eye would see it, the imaging team had to compensate for unnatural saturation in the first image and to correct for contamination of the primary colours by radiation in the near infrared region. Correction for the infrared leak typically emphasizes yellow at the expense of red, turning sienna to ochre. But it must be borne in mind that soil which would appear yellow-brown to a human eye on Earth takes on a more orange hue on Mars through the filtering effect of airborne dust.

In this image the Sun is nearly overhead as the camera scans the southeasterly view. Small blocks of rock litter the surface, probably composed of an iron-rich clay, as far as the eye can see. From the Orbiter the Chryse region looks not unlike a lunar mare, but the density of rocky fragments is higher when studied at ground level. The blocks were probably formed in the course of an ancient meteoritic impact.

Date: 21 July 1976
Place: Chryse Planitia, Mars
Apparatus: "Facsimile" scanning camera with colour filters; computer reconstruction
Exposure time: 6 min (slow scan)
Source: Jet Propulsion Laboratory, Pasadena, California; NASA
References: Huck *et al.* 1975, Huck *et al.* 1977, Anon. [Mutch & Jones] 1978, Carr 1981

The Wrinkles of Phobos

The two small satellites of Mars Phobos and Deimos – literally Fear and Terror – received names appropriate to accolytes of a planet called after the god of war. Strict accuracy would require that the Greek god Ares be substituted for his Roman equivalent Mars, but no matter. Although they were first imaged by Mariner 9, it was Viking which transferred their violent associations from mythology to science. Here Phobos can be seen raked with fracture lines produced perhaps by tidal stresses induced by its bellicose parent, perhaps by the impact of a large meteoroid.

The first analysis of Phobos and Deimos based on Viking imagery inadvertently celebrated their discovery by Asaph Hall at the U.S. Naval Observatory (USNO) in 1877. Phobos, the closer moon, averages 11 km in radius and orbits Mars in 7.7 hours; Deimos averages 6 km and orbits in 30.3 hours. Both are highly aspherical lumps, heavily cratered (Phobos more obviously so than Deimos) and dark as volcanic ash. But Phobos differs in two important respects, its secular acceleration and the parallel striations on its surface.

The slow, steady decrease in the orbital period of Phobos was detected by another USNO observer, A. B. Sharpless, in 1945. This puzzling decline remained controversial for several decades, but Mariner 9 confirmed it. Iosif Shklovskii and Carl Sagan averred that it might point to a low density, such as occurs in largely hollow artificial satellites. But Mariner 9 disposed of the intriguing notion that an extraterrestrial intelligence might be responsible when its cameras imaged a satellite resembling a battered asteroid rather than a technological artefact. It is now clear that atmospheric drag gives rise to the secular acceleration. Perhaps it sounds odd that drag should induce an *acceleration*, or concomitantly a *decline* in period. The reason is that the slight but persistent frictional drag forces Phobos into a lower orbit where by Kepler's third law it must revolve faster. The process will terminate in a mere 100 million years when Phobos or what is left of it plunges to the surface of Mars.

Well before that cataclysm, Phobos can be expected to break up, torn apart by tidal forces wrought in its solid crust by Mars itself. At 9450 km Phobos has already strayed within the distance first identified by Edouard Roche in 1850 at which the differential force of gravity on the front and back of the satellite overwhelms its self-gravitation.

(Some texts claim that Phobos lies just *outside* the Roche limit, which would be true if its density were 3 g per cc, corresponding to a mainly basaltic composition. Measurement of the satellite's mass during an encounter by Viking implied a density of 2 g per cc – at a stroke confirming a composition akin to that of the ancient carbonaceous chondrite meteorites and nudging the Roche limit out to 10,400 km.)

The first scientific reaction to the parallel grooves on Phobos was that they might mark successive flows of lava on a parent body from which this jagged fragment was sundered. That explanation was soon supplanted by the idea that tidal fracturing has already begun, the first step in a process which will split the satellite apart and could eventually generate Mars' own ring system from the remnants. Since the linear grooves appear to be associated with Stickney, the largest crater on the satellite, there is also the possibility that they may be simply the aftermath of a violent impact.

Grooves in the image opposite, typically 150 to 200 m in width, can be traced for at least 5 km in length. The crater Stickney, 10 km in diameter, lies beyond the terminator at right. The second largest crater, Hall, lies in the south polar region out of sight at the bottom. (The names originate in discoverer Hall and his wife Angeline, née Stickney.) Roche, the third largest, is visible as a large depression overlain with fresh, young craters in the north polar region at the top of the image. The whole area is about 9 by 18 km and the resolution 40 m or a bit more. The significance of this particular image lies not only in the fact that it can claim to be the discovery photograph of the controversial grooved lines, but also in the nature of the martian moons. Since they were very probably captured from the asteroid belt, this may be our first close-up view of one of the chunks of rock in the zone between Mars and Jupiter.

Date:	18 September 1976
Place:	Viking 2 orbiter at 885 km from Phobos
Apparatus:	Vidicon camera with telephoto lens of focal length 47.5 cm; computer reconstruction
Exposure time:	50 msec
Source:	Jet Propulsion Laboratory, Pasadena, California; NASA
References:	Veverka 1977, Gornitz 1979, Spitzer 1980, Yoder 1982

The Gaseous Torus of Io

Not all the greatest advances in exploration of the giant planets can be laid at the door of the Pioneer and Voyager probes. The startling discovery in 1973 that Io, innermost of the four Galilean satellites orbiting Jupiter, displayed sodium emission lines led to this remarkable photograph four years later. The lines originate in a cloud of gaseous sodium centred on Io (white dot) and distributed along its orbit (white lines) in a huge if patchy torus.

Well before the startling surface features of Io were imaged with remarkable clarity by the two Voyager spacecraft (pp 192–193), it was recognized that it possesses some odd characteristics. It has the high reflectivity one might expect from a sphere of ice, yet infrared observations failed to support this supposition. It modulates the decametric radio emission generated in bursts within the jovian magnetosphere. Then Robert Brown discovered the sodium emission and the following year Larry Trafton and his colleagues at the University of Texas realized that the spectral features arise in an extended region about Io. Spectrophotometry carried out around the same time suggested a surface of metallic salts with sodium predominant. The notion that atoms of sodium were somehow being ejected from the surface emerged, and in 1977 Bruce Goldberg photographed the sodium cloud with his colleagues Torrence Johnson, Dennis Matson and James Young of the Jet Propulsion Laboratory (JPL).

A major difficulty in recording sodium from Io and vicinity is the fact that we see the satellite by reflected sunlight – and the Sun contains plenty of sodium in its own right. So the research team settled on slitless spectroscopy at the coudé focus of the 61 cm reflecting telescope of Table Mountain Observatory, a glass plate with an elliptical aluminium dot replacing the usual slit. Io was cunningly eclipsed by the dot while the data used to prepare the image shown here were acquired with a vidicon-tube image intensifier. Another mask occulted Jupiter.

The false-colour photograph below is a composite prepared by computer, the image of Jupiter (north pole at top) having been taken at a different time and place. Immediately obvious is the asymmetry of the cloud, clearly most intense in the west (to right) ahead of Io in its orbit. (The dark patch where a dot the size of Io has been added reveals the shadow of the aluminium occulting disc.) In extent it runs apparently 200,000 km ahead of Io, but of course it may spread much farther along yet fall below the detector's limit of sensitivity. Indeed, independent spectroscopic measurements subsequently showed that the cloud continues at least half-way round the orbit and contains potassium and sulphur atoms in addition to sodium. The portion of the torus nearest Io is likened to a banana by the JPL team, but the artificial orange-yellow colour was chosen for a quite different reason: it corresponds to the wavelengths of the sodium D lines emitted by the cloud, and for that matter by sodium-vapour streetlights. Data were

recorded digitally for each of the two D lines separately and later added to create this photographic end-product.

It need hardly be said that the reconstruction below, although incorporating the Table Mountain observations, is a far cry from the character of the original data set. It seems fitting that the vidicon image frame from which the historic photograph below was prepared should be shown as well. This monochrome image appears below left with the same orientation as the false-colour composite. The spectrograph was aligned to disperse light vertically, yielding two images of the cloud, one for each of the sodium D lines (5896 Å above and 5890 Å beneath). Despite the oval mask (the two dark spots) some reflected sunlight spills over to give the two parallel streaks running from top to bottom at centre. The glow increasing toward the right betrays the presence of Jupiter whose brilliant light cannot be completely masked.

In his famous Adams Prize Essay of 1857, James Clerk Maxwell proved that gaseous rings are unstable. That we can see a ring which is bound to disperse soon after formation must therefore mean that it is constantly being replenished. What feeds the Io torus? Presumably it must be some form of surface emission from Io itself, but at the time when this picture was taken volcanism seemed too outrageous to consider seriously. (Volcanoes on Io were not discovered until 1979 [p 194].) The best model on the basis of these cloud images was one which called for anisotropic sputtering of atoms from Io's surface by the flux of energetic particles accelerated in Jupiter's magnetic field.

Volcanism looked attractive as a supply mechanism for the sodium cloud for only a short time: it soon became clear that escape velocity from Io tends to be higher than the rate at which its volcanoes spew out matter. Sputtering seems to be the correct process after all, although additional refinements are required to account for the change in the cloud's shape according to Io's orbital position. The sputtering agents appear to be electrons volleying up from Jupiter in response to bombardment by protons from the jovian magnetosphere. Emission intensity is 20% lower at western than at eastern elongation, which Io had just passed at the time this image of the cloud was recorded. The greater part of the cloud visible here remains stable over periods of a few years (perhaps longer), but the farther reaches of the torus fluctuate in the course of a month or less.

Date: 19 February 1977
Place: Table Mountain Observatory, California
Photographers: B. A. Goldberg, D. L. Matson, T. V. Johnson & J. W. Young
Apparatus: 61 cm telescope with Silicon Imaging Photometer System, RCA 4804 SIT detector; false-colour reconstruction
Exposure time: 3 hr
Source: B. A. Goldberg, Jet Propulsion Laboratory, Pasadena, California
References: Matson et al. 1978, Goldberg et al. 1980, Morrison & Samz 1980

Oasis on the Ocean Floor

Increasingly accurate maps of our planet, both land and sea, have diminished the chances of finding fundamentally new territory anywhere on the globe. Yet as recently as 1977 a spectacular oceanographic discovery brought new life-forms and new seabed land-forms into the limelight. First indications of a potential find consisted of higher temperatures in seawater near the boundaries of crustal plates in the Pacific Ocean, but the ultimate discovery of hot-water vents was essentially photographic.

In February 1977 the research vessel *Knorr* set out for the Galápagos Rift, an oceanic ridge created as the huge Cocos and Nazca Plates spread slowly apart. Sea-floor spreading, a principal feature of the once controversial theory of continental drift, arises when hot magma welling up from the underlying mantle shoves the plates aside. With the aid of a previous bathymetric survey, the *Knorr* was positioned near the rift valley and the unmanned sled ANGUS readied for lowering.

ANGUS – an acronym for "acoustically navigated geophysical underwater system" – bore an automatic camera to take strobe photographs every ten seconds as the sled traversed the ocean bottom in long straight swaths. Half-way through the twelve-hour scan, a temperature sensor aboard ANGUS showed an abrupt rise before falling back to its usual value, two degrees above freezing. After 3000 colour photographs had been automatically exposed on the 130-metre roll, ANGUS was winched upward and the film processed aboard ship.

As one might expect of a mid-ocean ridge, the dominant feature of the photographs was lava – sometimes mounds of pillow lava, sometimes the black glassy form known in Hawaii as "pahoehoe". Let geologist Robert Ballard of Woods Hole Oceanographic Institution describe what happened as the frames corresponding to the temperature rise came into view: "The photograph taken just seconds before the temperature anomaly showed only barren, fresh-looking lava terrain. But for thirteen frames (the length of the anomaly), the lava flow was covered with hundreds of white clams and brown mussel shells. This dense accumulation, never seen before in the deep sea, quickly appeared through a cloud of misty blue water and then disappeared from view. For the remaining 1500 pictures, the bottom was once again barren of life." One of the thirteen crucial frames is reproduced opposite.

At this stage it was amazing enough to find life 2500 metres beneath the sea, but greater surprises lay in store. Water samples collected by divers in the submersible *Alvin* stank of hydrogen sulphide, the odour of rotten eggs. The giant clams proved to be the first of many new additions to the annals of marine biology (p 184). These creatures belong to submarine communities clustered round the hot water of a thermal vent – oases of life in a sea otherwise so cold as to discourage living organisms.

The first vent community, shown here, was predictably named Clambake I; with ANGUS' assistance it was soon joined by others. This is an active vent, but at others a cemetery of white shells attests to extinction of the hot spring. The warmer temperatures, 6 to 14°C above normal, may encourage colonies of marine animals but the major puzzle was how they could thrive in the absence of sunlight.

When sample clams of the variety shown opposite were brought to the surface and prised open, they revealed scarlet tissues reflecting a high haemoglobin content – the same iron-rich substance found in red blood-cells. The presence of haemoglobin, with its strong chemical affinity for oxygen, probably signifies adaptation to an oxygen-poor environment. The clams turned out to be a new species of the genus *Calyptogena*, larger (up to 30 cm) and faster-growing (3.8 cm a year) than their deep-sea cousins. *Calyptogena magnifica*, as they are called, feed by filtering nourishing organic débris and sulphur-oxidizing bacteria from water around the vent. Their gills are found to contain enzymes capable of taking full advantage of the sulphide-rich environment of submarine hot springs.

The significance of the discovery of hydrothermal vents is at once biological and geological. The ecosystem of a vent community is founded on chemosynthesis, not photosynthesis: the first time that chemical reactions, fuelled by a geothermal source, have been found to supplant sunlight as the driving force. The hot vents themselves contribute to our understanding both of plate tectonics and of the chemical composition of the ocean.

Date:	16 April 1977
Place:	Galápagos Rift, Pacific Ocean
Photographers:	Galápagos Hydrothermal Expedition
Apparatus:	ANGUS sled with Benthos 35 mm camera plus strobe (250 J)
Emulsion:	Ektachrome (200 ASA)
Exposure time:	1 msec
Source:	R. D. Ballard, Woods Hole Oceanographic Institution, Massachusetts
References:	Ballard 1977, Corliss & Ballard 1977, Ballard & Grassle 1979

Discovery of Charm

The first nuclear event to convince physicists that "charmed" particles exist came to light in a stack of photographic emulsions placed at the window of a hydrogen bubble chamber. Charm is one of the "flavours" of quarks, the constituent particles of what were once considered truly elementary particles.

The quest for the fundamental building blocks of matter has attracted interest since the days of Democritus and Lucretius. Dalton in the last century had reason to believe that the most elementary level had been reached with atoms; Lord Rutherford and his generation, with half a dozen particles (1933) which grew to a score (1950), doubled by 1965 and now exceed a hundred. As elementary particles grow in number, so does the philosophical temptation to reduce the increasing complexity to a fresh simplicity. By 1961 physicists prepared to take over from the philosophers.

In that year Murray Gell-Mann and George Zweig (and Y. Ne'eman independently) found by means of group theory that particles could be classified far more tidily if they were viewed as collections of constituents called quarks following Muster Mark in Joyce's *Finnegans Wake*. Naturally these subunits would have to possess fractional charge. After some modifications the theory now calls for six flavours of quark (up, down, strange, charmed, bottom and top), each flavour coming in three colours (blue, yellow and red). These evocative labels could not have less in common with the normal meanings of flavour and colour but must be preferable to, say, quarks numbered 1 to 6 with x, y or z characteristics. To each quark there corresponds an antiquark; so all told, the number of new subparticles could be 36.

The nuclear particles called leptons (including the light particles like electrons and neutrinos) which are not affected by the strong nuclear force escape subdivision in the new scheme of things. However, heavier particles called hadrons – susceptible to the strong force – are thought to be composed of subunits, three quarks for baryons like the proton and neutron, a quark and antiquark for certain mesons. A still heavier particle first implied the existence of a subunit bearing charm: the particle called J by Samuel Ting in Michigan, psi by Burton Richter in Stanford, and inevitably "gypsy" by the scientific press. The attribute of charm is suggested by its surprising stability, its delay in decay. Sir Denys Wilkinson once said of this peculiar behaviour that "it is as astonishing as if Cleopatra had fallen off her barge in the Nile in 35 BC but splashed into the water only today."

The slow decay of charmed quarks brought them within reach of detection by traditional stacks of nuclear photographic emulsions. They possess high spatial (if poor temporal) resolution and suit the task ideally when coupled with a bubble chamber, which through its alternate expansion and recompression supplies the time resolution. The other great advantage of this partnership is purely practical. To scan the 30 litres of silver bromide film with a microscope at a resolution of 250 billionths of a metre would require, in the facetious estimate of experimenter Don Davis, 1500 man-years! Alternatively, one can use the tracks observed on

a bubble-chamber photograph as pointers to the positions worth investigating in emulsion stacks by the relevant window.

In this historic experiment, the Super Proton Synchrotron of CERN was employed to provide an energetic (350 GeV) neutrino beam passing through the stacked emulsion into the Big European Bubble Chamber, filled with liquid hydrogen. This time (cf. pp 134–135) neutral currents were not sought, only charged currents in the form of a neutrino interaction yielding a stable charmed particle. Of 169 charged-current neutrino events found in a search of 206,000 photographs, eight produced charmed particles but only one yielded a charmed baryon of unambiguous identity. On the photograph at right taken by xenon flash, the decay products of what proved to be a charmed particle are visible, labelled (left to right) as a proton, elastically scattered at the end of its range; a positively charged pion; and a negative K meson, or kaon.

Extrapolating backward, the experimenters (a team of 41 from 9 institutions in 6 countries) found the long, nearly straight track of the charmed lambda particle of positive charge between its creation in a neutrino interaction (star at left, below) and its decay (three prongs at right). Very close scrutiny will confirm that the photomicrograph below, far from being all of a piece, is actually assembled from many vertical strips representing different depths in the nuclear emulsion. The length of the track of this first charmed baryon to be directly observed is only 0.35 mm and its duration (decay time) is almost a million millionth of a second – remarkably long by nuclear standards!

Date: October 1977
Place: CERN, Geneva
Photographers: Ankara – Brussels – CERN – UC Dublin – UC London – Open University – Pisa – Rome – Turin Collaboration
Apparatus: Emulsion stacks (below) facing Big European Bubble Chamber fed by Super Proton Synchroton; field 35,000 gauss; Zeiss wide-angle lens (above)
Emulsion: Ilford G5 (below); Agfa 39–D–65 (above)
Exposure time: Flash duration 2–3 μsec (above)
Source: D. H. Davis, University College London
References: Angelini *et al.* 1979, Davis 1981, Mulvey 1981

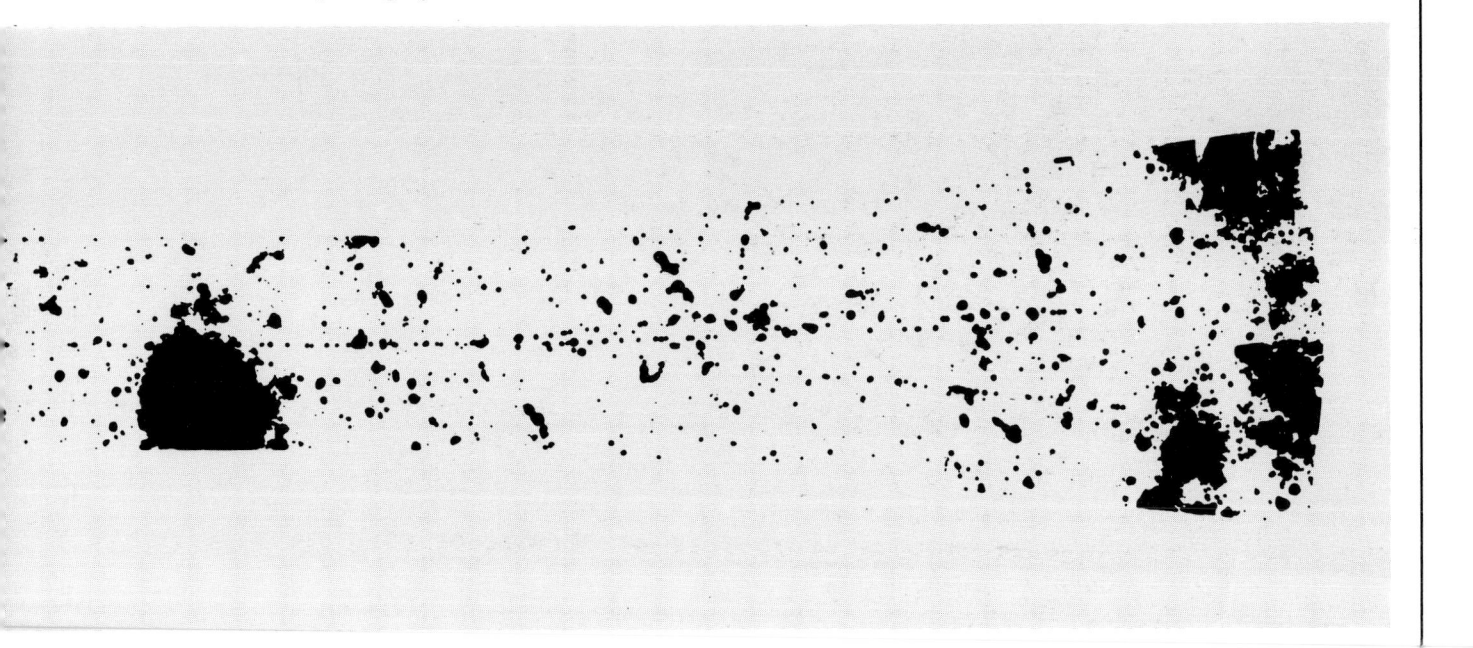

Analemma in the Sky

Sundial owners will be familiar with the figure-of-eight which the Sun traces out against the sky in the course of a year. They know it as the analemma, and it provides a correction to solar time (the so-called equation of time) to allow for the changing rate at which the Sun traverses the sky. The analemma used to figure on terrestrial globes but under the influence of modern time-keeping practices it seems to have died out.

This photograph is a masterpiece of time-lapse photography, a supreme illustration of scientific principles even though it serves aesthetic more than scientific ends. The extent of its impact may be gauged from a comment by the photographer, Dennis di Cicco (assistant editor of the popular journal *Sky and Telescope*): "I knew it would be a unique picture, and figured it would catch the attention of astronomers and might end up in astronomy books. I did not expect it to appear in more than a score of major magazines, over a dozen books, national advertising by Kodak, and something like 10 different languages! Counting the press runs of the different publications that the picture has appeared in, it has been reproduced well over 10 million times." Moreover, it won a top prize in the first science photography contest (1983) held by the American Association for the Advancement of Science.

In a model world where the Earth orbits the Sun in a perfect circle, its equator coplanar with its orbit, di Cicco's photograph would have been reduced to a single saturated dot. But the Solar System is less perfect than the Aristotelians supposed. The loops result from the inclination of the Earth's equator to its orbital plane (by 23.44 degrees); the fact that the loops are unequal, from the slight eccentricity of the Earth's orbital path about the Sun. The eccentricity amounts to only 0.01675, so the Earth's orbit does look very nearly circular. It is this orbital eccentricity which causes us to accelerate near perihelion (closest approach to the Sun) and slow down near aphelion (farthest recession).

Because of our axial inclination, the Sun apparently climbs in northern-hemisphere skies from December to June (underlying curve from bottom right to top left) and apparently drops down again from June to December. At the extremities we experience the winter solstice and the shortest day (bottom right) or the summer solstice and longest (top left). The curves cross on the celestial equator where we encounter the vernal and autumnal equinoxes.

Taking the picture required careful planning; as a matter of fact, the first time-lapse photograph did not work out as intended and di Cicco refers to it jocosely as his one-year test exposure. For the photograph opposite one exposure per week – every seven or eight days according to the weather – was taken automatically at exactly 13:30 (Universal Time), that is 8:30 or 9:30 local time, through a filter of neutral density (ND) 4.0. The three streaks show the rising Sun (through a filter of ND 6.0) near the solstices and near one equinox – the autumnal one since the presence of leaves on the foreground tree avoided a strongly exposed solar image. (No such option was available at the winter solstice, and consequently the Sun appears partly in front of the tree.) The foreground exposure was completed in the same season with a polarizing filter to darken the sky.

Note that this photograph is *not* a photomontage of separate pictures. All 48 exposures (44 solar dots, 3 solar streaks, 1 foreground) were recorded on a single frame of film. In fact a 45th Sun cropped up inadvertently when a power failure at a critical time fooled the mains-powered timer into taking a photograph well past 13:30 UT. It was later expunged by photographic retouching.

Date: 27 February 1978 to 17 February 1979
Place: Watertown, Massachusetts
Photographer: D. di Cicco, Sky Publishing Corporation
Apparatus: 10 × 12 cm plate camera with 90 mm wide-angle lens plus electronic timer
Emulsion: Kodak Vericolor II
Source: Photographer
References: Franklin 1962, Oliver 1972, di Cicco 1979

Pluto as a Double Planet

Since the discovery of Phoebe (ninth moon of Saturn) in 1898, all new satellites about planets in the Solar System have been found photographically. Charon, the only known satellite of Pluto, is no exception even though the distance is too great to produce distinct images on a photographic plate. At most it makes its presence known as an elongation of Pluto's image, as shown opposite in a blow-up from an historic early negative. At other times it remains wholly invisible.

The discovery image, properly speaking, antedates the pair of exposures opposite above by almost three months. A positive enlargement from the earlier photograph is reproduced below, showing three exposures within the scrawled parentheses. The departure from a point image – in practice a small spherical clump of silver halide grains – was found with an automatic measuring machine called STARSCAN on 22 June 1978 by James Christy of the U.S. Naval Observatory (USNO). It was so slight, however, that the existence of a companion could not be safely claimed on the basis of this single image. Fortunately, two additional photographs had been taken, with three exposures per plate, and these confirmed the slight protrusion albeit in a different direction on each of the three nights. Archival plates from 1965, 1970 and 1971 further corroborated suspicions that Pluto possessed a moon. At once discoverer James Christy and his collaborator Robert Harrington of USNO initiated a crash programme with the help of C.C. Dahn and H.D. Ables to obtain more photographs and thereby to calculate an orbit for the new satellite.

The name Charon was chosen for the boatman who ferries souls across the River Styx to Hades, the underworld ruled by Pluto. A flood of photographs, both pre- and post-discovery, soon provided all the verification one could ask for and supplied a surprising amount of information about so marginally observable a satellite. Charon orbits Pluto every 6.39 days, maintaining the same face toward the planet just as the Moon does toward the Earth. But Pluto, unlike the Earth, also keeps the same face toward Charon. Thus the two bodies are locked in a spin-orbit coupling such that Charon's rotation period, Pluto's rotation period and their mutual orbital period are all equal. Pluto's rotation period had been determined some five years previously from photometric variations, and the danger that Charon's revolution was masquerading as Pluto's rotation had to be considered. Charon, however, is only 20% as bright as Pluto and the light variation had been far too great for Charon to be the source;

the variation was indeed intrinsic to Pluto and must signify global contrasts in reflectivity.

The fact that Charon's mass is 10% that of its parent planet – the highest ratio in the Solar System – probably accounts for the mutually synchronous revolution. One-sided synchrony is the norm among the planets: satellites evolve dynamically until they spin exactly once per orbit about their parent planets. Large planets, on the contrary, can scarcely be expected to obey the whims of their small satellites, and two-sided synchrony is thus much rarer. After the Pluto-Charon system, the largest mass ratio belongs to the Earth-Moon system although the actual masses of the former are much smaller: 0.002 Earth masses for Pluto and 0.02 Moon masses for Charon.

In diameter Charon is estimated to measure 1400 km as against 3000 km for Pluto – again so large a ratio that the system is sometimes considered as a double planet. They are both thought to consist of icy volatiles yielding a bulk density slightly below that of water. But it would be unwise to draw any conclusions about gross composition; a small underestimate in size, for example, would imply a severe overestimate in density.

Pluto's equator is apparently aligned with the orbital plane as one might expect of two bodies which have evolved to reach rotational synchrony. The orbit is nearly circular, with a semi-major axis (average separation, centre to centre) of 17,000 km. At Pluto's distance this figure corresponds to an angular separation just short of one second of arc; if it had been any smaller, Charon probably would not yet have been discovered. (It is also fortunate that the magnitude difference is no greater.) The orbital plane oscillates with respect to our line of sight to Pluto and thereby affords opportunities for transits and eclipses. These are vital for pinning down the diameters of the "double planet" and thus their densities – which in turn will shed light on chemical evolution in the outer Solar System.

Date: 2 July 1978 (opposite above); 13 April 1978 (below)
Place: Flagstaff, Arizona
Photographers: J. W. Christy & C. C. Dahn, U.S. Naval Observatory
Apparatus: 1.55 m USNO astrometric reflector; GG14 filter
Emulsion: Kodak IIa-D
Exposure time: 2.5 min (opposite above); 1.5 min (below)
Source: R. S. Harrington, USNO, Washington, D.C.
References: Christy & Harrington 1978, Christy & Harrington
 1980, Harrington & Christy 1980,
 Harrington & Christy 1981

Infrared Image of Venus

Viewed by the Pioneer orbiter satellite in the infrared, Venus proved as exciting and unexpected as in the ultraviolet (pp 154–155). The Pioneer Venus orbiter arrived at the planet on 4 December 1978 and whereas its multiprobe companion plunged through the atmosphere five days later, the orbiter is expected to remain active until at least 1986. Invaluable observations have been made *inter alia* of the surface by the radar altimeter, of the cloud tops by the ultraviolet photopolarimeter and for the first time of the middle atmosphere above the clouds (seen here) by the infrared radiometer.

The Orbiter Infrared Radiometer – also called VORTEX for Venus Orbiter Radiometric Temperature Experiment – measures radiation in eight channels from about 0.2 to 50 micrometres (μm), bracketing the range of thermal infrared used for diagnostic thermography (p 126). Thermal emission in the five channels used for temperature sounding corresponds to altitudes of 60 to 105 km in the atmosphere of Venus, or in other words from just inside the cloud tops up to the lower ionosphere. Sadly, failure of its power supply terminated VORTEX on 14 February 1979.

All 72 days of the data available at 11.5 μm were pooled to produce the false-colour composite opposite, centred on the north pole and extending to 50° N at the periphery. It summarizes the two most extraordinary phenomena found by VORTEX: a hot dipole structure (the orange-white dumb-bell) and a cold encircling collar (the violet ring). The colours were chosen arbitrarily to run from violet at about 210 K through orange to white at 260 K.

The collar about the north pole – like its southern counterpart – waxes and wanes over a period of months and also varies in temperature by 5 to 20 K from one (terrestrial) day to the next. With a width of 1000 km but a depth of only 10 km, it resembles not so much a doughnut as a warped washer. Its position in latitude is about 65–75° N or S; and in altitude about 75 km above the surface, or 15 km above the visible cloud tops. Filamentary fine structure, sometimes spiral in shape, can often be seen in the collar although it is totally smeared out in the image on the facing page – not only because of the averaging process but also because the coordinate system is chosen to rotate with the spinning dipole. Thus we see a digitally reconstructed image, gyrating in space, averaged in time, coded in false colours – a more extreme example of "photography" is difficult to imagine!

The polar dipole apparently rotates in the same retrograde sense (clockwise here) as the ultraviolet cloud-top features but almost twice as fast: the average period is 2.7 days. Whereas the collar lies above the cloud tops, the two eyes of the dipole are features scooped out of them to reveal the warmer atmosphere below. The dipole is a pair of clearings in the infrared cloud cover. A clearing of sorts is not unexpected at each pole because the hemisphere-wide Hadley cell (p 154) descends to form a polar vortex like the centre of a maelstrom or the eye of a cyclone. The elongation of the single eye into a dumb-bell, however, presents a challenging mystery. The dipole extends some 15° from the pole on either side over a total distance of about 2000 km. The hot eyes (coded white) of the dipole may reach a brightness temperature of 280 K at 11.5 μm, well short of the surface temperature of 737 K but typically 35 K warmer than the circumpolar collar.

It is remarkable how very different the atmosphere of Venus appears in the ultraviolet (spiral swirls), the visible (blank yellow-white face) and the infrared (polar dipole and collar). One could argue of course that the peak radiative contribution at a given wavelength changes with depth, but in fact the images on p 155 and opposite originate essentially within just 10 to 15 kilometres of each other in vertical depth! The one feature seemingly common to both ultraviolet and infrared is a ring about the pole(s) – yet the polar collar here and the girdle of white cloud on p 155 turn out to be geographically independent. The main reason for the poor correlation between UV and IR is that they are measuring physically distinct phenomena: respectively, absorption of sunlight by compounds in the cloud bank and thermal emission at different levels in the atmosphere. Moreover, the behaviour of the atmosphere changes dramatically with height. The four-day zonal wind which dominates ultraviolet images of the cloud tops at about 60 km drops to zero by 80 or 90 km (in the higher latitudes, at least) where the greater part of the infrared emission originates, the dipole notwithstanding.

Venus offers the prospect of studying on the global scale a meteorological laboratory where Mariner, Venera and Pioneer spacecraft have discovered quite unforeseen phenomena. The equatorial ⊱-pattern, the polar dipole and circumpolar collar are planetary waves for which we have no precedents in the terrestrial atmosphere.

Date: 4 December 1978 to 14 February 1979
Place: Pioneer Venus Orbiter, 150 to 67000 km over Venus
Apparatus: Orbiting Infrared Radiometer, 11.5 μm channel;
 false-colour reconstruction
Source: F. W. Taylor, Clarendon Laboratory, Oxford
References: Taylor *et al.* 1980, Fimmel *et al.* 1983,
 Hunten *et al.* 1983

Solid-State Jellyfish

One of the most remarkable new creatures discovered around hydrothermal vents on the ocean bottom (p 174) is the jellyfish pictured here. For want of a formal name, divers on the submersible *Alvin* who first spotted it in February 1977 dubbed these unknown organisms "dandelions". They are now recognized as a new genus *Thermopalia* in the Rhodaliid family of benthic siphonophores – not the same family as the Portuguese Man O'War but clearly in the same order. The original, jocular designation has in a sense been preserved. The full name of this new siphonophore is *Thermopalia taraxaca*, which could be translated as "dandelion from the hydrothermal vent".

In many ways the photograph by veteran marine photographer Al Giddings is no less remarkable than its subject. When *Thermopalia* jellyfish are transported to the surface from the ocean bed at 2500 m below sea level, their central gas bag crumples in the comparative vacuum of atmospheric pressure. Thus they are properly pictured only *in situ*, their peach-coloured gas bag inflated and their fine tendrils clinging to rocks on the sea bottom. This photograph has another special quality: it is not the result of photochemistry in a film emulsion. Instead it exemplifies a new type of "solid-state" image in which the light input is recorded as a two-dimensional pattern of electrical impulses, reconverted to generate the photograph. The camera consists of a charge-coupled device (CCD) developed by RCA and connected to a colour video system. CCD detectors behave especially well under conditions of low illumination.

The "dandelion" siphonophore may look like a single animal but on closer scrutiny it proves to be a miniature community. The gas bag, or pneumatophore, provides buoyancy; swimming bells, or nectophores (not visible opposite) facilitate movement; the spiral "petals" of the dandelion, or cormidia, serve for feeding and other functions, with bracts for self-protection; the filamentary tentacles anchor the creature to underlying rocks of pillow lava.

Although the towed camera sled ANGUS (operated from the *Knorr* ship) and the manned submersible *Alvin* (from the catamaran tender *Lulu*) photographed the "dandelions" in the Galápagos Rift region in February and March 1977, specimens were not collected until January 1979. Later that year they were also seen in the East Pacific Rise,

another rift area dotted with hydrothermal vents. As a rule they share the vent with other curious submarine fauna though they do tend to prefer the outer edges of the oasis where the temperature is lower. At one site ("Dandelions") in the Galápagos Rift, however, these siphonophores predominate. It must be significant that this is the one vent whose water contains little or no hydrogen sulphide.

Aside from *Thermopalia*, a plethora of new denizens of the deep greeted the cameras of ANGUS and *Alvin*. White galatheid crabs and blind brachyuran crabs circulate among the clam shells. Extraordinary tube worms (a new family of *Vestimentifera*) extending spongy red plumes from flexible white tubes dominate most vents. Bristle worms, aptly called Pompeii worms, survive close to the mineral-rich hot springs whilst spaghetti-like acorn worms (enteropneusts) drape themselves over any solid surface. Other worms, blood-red, live inside mussels in a symbiotic relationship called commensalism. Previously known species also crop up: grenadier fish, sea cucumbers, anemones, limpets.

Since the food cycle of most inhabitants at a vent community is thought to be based on sulphur-oxidizing bacteria, the preference of *Thermopalia* for vents low on hydrogen sulphide strikes a discordant note. The vestimentiferan worms, for example, feed – without the benefit of mouth or digestive system – by means of a happy symbiosis with sulphur-oxidizing bacteria. These tube worms absorb the required inorganic materials through their gill-like crowns, and resident bacteria synthesize organic nutriment. The basic source of energy is not the Sun, as in photosynthesis, but chemical reactions. The food chains for other creatures, however, remain controversial and *Thermopalia* may pick up organic material caught on their filamentary tendrils instead of filter feeding off bacteria.

Date: 1979
Place: Galápagos Rift, Pacific Ocean
Photographer: Al Giddings, Sea Films, Inc.
Apparatus: Video CCD camera by RCA in Benthos housing
Source: National Geographic Society, Washington, D.C.
References: Corliss & Ballard 1977, Ballard & Grassle 1979, Pugh 1983

Atomic Physics Strikes Gold

The dream that single atoms could be visualized was first fulfilled by the field-ion microscope. By now at least three other techniques have also won their laurels: electron-wave holography, scanning and conventional transmission electron microscopy. Electron microscopes did not lag far behind in the hunt for atomic detail, but their progress was impeded by many practical difficulties: electrical and mechanical instabilities, thermal motion in the specimen, radiation damage and low image contrast. Since 1970 several microscopists have independently managed to overcome these problems and have published direct images of atoms and molecules, the first to do so being Albert V. Crewe with his scanning transmission electron microscope at the University of Chicago (p 13).

There is some irony in the fact that the earliest form of electron microscope, the transmitting type designed by Ernst Ruska in 1932, should be the last to become capable of atomic imaging. The conventional transmission electron microscope (TEM) behaves analogously to the optical microscope, but sends an electron beam instead of visible light through the thinly sectioned specimen and utilizes magnetic focusing in place of an optical lens. By the end of the 1960s the best resolution it could achieve was about 5 Å, tantalizingly close to that required to pick out individual atoms but marginally too poor except under special conditions. Crystal lattices, first observed by J. W. Menter (pp 100–101), certainly lay within reach but their component atoms looked inseparably blurred.

The first convincing TEM image at atomic resolution – a dark field with bright spots representing thorium atoms – was published in 1971 by Hatsujiro Hashimoto and his research team at Osaka University. They have devised methods for increasing the contrast and adjusting the focus of a conventional TEM to push its 2.5 Å "best" resolution even further to 0.5 Å, the régime where the behaviour of single atoms in crystals and molecules can be studied directly. The novelty of Hashimoto's work lies in two claimed achievements: visualization of the movement of atoms as they rearrange themselves around dislocations in a crystal and analysis of fine structure *within* the atomic images. It need hardly be said that the latter claim remains rabidly controversial because if substantiated it signifies the first direct observation of images of the nucleus and the electron cloud!

Gold crystals have long been a favourite source of lattice images. It was in his experiments on gold films as early as 1966 that Tsutomu Komoda, a researcher with Hitachi Ltd., worked out what orientations of specimen and illuminating beam yielded highest resolution and lowest chromatic aberration. Hashimoto and his colleagues, working a decade later with gold films deposited on rock salt, were able to improve resolution not only in space but in time as well. Coupled with their powerful electron microscope, a television recording system operating at 12 or 30 frames per second (with dark- or bright-field illumination, respectively) was employed to produce magnifications on the television screen of more than 26 million times.

One particularly interesting frame from this atomic movie is shown here. Each white dot is an atom of gold lying along one crystalline plane, labelled (111). The gold atoms all look identical, with nothing to distinguish those in one layer (A, B, or C) of the crystal from those in another. Picture the crystals stacked one above the other, running obliquely upward. (This image is effectively the face-on counterpart of Menter's micrograph, p 101.) Most of the atoms are strung out in unbroken chains (ABC, ABC, …). Near the centre of the image, however, a crystal dislocation – a fault in the way the crystals are stacked one upon the other – interrupts the sequence. A moment later the fault might be seen to spread or perhaps to vanish as the atoms rearrange themselves. For atomic physicists photographs like these are a veritable gold-mine.

Date: 1979
Place: Osaka University, Japan
Photographer: H. Hashimoto and colleagues
Apparatus: JEM 120C electron microscope (100 kV)
 → TV recording system
Source: Science Museum, London
References: Cosslett 1973, Kihlborg 1979, Hashimoto *et al.* 1980

Jupiter Shows his Colours

Comparison of infrared and visible discs of Jupiter (facing page, left and right) is more than a match of heat against light. It is also a contrast of technologies. The picture at right was taken by the Voyager 1 satellite en route to the giant planet; its equally impressive infrared counterpart, by an Earth-based telescope almost simultaneously.

Two previous probes, Pioneer 10 and 11, employed an imaging photopolarimeter to provide the first close-up views of Jupiter, largest planet in the Solar System, when they flew past on 3 December 1973 and 2 December 1974 respectively. Voyager 1 and 2, equipped with more sophisticated detectors, encountered Jupiter on 5 March and 9 July 1979 respectively. This time a pair of vidicon cameras mounted on a scan platform imaged satellites and jovian clouds. Both spacecraft missions included infrared radiometers, but neither was capable of *imaging*; pictures like the one at left have been taken only from the ground, with consequent restrictions in wavelength.

Whereas Pioneer 1 and 2 relayed back a total of about 1000 images of the jovian system, the pair of Voyager probes transmitted over 35,000. At close encounter the best resolution achieved by the photomultipliers of Pioneer was 190 km; by the slow-scan vidicons of Voyager, 2 or 3 km. The origin of this huge difference lies not in the encounter geometry but in the instruments themselves. The twin cameras of Voyager consisted of a wide-angle lens (focal length 20 cm, field of view 3°) and a narrow-angle lens (focal length 150 cm, field of view 0°.4), each being attached to a selenium-sulphur vidicon tube. Colour pictures like the one at far right are generated by combining successive images taken through blue, green and orange filters. (The filter wheel provided other options as well.) Every image contains an array of 800 by 800 pixels, and every pixel is assigned an intensity on a scale of 1 to 255. The data are digitized for transmission to Earth at a rate 14,000 times faster than Mariner 4 could manage in 1965 (p 122) from a distance thrice as far.

By contrast, the 5 µm infrared (IR) image at left, taken at Cassegrain focus of the Hale reflector on Mount Palomar, was constructed from an array of 128 by 128 pixels (again on a grey scale of 256 levels) recorded on a cryogenically cooled indium antimonide detector. Several years before the Voyager encounters, Richard Terrile and James Westphal of Caltech had shown by comparing simultaneous *ground-based* optical and IR images that the hottest regions – the brightest in the false-colour image at left – correlate well with the blue-grey features in the darker stripes called "belts" and anticorrelate with the paler, yellow-white stripes called "zones". However, atmospheric seeing limits the resolution to 4300 km at best.

The optical image at right (north at top) was obtained by Voyager 1 one hour after the IR image at left. (The time delay accounts for the shift of the Great Red Spot one fifth the distance across the planet's face from lower left to lower centre.) It is abundantly clear that the white zonal band in the northern hemisphere is cold (hence black on the IR image) whereas the darkest features in the North Equatorial Belt are hot (hence yellow-white on the IR image). The Great Red Spot is itself cold, but it is limned in a warm red oval.

The significance of the correlation between colour and 5 µm brightness temperature (see p 152) goes beyond a mere surface distribution. The hotter areas lie deeper in the atmosphere, closer to the internal heat source which – as Westphal discovered in 1969 – enables Jupiter to radiate twice as much thermal energy as it receives from the Sun. The infrared excess peaks at around 5 µm; so in effect in the image at near right we are seeing Jupiter by the light of its own heat radiation.

Further study of the Voyager images by Terrile and Tobias Owen yielded this sequence: overlying cirrus haze of ammonia crystals forming a white cloud deck; a layer of tawny cloud underneath, perhaps composed of ammonium hydrosulphide, such as one sees in the North Equatorial Belt; holes in the tawny layer revealing the dark brown clouds or "barges" observed at certain latitudes in the northern hemisphere; and finally the deepest holes, hot spots of a vague blue-grey colour found in the equatorial region. The blue-grey colour might be intrinsic to this lowest layer; alternatively it could represent the effect of light scattering in the clearest skies on the planet – the jovian equivalent of cerulean blue. The Great Red Spot appears to be a fly in the ointment, however, for it rises above the highest white clouds yet remains obstinately orange-red.

Date: 10 January 1979
Place: Palomar Observatory, California (left); Voyager 1 at 535 million km from Jupiter (right)
Photographers: R. J. Terrile & R. F. Beebe (left)
Apparatus: 5 µm IR scanner on 5 m reflecting telescope (left); wide-angle vidicon camera of focal length 20 cm plus filter wheel (right)
Source: Jet Propulsion Laboratory, Pasadena, California; NASA
References: Smith *et al.* 1977, Terrile *et al.* 1979, Owen & Terrile 1981

Enigma of the Great Red Spot

The Great Red Spot has dominated the face of Jupiter since about 1830 although it was first observed by Robert Hooke in 1664. The highest-resolution image we have of it, reproduced here, was furnished by Voyager 1 in the course of its fly-by in March 1979. Vortical structure is displayed by both the famous spot and its white oval neighbour.

The earlier Voyager image on p 189 shows the Great Red Spot in its geographical context within the South Tropical Zone but overlapping the South Equatorial Belt above and the South Temperate Belt below. Like other discrete features in the jovian atmosphere, its size, colour and longitudinal position vary with time. The deep orange-red colour evident opposite can fade over periods of years, even to vanishing point: the spot has a history of 17 fresh apparitions to date. Superimposed on an irregular westward drift which has carried it thrice around the planet in 150 Earth years is a minute east-west oscillation with a period of 90 Earth days. Meanwhile the planet as a whole rotates on its axis in 9.925 hours, the precise value depending on what is being measured. The spot itself rotates in about six days.

Several theories have been advanced about the nature of the Great Red Spot. It has been claimed as a volcano, as a floating ovoid raft or "Cartesian diver", as a "Taylor column" – a phenomenon encountered in rapidly rotating fluid cylinders. Proponents of the volcanic theory have only to look at the cold black ellipse on the infrared image overleaf (p 189) to abandon that notion. The other two ideas have fallen from favour.

In the Voyager images the Great Red Spot reveals itself as a gigantic anticyclone, and the analogy of a terrestrial hurricane naturally arises. A typical hurricane is driven by air warmed over the ocean, and one could imagine that huge jovian vortices would be similarly powered by underlying hot spots. Viewed in the southern hemisphere from above, both hurricane and oval spot are seen to rotate anticlockwise. There are serious snags, however: the spot lacks a fully developed spiral structure with a central "eye" – Voyager scientists purport to see a reversed S in both the red spot and its companion oval – and the drift in position remains difficult to explain.

A promising new theory holds that the Great Red Spot behaves as a solitary wave or "soliton", another concept drawn from fluid dynamics. It would derive its energy from the velocity gradient existing between two parallel flows. But why should there be only one Great Red Spot? In fact, there are many smaller transient red spots and white ovals – including the splendid example in this image at lower right – which could be similarly interpreted. The greater longevity of the Great Red Spot may devolve from its sheer size.

The white oval seen alongside the Great Red Spot did not lie adjacent at the time of the Pioneer encounters five years earlier, and a different white oval replaced it by the time Voyager 2 arrived four months later. Along with two other white ovals in the southern hemisphere, it has nevertheless been observed since 1939. It too rotates anticlockwise, but the turbulent vortices below and to the west of the two larger spots whirl in the opposite sense. Fine detail (down to 30 km) in the vortices is brought out in the version of this image below in exaggerated colour, where blue and red are enhanced over green. The ammonia cirrus cloud draping the northern reaches of the red spot is more readily distinguished. The whole image spans 37,000 by 24,000 km and the elliptical heart of the Great Red Spot about 22,000 by 11,000 km – a maelstrom several times the size of the Earth.

Date: 4 March 1979
Place: Voyager 1 at 1.8 million km from Jupiter
Apparatus: Narrow-angle vidicon camera of focal length 150 cm plus filter wheel; computer reconstruction (above in false colour)
Exposure times: 0.7 to 1.0 sec (according to filter)
Source: Jet Propulsion Laboratory, Pasadena, California; NASA
References: Smith *et al.* 1979a, Smith *et al.* 1979b, Fimmel *et al.* 1980, Morrison & Samz 1980

Io: A View of the Infernal Regions

The best full-disc colour mosaic we can compile for Io, with two gaps for unavailable data, musters an extraordinary world. Volcanic craters, steep scarps, smooth plains and polar mountains characterize the surface, which owes its coloration to sulphur in various forms. With its violently eruptive volcanoes, Io could be accurately described as a world of fire and brimstone.

Io had already gained considerable notoriety before the arrival of the Voyager probes in 1979. In the first place, it is bathed in a cloud of sodium atoms detected by means of ground-based observations in 1973 (pp 172–173). In December of the same year, Pioneer 10 found that the torus included atomic hydrogen and moreover that Io possessed an ionosphere out to 700 km above its Sun-illuminated hemisphere. The imaging photopolarimeter failed to record Io, but a year later Pioneer 11 transmitted a single indistinct spin-scan image centred on the north pole.

Io resembles our Moon in size (3632 km as against the lunar diameter of 3476 km) and density (3.53 versus 3.34 g per cc) – but in virtually nothing else. The craters observed by Voyagers 1 and 2 are attributable not to impacts but rather to volcanic activity, indeed to at least eight currently active volcanoes (see pp 194–195). The unique red, orange, yellow and white colours result from a surface of sulphur in diverse allotropes and compounds. Large white areas are thought to be covered with sulphur dioxide frost, while the blue-white patches may reveal fumaroles venting sulphur dioxide gas.

At closest approach Voyager 1 passed 20,570 km from Io; Voyager 2, over a million km. The picture opposite (north at top) is a mosaic comprised of four sets of Voyager 1 images through violet and orange filters. At the press briefing in the Jet Propulsion Laboratory on encounter day, Brad Smith (the team leader for imaging science) likened Io to a superior pizza. Certainly its surface features have no known counterpart anywhere else in the Solar System.

Hundreds of caldera-like depressions have been spotted on Io, and 43 of these "paterae" (literally dishes or saucers) have now been named. One example is the ink-blot in the southern hemisphere, centred in the view opposite, called Svarog Patera. Here the caldera is surrounded by a halo of dark material in a colour similar to that found in the polar regions, known long before the advent of Voyager to be darker than the equatorial regions. Other calderas possess bright haloes in a variety of colours, and still others show no such evidence of volcanic outflow. Between centres of volcanism, especially in the equatorial regions, stretch smooth plains segmented by scarps typically a few hundred metres high. Isolated mountains arise in the polar regions.

Of the nine named volcanoes on Io, the two most striking are visible in this image: Pele (named for the Hawaiian goddess of fire) and Loki (after a Scandinavian demon god). Pele, the first volcano to be seen in eruption (p 195), is the huge orange hoofprint below centre right measuring 700 by 1000 km. The half-eaten dark brown doughnut in the northwest surrounds Loki; here Voyager's infrared radiometer measured the highest temperature on Io (about 17°C). This relatively warm feature has been interpreted as a crusted lake of molten lava, perhaps sulphur. Fresh eruptions had bitten further into the doughnut by the time Voyager 2 arrived.

Whether the flow patterns we see represent sulphur or silicate volcanism is not yet clear. Either oceans of molten sulphur sporadically burst through a thin surface veneer, or sulphur-rich silicate magma forces its way through a silicate crust in a manner similar to terrestrial volcanism. Whatever the mechanism, Io must be regarded as the only body in the Solar System known to be tectonically more active than the Earth.

Date:	5 March 1979
Place:	Voyager 1 at 377,000 km from Io
Apparatus:	Narrow-angle vidicon camera of focal length 150 cm plus filter wheel; computer mosaic of 4 image sets
Source:	Jet Propulsion Laboratory, Pasadena, California; NASA
References:	Masursky et al. 1979 et seqq., Smith et al. 1979a, Smith et al. 1979b, Johnson & Soderblom 1983

Discovery of an Extraterrestrial Volcano

On this image was found the first evidence for an active volcano on a body in the Solar System other than the Earth itself. As Voyager 1 hurtled past Io in its Jupiter fly-by of March 1979 (pp 192–193), planetary scientists realized that the circular features could not conceivably be *impact* craters. Suspicions that they must be volcanic in origin were confirmed when this image revealed a plume from the crater Pele on the illuminated limb and a second sunlit eruption from Loki just inside the crescent near the terminator. From Io, Jupiter looks forty times larger and two hundred times brighter than the full Moon does from the Earth, and in consequence even the "dark" side of the satellite is clearly visible by twice reflected light.

Like so many historic discoveries, this one was made virtually by accident. Linda Morabito, an optical navigation engineer on the Voyager project, was examining an image of Io taken three days after closest encounter in order to obtain a positional fix from two faint field stars (AGK3–10021 and AGK3–20006, neither of which is bright enough to be seen in the reproduction here). The intention was to chart Voyager's course with improved accuracy and to calculate superior ephemerides for the inner satellites of Jupiter. When the image on her video screen was enhanced to bring out the faint stars, the illuminated crescent of Io sprouted an unexpected plume. Once the possibility of an error in the image-processing software had been eliminated, along with the unlikely chance that the plume be the crescent of some new satellite in the jovian system, the identification of the first active volcano beyond the Earth was secure.

Alerted to the occurrence of eruptions on Io, scientists at the Jet Propulsion Laboratory poring over Voyager 1 imagery identified eight eruptions over a period of almost seven days. Six of these (and no new ones) were seen four months later by Voyager 2 – excluding somewhat ironically the first and largest: the Pele plume opposite, 280 km high and 1000 km wide. A clue to the eruption mechanism can perhaps be gleaned from the fact that the smallest plumes reach a minimum height of 70 km above the limb; smaller ones seem not to arise. Implied ejection velocities run from 0.3 to 1.0 km per sec, far faster than the fiercest eruptions known on Earth. The total volcanic output on Io is estimated at 100 million kg per sec, of which 0.01% reaches escape velocity and joins the gaseous torus (pp 172–173).

The plumes may be symmetric umbrellas on high thin stalks like this one; but they can also be asymmetric and diffuse, wide or narrow, tall or squat. Sulphur or sulphur dioxide is the favoured candidate for the composition of the plumes. According to the thermodynamics of the eruption, the plumes will consist of a mixture of solid, liquid and vapour phases; but in the exiguous atmosphere of Io rapid expansion and condensation soon converts the fluid ejecta into a fine snow of sulphur and sulphur dioxide particles.

Like craters on Mars (pp 122–123), volcanism on Io had in fact been predicted before close-up photographs became available. Stanton Peale of the University of California at Santa Barbara, together with Pat Cassen and Ray Reynolds of the NASA-Ames Research Center published a prescient theoretical model of Io just three days before the first Voyager encounter; they anticipated that "widespread and recurrent surface volcanism might occur". The heat source would lie not in radioactive decay in the interior, unlike the case of the inner ("terrestrial") planets, but rather in tidal effects caused in two ways: by the proximity of the giant planet Jupiter and by orbital perturbations induced by the other Galilean satellites. As Io is thrust to and fro with respect to its mean orbital position, tidal heating channels quite sufficient energy into its interior to provide a driving force for the volcanoes. According to one estimate, volcanoes release as much as 40% of the heat flux from within the satellite. Their eruptions renew the surface topography of Io on a time scale of less than a thousand years, and only the steepest scarps and elevated features in the polar regions will be older.

Date: 8 March 1979
Place: Voyager 1 at 4.5 million km from Io
Apparatus: Narrow-angle vidicon camera of focal length
 150 cm; computer reconstruction
Exposure time: 0.96 sec
Source: Jet Propulsion Laboratory, Pasadena, California;
 NASA
References: Morabito *et al.* 1979, Peale *et al.* 1979, Smith *et al.*
 1979a, Strom *et al.* 1979 *et seqq.*

The First Black Smoker

In the interstices between sub-oceanic crustal plates, driven apart by hot magma, it is only natural that the temperature should be higher. But until this photograph was taken, direct evidence for active hot volcanic vents on the sea floor was absent.

The circumstances of the photograph could hardly have been more dramatic. The manned submersible *Alvin*, lowered 2.5 km to a ridge of the East Pacific Rise (dive 914), literally bumped into a submarine chimney. The toppled column can be seen behind the smoking remnant at centre. Some of *Alvin*'s instruments appear in the foreground, notably the temperature probe at left. Moments later, the pilot Dudley B. Foster thrust the probe into the geyser. As the temperature readout soared off-scale, the plastic probe was quickly withdrawn but the portion in contact with the geyser had already begun to melt. A later check revealed that the probe had been designed to withstand temperatures up to 330°C, slightly below that of the smoking chimney.

This, then, is the first photograph of a "black smoker" – a hot spring in the volcanic region between diverging plates. The Galápagos sites first explored (see pp 174–175) had provided mineral-rich water at temperatures up to 23°C but no hot-water jets. The East Pacific Rise south of the entrance to the Gulf of California off the coast of Mexico, however, fulfilled geochemists' wildest hopes. At the high temperatures of black smokers, water might be expected to reach the surface as steam; but under the prevailing pressure of 250 atmospheres it behaves as a superheated liquid, rising with incredible buoyancy and cooling rapidly as it meets seawater only a few degrees above freezing.

Smoke arises from the abrupt precipitation into cold seawater of minerals dissolved in the hot geyser. Metals such as iron, copper, nickel and zinc occur in concentrations up to 100 million times greater in the geyser than in normal seawater. Silicon and hydrogen sulphide are also hugely enhanced. Black smokers reveal mineral deposits in the very act of formation. Their chimneys reach a maximum flue diameter of 30 cm and a maximum height of 10 m though most rise only 1 to 5 m above the basal mound. These mounds, honeycombed with fossil worm tubes, can spread out as far as 30 m; through the effects of oxidation they display "Hallowe'en colours of ochre, orange and black" in the words of the RISE Project Group (the two dozen earth scientists in charge of *Alvin*'s explorations).

Is exploitation by mining engineers feasible? It would hardly be worthwhile mining the hot springs themselves, but the deposits they leave behind are bound to attract strong interest. Huge, pure lodes of commercially valuable deposits, especially of polymetallic sulphides, have now been located on the East Pacific Rise (Guaymas Basin), in the Juan de Fuca and Galápagos Rifts and also in the Atlantic east of Florida.

In times past the mantle exuded basaltic lava to form the ocean crust, but we now observe geysers of hot water. Where, then, does the water originate? Seawater is thought to seep through porous rock, mixing with the hot magma and dissolving minerals (sulphides and sulphates), spreading laterally until it finds a weak point in the crust and spurting upward. The precipitating mineral compounds gradually create their own smokestacks, sometimes resembling organ pipes.

The existence of black smokers in sufficient numbers can resolve several outstanding problems of marine geology. The heat balance between surface and interior had never looked quite satisfactory: it did not seem that heat conduction up through the crust was effective enough to account for its rate of solidification. The new source of heat loss balances the equation nicely. Another problem arises in the mineral content of the ocean bed, assumed to be fed by the world's rivers. That source appeared to be inconsistent with the rich mineral deposits (e.g., manganese nodules) paving the sea floor. Currents fed by submarine hot springs offer a reasonable solution.

Between the hairline fissures seeping warm water (as in the Galápagos Rift) and the black smokers vomiting mineral-rich water at several metres per second, a middle course is occupied by "white smokers" of intermediate temperature and output velocity. Whereas black smokers inhibit the growth of organic matter, white smokers host crabs, a new genus of barnacle and a suspected new family of worms. Marine geology and biology have received a simultaneous and powerful stimulus.

Date: 21 April 1979
Place: East Pacific Rise
Photographer: D. B. Foster, Woods Hole Oceanographic Institution
Apparatus: Stereo camera aboard submarine *Alvin*
Source: National Geographic Society, Washington, D.C.
References: Ballard & Grassle 1979, RISE Project Group 1980, Edmond & Von Damm 1983, Haymon 1983

Ice Volcanism on Ganymede

Not only is Ganymede the largest satellite in the Solar System; with a radius of 2638 km, it even exceeds two of the planets, Mercury and Pluto. In the highest-resolution colour mosaic of Ganymede, captured by the Voyager vidicons through green, blue and violet filters, we see a complex patchwork of dark areas and brighter grooved terrain. Fault systems are everywhere in evidence, but the overall relief remains relatively flat.

The higher density of craters on the dark terrain testifies to its greater age. The largest single remnant of this ancient crust forms a circular region 3200 km in diameter called Regio Galileo, part of it visible at upper left. Occupying a third of a hemisphere, it has even been glimpsed through Earth-based telescopes under superior seeing conditions. Three features characterize the dark terrain: relatively fresh impact craters that resemble those on the Moon; pale streaks of parallel rimmed furrows thought to be "graben", depressions bounded by geological faults; and the whitish roundels of ghost craters ploughed over by slow but persistent geological activity. The ridges adjoining the graben furrows typically rise only 100 m in height, extend 5 to 10 km in width and lie 50 km apart. The evocative description "palimpsests" has been applied to the ghost craters after ancient manuscripts where the writing is all but effaced to permit re-use.

The brighter, younger terrain looks even more complicated, displaying a "wonderful complexity" in the words of one investigator. White bands like muscle fibres stretch here and there across the surface. The bands have been called "sulci" from the Latin word for furrow or groove, but they are not to be confused with furrows such as those in Regio Galileo. Uruk Sulcus bordering Regio Galileo sweeps through the middle of the image opposite; its intricate pattern of crisscrossing furrows shows up rather better in the blow-up at near right. By contrast with the furrows of the dark regions, these grooves exhibit substantial if still modest relief: they are typically up to 1000 m high, 2 or 3 km wide and only 3 to 10 km apart. Grooves do occasionally intrude into the darker, cratered terrain, but tend to prefer the bright areas.

Ganymede's low density of 1.93 g per cc offers a clue to its composition and in turn to the patterns on its surface. About half its mass must consist of ice in some form. Even if the satellite originated as a homogeneous mixture of rock and ice, radioactive components will have melted the ice sufficiently to induce chemical differentiation culminating in a rocky silicate core and an icy mantle. (The surface will not have retained its purity for long, however, in the face of meteoritic bombardment.) In the course of internal redistribution, phase transitions among the various crystalline forms of ice are thought to have caused the entire body to expand at some time in its history, thereby increasing its surface area by as much as 6% (though some estimates of this upper limit are lower).

Crustal stresses resulting from this expansion yield faults and depressions (graben) into which water, slush or solid ice flowing like a glacier is forcibly erupted. This process, which Steven Squyres of the NASA-Ames Research Center calls "ice volcanism", could certainly produce the bright bands. The grooves may themselves be graben on a narrower scale, but could also be crevasses.

Ice volcanism can account for the resurfacing of Ganymede in response to stresses external as well as endogenic. After a meteorite has gouged a hole in the surface, the gradual flow of solid ice degrades the crater until only a scar, or palimpsest, remains. Young craters such as Osiris at the edge of the field generate long rays which fill with water ice, the brighter for being cleaner. But 43 craters with *dark* rays have also been identified, their once bright pattern dimmed by sputtering of water from the surface by energetic particles from the jovian magnetosphere.

Date: 7 July 1979
Place: Voyager 2 at 310,000 km from Ganymede
Apparatus: Narrow-angle vidicon camera of focal length 150 cm plus filter wheel; computer mosaic of 6 image sets
Source: Jet Propulsion Laboratory, Pasadena, California; NASA
References: Smith *et al.* 1979b, Morrison & Samz 1980, Soderblom 1980, Squyres 1983

Cratered Callisto

Voyager 2 supplied our best global mosaic of Callisto, outermost of Jupiter's Galilean satellites. In contrast to its neighbour Ganymede (pp 198–199), it has evolved little since a large influx of meteorites bombarded its crust aeons ago. It is even less dense, and at 1.79 g per cc probably contains more water ice than silicate rock. Apart from two large ancient impact basins, the distribution of craters is remarkably uniform – indeed, Callisto sports the most heavily cratered surface in the Solar System.

More craters surely ought to imply a higher rate of bombardment, but in fact the logic is fallacious. Ganymede is twice as heavily peppered with meteoritic débris as Callisto; Europa and Io, even more so. But whereas their surfaces undergo renewal on a time scale shorter than 4000 million years – when the last torrential bombardment is thought to have occurred – Callisto has preserved its crustal record. The only sign of slow, viscous crustal flow is the relatively low relief all over the satellite. Much of the surface is reminiscent of the dark terrain of Ganymede except for the absence of streaks (rimmed furrows, or graben).

The streaks *may* have their counterpart, nevertheless, in the rings surrounding such large impact basins as Asgard, visible at upper right. Valhalla, on the other hemisphere, is even more impressive; it appears on the limb in the adjacent image (north at upper right). But the parallel furrows of Ganymede seem more readily explicable by expansion-induced stresses than by impacts, and perhaps a better analogy for the concentric rings can be found in other impact structures like the Caloris Basin on Mercury. The superficial resemblance dissolves on closer inspection, however. On rocky planets, only two or three rugged rings are visible (e.g., Mare Orientale on the Moon); and where there are more, farther rings are more widely spaced. With its crust of "dirty ice", Callisto responds differently to these huge impacts, developing many rings of low relief and equal spacing as if from a pebble dropped into still water. Nor do the bull's-eye patterns on Callisto possess much of a central basin; Asgard, opposite, consists of fifteen concentric rings around an unimposing bright patch.

Save for its more reflective crater floors, Callisto looks surprisingly dark (albedo 0.2) for a body which is so full of ice – albeit that it is still far brighter than our own Moon (albedo 0.067). A larger proportion of impurities than on Ganymede must be partly responsible; but in addition the process of differentiation into an icy crust and mantle around a rocky core would have progressed less far. The sources of heat which encourage melting and differentiation are all of smaller magnitude in Callisto: less radiogenic heating through the lower silicate content, as well as less accretional heating and tidal dissipation through its smaller size and greater distance from Jupiter. Callisto's stunted thermal evolution, subduing or preventing any expansion, has kept it grooveless – if not exactly craterless.

Date: 8 July 1979 (opposite); 6 March 1979 (above)

Place: Voyager 2 at 390,000 km from Callisto (opposite); Voyager 1 at 400,000 km (above)

Apparatus: Narrow-angle vidicon camera of focal length 150 cm; computer photomosaic of 9 frames (opposite), 4 frames (above)

Exposure time: 0.5 sec (opposite)

Source: Jet Propulsion Laboratory, Pasadena, California; NASA

References: Smith *et al.* 1979a, Smith *et al.* 1979b, Morrison & Samz 1980, Squyres 1983

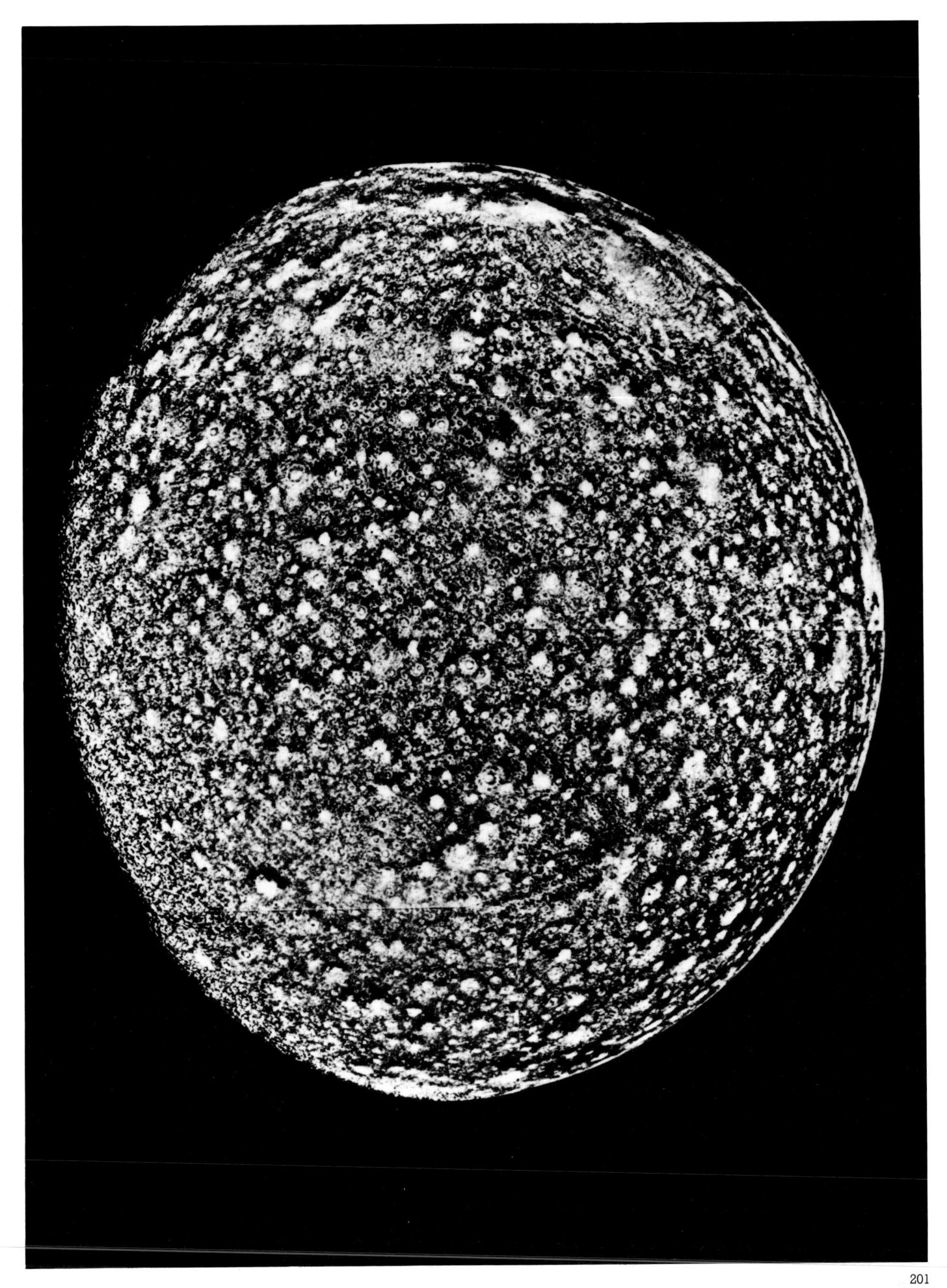

Serendipitous Comets

Like the princes of Serendip, physicists at the Naval Research Laboratory (NRL) studying the solar corona by satellite came up with a discovery as exciting as it was unexpected. With a coronagraph called SOLWIND, part of the payload of the satellite P78–1, Donald Michels and his colleagues Russell Howard and Martin Koomen were monitoring changes in the structure of the Sun's outer atmosphere when they encountered a comet on a collision course with the Sun (Comet 1979 XI). Since then two more "kamikaze comets", as *New Scientist* christened them, have emerged from their data tapes.

The SOLWIND coronagraph consists of a video telescope with an occulting disc which blocks out the Sun plus the bright inner corona out to 2.5 solar radii. One image is recorded every 10 minutes through the sunlit portion of the satellite's polar orbit (60 out of 97 minutes). The images are telemetered to ground stations and the data tapes eventually forwarded to the principal investigator, in the case of Comet 1979 XI two years after the event. Although comets have been observed by satellite before (notably Comet Kohoutek from Skylab), this was the first comet to be *discovered* by one.

The false-colour images on the facing page, generated at NRL by S. A. Mango for the cover of *Science*, show Comet 1979 XI streaking sunward through the much fainter corona (above) and subsequent enhancement of the whole corona sprinkled with the cometary débris following impact (below). A simulacrum of the Sun, in reality hidden by the coronagraph, was added photographically. The bright dot to the northeast (upper left) is the planet Venus, its magnitude roughly the same as that of the coma about the comet's head and both far brighter than the outer corona itself. The comet was first detected at 6 solar radii, apparently closing at nearly 300 km per sec and strewing tail material in its wake.

The comet of August 1979 pictured here and its two successors discovered by SOLWIND in January and July 1981 constitute more than mere strays missed by terrestrial observers caught napping. They belong to a family of comets difficult to observe from the Earth but known to follow Sun-grazing (or Sun-striking!) orbits since H. Kreutz first recognized them following the "Great September Comet" of 1882 (see pp 36–37). The three satellite-found comets supplement the nine known members of the Kreutz group, long-period comets in eccentric retrograde orbits (planets orbit the other way) with small or vanishing perihelion distances. Of course, the fact that these three comets were detected approaching the Sun from one side but failing to re-emerge from behind it on the opposite side does not prove that all three actually impacted on the surface of the Sun; despite their high approach velocity, they may simply have evaporated in the intense heat of the solar atmosphere. The NRL researchers think sublimation unlikely, however.

Why should the corona glow so brilliantly in the aftermath of the comet's demise? Although the kinetic energy imparted by the comet matches that of a solar flare, the brightening arises not in a comet-sparked flare but in material from the comet itself. As the comet disintegrates in a trail of smaller particles, the débris become subject to the considerable outward pressure exerted by the solar wind and to random turbulent motion in the solar atmosphere. Because larger, heavier particles resist the buffeting better than finer grains of débris, particles of different size gradually spread to different heights in the atmosphere by what the NRL investigators call a "cosmic winnowing process". The dispersal occurs in much the same way that aeroplane contrails are formed after the passage of a jet at high altitude.

With Comet 1979 XI, SOLWIND scored a double success: not only the first comet to be discovered by a spacecraft but the first seen to collide with the Sun. The fact that three such comets were serendipitously encountered within 2.3 years, all with remarkably similar if somewhat approximate orbital elements, suggests that members of the Kreutz family are rather more numerous than astronomers had guessed. Quite possibly fragments of an ancient, larger comet sundered on a closer encounter with the Sun, many of these comets continue to elude ground observers, on solar approach because the orbital geometry is so unfavourable and on recession because they fail to survive past perihelion.

Date: 30 (above) and 31 (below) August 1979
Place: P78–1 in Earth orbit
Apparatus: SOLWIND coronagraph with SEC vidicon;
 false-colour reconstruction
Exposure time: 2.5 sec
Source: D. J. Michels, Naval Research Laboratory,
 Washington, D.C.
References: Marsden 1967, Sheeley *et al.* 1980, Michels *et al.*
 1982, Sheeley *et al.* 1982

Zenith of Eclipse Photography

So many scientific photographs look no better than dirty windscreens that it is astonishing to find so splendid a picture as this one scientifically significant. To claim that any photograph is the best of its kind is at the very least invidious; at worst it invites rapid repudiation by the advent of a still better one. Nevertheless, these colour images of the solar corona during eclipse – opposite and on the front cover – will be surpassed with difficulty. (Admittedly greater detail can be traced farther from the Sun on *monochrome* photographs; see pp 150–151.)

Taken under excellent conditions in India during the 16 February 1980 eclipse by Swiss astronomer J. Dürst, these photographs are able to show the solar corona out to 6 solar radii despite the great variation in intensity from inner to outer corona. The trick is to use a neutral-density filter with a radial gradient even though it can give rise to spurious rings in the image. In order to combine the advantages of high resolution and a wide field – mutually inimical requirements – Dürst employed both a long-focus camera designed with a high-quality apochromatic lens specially for the 1980 eclipse and an older short-focus camera. During the mere 170 seconds of totality, he secured 8 exposures on the long-focus camera for photometric purposes and 13 on the short-focus camera for calibration and polarimetry.

Superposed on the coronal image opposite, obtained with the long-focus camera, is a spider-web of isopleths, contours of equal polarization derived with the other camera. Numbers give percentage of polarization. Since polarization is induced by electron scattering in the corona, the isopleths represent an averaged map of the electron distribution. Scrutiny of the isopleths thus reveals the three-dimensional structure of the solar corona and makes it clear that except in the places lanced by powerful streamers the distribution of electron density in the corona – at least out to 3.3 solar radii – is basically spherical.

In this coronal photograph as on the bottom of p 151 (same eclipse), the filamentary structure follows the configuration of the solar magnetic field. (North is at top, west to right.) During a time of high solar activity, as at the 1980 eclipse, magnetic loops tend to snap and to trail out into interplanetary space – whence the long radial coronal streamers in evidence here. Such long streamers generally persist for months, but the detailed structure changes continuously.

In terms of coronal radiation it is convenient to differentiate between the K and the F corona. The K corona emits a continuum of radiation produced by electron scattering. (Emission lines also occur but scarcely affect photometry.) The F corona smears out light from the photospheric spectrum as it scatters off particles of interplanetary dust. Dürst used the polarization measurements to distinguish between the gaseous K and dusty F coronae, and found that the former *does* deviate from a spherical distribution beyond 2 solar radii.

The long-focus image opposite was taken 49 seconds into totality through the three-lens apochromat plus graded neutral-density filter. A planoconcave lens cemented to the radial-gradient filter flattened the field, dramatically reducing astigmatism. At lower right the star Mu Capricorni is just discernible. Another image (on the front cover) was taken starting 9 seconds later with the short-focus camera equipped with orange and neutral-density filters plus a polarizing screen. The contrast has been slightly enhanced by comparison with the original to the benefit of the fainter streamers.

Date: 16 February 1980
Place: Yellapur, India
Photographer: J. Dürst, ETH Zentrum, Zürich
Apparatus: Camera of aperture 12.5 cm, focal length 188 cm (opposite); Camera of aperture 2.9 cm, focal length 37 cm (on front cover)
Emulsion: Agfachrome 50S (opposite); Plus-X (on front cover)
Exposure time: 10 sec (opposite); 8 sec (on front cover)
Source: Photographer
References: Dürst & Zelenka 1980, Keller & Liebenberg 1981, Dürst 1982

Light Caught in Flight

Until quite recently not even the most imaginative practitioners of high-speed photography dared to hope that it would become possible to arrest the motion of a light-wave, to reveal light itself in flight. Yet in the past decade two completely independent techniques have accomplished this egregious feat, one using an ultrafast Kerr shutter and the other a holographic apparatus. Both employ lasers.

Among laboratory researchers it is a common rule of thumb that light travels about one foot per nanosecond (a billionth of a second) though in public they will refer more circumspectly to the international standard of 2.998×10^8 m per sec. High-speed photography and its cousin photonics – which records photons of light but not by traditional photographic means – currently thrive in the sub-nanosecond régime, so it might be thought quite routine to record light in flight. However, most current ultrahigh-speed techniques do not rely on direct imaging but on streak cameras, image converters and the like.

The first technique for photographing light in flight was evolved in 1971 by Michel Duguay and his colleagues at Bell Laboratories in New Jersey. Lasers have been capable of generating extremely short, very powerful light pulses for some years; the picosecond (million millionth of a second) barrier was broken in 1974 and the current record, predictably achieved once again at Bell Labs, is 30 femtoseconds (0.03 picoseconds)! It is curious that picosecond lasers had been in use for several years before their photographic potential was fully exploited. With ultrashort pulses Duguay devised a laser-driven shutter on the principle of the Kerr cell, opaque until an impulse renders it transparent. As he relates, however, "For a year we had this ultrafast camera shutter in the laboratory and did not know what to photograph with it until one day the notion emerged that a laser pulse, when propagating through a light-scattering medium, becomes itself a visible object that is worth photographing." At near right is a "bullet" of green light made visible as it flashes through a flask of milk-tinged water marked with a scale in millimetres.

The other technique for stopping light in its tracks depends on holography. Reduced to its simplest terms, holography records on a photographic plate the interference pattern produced when laser light bounced off the subject meets a "reference beam" directly from the laser. Latent in that pattern is all the information required to reproduce a three-dimensional image of the subject, which can be generated by reillumination of the hologram with the laser beam.

How can holography be harnessed to freeze light in flight? In 1972 Nils Abramson of the Royal Institute of Technology in Stockholm foresaw the principle, and six years later he published the first practical demonstration of holography parading as high-speed cinematography. In the first place, a pulse of light will be visible as such only if it is much shorter than the plate along which its passage is recorded. Since a 10-picosecond laser pulse corresponds to a length of 3 mm, no problem arises here. In the second place, some ultrafast shutter mechanism is required to capture the swiftly moving pulse – and herein lies the beauty of Abramson's method. The beam of laser light itself provides its own weightless, non-mechanical shutter.

In the experimental set-up a flat white card serves as subject. Holographic plate and card are placed at an oblique angle to the incident beam: as the reference pulse rakes across the plate it thus records its position in both space and time. At first sight it sounds as though the whole plate will be uniformly exposed – not a good recipe for a picosecond movie. But the crucial feature is this: the holographic plate records information only where it is simultaneously illuminated by the reference beam and the reflected beam from the subject. In between the interfering pulses the hologram is blank. So the reference beam behaves like an ultrafast shutter as it sweeps across the holographic plate.

Although Abramson undertook his first experiments in Sweden, the historic record of a spherical wave-front of light intersecting a lens – shown above as a composite of five exposures – was achieved in the laboratory of the laser manufacturers Spectra-Physics in California. For five days and no longer their laboratory was at Abramson's disposal. He graphically describes how on Monday the plates suffered from gross overexposure, which he traced to stray ultraviolet light. On Tuesday, they came out underexposed. On Wednesday the exposures were perfect – but no interference pattern was visible. On Thursday, it was realized that minute vibrations were the culprit and the apparatus was accordingly cushioned to damp them. On Friday morning positive results of poor quality were obtained, but by Friday afternoon with a reference beam of lower intensity a superb movie of light in flight was captured at last.

Note how light passing from right to left through the lens (added in the composite above but invisible in the original hologram) is brought to a focus. Here too is visible proof that light waves travel more slowly in solid glass than in air. Equally stunning results have been recorded for light reflected by mirrors. The time resolution in these holograms is about a picosecond, but Abramson sees no impediment to bettering that value a thousandfold in the near future.

Date:	July 1980 (above); July 1970 (opposite)
Place:	Spectra-Physics Facility Laboratory, California; Bell Telephone Laboratories, Murray Hill, New Jersey
Photographer:	N. Abramson, Royal Institute of Technology, Stockholm; M. A. Duguay & A. T. Mattick, Bell Labs
Apparatus:	Spectra-Physics synchronously pumped mode-locked dye laser + white screen facing holographic plate; Nd:glass laser pulse through water + 35 mm Yashica with CS_2 Kerr-cell shutter
Emulsion:	Agfa-Gevaert 8E70; Eastman Kodak High-Speed Ektachrome
Exposure time:	5 sec (laser pulse 10 psec); 10 psec
Source:	Photographers
References:	Duguay 1971, Abramson 1981, Abramson 1983

The Cyclopean Eye of Mimas

Scientifically the most significant image of Mimas, this picture hints at a complex history of meteoritic impacts. The enormous crater at upper right, dubbed Herschel, falls just short of the limit at which this moon of Saturn would be split apart. An equivalent impact on the Earth would probably wipe civilization from the globe.

In the aftermath of the Voyager encounters with Saturn, the entourage of satellites has expanded to a total of 23, a few of which have still to be confirmed. As the innermost of the nine classical satellites of Saturn, all discovered prior to 1900, Mimas is the most difficult to observe against the glare of its ringed parent. Voyager 1 compensated with a relatively close encounter at 88,440 km on 12 November 1980; Voyager 2 managed only 310,000 km at nearest approach on 25 August 1981. Best resolution in the Voyager 1 image opposite, a perspective not available at closest encounter, is about 8 km.

Still it is sufficient to show Herschel, the single large crater on Mimas, its diameter 130 km with rims 5 km high and a central peak of 6 km. The diameter of the crater is very nearly a third the diameter of the entire satellite. Although Tethys can lay claim to an even larger crater/satellite ratio with its own giant Odysseus, Herschel is far better preserved. The blow must have been dealt by an object some 10 km in diameter, perhaps a small stray asteroid or a fragment left over from the formation of the saturnian system.

The vast majority of craters on Mimas have a diameter less than 50 km, and those greater than 20 km generally possess a central peak. Below 20 km in size, craters are distributed quite uniformly over the surface imaged by Voyager (the north polar regions remain to be surveyed). No rayed craters have been observed. At highest resolution long grooves (up to 90 km) produced by faulting of some kind can be seen. They are typically 10 km in width and 1 or 2 km in depth. The impact responsible for Herschel may be the source of the grooves, perhaps also of the small clusters of hummocky hills.

So far 29 craters and 7 grooves ("chasmata") have been formally named on Mimas. With the sole exception of Herschel, so dubbed because Mimas was discovered by William Herschel in 1789, all the features have been assigned names drawn from *Le Morte d'Arthur* of Thomas Malory. Herschel itself was nicknamed Arthur before the International Astronomical Union issued a firm edict.

With a density of 1.44 g per cc, Mimas contains a large proportion of ice, but its surface is less reflective than that of its neighbour Enceladus. Presumably the surface of Mimas is contaminated with more impurities. Enceladus has a diameter only 100 km larger than that of Mimas, and planetary scientists anticipated that they would find two very similar bodies. They guessed wrong. Whereas Mimas bears only a few grooves to hint at internal activity (not visible opposite), Enceladus turns out to be tectonically the most active satellite in Saturn's family. Why should Enceladus be endowed with diverse new landforms and Mimas with little more than an archive of ancient impact craters? The most promising explanation is that Enceladus undergoes tidal heating through an orbital resonance with Dione, the next satellite outward but one (after Tethys).

Readings from the cosmic-ray detector aboard Voyager have been interpreted to imply the existence of another satellite in the same orbit as Mimas so placed that one chases the other at a large enough distance to avoid interacting directly. The electron flux tends to rise steadily with increasing penetration of Saturn's magnetosphere whilst the proton flux displays blips whenever the spacecraft crosses the orbit of a satellite. High-energy protons, the particles of which "cosmic rays" are mainly composed, are continually swept up by orbiting bodies to produce rings of low particle density – whence the blips, or properly speaking "macroabsorption signatures". Mimas generates an especially wide, deep absorption because of the relatively high eccentricity of its orbit.

As Voyager 2 receded from Saturn and recrossed the orbit of Mimas, the electron detectors registered small blips (a "microabsorption signature") attributable to an object in roughly Mimas' orbit. That Mimas itself could have been responsible looks implausible since it should have produced signatures on both inbound and outbound passes. However, a satellite co-orbital with Mimas but half a revolution out of phase could well explain the observation. Steve Synnott of the Jet Propulsion Laboratory announced the discovery of the optical counterpart to this magnetospheric shadow in February 1982, but its orbit remains to be determined.

Date: 12 November 1980
Place: Voyager 1 at 425,000 km from Mimas
Apparatus: Narrow-angle vidicon camera of focal length
 150 cm; computer reconstruction
Exposure time: 0.24 sec
Source: J. E. Guest, University of London Observatory;
 U.S. Geological Survey, Flagstaff, Arizona; NASA
References: Smith *et al.* 1981, Morrison 1982, Soderblom &
 Johnson 1982, Vogt *et al.* 1982

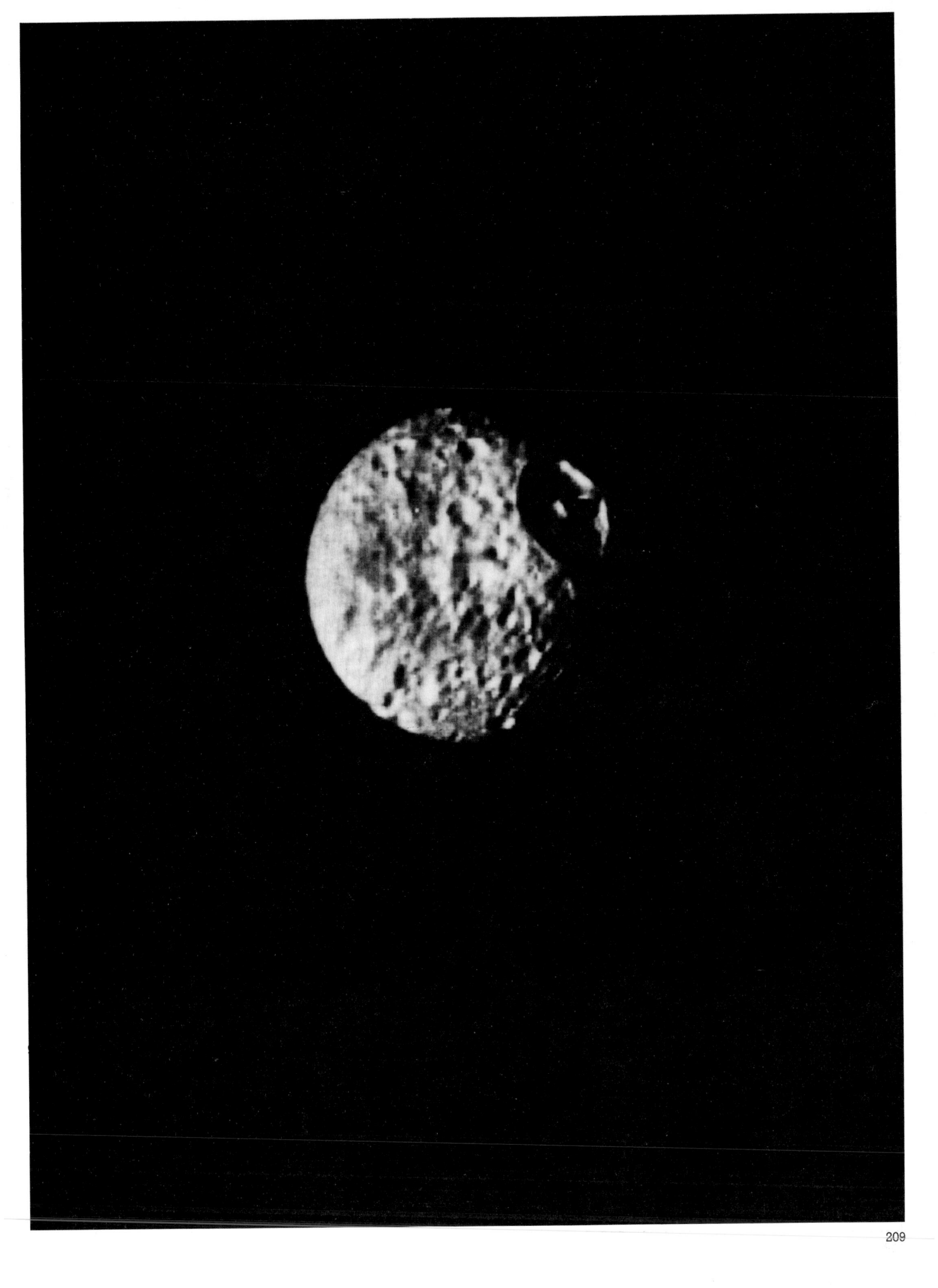

Gravitational Sheepdogs for a Kinky Ring

This image of Saturn's F ring returned by Voyager 1 discloses a phenomenon which ought to be impossible: the braiding of rings of particles about each other in space. When it was first screened at the Jet Propulsion Laboratory, the team leader for imaging science Brad Smith exclaimed that what he saw appeared to defy the laws of orbital mechanics. "Obviously the rings are doing the right thing," he pursued lamely. "It is just that we don't understand the rules."

The F ring was discovered by the imaging photopolarimeter of Pioneer 11 on 1 September 1979, but the resolution was too poor to provide a detailed view. When it was detected again by the spin-scan vidicon of Voyager on 5 November 1980, it looked decidedly eccentric. No departure from circularity had been anticipated, but there was "worse" to come. By 8 November, it was clear that the brightness was not uniform around the ring but increased at several points to form knotty condensations. November 12 brought the revelation that the narrow F ring consists of two intertwined strands plus a third diffuse component (image opposite). When Voyager 2 photographed the F ring on 26 August 1981 at very high resolution, only a few kilometres, it found *four* components but no kinks; a few days later additional fine structure showed up in an occultation experiment observed with the photopolarimeter. Imaging team member Torrence Johnson was later to remark that the rings "are not just eccentric; they are stark raving mad!"

The entirety of the F ring spans perhaps 500 km in width, with clumps or knots spaced on average 9000 km apart along its length, and lies just over 80,000 km above the cloud tops. The eccentricity of the ring amounts to ± 400 km around its orbit. Photographs at high resolution distinguish several strands, sometimes braided about each other but at other times and positions roughly parallel. How permanent are the fine structure, braiding and knots is a matter of conjecture.

The mystery is partly deepened, partly alleviated, by the discovery of two satellites bordering the rings, an inner one provisionally called 1980S27 and an outer one 1980S26. Their gravitational influence may very well account for the braiding and other structural oddities but the exact mechanism has yet to be pinned down. In the image at near right, a Voyager vidicon captures the two satellites just two hours short of conjunction, which occurs every 24.8 days. Although the dots on the image here may look round, the objects are highly irregular with a longest axis of 140 km for 1980S27 and 110 km for 1980S26 and shortest axes only 55–60%

as big. (In both images the A ring looms at right, prominent in reflected sunlight here and faint in transmitted light on the facing page.) The presence of these satellites and their role as gravitational sheepdogs would be somewhat less puzzling if equivalent satellites flanked the other rings – but a search for them proved negative.

The peculiar structure of the F ring may devolve partly from the very small average size of its constituent particles, on the order of tenths of a micrometre – a million times smaller than a typical particle in the other rings. For particles of this size electrostatic effects could become important as in the B-ring spoke phenomenon (p 214). Dynamical models can account for the clumping without resorting to charged particles, but no one has yet unravelled the braids.

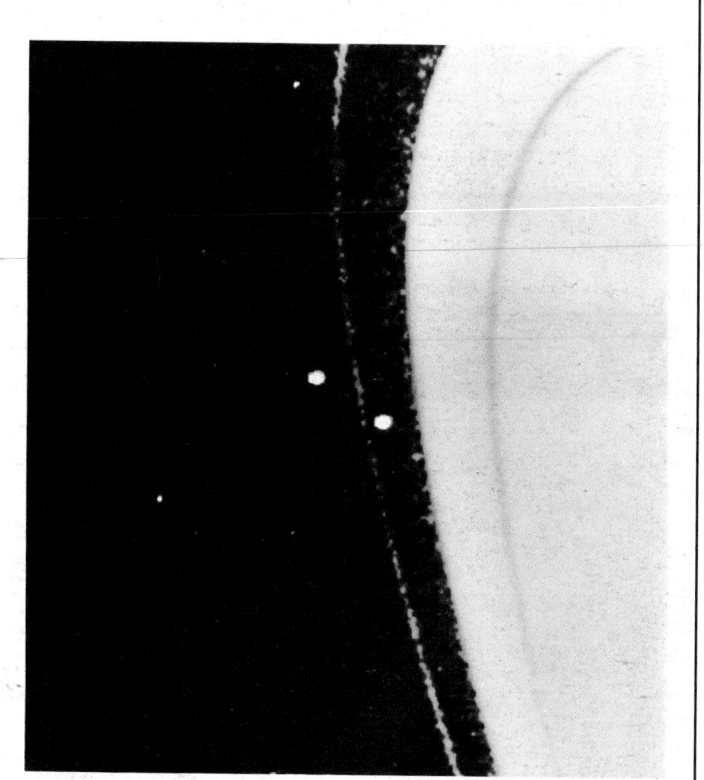

Date:	12 November 1980 (opposite); 15 August 1981 (above)
Place:	Voyager 1 at 750,000 km from F ring (opposite); Voyager 2 at 10.4 million km (above)
Apparatus:	Narrow-angle vidicon camera of 150 cm focal length; computer reconstruction
Exposure time:	1.44 sec (opposite)
Source:	Jet Propulsion Laboratory, Pasadena, California; NASA
References:	Smith *et al.* 1981, Showalter & Burns 1982, Smith *et al.* 1982, Synnott *et al.* 1983

Iapetus: Still in the Dark

Iapetus posed quite a conundrum well before the encounter with Voyager. Observing with an early telescope, J. D. (= G. D.) Cassini in 1671 found the satellite easily at western elongation but could not detect it on the opposite side at eastern elongation. In keeping with all of Saturn's satellites except the outermost, Phoebe, Iapetus is locked into a spin-orbit resonance so that like the Moon it rotates exactly once per orbital revolution. Hence one hemisphere always leads along its orbit and the other trails – the one so dark as to be nearly invisible, the other as bright as a dirty snowball.

Voyager 1 only managed to fly within 2.5 million km of Iapetus, but Voyager 2 approached to 909,070 km where it achieved a resolution of 17 km – not so high as for most of the other satellites but adequate for viewing the contrasting hemispheres. The bulk density of 1.16 g per cc is the lowest in the Saturnian system – barring Saturn itself, only two thirds as dense as water – and it must consist largely of ices or icy clathrates (water, methane, ammonia). So it is tempting to speculate *a priori* that the primary material of the satellite is bright, with a dark coating on the leading hemisphere, rather than vice versa.

Our best colour image of Iapetus appears opposite. There are two borders between light and dark: the day-night terminator on the left and the trailing-leading boundary toward the right. The boundary is by no means precise; a tongue of dark material thrusts into the bright trailing hemisphere in the equatorial region (the three to five o'clock position opposite; the north pole lies at upper left). Moreover, a ring of dark material 400 km in diameter (not visible here) figures on bright terrain near the boundary on the other side of the satellite. The resolution in this image is about 20 km.

The first idea advanced to account for the asymmetry in albedo was that the body must be so irregular as to vary dramatically in cross-section according to the viewing geometry. Measurements of thermal emission and polarization soon laid that notion to rest. Subsequent suggestions for the preferential depletion of high-albedo material from the leading hemisphere or preferential deposition of high-albedo material onto the trailing hemisphere run into serious difficulties, the first of which is our *a priori* assumption that the basic composition of Iapetus ought to favour ice-bright over ash-dark constituents.

A more compatible solution is to postulate that Iapetus gathers up dark material from space on its leading side. Indeed, it has been suggested that matter expelled from dark Phoebe by meteoritic impacts would later be swept up by Iapetus, preferentially on its leading face. But the equatorial tongue and the dark ring would be difficult to explain on this or any other exogenic hypothesis. Infrared photometry has in any case shown that the dark matter of Iapetus and that of Phoebe are dissimilar.

An endogenic origin for the dark material on the leading hemisphere seems more plausible. If Iapetus has been chemically differentiated in the course of its evolution, then volcanism could ejaculate from its depths matter quite unlike its icy bulk. This matter looks as dark as pitch, with a reddish tinge, but to date we have no firm clues to its identity. The colour is consistent with organic substances found in the primitive carbonaceous-chondrite meteorites. The methane content of Iapetus may be in some way responsible, darkened by solar ultraviolet radiation. Of course volcanoes are literally and figuratively a stab in the dark since no detail can be perceived on the leading face.

The bright face, on the other hand, is riddled with craters. A few larger ones can be seen opposite, including Charlemagne and Ogier just emerging from the terminator at lower left' and Berenger standing prominently at upper centre. (Nomenclature for surface features on Iapetus is drawn from the Song of Roland.) Although the cratered terrain of the trailing hemisphere may be older, it is quite possible that craters too dark to see occur on the opposite hemisphere as well. Dark material discernible on some crater floors on the trailing face lends additional support to the internal hypothesis. Its protagonists have nonetheless been unable to explain away one overwhelming difficulty. If endogenic sources are supposed to account for the dark areas, why do they favour one hemisphere so emphatically over the other?

Date:	22 August 1981
Place:	Voyager 2 at 1.1 million km from Iapetus
Apparatus:	Narrow-angle vidicon camera of 150 cm focal length plus filter wheel; computer photomosaic
Exposure time:	0.5 sec
Source:	Jet Propulsion Laboratory, Pasadena, California; NASA
References:	Morrison 1982, Smith *et al*. 1982, Soderblom & Johnson 1982, Cruikshank *et al*. 1983

A Ringside View from Voyager

One of the great discoveries of the Voyager space probes, one not really anticipated by Pioneer 11 in its August 1979 encounter, is the subdivision of the major rings into thousands of ringlets. The narrowest features in the image opposite, perhaps the optimum one for counting purposes, may be only transitory, brightening and fading according to the play of gravitational forces in Saturn's system.

The rings begin just above the cloud tops with the faint bands of the D ring discovered by Pierre Guérin in 1969. After a gap informally called the French Division come the classical rings: the C or crêpe ring flanked by the B ring and then following the Cassini Division the A ring. (Rings F, G and E lie farther out still, interspersed among the inner satellites.) Broadest and brightest of the rings is the B ring. Voyager 1 found divisions down to a limiting resolution of about 70 km and Voyager 2 to its own limit of 10 km (opposite); so we still do not know how narrow are the smallest distinct ringlets. The width of this image is some 6000 km, running from the Cassini Division (upper left) at 57,100 km above the cloud tops almost a quarter of the way into the expanse of the B ring. The inner edge lies 31,900 km from the cloud tops.

So thick is the B ring that it casts a shadow onto Saturn's clouds and unlike other rings appears impenetrable to light or radio waves. As a result it is difficult to estimate the size of its constituent particles although ground-based radar observations suggest a range from 10 to 100 cm. An upper limit to the thickness of the B ring is 2 km. Planetary scientists recognize four radial zones, and each probably has a different size distribution, perhaps even a different composition. Basically the rings consist of dust- to boulder-sized particles of water ice laced with various impurities.

After the sheer abundance of its ringlets, the most remarkable phenomenon discovered in the B ring is its spokes. The Voyager cameras recorded dark radial streaks by back-scattered light (Sun behind camera) and bright streaks by forward scattering (Sun ahead of camera, albeit not directly!). They tend to point outward from the middle of the B ring over a distance of 10,000 km with widths of 100 to 2000 km. Spokes are transient, appearing as fine lines, broadening to wedges and vanishing in the space of hours. They arise in the B ring between 43,000 and 57,000 km above the cloud tops and apparently shun all other rings.

That radial features exist at all is not a little surprising. By 1857 it was realized that the rings must be comprised of myriad small solid particles obeying Kepler's laws; thus the inner edge of a ring revolves faster than the outer edge and any radial structure should be rapidly destroyed. Yet spokes patently exist and moreover co-rotate with the rings. Saturn's magnetic field is widely held responsible for the spokes, but the exact mechanism for generating and sustaining them remains obscure. The different behaviour according to the position of the light source points to very fine particles, little larger than the wavelength of light. Electrostatic charging could raise them out of the ring plane. A recent model postulates elevation by means of dense columns of charged particles generated by meteoritic impacts on the ring.

B ringlets are circular although elliptical rings occur elsewhere. Current thinking ascribes them to "density waves" generated by gravitational resonances with the satellites. Gravitational perturbations have long been held responsible for the gross structure of the rings, but the degree of fine structure was certainly not anticipated. To decide whether the ringlets are transient or stable will require not a fly-by mission but an orbiter.

Date: 25 August 1981 (opposite); 3 August 1981 (above)
Place: Voyager 2 at 743,000 km (opposite), 22 million km (above) from B ring
Apparatus: Narrow-angle vidicon camera of focal length 150 cm (opposite); computer reconstruction
Exposure time: 1.0 sec (opposite)
Source: Jet Propulsion Laboratory, Pasadena, California; NASA
References: Smith *et al.* 1981, Morrison 1982, Smith *et al.* 1982, Goertz & Morfill 1983

Puck's Girdle

The aurora borealis, or northern lights, figured in poetry and folklore for centuries before coming within the ambit of science. (The aurora australis never achieved comparable renown.) It is the aurora in the upper atmosphere whose flickerings inspired Browning's "belch of fire" as from a "dragon's nostril", Coleridge's "streamy banners of the North", Southey's "gleams of glory, streaks of flaming light", Tennyson's belt of "luminous vapour", James Thomson's "ether coursing in a maze of light", Whittier's "strange fire in Heaven". Popular lore has attributed the play of lights in the sky to one of two widespread myths: either games or battles among the spirits of the dead or else reflections from Arctic icefields or silvery shoals of herring.

What does science make of the aurora? The two main ingredients are the solar wind, a stream of charged particles ejected from the Sun; and the magnetosphere, the circumterrestrial region dominated by lines of the Earth's magnetic field. The interaction between the fluctuating solar wind and our magnetospheric cocoon produces the aurora – but how? The near-Earth magnetic field looks like a tolerably symmetric dipole – not unlike a bar magnet – but farther out the sunward side looks totally different from the nightside. The electrons and protons of the solar wind slam into the Earth's magnetic shield at 500 km per sec, compressing the closed field lines on the dayside and distending the field lines on the nightside so far that their loops snap open to form a long magnetic tail. The dynamo created by the blowing of the electrically conductive wind across the stretched boundary of the magnetosphere causes the wind's charged particles to drift toward the centre of the tail where they form a plasma sheet. Electrical discharge from the plasma sheet feeds electrons (and some protons) down to the closed field lines anchored on an oval band at about 20° from the geomagnetic poles.

So contrary to what one might imagine, the polar aurora does not sit like a skullcap above the geographic poles but lies like a deformed quoit in the ionosphere around the geomagnetic poles. As the Earth rotates the oval finds itself hovering over changing territory. This global picture may sound simple but has required thousands of small-scale individual observations to piece together. As Lou Frank of the Physics Department at the University of Iowa once said, the auroral researcher's task is that of "an ant walking around the Rocky Mountains trying to understand their geology". Even those satellite probes equipped for photography – notably the DAPP or DMSP satellites launched by the U.S. Air Force – achieved only fragmentary views until the launch of Dynamics Explorer 1.

On the facing page we can see at a stroke the whole auroral oval for the first time. Placed into orbit on 3 August 1981, Dynamics Explorer 1 follows an eccentric ellipse which carries it out to apogee (farthest point) at over 3 Earth radii, or 5% of the Moon's distance. Soon after launch apogee was reached over the north pole but precession of the satellite's orbit displaces apogee to the south pole in about 18 months. In a single orbit the satellite sends back a continuous picture of the aurora for as long as five hours.

The photograph opposite is a false-colour picture built up from ultraviolet data received at Goddard Space Flight Center (GSFC) in Maryland and processed at Langley Research Center in Virginia. Taken in the light of atomic oxygen emission (1305 and 1355 Å), the image shows higher intensities white, lower intensities red. Note how the oval extends from the nightside continuously to the sunlit side, albeit not with equal intensity throughout. Two bright spots stand out at the positions of noon and midnight whilst atmospheric turbulence at a height of about 120 km smears the otherwise sharp loop where it intersects the terminator (dividing line between dayside and nightside). The auroral oval displays itself here at quiescence; when a solar flare triggers an "auroral substorm", the oval intensifies and swells.

The auroral glow itself is a discharge which S.-I. Akasofu has likened to a "natural neon sign". Electrons discharged from the plasma sheet strike atoms of nitrogen and oxygen in the tenuous ionosphere (60 to 400 km or higher), exciting them to energy states unattainable in the denser air below. As each type of atom returns to normal it emits light of its own characteristic colour, green for nitrogen and red for oxygen. The interplay of electric currents in the atmosphere generates the flames, arcs and curtains we see from the ground. But these are the trees and at last we have acquired a synoptic view of the wood.

Date:	25 September 1981
Place:	22,000 km above north pole
Apparatus:	University of Iowa spin-scan imaging photometer on Dynamics Explorer 1 (NASA/GSFC); false-colour reconstruction
Source:	L. A. Frank & J. D. Craven, University of Iowa
References:	Eather 1980, Frank et al. 1981, Spencer & Nagy 1982

The Farthest Frontier

Although the crown is bound to pass to other heads, the arrowed dot in the star field opposite (north at left) is currently the most distant known object in the Universe – and also the most luminous. It is a quasar, one of that enigmatic breed of extragalactic objects whose energy output is almost inconceivably huge for its relatively small size – the power of a galaxy generated in the volume of a solar system.

Its designation, PKS 2000–330, testifies to its identification first as a radio source by the 2.7-gigahertz survey conducted at Parkes in New South Wales and published in 1974. Radio positions from such surveys are notoriously less accurate than those derived optically, and it was not until nearly a decade later that further radio observations with the Tidbinbilla Interferometer enabled Ann Savage of the Royal Observatory, Edinburgh (ROE) to pinpoint PKS 2000–330 on a photographic plate taken years earlier on the U.K. Schmidt Telescope (UKST) in Australia. PKS 2000–330 does not exactly stand out in a crowd, and it generated no special excitement until the night of 25 March 1982, when Ann Savage and Bruce Peterson recorded its spectrum with the 3.9 m Anglo-Australian Telescope (AAT) located on Siding Spring Mountain alongside the UKST.

It was soon clear that emission lines characteristic of a quasar were present (cf. pp 114–115) and that they were shifted by an unprecedented amount from their rest positions in the ultraviolet region far toward the red – indeed, right into the visible region. This "redshift" occurs when an object is receding in the line of sight from the Earth, and over half a century ago Edwin Hubble showed that other galaxies recede from our own at a rate proportional to their distance. In our expanding Universe the farther a galaxy, the faster its flight and the greater its redshift. The most distant known galaxies have a redshift of about 1 (thereby overlapping with the nearest quasars) whereas PKS 2000–330 sets a new record of 3.78.

Since the speed of light is finite, observation at increasing redshift implies insight into earlier times in cosmic history. The nethermost galaxies we can detect correspond to half the present age of the Universe; the newly found farthest quasar, to one fifth its age. Quasars are evidently a phenomenon of the early universe; it is not yet clear whether the majority of galaxies at our epoch underwent a quasar phase at an earlier one.

Direct photography alone cannot discriminate between the distant quasar and a relatively nearby faint star on the blue-sensitive plate. Spectroscopy, on the other hand, is decisive and below is reproduced a portion of the quasar spectrum taken on the UKST at low dispersion with an objective prism. The most prominent spectral feature is the Lyman alpha line of hydrogen, and in the intensity tracing beneath the spectrum labels identify emission lines produced by ionized atoms of oxygen, nitrogen, silicon and carbon.

Faint though its image appears to a terrestrial observer, PKS 2000–330 also accedes to the title of most luminous known object. In order to achieve its visual magnitude of about 17, it must be radiating light equivalent to that of a hundred million million stars, or a thousand times the output of our entire Galaxy. The importance of its high luminosity does not lie only in the mystery of its energy source; that problem, after all, applies to all quasars. Of greater significance is the fact that this, the most distant known quasar, lies comfortably within the grasp of our larger instruments. Thus there is every hope that yet more ancient and more distant quasars will soon be filling in our sketchy picture of the Universe in its youth.

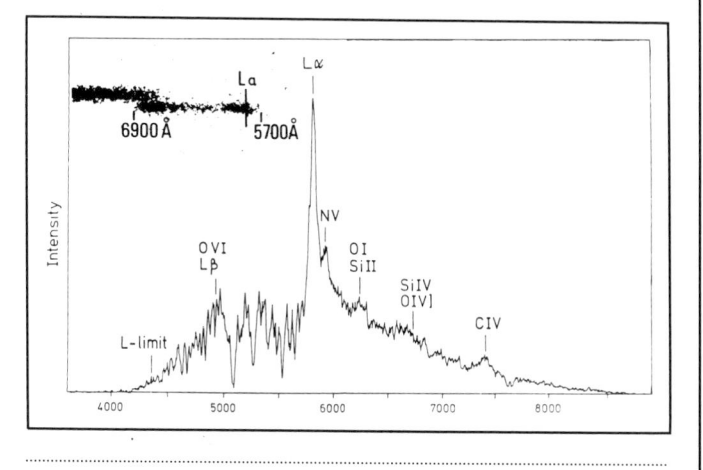

Date: 21 July 1974 (opposite); 27 June 1982 (above)
Place: U.K. Schmidt Telescope, New South Wales
Photographers: A. Savage & B. A. Peterson (above)
Apparatus: 1.2 m UKST (above with objective prism)
Emulsion: Kodak IIIa-J (opposite); IIIa-F (above)
Exposure time: 40 min (opposite); 70 min (above)
Sources: Photolabs, ROE (opposite);
 D. F. Malin, AAT (above)
References: Rees 1978, Peterson et al. 1982,
 Savage & Peterson 1983

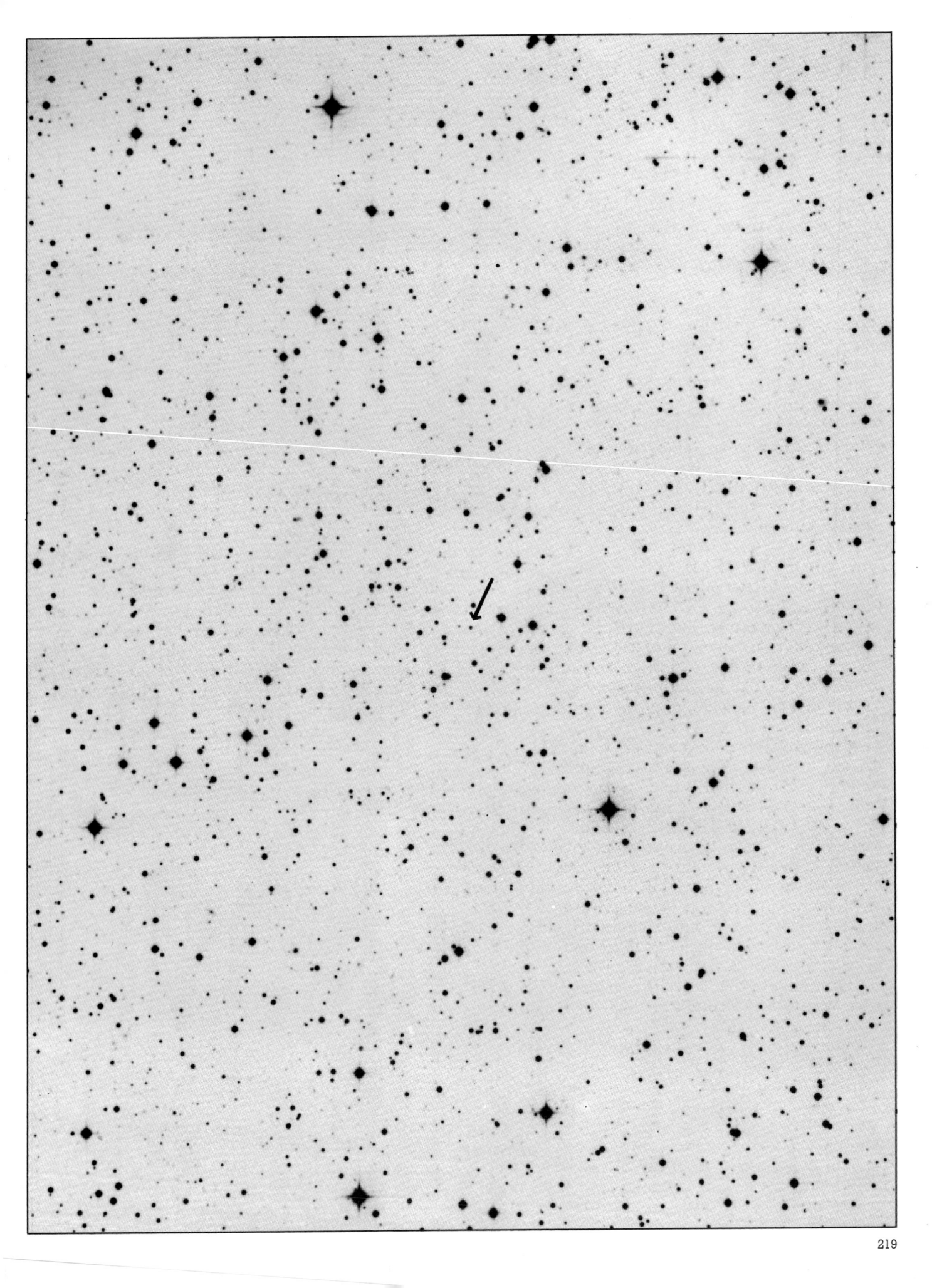

References

Abramson, N., 1981. *The Making and Evaluation of Holograms* (Academic Press: New York).

Abramson, N., 1983. "Light-in-flight recording: High-speed holographic motion picture of ultrafast phenomena", *Applied Optics* 22, 215–232.

Allen, D.A., 1982. "At the faintest limits", in P. Moore, ed, *1983 Yearbook of Astronomy* (Sidgwick & Jackson: London).

Allison, L.J., ed, 1980. "Meteorological satellites", *NASA TM–80704*.

Alpgård, K. *et al.*, 1982. "Production of photons and search for Centauro events at the SPS collider", *Physics Letters* 115B, 71–76.

Anderson, C.D., 1933. "The positive electron", *Physical Review* 43, 491–494.

Anderson, C.D., 1961. "Early work on the positron and muon", *American Journal of Physics* 29, 825–830.

Angelini, C. *et al.*, 1979. "On the lifetime of charged, charmed particles: First direct observation of a charmed baryon decay", *Physics Letters* 84B, 150–155.

Anon., 1858. [T. Skaife's camera for instantaneous photography], *Liverpool and Manchester Photographic Journal* 2, 235–236.

Anon., 1868. "How Mr Warren De La Rue photographed the Moon", *The Engineer* 25, 374–376.

Anon., 1954. "Cloud and stem phenomena: Operation Ivy", *EG&G Report* n° 1136 (Edgerton, Germeshausen & Grier, Inc: Boston).

Anon. [Spreen, W.C., ed], 1966. "Significant achievements in satellite meteorology, 1958–1964", *NASA SP–96*.

Anon., 1967. "Mariner-Mars 1964: Final project report", *NASA SP–139*.

Anon. [Mutch, T.A. & Jones, K.L.], 1978. "The martian landscape", *NASA SP–425*.

Arnison, G. *et al.*, 1983. "Search for Centauro-like events at the CERN proton-antiproton collider", *Physics Letters* 122B, 189–196.

Arnold, H.J.P., 1977. *William Henry Fox Talbot* (Hutchinson Benham: London).

Atkinson, R.J.C., 1982. "Aspects of the archaeoastronomy of Stonehenge", in D.C. Heggie, ed, *Archaeoastronomy in the Old World* (Cambridge University Press: Cambridge).

Ballard, R.D., 1977. "Notes on a major oceanographic find", *Oceanus* 20 (n° 3), 35–44.

Ballard, R.D. & Grassle, J.F., 1979. "Return to oases of the deep", *National Geographic* 156, 689–705; see also 680–688.

Barabashov, N.P., Mikhailov, A.A. & Lipsky, Yu. N., 1961. *An Atlas of the Moon's Far Side* (Interscience Publishers: New York).

Barbour, R.W. & Davis, W.H., 1969. *Bats of America* (University Press of Kentucky: Lexington), pp197–212.

Barnard, E.E., 1893. "On the photographic discovery of Comet a (Oct.12, 1892)", *Observatory* 16, 92–95.

Barnes, R.B., 1968. "Diagnostic thermography", *Applied Optics* 7, 1673–1685.

Bartell, L.S., 1975. "Images of gas atoms by electron holography, I: theory; II: experiment and comparison with theory", *Optik* 43, 373–390 and 403–418.

Bartell, L.S. & Johnson, R.D., 1977. "Molecular images by electron-wave holography", *Nature* 268, 707–708.

Bartell, L.S. & Ritz, C.L., 1974. "Atomic images by electron-wave holography", *Science* 185, 1163–1165.

Batchelor, G.K., 1975. "An unfinished dialogue with G.I. Taylor", *Journal of Fluid Mechanics* 70, 625–638.

Baum, W.A., Johnson, F.S., Oberly, J.J., Rockwood, C.C., Strain, C.V. & Tousey, R., 1946. "Solar ultraviolet spectrum to 88 kilometers", *Physical Review* 70, 781–782.

Beatty, J.K., 1982. "The amazing Olympus Mons", *Sky and Telescope* 64, 420–422.

Becquerel, E., 1842. "Mémoire sur la constitution du spectre solaire", *Compte(s) Rendu(s) de l'Académie des Sciences de Paris* 14, 901–904.

Beresford, Q. & Bailey, G., 1981. *Search for the Tasmanian Tiger* (Blubber Head Press: Hobart).

Blackett, P.M.S., 1929a. "On the automatic use of the standard Wilson chamber". *Journal of Scientific Instruments* 6, 184–191.

Blackett, P.M.S., 1929b. "On the design and use of a double camera for photographing artificial disintegrations", *Proceedings of the Royal Society* A123, 613–629.

Blackett, P.M.S. & Lees, D.S., 1932. "Investigations with a Wilson chamber, I: On the photography of artificial disintegration collisions", *Proceedings of the Royal Society* A136, 325–338.

Blackmore, J.T., 1972. *Ernst Mach: His Work, Life and Influence* (University of California Press: Berkeley).

Blake, R.L., Chubb, T.A., Friedman, H. & Unzicker, A.E., 1963. "Interpretation of X-ray photograph of the Sun", *Astrophysical Journal* 137, 3–15.

Bradfield, J.R.G., 1951. "Radiographic studies on the formation of the hen's egg shell", *Journal of Experimental Biology* 28, 125–140.

Brandt, J.C. & Chapman, R.D., 1981. *Introduction to Comets* (Cambridge University Press: Cambridge).

Buckland, G., 1981. *First Photographs* (Robert Hale: London).

Butler, C.P., 1962. "The light of the atomic bomb", *Science* 138, 483–489 + cover.

Cairns, J., Stent, G.S. & Watson, J.D., eds, 1966. *Phage and the Origins of Molecular Biology* (Cold Spring Harbor Laboratory of Quantitative Biology: Long Island, New York).

Carr, M.H., 1981. *The Surface of Mars* (Yale University Press: New Haven).

Carr, M.H., Crumpler, L.S., Cutts, J.A., Greeley, R., Guest, J.E. & Masursky, H., 1977. "Martian impact craters and emplacement of ejecta by surface flow", *Journal of Geophysical Research* 82, 4055–4065.

Chadwick, J., 1932. "The existence of a neutron", *Proceedings of the Royal Society* A136, 692–708.

Chandrasekhar, S., 1979. "Einstein and general relativity: Historical perspectives", *American Journal of Physics* 47, 212–217.

Christy, J.W. & Harrington, R.S., 1978. "The satellite of Pluto", *Astronomical Journal* 83, 1005–1008.

Christy, J.W. & Harrington, R.S., 1980. "The discovery and orbit of Charon", *Icarus* 44, 38–40.

Clayton, D.D., 1975. *The Dark Night Sky* (Quadrangle/New York Times Book Co: New York).

Clerke, A.M., 1893. *A Popular History of Astronomy during the 19th Century*, 3rd edn (Adam & Charles Black: London).

Cocke, W.J., Disney, M.J. & Taylor, D.J., 1969. "Discovery of optical signals from pulsar NP0532", *Nature* 221, 525–527 et seq.

Common, A.A., 1883. "Note on a photograph of the Great Nebula in Orion and some new stars near Theta Orionis", *Monthly Notices of the Royal Astronomical Society* 43, 255–257.

Common, A.A., 1884. "Note on stellar photography" and "Note on a method of giving long exposures in astronomical photography", *Monthly Notices of the Royal Astronomical Society* 45, 22–27.

Corliss, J.B. & Ballard, R.D., 1977. "Oases of life in the cold abyss", *National Geographic* 152, 440–453.

Cortwright, E.M., ed, 1968. "Exploring space with a camera", *NASA SP–168*.

Cosslett, V.E., 1973. "Can the electron microscope reveal atomic detail?", *Manchester Literary and Philosophical Society Memoirs and Proceedings* 115, 17–31.

Crawford, O.G.S., 1924. "The Stonehenge Avenue", *Antiquaries Journal* 4, 57–58.

Crawford, O.G.S. & Keiller, A., 1928. *Wessex from the Air* (Clarendon Press: Oxford).

Crookes, W., 1853. "On the application of photography to the study of certain phenomena of polarization", *Journal of the Photographic Society of London* 1, 70–74.

Cruikshank, D.P., Bell, J.F., Gaffey, M.J., Brown, R.H., Howell, R., Beerman, C. & Rognstad, M., 1983. "The dark side of Iapetus", *Icarus* 53, 90–104.

Curie, I. & Joliot, F., 1932a. "Projections d'atomes par les rayons très pénétrants excités dans les noyaux légers", *Comptes Rendus de l'Académie des Sciences de Paris* 194, 876–877.

Curie, I. & Joliot, F., 1932b. "La projection de noyaux atomiques par un rayonnement très pénétrant; L'existence du neutron", *Actualités Scientifiques et Industrielles* n° 32.

Danckwerts, P., 1982. "Oppenheimer, Teller and the superbomb", *New Scientist* 95, 573–574 and 641–642; see also 97, 751.

Danysz, M. & Pniewski, J., 1953. "Delayed disintegration of a heavy nuclear fragment, I", *Philosophical Magazine* 44, 348–350.

Darius, J., 1984. "William Crookes: The chemist as photographer", forthcoming.

da Silva, M., ed, 1982. *Catálogo da Exposição Itinerante da Obra Egas Moniz e Reynaldo dos Santos* (Lisbon).

Davis, D.H., 1981. "Searches for the new short-lived particles using photographic emulsion", *Science Progress* 67, 295–308.

De La Rue, W., 1859. "Report on the present state of celestial photography in England", *Report of 29th Meeting of the British Association for the Advancement of Science*, pp130–153.

De La Rue, W., 1862. "On the total solar eclipse of July 18th, 1860 observed at Rivabellosa, near Miranda de Ebro, in Spain [Bakerian Lecture]", *Philosophical Transactions of the Royal Society* 52, 333–416.

De La Rue, W., 1864. "Comparison of Mr De La Rue's and Padre Secchi's eclipse photographs", *Proceedings of the Royal Society* 13, 442–444.

Deuel, L., 1971. *Flights into Yesterday: The Story of Aerial Archaeology* (MacDonald: London).

di Cicco, D., 1979. "Exposing the analemma", *Sky and Telescope* 57, 536–540 + cover.

Dietz, R.S. & French, B.M., 1973. "Two probable astroblemes in Brazil", *Nature* 244, 561–562.

Donné, A., 1840. "Images photogéniques d'objets microscopiques", *Compte(s) Rendu(s) de l'Académie des Sciences de Paris* 10, 339.

Donné, A. & Foucault, L., 1845. *Cours de Microscopie: Atlas Exécuté d'après Nature au Microscope-Daguerréotype* (J.-B. Baillière: Paris).

Draper, J.W., 1878. *Scientific Memoirs* (Sampson Low, Marston, Searle & Rivington: London).

Duguay, M.A., 1971. "Light photographed in flight", *American Scientist* 59, 550–556.

Dunne, J.A. & Burgess, E., 1978. "The voyage of Mariner 10: Mission to Venus and Mercury", *NASA SP–424*.

Dürst, J., 1982. "Two-colour photometry and polarimetry of the solar corona of 16 February 1980", *Astronomy and Astrophysics* 112, 241–250.

Dürst, J. & Zelenka, A., 1980. "A corona to remember", *Sky and Telescope* 60, 8–9; Letter, *ibid.*, 475.

Dyson, F.W., Eddington, A.S. & Davidson, C., 1920. "A determination of the deflection of light by the Sun's gravitational field, from observations made at the total eclipse of May 29, 1919", *Philosophical Transactions of the Royal Society* A220, 291–333.

Earman, J. & Glymour, C., 1980. "Relativity and eclipses: The British eclipse expeditions of 1919 and their precedessors", *Studies in the History and Philosophy of Science* 11, 49–85.

Eather, R.H., 1980. *Majestic Lights: The Aurora in Science, History and the Arts* (American Geophysical Union: Washington, D.C.).

Eddy, J.A., ed Ise, R., 1979. "A new sun: The solar results from Skylab", *NASA SP–402*.

Eder, J.M., 1945. *History of Photography* [4th edn] (Columbia University Press: New York); reprinted 1978 (Dover: New York).

Edgerton, H.E., 1955. "Photographing the sea's dark underworld", *National Geographic* 107, 523–537.

Edgerton, H.E., 1979. *Electronic Flash, Strobe*, 2nd edn (MIT Press: Cambridge, Massachusetts).

Edgerton, H.E. & Cousteau, J.-Y., 1959. "Underwater camera positioning by sonar", *Review of Scientific Instruments* 30, 1125–1126.

Edgerton, H.E. & Hoadley, L.D., 1955. "Cameras and lights for underwater use", *Journal of the Society of Motion Picture and Television Engineers* 64, 345–350.

Edgerton, H.E. & Killian, J.R., Jr., 1979. *Moments of Vision* (MIT Press: Cambridge, Massachusetts).

Edgerton, H.E., Spangle, P.F. & Baker, J.K., 1966. "Mexican freetail bats: Photography", *Science* 153, 201–203 + cover.

Edmond, J.M. & Von Damm, K., 1983, "Hot springs on the ocean floor", *Scientific American* 248 (n° 4), 70–85.

England, M.A., 1983. *A Colour Atlas of Life before Birth* (Wolfe Medical Publications: London).

Fimmel, R.O., Colin, L. & Burgess, E., 1983. "Pioneer Venus", *NASA SP–461*.

Fimmel, R.O., Van Allen, J.A. & Burgess, E., 1980. "Pioneer, first to Jupiter, Saturn, and beyond", *NASA SP–446*.

Florkin, M., 1972. "A history of biochemistry", *Comprehensive Biochemistry* **30**, ch 16.

Forssmann, W., 1929. "Die Sondierung des rechten Herzens", *Klinische Wochenschrift* **8**, 2085–2087.

Forssmann, W., 1974. *Experiments on Myself* (Saint Martin's Press: New York and St. James Press: London).

Frank, L.A., Craven, J.D., Ackerson, K.L., English, M.R., Eather, R.H. & Carovillano, R.L., 1981. "Global auroral imaging instrumentation for the Dynamics Explorer mission", *Space Science Instrumentation* **5**, 369–393.

Franklin, K.L., 1962. "The astronomer's odd figure 8", *Natural History* **71** (n° 8), 8–15.

Frizot, M., ed, 1977. *É.-J. Marey, 1830–1904: La Photographie du Mouvement* (Centre National d'Art et Culture Georges Pompidou: Paris).

Fry, S., 1861. "Lunar photography" and subsequent discussion, *Photographic Journal* **7**, 80–85.

Fuchs, A.W., 1960. "Radiography of 1896", *Image* **9**, 4–17 + cover.

Gentner, W., Maier-Leibnitz, H. & Bothe, W., 1954. *An Atlas of Typical Expansion Chamber Photographs* (Pergamon Press: London).

Gernsheim, A., 1961. "Medical photography in the nineteenth century", *Medical and Biological Illustration* **11**, 85–92 and 147–156.

Gernsheim, H. & Gernsheim, A., 1969. *The History of Photography*, 2nd edn (Thames & Hudson: London); also Gernsheim, H., 1982, *The Origins of Photography*, 3rd edn of 1st part (Thames & Hudson: London).

Gill, D., 1887. "The applications of photography in astronomy", *Observatory* **10**, 267–272 and 283–294.

Gill, D., 1911. "Observations of the Great Comet, 1882 II", *Annals of the Royal Observatory, Cape of Good Hope*, vol 2, pt 1.

Gill, D., 1913. *A History and Description of the Royal Observatory, Cape of Good Hope* (HMSO: London).

Glasser, O., ed, 1933. *The Science of Radiology* (Baillière, Tindall & Cox: London).

Glasser, O., 1959. *Wilhelm Conrad Röntgen und die Geschichte der Röntgenstrahlen*, 2nd edn (Springer Verlag: Berlin); 1933 transl. of 1st edn as *Wilhelm Conrad Röntgen and the Early History of the Roentgen Rays* (John Bale, Sons & Danielsson: London).

Glasstone, S., ed, 1962. *The Effects of Nuclear Weapons*, 2nd edn [*Nota bene*] (United States Atomic Energy Commission: Washington, D.C.)

Gloersen, P. & Salomonson, V.V., 1975. "Satellites – new global observing techniques for ice and snow", *Journal of Glaciology* **15**, 373–389.

Gloersen, P., Wilheit, T.T., Chang, T.C., Nordberg, W. & Campbell, W.J., 1974. "Microwave maps of the polar ice of the Earth", *Bulletin of the American Meteorological Society* **55**, 1442–1448.

Goertz, C.K. & Morfill, G., 1983. "A model for the formation of spokes in Saturn's ring", *Icarus* **53**, 219–229 et seq.

Goetz, A.F.H. & Rowan, L.C., 1981. "Geologic remote sensing", *Science* **211**, 781–791.

Goldberg, B.A., Mekler, Yu., Carlson, R.W., Johnson, T.V. & Matson, D.L., 1980. "Io's sodium emission and the Voyager 1 encounter", *Icarus* **44**, 305–317.

Goodman, P., ed, 1981. *Fifty Years of Electron Diffraction* (International Union of Crystallography/ D. Reidel: Dordrecht, Holland).

Gornitz, V., ed, 1979. *Geology of the Planet Mars* (Dowden, Hutchinson & Ross: Stroudsburg, Pennsylvania).

Greenler, R.G., 1971. "Infrared rainbow", *Science* **173**, 1231–1232 + cover.

Greenler, R.G., 1980. *Rainbows, Halos and Glories* (Cambridge University Press: Cambridge).

Greenstein, J.L. & Schmidt, M., 1964. "The quasistellar radio sources 3C 48 and 3C 273", *Astrophysical Journal* **140**, 1–34.

Griffith, J., 1972. "The search for the Tasmanian tiger", *Natural History* **81** (n° 10), 70–77.

Grigg, E.R.N., 1965. *The Trail of the Invisible Light* (Charles C. Thomas: Springfield, Illinois).

Haas, R.B., 1976. *Muybridge, Man in Motion* (University of California Press: Berkeley).

Haggerty, R., Simon, R., Golub, L., Silk, J.K., Timothy, A.F., Krieger, A.S. & Vaiana, G.S., 1975. "Soft X-ray imaging on photographic film", *AAS Photobulletin* n° 10, pp 8–14.

Hallion, R.P. & Crouch, T.D., eds, 1979. *Apollo, Ten Years since Tranquillity Base* (National Air and Space Museum: Washington, D.C.).

Hanson, N.R., 1963. *The Concept of the Positron* (Cambridge University Press: Cambridge).

Harrington, R.S. & Christy, J.W., 1980. "The satellite of Pluto, II", *Astronomical Journal* **85**, 168–170.

Harrington, R.S. & Christy, J.W., 1981. "The satellite of Pluto, III", *Astronomical Journal* **86**, 442–443.

Harris, H.A., 1948. "De formatione ovi et pulli", *British Medical Journal*, 1st vol, pp 585–586.

Hartmann, W.K. & Raper, O., 1974. "The new Mars", *NASA SP–337*.

Hasert, F.J. et al., 1973a. "Search for elastic muonneutrino electron scattering", *Physics Letters* **46B**, 121–124.

Hasert, F.J. et al., 1973b. "Observation of neutrinolike interactions without muon or electron in the Gargamelle neutrino experiment", *Physics Letters* **46B**, 138–140.

Hashimoto, H., Takai, Y., Yokota, Y., Endoh, H. & Fukada, E., 1980. "Direct observations of the arrangement of atoms around stacking faults and twins in gold crystals and the movement of atoms accompanying their formation and disappearance", *Japanese Journal of Applied Physics* **19**, L1–L4.

Haymon, R.M., 1983. "Growth history of hydrothermal black smoker chimneys", *Nature* **301**, 695–698.

Herschel, J.F.W., 1843. "On the action of the rays of the solar spectrum on the daguerreotype plate", *Philosophical Magazine* (3rd series) **22**, 120–132.

Hersey, J.B., ed, 1967. *Deep-Sea Photography* (Johns Hopkins Press: Baltimore).

Hounsfield, G.N., 1979. "Computer reconstructed X-ray imaging", *Philosophical Transactions of the Royal Society* **292A**, 223–232.

Hoyle, F., 1960. *The Nature of the Universe*, 2nd edn (Basil Blackwell: Oxford).

Hoyt, W.G., 1980. *Planets X and Pluto* (University of Arizona Press: Tucson).

Hren, J.J. & Ranganathan, S., eds, 1968. *Field-Ion Microscopy* (Plenum Press: New York).

Huck, F.O., Jobson, D.J., Park, S.K., Wall, S.D., Arvidson, R.E., Patterson, W.R. & Benton, W.D., 1977. "Spectrophotometric and color estimates of the Viking lander sites", *Journal of Geophysical Research* **82**, 4401–4411.

Huck, F.O., McCall, H.F., Patterson, W.R. & Taylor, G.R., 1975. "The Viking Mars lander camera", *Space Science Instrumentation* **1**, 189–241.

Hunten, D.M., Colin, L., Donahue, T.M. & Moroz, V.I., eds, 1983. *Venus* (University of Arizona Press: Tucson).

Johnson, T.V. & Soderblom, L.A., 1983. "Io", *Scientific American* **249** (n° 6), 60–71.

Judson, H.F., 1979. *The Eighth Day of Creation* (Simon & Schuster: New York).

Kahle, A.B., Madura, D.P. & Soha, J.M., 1980. "Middle infrared multispectral aircraft scanner data: Analysis for geological applications", *Applied Optics* **19**, 2279–2290.

Kahle, A.B. & Rowan, L.C., 1980. "Evaluation of multispectral middle infrared aircraft images for lithologic mapping in the East Tintic Mountains, Utah", *Geology* **8**, 234–239 + cover.

Kane, T.R. & Scher, M.P., 1969. "A dynamical explanation of the falling cat phenomenon", *International Journal of Solids and Structures* **5**, 663–670.

Keller, C.F., Jr. & Liebenberg, D.H., 1981. "The solar corona at totality", *Los Alamos Science* **2** (n° 1), 4–37.

Kihlborg, L., ed, 1979. Nobel Symposium 47, "Direct imaging of atoms in crystals and molecules", *Chemica Scripta* **14**.

Kopal, Z. & Mikhailov, Z.K., eds, 1962. *The Moon* (Academic Press: New York).

Krider, E.P., 1973. "Lightning spectroscopy", *Nuclear Instruments and Methods* **110**, 411–419.

Labeyrie, A., 1978. "Stellar interferometry methods", *Annual Review of Astronomy and Astrophysics* **16**, 77–102.

Lattes, C.M.G., Fujimoto, Y. & Hasegawa, S., 1980. "Hadronic interactions of high energy cosmic-ray [sic] observed by emulsion chambers", *Physics Reports* **65**, 151–229.

Lécuyer, R., 1945. *Histoire de la Photographie* (SNEP-Illustration: Paris).

Ledley, R.S., Huang, H.K. & Mazziotta, J.C., 1977. *Cross-sectional Anatomy – an Atlas for Computerized Tomography* (Williams & Wilkins: Baltimore).

Lipsky, Yu.N., 1961. "Charting the hidden side of the Moon", *Sky and Telescope* **21**, 132–139; Letter, *ibid.*, 199.

Luria, S.E. & Anderson, T.F., 1942. "The identification and characterization of bacteriophages with the electron microscope", *Proceedings of the National Academy of Sciences* **28**, 127–130.

Luria, S.E., Delbrück, M. & Anderson, T.F., 1943. "Electron microscope studies of bacterial viruses", *Journal of Bacteriology* **46**, 57–76.

Lynds, C.R., Worden, S.P. & Harvey, J.W., 1976. "Digital image reconstruction applied to Alpha Orionis", *Astrophysical Journal* **207**, 174–180.

Mach, E., 1910. *Popular Scientific Lectures*, 4th edn (Open Court: Chicago).

Mach, E. & Mach, L., 1889. "Weitere ballistisch-photographische Versuche", *Sitzungsberichte der Kaiserlichen Akademie der Wissenschaften, Mathematisch-Naturwissenschaftliche Classe* **98**, 1310–1332.

Mach, E. & Salcher, P., 1889. "Über die in Pola und Meppen angestellten ballistisch-photographischen Versuche", *Sitzungsberichte der Kaiserlichen Akademie der Wissenschaften, Mathematisch-Naturwissenschaftliche Classe* **97**, 1–10.

Mack, J.E., 1946. "July 16th nuclear explosion: space-time relationships", *Los Alamos Report* LA–531.

Malin, D.F., 1978. "Photographic amplification of faint astronomical images", *Nature* **276**, 591–593.

Malin, D.F., 1979. "A jet associated with M89", *Nature* **277**, 279–280.

Malin, D.F., 1980. "Colour photography in astronomy", *Vistas in Astronomy* **24**, 219–238.

Marey, E.-J., 1883. "Emploi des photographies partielles pour étudier la locomotion de l'homme et des animaux", *Comptes Rendus de l'Académie des Sciences de Paris* **96**, 1827–1831.

Marey, E.-J., 1890. *Le Vol des Oiseaux* (G. Masson: Paris).

Marey, E.-J., 1894. "Des mouvements que certains animaux exécutent pour retomber sur leurs pieds, lorsqu'ils sont précipités d'un lieu élevé", *Comptes Rendus de l'Académie des Sciences de Paris* **119**, 714–717 et seqq.

Marey, E.-J., 1895. *Movement* (William Heinemann: London).

Marey, E.-J., 1901. "Les mouvements de l'air étudiés par la chronophotographie", *La Nature*, 29e Année, pp 232–234.

Marey, E.-J., 1902. "The history of chronophotography" *Annual Report of the Smithsonian Institution for 1901*, 317–340.

Marsden, B.G., 1967. "The sungrazing comet group", *Astronomical Journal* **72**, 1170–1183.

Martinez, J., 1978. "A better photograph of coronal streamers", *Sky and Telescope* **56**, 92–94.

Masursky, H., Schaber, G.G., Soderblom, L.A. & Strom, R.G., 1979. "Preliminary geological mapping of Io", *Nature* **280**, 725–729 et seqq.

Matson, D.L., Goldberg, B.A., Johnson, T.V. & Carlson, R.W., 1978. "Images of Io's sodium cloud", *Science* **199**, 531–533.

McAlister, H.A., 1976. "Speckle interferometry of Eta Orionis", *Publications of the Astronomical Society of the Pacific* **88**, 957–959.

McAlister, H.A., 1977. "Binary-star speckle interferometry", *Sky and Telescope* **53**, 346–350.

McAlister, H.A., 1985. [Review of speckle interferometric measurements of binary stars], *Annual Review of Astronomy and Astrophysics*.

McCall, G.J.H., ed, 1979. *Astroblemes–Cryptoexplosion Structures* (Dowden, Hutchinson & Ross: Stroudsburg, Pennsylvania).

McCrosky, R.E., 1970. "The Lost City meteorite fall", *Sky and Telescope* **39**, 154–158.

McCrosky, R.E., Posen, A., Schwartz, G. & Shao, C.-Y., 1971. "Lost City meteorite – its recovery and a comparison with other fireballs", *Journal of Geophysical Research* **76**, 4090–4100.

McCrosky, R.E., Shao, C.-Y. & Posen, A., 1976 & 1977. "Prairie Network fireball data", *Center for Astrophysics Preprint* n°s 665 & 721 resp. (published in Russian in *Meteoritika* n° 37, pp 44–59 [1978] and n° 38, pp 106–156 [1979] resp.).

McDonnell, M.J. & Bates, R.H.T., 1976. "Digital restoration of an image of Betelgeuse", *Astrophysical Journal* **208**, 443–452.

Menter, J.W., 1956. "The direct study by electron microscopy of crystal lattices and their imperfections", *Proceedings of the Royal Society* **A236**, 119–135.

Michels, D.J., Sheeley, N.R., Jr., Howard, R.A. & Koomen, M.J., 1982. "Observations of a comet on collision course with the Sun", *Science* **215**, 1097–1102 + cover.

Miller, J.S. & Wampler, E.J., 1969. "Television detection of the Crab Nebula pulsar", *Nature* **221**, 1037–1038.

Miller, O.L., Jr., 1973. "The visualization of genes in action", *Scientific American* **228** (n° 3), 34–42; also *Offprint* n° 1267.

Miller, O.L., Jr., 1981. "The nucleolus, chromosomes, and visualization of genetic activity", *Journal of Cell Biology* **91**, 15s–27s.

Miller, O.L., Jr. & Beatty, B.R., 1979. "Visualization of nucleolar genes", *Science* **164**, 955–957 + cover.

Miller, O.L., Jr., Hamkalo, B.A. & Thomas, C.A., Jr., 1970. "Visualization of bacterial genes in action", *Science* **169**, 392–395.

Miller, W.C., 1959. "First color portraits of the heavens", *National Geographic* **115**, 670–679.

Miller, W.C., 1961. *Ansconian* n° 3, pp 1–9 + cover.

Miller, W.C., 1962. "Color photography in astronomy", *Publications of the Astronomical Society of the Pacific* **74**, 457–473.

Morabito, L.A., Synnott, S.P., Kupferman, P.N. & Collins, S.A., 1979. "Discovery of currently active extraterrestrial volcanism", *Science* **204**, 972.

Morrison, D., 1982. "Voyages to Saturn", *NASA SP–451*.

Morrison, D. & Samz, J., 1980. "Voyage to Jupiter", *NASA SP–439*.

Mouginis-Mark, P., 1981. "Ejecta emplacement and modes of formation of martian fluidized ejecta craters", *Icarus* **45**, 60–76.

Mozley, A.V., ed, 1972. *Eadweard Muybridge: The Stanford Years, 1872–1882* (Department of Art, Stanford University: Stanford, California).

Mulkin, B., 1981. "In flight: The story of Los Alamos eclipse missions", *Los Alamos Science* **2** (nᵒ 1), 38–47.

Müller, E.W., 1965. "Field ion microscopy", *Science* **149**, 591–601.

Müller, E.W. & Tsong, T.T., 1969. *Field Ion Microscopy: Principles and Applications* (American Elsevier: New York).

Mulvey, J.H., ed, 1981. *The Nature of Matter* (Clarendon Press: Oxford).

Murray, B.C. *et al.*, 1974. "Venus: Atmospheric motion and structure from Mariner 10 pictures", *Science* **183**, 1307–1315.

Muybridge, E.J., 1882. "The attitudes of animals in motion, illustrated with the zoopraxiscope", *Notices of the Proceedings of the Royal Institution* **10**, 44–56.

Nabarro, F.R.N., 1967. *Theory of Crystal Dislocations* (Clarendon Press: Oxford).

Neddermeyer, S.H. & Anderson, C.D., 1938. "Cosmic-ray particles of intermediate mass", *Physical Review* **54**, 88–89.

Neddermeyer, S.H. & Anderson, C.D., 1939. "Composition of cosmic rays, III: Nature of cosmic-ray particles", *Reviews of Modern Physics* **11**, 191–207.

Newhall, B., 1972. *The History of Photography*, rev edn (Secker & Warburg: London).

Nicks, O.W., 1967. "A review of the Mariner 4 results", *NASA SP–130*.

Nilsson, L., Furuhjelm, M., Ingelman-Sundberg, A. & Wirsén, C., 1977. *A Child is Born*, rev edn (Faber & Faber: London).

Nilsson, L., Lindberg, J., Ingvar, D.H., Nordfeldt, S. & Pettersson, R., 1974. *Behold Man* (Harrap: London).

Nitske, W.R., 1971. *Wilhelm Conrad Röntgen* (University of Arizona Press: Tucson).

Norman, D., 1938. "The development of astronomical photography", *Osiris* **5**, 560–594.

Nussenzweig, H.M., 1977. "The theory of the rainbow", *Scientific American* **236** (nᵒ 4), 116–127 + cover; also *Offprint* nᵒ 361.

Olby, R., 1974. *The Path to the Double Helix* (Macmillan Press: London).

Oldendorf, W.H., 1980. *The Quest for an Image of Brain* (Raven Press: New York).

Oliver, B.M., 1972. "The shape of the analemma", *Sky and Telescope* **44**, 20–22; see also 217.

Ordway, F.I., III, 1975. *Pictorial Guide to Planet Earth* (Thomas Y. Crowell: New York).

Ostriker, J.P., 1971. "The nature of pulsars", *Scientific American* **224** (nᵒ 1), 48–60.

Owen, T. & Terrile, R.J., 1981. "Colors on Jupiter", *Journal of Geophysical Research* **86**, 8797–8814.

Palade, G.E., 1971. "Albert Claude and the beginnings of biological electron microscopy", *Journal of Cell Biology* **50**, 5D–19D.

Peale, S.J., Cassen, P. & Reynolds, R.T., 1979. "Melting of Io by tidal dissipation", *Science* **203**, 892–894.

Peano, G., 1895. "Il principio delle aree e la storia d'un gatto", *Rivista di Matematica, Università di Parma* **5**, 31–32.

Peterson, B.A., Savage, A., Jauncey, D.L. & Wright, A.E., 1982. "PKS 2000–330: A quasi-stellar radio source with a redshift of 3.78", *Astrophysical Journal* **260**, L27–L29.

Pocock, R.I., 1926. "The external characters of *Thylacinus*, *Sarcophilus* and some related marsupials", *Proceedings of the Zoological Society* **68**, 1037–1084.

Porter, K.R., Claude, A. & Fullam, E.F., 1945. "A study of tissue culture cells by electron microscopy", *Journal of Experimental Medicine* **81**, 233–246.

Portugal, F.H. & Cohen, J.S., 1977. *A Century of DNA* (MIT Press: Cambridge, Massachusetts).

Powell, C.F., Fowler, P.H. & Perkins, D.H., 1959. *The Study of Elementary Particles by the Photographic Method* (Pergamon Press: London).

Pugh, P.R., 1983. "Benthic siphonophores: A review of the family Rhodaliidae (Siphonophora, Physonectae)", *Philosophical Transactions of the Royal Society* **301B**, 165–300.

Quam, L., Tucker, R., Eross, B., Veverka, J. & Sagan, C., 1973. "Mariner 9 picture differencing at Stanford", *Sky and Telescope* **46**, 84–87.

Rees, M.J., 1978. "Quasars", *Observatory* **98**, 210–223.

RISE Project Group, 1980. "East Pacific Rise: Hot springs and geophysical experiments", *Science* **207**, 1421–1433 + cover.

Rochester, G.D. & Butler, C.C., 1947. "Evidence for the existence of new unstable elementary particles", *Nature* **160**, 855–857.

Rochester, G.D. & Wilson, J.G., 1952. *Cloud Chamber Photographs of the Cosmic Radiation* (Pergamon Press: London).

Russo, A., 1981. "Fundamental research at Bell Laboratories: The discovery of electron diffraction", *Historical Studies in the Physical Sciences* **12**, 117–160.

Salanave, L.E., 1961. "The optical spectrum of lightning", *Science* **134**, 1395–1399.

Salanave, L.E., 1980. *Lightning and its Spectrum* (University of Arizona Press: Tucson).

Savage, A. & Peterson, B.A., 1983. "Unbiased searches for quasars beyond a redshift of 3.5", in G.O. Abell & G. Chincarini, eds, *Early Evolution of the Universe and its Present Structure* (D. Reidel: Dordrecht, Holland), pp 57–64.

Schmidt, M., 1963. "3C 273: A star-like object with large redshift", *Nature* **197**, 1040 *et seq*.

Schnapf, A., 1982. "The development of the TIROS global environmental satellite system", in "Meteorological satellites: Past, present and future", *NASA CP–2227*, pp 7–16.

Schonland, B.F.J., 1950. *The Flight of Thunderbolts* (Clarendon Press: Oxford).

Sciulli, F., 1979. "An experimenter's history of neutral currents", *Progress in Particle and Nuclear Physics* **2**, 41–87.

Sears Foundation for Marine Research, 1966. "Fishes of the western North Atlantic", Memoir nᵒ 1, pp 117–122.

Segrè, E., 1980. *From X-rays to Quarks* (W.H. Freeman & Co; San Francisco).

Sekido, Y. & Elliot, H., eds, 1984(?). *Early History of Cosmic-Ray Studies* (D. Reidel: Dordrecht, Holland).

Sharp, R.P. & Malin, M.C., 1975. "Channels on Mars", *Geological Society of America Bulletin* **86**, 593–609.

Sheeley, N.R., Jr., Howard, R.A., Koomen, M.J. & Michels, D.J., 1982. "Coronagraphic observations of two new sungrazing comets", *Nature* **300**, 239–242 + cover.

Sheeley, N.R., Jr., Michels, D.J., Howard, R.A., & Koomen, M.J., 1980. "Initial observations with the SOLWIND coronagraph", *Astrophysical Journal* **237**, L99–L101.

Short, N.M., Lowman, P.D., Jr., Freden, S.C. & Finch, W.A., Jr., 1976. "Mission to Earth: Landsat views the world", *NASA SP–360*.

Showalter, M.R. & Burns, J.A., 1982. "A numerical study of Saturn's F-ring", *Icarus* **52**, 526–544.

Skaife, T., 1860 & 1861. *Instantaneous Photography*, 1st & 2nd edns (Henry S. Richardson: Greenwich, J. Hogarth: London) resp.

Smith, B.A. *et al.*, 1977. "Voyager imaging experiment", *Space Science Reviews* **21**, 103–127.

Smith, B.A. *et al.*, 1979a. "The Jupiter system through the eyes of Voyager 1", *Science* **204**, 951–972.

Smith, B.A. *et al.*, 1979b. "The Galilean satellites and Jupiter: Voyager 2 imaging science results", *Science* **206**, 927–950.

Smith, B.A. *et al.*, 1981. "Encounter with Saturn: Voyager 1 imaging science results", *Science* **212**, 163–191.

Smith, B.A. *et al.*, 1982. "A new look at the Saturn system: The Voyager 2 images", *Science* **215**, 504–537.

Smith, F.G., 1977. *Pulsars* (Cambridge University Press: Cambridge).

Snellen, H.A., Dunning, A.J. & Arntzenius, A.C., eds, 1981. *History and Perspectives of Cardiology* (Leiden University Press: The Hague).

Soderblom, L.A., 1980. "The Galilean moons of Jupiter", *Scientific American* **242** (nᵒ 1), 88–100; also *Offprint* nᵒ 3071.

Soderblom, L.A. & Johnson, T.V., 1982. "The moons of Saturn", *Scientific American* **246** (nᵒ 1), 100–116; also *Offprint* nᵒ 3115.

Soha, J.M., Lynn, D.J., Mosher, J.A. & Elliott, D.A., 1977. "Digital processing of the Mariner 10 images of Venus and Mercury", *Journal of Applied Photographic Engineering* **3**, 82–92.

Spencer, N.W. & Nagy, A.F., eds, 1982. "Dynamics Explorer results", *Geophysical Research Letters* **9**, 911–1004.

Spitzer, C.R., ed, 1980. "Viking orbiter views of Mars", *NASA SP–441*.

Squyres, S.W., 1983. "Ganymede and Callisto", *American Scientist* **71**, 56–64.

Strain, C.V., 1947. "Solar spectroscopy at high altitudes", *Sky and Telescope* **6** (nᵒ 64), 3–6.

Strom, R.G., Terrile, R.J., Masursky, H. & Hansen, C., 1979. "Volcanic eruption plumes on Io", *Nature* **280**, 733–736 *et seqq*.

Synnott, S.P., Terrile, R.J., Jacobson, R.A. & Smith, B.A., 1983. "Orbits of Saturn's F-ring and its shepherding satellites", *Icarus* **53**, 156–158.

Tandberg-Hanssen, E., 1974. *Solar Prominences* (D. Reidel: Dordrecht, Holland).

Taylor, F.W. *et al.*, 1980. "Structure and meteorology of the middle atmosphere of Venus: Infrared remote sensing from the Pioneer orbiter", *Journal of Geophysical Research* **85**, 7963–8006.

Taylor, G.I., 1934. "The mechanism of plastic deformation of crystals, part I – theoretical; part II – comparison with observations", *Proceedings of the Royal Society* **A145**, 362–387 and 388–404.

Terrile, R.J., Capps, R.W., Backman, D.E., Becklin, E.E., Cruikshank, D.P., Beichman, C.A., Brown, R.H. & Westphal, J.A., 1979. "Infrared images of Jupiter at 5-micrometer wavelength during the Voyager 1 encounter", *Science* **204**, 1007–1008.

Thompson, D'A.W., 1942. *On Growth and Form*, 2nd edn (Cambridge University Press: Cambridge).

Thomson, G.P., 1928. "Experiments on the diffraction of cathode rays", *Proceedings of the Royal Society* **A117**, 600–609; **A119**, 651–663.

Thomson, G.P., 1962. "Early work in electron diffraction", *American Journal of Physics* **29**, 821–825.

Tidman, D.A., Davis, G., Herz, A.J. & Tennent, R.M., 1953. "Delayed disintegration of a heavy nuclear fragment, II", *Philosophical Magazine* **44**, 350–352.

Tombaugh, C.W., 1960. "Reminiscences of the discovery of Pluto", *Sky and Telescope* **19**, 264–270.

Tombaugh, C.W. & Moore, P., 1980. *Out of the Darkness: The Planet Pluto* (Lutterworth Press: Guildford).

Tousey, R., 1967. "Highlights of twenty years of optical space research", *Applied Optics* **6**, 2044–2070.

Tousey, R., 1977. "Apollo Telescope Mount of Skylab: An overview", *Applied Optics* **16**, 825–836.

Tsong, T.T., 1978. "Field-ion image formation", *Surface Science* **70**, 211–233.

Uematsu, S., ed, 1976. *Medical Thermography, Theory and Clinical Applications* (Brentwood: Los Angeles).

Ulrich, M.-H., 1980. "3C 273: A review of recent results", *Space Science Reviews* **28**, 89–104.

Uman, M.A., Seacord, D.F., Price, G.H. & Pierce, E.T., 1972. "Lightning induced by thermonuclear detonations", *Journal of Geophysical Research* **77**, 1591–1596.

Vaiana, G.S., Van Speybroeck, L., Zombeck, M.V., Krieger, A.S., Silk, J.K. & Timothy, A., 1977. "The S–54 X-ray telescope experiment on Skylab", *Space Science Instrumentation* **3**, 19–76.

Veiga-Pires, J.A. & Grainger, R.G., eds, 1982. *Pioneers in Angiography* (MTP Press: Lancaster).

Veverka, J., 1977. "Phobos and Deimos", *Scientific American* **236** (nᵒ 2), 30–37 + cover; also *Offprint* nᵒ 352.

Vogt, R.E., Chenette, D.L., Cummings, A.C., Garrard, T.L., Stone, E.C., Schardt, A.W., Trainor, J.H., Lal, N. & McDonald, F.B., 1982. "Energetic charged particles in Saturn's magnetosphere: Voyager 2 results", *Science* **215**, 577–582.

Waldrop, M.M., 1981. "Nature's own particle accelerator", *Sky and Telescope* **62**, 208–215.

Watson, J.D., ed Stent, G.S., 1981. *The Double Helix* (Weidenfeld & Nicolson: London).

Whitaker, E.A., 1962. "Evaluation of the Russian photographs of the Moon's far side". *Communications of the Lunar and Planetary Laboratory* **1**, 67–71.

Wiener, D., 1983. "The photography of the first atomic bomb", *Photographic Journal* **123**, 486–491.

Wilkerson, M.S. & Worden, S.P., 1977. "Further speckle interferometric studies of Alpha Orionis", *Astronomical Journal* **82**, 642–645.

Wilson, C.T.R., 1911. "On a method of making visible the paths of ionising particles through a gas", *Proceedings of the Royal Society* **A85**, 285–288.

Wilson, C.T.R., 1912. "On an expansion apparatus for making visible the tracks of ionising particles in gases and some results obtained by its use", *Proceedings of the Royal Society* **A87**, 277–290.

Wood, E.H., 1965. "Thermography in the diagnosis of cerebrovascular disease", *Radiology* **85**, 270–283.

Worthington, A.M., 1908. *A Study of Splashes* (Longmans, Green & Co: London).

Worthington, A.M. & Cole, R.S., 1897. "Impact with a liquid surface, studied by the aid of instantaneous photography", *Philosophical Transactions of the Royal Society* **189A**, 137–148.

Worthington, A.M. & Cole, R.S., 1900. "Impact with a liquid surface studied by the aid of instantaneous photography – Paper II", *Philosophical Transactions of the Royal Society* **194A**, 175–200.

Yoder, C.F., 1982. "Tidal rigidity of Phobos", *Icarus* **49**, 327–346.

Zwally, H.J. & Gloersen, P., 1977. "Passive microwave images of the polar regions and research applications", *Polar Record* **18**, 431–450.

Subject Index

Index of Names